RADICAL HISTORY &
THE POLITICS OF ART

New Directions in Critical Theory

New Directions in Critical Theory

Amy Allen, General Editor

New Directions in Critical Theory presents outstanding classic and contemporary texts in the tradition of critical social theory, broadly construed. The series aims to renew and advance the program of critical social theory, with a particular focus on theorizing contemporary struggles around gender, race, sexuality, class, and globalization and their complex interconnections.

GABRIEL ROCKHILL

RADICAL HISTORY &

THE POLITICS OF ART

Columbia University Press / New York

Columbia University Press
Publishers Since 1893
New York Chichester, West Sussex
cup.columbia.edu
Copyright © 2014 Columbia University Press

Library of Congress Cataloging-in-Publication Data
Rockhill, Gabriel.
 Radical history & the politics of art/ Gabriel Rockhill.
 pages cm. — (New directions in critical theory)
 Includes bibliographical references and index.
 ISBN 978-0-231-15200-6 (cloth : alk. paper) —ISBN 978-0-231-15201-3
(pbk. : alk. paper) —ISBN 978-0-231-52778-1 (e-book)
 1. Aesthetics—Political aspects. 2. History—Philosophy. 3. Critical theory.
4. Radicalism. I. Title. II. Title: Radical history and the politics of art.

BH301.P64R63 2014
701'.17—dc23 2013046212

Columbia University Press books are printed on permanent and durable
acid-free paper.
This book is printed on paper with recycled content.
Printed in the United States of America

c 10 9 8 7 6 5 4 3 2 1
p 10 9 8 7 6 5 4 3 2 1

Cover design by Noah Arlow

To Finley

CONTENTS

ACKNOWLEDGMENTS

I would like to express my deep gratitude to all of those who have contributed to this book. First and foremost, I would like to thank the friends and colleagues who read and commented on earlier versions of the manuscript: Amy Allen, Avi Alpert, Esteban Buch, Nadir Lahiji, John-Patrick Schultz, Julian Sempill, and Ádám Takács. I would also like to express my gratitude to all of those who have provided crucial feedback on various stages of this project, including Roei Amit, Richard Beardsworth, Bruno Bosteels, Walter Brogan, Eric Carlson, Pierre-Antoine Chardel, Andrès Claro, Jean-Pierre Cometti, Tom Conley, Mladen Dolar, Thomas R. Flynn, Nancy Fraser, Alfredo Gomez-Muller, Solange Guénoun, Nathalie Heinich, Alexi Kukuljevic, Marielle Macé, Todd May, Eric Méchoulan, Jairo Moreno, Stephan Packard, Jean-Michel Rabaté, Jacques Rancière, Zach Rockhill, Philip Roussin, Pierre Rusch, Natacha Smolianskaia, Jan Spurk, Annika Thiem, Philip Watts, and Yves Winter. The Machete Group members and our various collaborators deserve particular mention for the opportunity to work together on sundry projects in an extra-academic setting and test some of the ideas advanced in this book.

This work owes a special debt to all of the institutions and research centers that provided me with the opportunity to present various aspects of this project, which include the Centre de Recherches sur les Arts et le

Langage (CRAL) at the CNRS and the EHESS, the Collège International de Philosophie, the Centre Franco-hongrois en Sciences Sociales at Eötvös Loránd University in Budapest, the Institut Français in Budapest, the Slought Foundation, the Institute of Contemporary Art in Philadelphia, Marginal Utility Gallery, the University of Giessen, the Jan Van Eyck Academie, the IWAB in South Korea, the University of Pennsylvania, Duquesne University's Philosophy Department, DePaul University's Philosophy Department, Proekt Fabrika, and the National Center for Contemporary Arts in Moscow.

I would like to extend a special thank you to Villanova University's Philosophy Department, which has provided ideal working conditions for completing this manuscript. Annika Thiem deserves special mention for her assistance with German translations as well as for the opportunity to co-teach a graduate seminar with her on critical theory in which I presented some of the ideas in this book. I am also grateful to the students in this seminar, who provided extremely useful input.

The Office of Research and Sponsored Projects at Villanova University was particularly supportive of this project, and I would like to express my sincere gratitude. Their Summer Research Fellowship and Research Support Grant were essential to the completion of the final version of the manuscript. Villanova University also deserves special mention for the generous support provided in the form of a semester sabbatical, as well as for the financial support administered by the Board of Publications for covering the costs of a professional indexer. I would also like to thank the Collège International de Philosophie and the CRAL for their material, institutional, and intellectual support.

I would like to express my gratitude to the editorial staff of the following journals, who have allowed me to publish earlier versions of certain texts and rework them for the current publication:

Chapter 5: "The Silent Revolution," *SubStance: A Review of Theory and Literary Criticism* 103, vol. 33, no. 1 (2004): 54–76.

Chapter 6: "Rancière's Productive Contradictions: From the Politics of Aesthetics to the Social Politicity of Artistic Practices," *Symposium* 15, no. 2 (Fall 2011): 28–56.

This book would not have been possible without the support and advice of Amy Allen, the general editor of the New Directions in Critical Theory series, and Wendy Lochner, the publisher for philosophy and religion at Columbia University Press. Their suggestions have been essential to bringing the manuscript into its final form.

Finally, I would like to express my deep gratitude to my family for all of their support through the years. Emily, Marlow, and Finley deserve particular mention *pour toutes les petites choses dont est tissée la vie de tous les jours.*

RADICAL HISTORY &
THE POLITICS OF ART

INTRODUCTION

Art and Politics in the Time of Radical History

POINTS OF DEPARTURE

Reflections on art and politics commonly begin with an inquiry into the specific nature of these two entities, as well as into possible connections between them. This tends to lead to two logical possibilities, which serve as bookends to numerous middle-ground and hybrid positions: either art and politics form completely autonomous spheres divided by an insurmountable barrier, or they constitute domains that do indeed influence each other through privileged points of interaction. These two extremes appear to be mutually exclusive insofar as they defend opposite conclusions regarding the possibility or impossibility of linking art and politics. However, it is important to recognize that they are founded on the same basic point of departure: the assumption that art and politics each have their own proper nature, and that there is a definitive and definable relationship between them. One of the central aims of this book is to critically examine the viability of this supposition by raising a series of questions concerning the precise status of the supposed entities called 'art' and 'politics.'

Everything hinges, as we will see, on the starting point, in the double sense of the beginning point for reflections on art and politics, as well as the point of departure for the constitution of these entities themselves. It

depends, in other words, on the historicity of these supposedly distinct elements, and the initial question raised by this work is: where did these entities come from? It is sometimes assumed—implicitly or not—that they have simply always existed. However, this is not at all self-evident. To take the most blatant case, there is abundant evidence that suggests that the modern European concept and practice of art are very far from being historical or cultural invariants. On the contrary, many have argued, as we will see, that these date from approximately the eighteenth century. Numerous authors have advanced analogous arguments regarding politics in the modern sense of the term. Even those who expand the time scale and assert, for instance, that politics has existed at least since the ancient Greeks, if not before, do not necessarily claim that politics has *always* existed. Such an affirmation would require grasping politics *sub specie aeternitatis* and proving that it existed prior to the historical emergence of the world as we currently know it. This ultimately includes—in the grand scheme of things—the historical appearance of sentient beings like Homo sapiens, as well as their practices and concepts. From the perspective of what we might call deep history, or the history that is not restricted by the anthropocentric time scale of traditional history, it is patently unclear how it could ever be truly proven that art and politics have indeed always existed.

If it is accepted, then, that these are dynamic entities that emerged in history—and certainly in deep history—at some point in time, there are at least two ways of conceiving of this dynamism. One consists in supposing that there is an invariant kernel at the heart of historical changes, which thereby correspond to so many different facets of the entity in question. Insofar as it remains a fixed reference point, this invariable essence is precisely what allows us to measure alterations and compare across time periods. However, if appearances can change with time, why must we presume that the core essence of phenomena cannot be transformed? If these did indeed appear in time, then they must have undergone at least one major historical transformation. Therefore, they could, at least in principle, disappear or undergo other significant alterations at different points in time. This line of thought leads to the conclusion that art and politics are fully historical in the sense that they have no transhistorical or ahistorical essence.

To be sure, this brief account of one possible intellectual itinerary leading from ahistoricism to what I will call selective historicism and finally to radical history or radical historicism does not purport to prove the superiority of a particular theoretical position. On the contrary, these prefatory remarks seek to succinctly elucidate some of the theoretical background for the decision to abandon the common sense point of departure in order to explore the consequences and implications of a radical historicist orientation. They also allow me the opportunity to begin introducing some of the key conceptual vocabulary that will guide us in the analyses that follow. Ahistoricism, to begin with, ignores or rejects the historical development of phenomena, whereas selective historicism recognizes the historicity of privileged entities or concepts, which themselves more or less escape the flow of time. It selects—hence its name—what transcends historical transformation: the deep kernels of reality that allow us to measure change. Radical history, on the contrary, recognizes that everything is historical, including our most privileged practices, cherished concepts, and venerated values. This does not mean in the least that all things are historically determined, which would lead to the position of reductive historicism (nor does it mean that everything is historical in the exact same sense). The adjective *radical* refers both to the dissolution of the supposedly natural objects of history and to the dynamic role of different forms of agency in history.

One of the central working hypotheses of this book is that radical history subverts the fundamental assumption that has undergirded much of the debate on art and politics: the idea that there are two distinct entities with a determinate relation. If what we call 'art' and 'politics' are recognized as variable sociohistorical practices that have no essential nature or singular relation, then we need to entirely rework our understanding of these practices, beginning with the very questions that are raised. The classic, common sense trinity—what is art? what is politics? what is their relation?—becomes obsolete as soon as it is acknowledged that there is not a single, ontological answer to any of these questions. Radical history thereby opens a fundamentally different field of inquiry and introduces a unique gamut of questions by maintaining that there is not, in fact, a firm starting point with clearly delimited entities whose unique relation

can be definitively described. It begins, in other words, by recognizing that there is no absolute point of departure: we always start in the middle, so to speak, in a complex nexus of immanent, historically constituted notions and practices.

Conceptually, radical history undermines the belief in transcendent ideas, meaning transhistorical notions that purport to guarantee the true meaning of our terms. The critique of the illusion of transcendence and of the assumption that there is—or must be—a common property unifying the fundamental building blocks of thought does not, however, lead to the conclusion that we are trapped in a relativist vortex of theoretical nonsense. Defenders of radical historicism, in resisting relativist blackmail, recognize that there are indeed immanent notions, meaning operative concepts that circulate in the social world at a given point in time. In our day and age, for instance, there are widely accepted uses of terms like *art* and *politics*. They do not necessarily have precise definitions or rigorously determined semantic borders, but they function instead as notions in struggle. They operate in a force field that is sometimes the site of interventionist concepts, which are *idées-forces* that attempt to reconfigure the given matrix of immanent conceptuality.

The theorization of radical history, as it is developed through the course of this book, functions as just such an intervention. It does not purport to describe the true nature of history or identify its invariable essence or structure. It is a situated and circumspect intervention into a field of struggle that seeks to operate a fundamental displacement. In terms of the vocabulary just introduced, it could be said that this is a displacement from a theory of transcendent ideas to an analytic of immanent practices. A theory, at least in the restricted sense of the term, begins with the presumed existence of natural objects of history or transcendent ideas (such as Art and Politics). An analytic, on the contrary, examines the differential relations between socially constituted practices as well as the historical formation of supposedly natural objects. It does not presume the existence of more or less fixed entities with a single, determinate relation. It acknowledges, in other words, that there is no absolute point of departure because we always 'begin' in a historically constituted immanent field of practice.

THE POLITICS OF ART, SOCIAL AGENCY, AND RADICAL HISTORY

In contesting the common point of departure for debates on art and politics, one of the primary objectives of this book is to open new vistas for rethinking artistic and political practices. This includes revisiting the basic methodological framework of the very question of art and politics, proposing a multidimensional theory of social agency and developing an alternative logic of history.

Regarding the methodological framework, to begin with, the common sense point of departure is based on the ontological illusion, or the unfounded assumption that there is a being or fixed nature behind phenomena such as art and politics. It is closely tied to the epistemic illusion, according to which it is possible to have *epistēmē* or rigorous knowledge of these phenomena as well as their relation. This methodological framework lends itself to the establishment of fixed formulas: *this* art has *this* political consequence or implication. Such recipes are often structured by an undergirding binary normativity, according to which the artistic world is divided between authentic and inauthentic art, truly political and apolitical artwork, and so forth. Regardless of the specific terms that are used, it is generally a matter of opposing good and evil according to a strict dichotomy. This not only presupposes a heightened form of *epistēmē*. It is also founded on a restrictive conception of political efficacy that aims at definitively distinguishing between successful and unsuccessful political art. Theorists thus regularly draw up balance sheets opposing, for instance, realism to avant-gardism, autonomous art to the culture industry, the aesthetic dimension to the affirmation of reality, and so forth. By isolating works of art in various ways from the complexity and variability of their social nexus, theorists often act as if there were only two possibilities: success or failure. Furthermore, the political valence of art is frequently situated in the artistic work itself. According to what I will call the talisman complex, it is assumed that the individual artwork is—or is not—the bearer of a unique political force comparable to the magical powers of a talisman. Like the latter, a successful

artistic object or practice is supposed to be capable of directly provoking changes in the world via an obscure preternatural alchemy.

One of the core problems in contemporary debates on art and politics is the social epoché, meaning the tendency to bracket the intricate social relations at work in aesthetic and political practices. When the social sphere is taken into account, it is often reduced to a binary and determinist social logic in which it is assumed that there is a single determinate matrix that works of art react to (by either confirming or rejecting it). It is rare that theorists take into full consideration the social force field constituted out of the multiple sites and types of agency involved in the production, distribution, and reception of aesthetic practices (and, for that matter, of political activities). Such a social epoché runs the risk, as we will see, of casting a long shadow over the social complex in which diverse dimensions of aesthetic and political practices overlap, entwine, and sometimes merge. By setting aside to a greater or lesser extent the social world—and hence the political realm as it is commonly understood—the politics of art is largely reduced to the magical powers of talisman-like objects to more or less miraculously produce political consequences (or fail to do so).

In order to definitively part ways with the politics of the isolated aesthetic artifact, it is important to explore the intertwined relationship between these three heuristically distinct social dimensions of aesthetic practices— creation, circulation, interpretation—in order to chart out their social politicity, meaning the political dimensions that play themselves out in the historical struggles between various forms of social agency. The central framing question is thus no longer: "what is the privileged connection between art—and more precisely the individual aesthetic artifact—and politics?" It is also not its pessimistic inversion: "why is there no link between art and politics?" Instead, the attempt to think the social politicity of aesthetic practices raises the question: "how do diverse dimensions of the practices socially labeled as 'aesthetic' and 'political' cross, intertwine, interlace, and at times become coextensive?"

The examination of the social politicity of aesthetic practices requires an alternative account of agency that recognizes its multiple types, tiers, ranges, and sites. The politics of art is not the result of one privileged point

of agency according, for instance, to the monocausal determinism inherent in the talisman complex. It is a battlefield of rival forces that are of various kinds, that operate at different levels of determinacy, that have specific ranges of efficacy, and that are anchored in concrete sites of agency. In fact, the expression *the politics of art* might not even be appropriate insofar as it suggests that there is a politics inherent in art. Since political and aesthetic practices play themselves out in a veritable force field of agencies and are generally irreducible to the monolithic opposition between complete success and absolute failure, it is more appropriate to speak of the social struggles over the politicity of aesthetic practices.

These battles are not synchronic but are part of a larger historical dynamic. It is important, therefore, to develop this multidimensional account of social agency in conjunction with an alternative historical order. By historical order or logic, I mean a practical mode of intelligibility of history that is at one and the same time a way of understanding and of practicing history. The historical order proposed in the following pages takes into account three heuristically distinct dimensions of history: the vertical dimension of chronology, the horizontal dimension of geography, and the stratigraphic dimension of social practice. Such an approach allows us to chart out historical constellations in time, space, and society, thereby avoiding the widespread problem of historical compression (which consists in flattening one or more of the dimensions of history). It also leads to an alternative account of historical change in terms of phases and metastatic transformations. A phase, unlike an epoch or time period, is variably distributed through the three dimensions of history. It changes by metastatic transformations, which are variable rate alterations that morph in diverse ways through time, space, and society.

This alternative logic of history and theory of agency provide for a very different account of aesthetic and political practices. In describing some of the specific conjunctural encounters between them, this book simultaneously seeks to intervene in the battlefields that it adumbrates. It mobilizes what I will call the dual position by detailing immanent fields of practice while also interceding in them in order to operate displacements through concrete points of leverage. Indeed, the descriptions provided are already

specific forms of anchored intervention. Although I will insist on this regarding the interpretations of aesthetic practices, this is obviously also the case for the interpretations of theoretical works that are advanced: they are descriptive interventions that seek to shift our understanding of these works in a particular direction (at times by heuristically relying on oppositional framing devices). In this light, the overall objective of this book is to leverage the debate on art and politics in the direction of a radically historicist analytic of aesthetic and political practices.

A PALIMPSEST OF RADICAL HISTORY

In what follows, the claims advanced in the preceding paragraphs will be drawn out of detailed historical explorations into the relationship between 'artistic' and 'political' practices. Divided into four parts comprising two chapters each, this book is organized as a series of layers whose superimposition seeks to produce the effect of a palimpsest. Early chapters will bleed through and become visible, in a different light, in later chapters, just as the latter will come to fill in lacunae in the opening sections. The juxtaposition of these different layers aims at creating a dense texture with multiple entrance points rather than a sequential or progressive narrative with a single beginning and a definite end.

Each tier can be read independently, but they ultimately infiltrate and inform one another. If the book is read from start to finish, the initial layer is composed of an outline of a radical historicist analytic of aesthetic and political practices, whose praxeological orientation stands in stark contrast to the quixotic search for the privileged link (or insurmountable dividing line) between art and politics. This chapter provides a sketch of the book's basic conceptual armature and develops many of the theoretical strategies that are used throughout the work as a whole, and whose numerous implications are drawn out in subsequent chapters. The next stratum consists in an examination of three major positions on art and politics in the twentieth century—realism, formalism, and commitment—

through the study of the work of prominent figures in the Marxian tradition: Georg Lukács, Herbert Marcuse, and Jean-Paul Sartre. This chapter combines an exegetical endeavor to rigorously present analytic positions found in certain of these authors' key publications with a critical account of some of their shared shortcomings, which range from the ontological illusion and the talisman complex to binary normativity, historical determinism, and the social epoché. A clear juxtaposition thereby emerges between the radical historicist analytic of practice discussed in the first chapter and three of the important positions on art and politics found in the twentieth century.

The second major plane of investigation concerns one of the central focal points for contemporary debates on art and politics: the status of the avant-garde and its relation to radical experiments in politics. Often considered to be one of the privileged historical moments of close encounter between art and politics, the avant-garde of the early twentieth century shared the historical stage, in many ways, with the vanguard of the Russian Revolution. Chapter 3 opens, therefore, by exploring the 'end of illusions' thesis and the widespread assumption, in the contemporary world, that the avant-garde and the revolutionary vanguard shared a common historical destiny, leading them both toward their eventual—but perhaps inevitable—failure. After briefly touching on the consequences of this thesis in contemporary critical theory, it undertakes a detailed investigation of the flagship publication by Peter Bürger, *Theory of the Avant-Garde*. Unearthing its deep-seated idealism, it calls into question its conceptual reduction of the avant-garde to an undertaking whose objective is logically impossible: to destroy the concept of art while producing inorganic works of art. Chapter 4 mobilizes the alternative historical logic and theory of social agency developed in chapter 1 in order to foreground specific elements that problematize the nearly ubiquitous thesis on the failure of the avant-garde. These range from the diversity and variability of avant-garde practices (as well as of their social circulation and reception) to different understandings of social efficacy, the spread of the temporality of avant-garde production in the art world, and what is arguably the triumph of the avant-garde in certain forms of architecture and design. The juxtaposition of these two chapters functions as an

untimely invitation to reopen, in a new light, the supposedly closed question of the avant-garde encounters between art and politics.

Part 3 introduces a new level of analysis by turning to the important work of a contemporary thinker, Jacques Rancière, who has proposed a complete rethinking of the relation between aesthetics and politics, and who has significantly reconfigured the historical models for understanding their development. Chapter 5 meticulously outlines his position and situates it in relationship to the work of some of his illustrious predecessors, including Michel Foucault and Gilles Deleuze. It highlights the specificity of what could be schematically referred to as his Copernican revolution insofar as he rejects the search for the privileged link between aesthetics and politics in favor of studying their consubstantiality as distributions of the sensible. Chapter 6 focuses on one of the fundamental contradictions that plagues Rancière's apparently novel reopening of the question of art and politics: his affirmation of the consubstantiality of aesthetics and politics is curtailed by his incessant claims that art and politics proper never truly meet in any determined sense. By unpacking this contradiction, it argues that Rancière's work is ultimately beset by many of the shortcomings highlighted in the writings of his precursors. In contrast to his approach, and in line with the arguments advanced in the preceding parts, this chapter proposes to shift the nature of the debate from the politics of aesthetics to the social politicity of aesthetic practices.

The fourth and final layer of analysis marshals many of the arguments of the previous chapters in order to develop an account of social politicity. Chapter 7 is an extended case study that seeks to demonstrate the relevancy of the conceptual reconfiguration undertaken in the book as a whole. By concentrating on the extreme case of works of art that are purportedly apolitical—the paintings by the Abstract Expressionists—it examines the social politicity of their work as it is bound up in the complex matrices of Cold War power politics. At the same time, it mobilizes the alternative logic of history and theory of social agency developed in the earlier parts of the book in order to provide a specific account of the cultural battlefield of artistic and political practices. The concluding chapter serves as a final stratum that draws out the ultimate consequences from the ongoing critique

of the ontological illusion and the talisman complex. It also expands the argument in favor of an examination of the social politicity inherent in the production, circulation, and reception of works of art. It thereby provides a developed overview and synthetic rearticulation of many of the key themes of the book.

As so many layers in a dense palimpsest, these eight chapters illuminate one another through juxtaposition and reciprocal resonance. The overall objective is to marshal motley points of view in a manifold of diverse argumentative strata in order to open space for rethinking art and politics in terms of a radical historicist orientation, which recognizes the existence of multiple forms of social agency and provides a praxeological account of cultural activities. Instead of purporting to have discovered the true or authentic bridge between two ontological entities, or definitively concluding that there is no connection between them, this book examines and intervenes in the social force field of immanently constituted practices in order to try to displace the theoretical coordinates governing the debate on 'art' and 'politics.'

PART I

HISTORICAL ENCOUNTERS
BETWEEN ART AND POLITICS

1

FOR A RADICAL HISTORICIST ANALYTIC OF AESTHETIC AND POLITICAL PRACTICES

IMMANENT, TRANSCENDENT, AND INTERVENTIONIST CONCEPTS

But if the colors in the original merge without a hint of any outline won't it become a hopeless task to draw a sharp picture corresponding to the blurred one? . . . This is the position you are in if you look for definitions corresponding to our concepts in aesthetics or ethics.

—LUDWIG WITTGENSTEIN

There is no such thing as art and politics in general. They do not exist as natural entities, cultural invariants, universal concepts, or strictly unified practices. There are only variable theoretical configurations and constellations of practices that are identified as artistic or political within variegated societies at diverse points in time. However, the naturalization of these terms and a lack of ethnographic distance from our own cultural practices tend to foster the ontological illusion, or the mistaken assumption that there is—or even must be—a 'being' of art and politics, which can be identified once and for all. This illusion has guided many a thinker in their quest for a theoretical El Dorado in which conceptual

elements would be forever present in their most pristine form. It has led, for instance, to the motley kinds of retrospective or archeological teleology by which thinkers myopically project the end point of history back onto its beginning as if art and politics as they exist today had always existed. It is equally at the origin of the ethnocentric projection of one's own cultural forms onto the sundry societies that have inhabited the planet. Finally, it is the primary source of the seemingly endless attempts to discover the privileged link between these hypostatized elements, as if there were a single, natural relation between art and politics that could be determined once and for all.

Relativist blackmail is one of the strongest deterrents to the full-scale rejection of the ontological illusion: we are told that if there are no stable entities or fixed concepts, then everything will be swept into an abysmal vortex of chaotic flux and relativist pandemonium. In countering this blackmail and the simplistic choice between universalism and relativism, we can take our cue from the work of the later Ludwig Wittgenstein:

> What is the meaning of a word? . . . The questions "What is length?," "What is meaning?," "What is the number one?" etc., produce in us a mental cramp. We feel that we can't point to anything in reply to them and yet ought to point to something. (We are up against one of the great sources of philosophical bewilderment: a substantive makes us look for a thing that corresponds to it.)[1]

The existence of terms such as *art* and *politics* immediately suggests that there must be some *thing* that corresponds to them. In fact, if we are unable to detail the common property at the core of such words, it is often assumed that we have not grasped their true meaning. However, this is precisely where Wittgenstein intervenes in order to break with an extremely widespread but misguided conception of the pragmatics of language:

> The idea that in order to get clear about the meaning of a general term one had to find the common element in all its applications has shackled philosophical investigation; for it has not only led to no result, but

also made the philosopher dismiss as irrelevant the concrete cases, which alone could have helped him to understand the usage of the general term. When Socrates asks the question, "what is knowledge?" he does not even regard it as a *preliminary* answer to enumerate cases of knowledge.[2]

Wittgenstein adeptly points out that problems only arise when we try to transcend the actual use of terms in order to establish conceptual generalities. There is, in fact, no problem at the level of pragmatic function. In many ways, he thereby takes sides with Socrates's interlocutors, who describe the use of terms rather than trying to abstract from them in order to isolate a supposedly essential feature. Taking the example of Socrates's question "what is knowledge?" he declares: "We should reply: 'There is no one exact usage of the word 'knowledge'; but we can make up several such usages, which will more or less agree with the ways the word is actually used.'"[3] The same could be said of terms like *art* and *politics*: there is no definitive conceptual feature unifying all of their uses. Therefore, it is a methodological mistake to search for an exact usage or a single, essential property.

This does not, however, mean that such general terms thereby fall prey to sheer relativism. On Wittgenstein's account, family resemblances link various uses together without reducing them to a common property:

> We are inclined to think that there must be something in common to all games, say, and that this common property is the justification for applying the general term "game" to the various games; whereas games form a *family* the members of which have family likenesses. Some of them have the same nose, others the same eyebrows and others again the same way of walking; and these likenesses overlap.[4]

The abandonment of the misguided search for common properties does not, therefore, condemn him to a form of linguistic relativism in which terminological and conceptual use endlessly fluctuates. On the contrary, he insists on the praxeological status of language and the role of the immanent normativity of social usage: rather than being a purified semantic order based on strictly defined rules and firm definitions, language is properly speaking

a practice whose variable forms are mediated by cultural customs and social norms.[5] Devoid of common properties, terms nonetheless function according to family resemblances within general fields of socially accepted usage. The fact that these fields do not have clearly delimited borders does not inhibit them from functioning (on the contrary):

> For remember that in general we don't use language according to strict rules—it hasn't been taught us by means of strict rules, either. *We*, in our discussions on the other hand, constantly compare language with a calculus proceeding according to exact rules. This is a very one-sided way of looking at language. In practice we very rarely use language as such a calculus. For not only do we not think of the rules of usage—of definitions, etc.—while using language, but when we are asked to give such rules, in most cases we aren't able to do so. We are unable clearly to circumscribe the concepts we use; not because we don't know their real definition, but because there is no real "definition" to them. To suppose that there *must* be would be like supposing that whenever children play with a ball they play a game according to strict rules.[6]

One of the drawbacks to Wittgenstein's methodological orientation is that he sometimes writes as if it were sufficient to simply describe the present state of a particular language, and he regularly appeals to a rather homogenous form of linguistic common sense based on what we would say in a particular instance (as if there were a generic *das Man* serving as the universal arbiter for linguistic use). Fortunately, there are, however, a number of important passages where he clearly distances himself from this ahistorical and partially extra-social account of language. In *The Blue Book*, for instance, he touches on the temporal process of language acquisition and correlates language games with "the forms of language with which a child begins to make use of words."[7] In the *Philosophical Investigations*, he also appeals to the importance of inquiring into the genetic process by which we learn the meaning of particular words. Moreover, he emphasizes, on at least a few occasions, the historicity of language itself, as in his description of language as an ancient city and his assertion that "new types of language,

new language-games, as we may say, come into existence and others become obsolete and get forgotten."[8]

This theme is important to Wittgenstein's posthumously published lectures on aesthetics. He begins by asserting that "the subject (Aesthetics) is very big and entirely misunderstood as far as I can see."[9] He then appeals to the genetic methodology just mentioned: "One thing we always do when discussing a word is to ask how we were taught it."[10] It is against the backdrop of these introductory remarks that he affirms that language games change with history as well as with the social and cultural context. For instance, he not only makes reference to historical changes in language, but he claims that "what we now call a cultured taste perhaps didn't exist in the Middle Ages. An entirely different game is played in different ages."[11] He also evinces an interest in sociocultural differences, clearly suggesting that language games can radically diverge from culture to culture: "Imagine an entirely different civilization. Here there is something you might call music, since it has notes. They treat music like this: certain music makes them walk like this."[12] Finally, he hints in passing at the ways in which individuals within the same culture can have divergent social trajectories that lead them to use words in different ways.[13]

Although it is ultimately true that Wittgenstein only provided rudimentary tools for thinking the historicity and cultural variability of linguistic practices, he nonetheless formulated a compelling critique of the 'craving for generality' and adumbrated a praxeological account of language that begins with social use rather than with the supposed calculus of common properties, essential meanings, and strict semantic rules. His praxeology can therefore serve as a helpful reference point for developing a heuristic distinction between three different conceptual registers, which are always part of specific practices: transcendent ideas, immanent notions, and interventionist concepts. Transcendent ideas, to begin with, emerge out of the pretension to have grasped the common property of general terms, which are thereby defined once and for all. Insofar as they seek to transcend the sociohistorical world or, at the very least, synthesize all social use at one point in time, they are ultimately rooted in the illusion of transcendence, or the mistaken assumption that a general term has a single meaning based on

a common conceptual property. For this assumption to hold, signification would have had to be established transcendently, and there would need to be some form of external, more or less metaphysical guarantee to meaning. "Let's not forget," Wittgenstein adeptly proclaims, "that a word hasn't got a meaning given to it, as it were, by a power independent of us, so that there could be a kind of scientific investigation into what the word *really* means. A word has the meaning someone has given to it."[14]

Unlike transcendent ideas, immanent notions are part and parcel of specific sociohistorical practices within a particular conjuncture. Since they emerge in unique fields of activity, they are bound up with distinctive cultural matrices, which themselves are dynamically negotiated and renegotiated between various forms and levels of agency. Moreover, insofar as they are social phenomena, immanent notions are not univocal. Within the same sociohistorical juncture there can be, and often are, motley and rival accounts of general concepts such as art and politics. Against the tendency of transcendent conceptuality to ignore or bracket the social dimension of thought, it is crucial to insist on the ways in which concepts are part of social practices. It should therefore be no cause for dismay that there are no strict limits to immanent notions. As Wittgenstein regularly explains, general terms do not need to be clearly delimited in order to function in social discourse. In discussing the word *game*, for instance, he writes: "how is the concept of a game bounded? What still counts as a game and what no longer does? Can you give the boundary [*Grenzen*]? No. You can *draw* one; for none has so far been drawn. (But that never troubled you before when you used the word 'game.')"[15] It is, of course, possible to give precise definitions in particular instances. However, these are by no means necessary, nor do they automatically hold for all other uses of the term: "we can draw a boundary—for a special purpose. Does it take that to make the concept usable? Not at all! (Except for that special purpose.) No more than it took the definition: I pace = 75 cm. to make the measure of length 'one pace' usable."[16]

There are no strict limits, in part, because immanent notions have a polyvocal social life. Various uses are proposed, corroborated or contested in the social sphere, and there are no predefined borders or strict guidelines for linguistic practice (although there are, of course, embodied norms

concerning common use as well as ex post facto grammatical rules). In spite of the fact that there is oftentimes a socially produced illusion of fixity, which is partially due to the operative timescale of human beings and a relative blindness to long-term historical transformations and social variability, the field of immanent conceptuality is dynamic. This is not only due to ongoing social struggles (which are sometimes masked by their institutionalized results), but as well to the interaction between diverse cultural matrices, which themselves are devoid of rigid borders. To foreground the dynamism of immanent notions and the fact that a purely given or stable immanence is an abstraction, it is worth proposing a working distinction between three forms of cultural transition: transit, transfer, and transplant.[17] Transit, to begin with, records the movement of objects—including texts, works of art, and other material traces of theoretical and cultural nexuses— over time and across social space. Human beings as well as their practices can, of course, transit between different cultural conjunctures, thereby serving as transformative vehicles in the ongoing reconfigurations of an immanent field. Transfer refers to the displacement of a system of meaning and value from one juncture to another due to the transit of historical phenomena manifesting an alternative immanent conceptuality. The transit of Aristotle's *Poetics* from Ancient Greece to seventeenth-century France, for instance, contributed to a cultural transfer in which Aristotle's work both was reconstituted and helped reconstitute a different sociohistorical conjuncture. Transplant indexes the importation or exportation of an entire theoretical and practical matrix, such as the spread of the modern European concept and practice of art around the world through the globalization of the art market. All three of these phenomena can intertwine in diverse ways, and they take place, of course, in a larger realm of interaction, since they do not necessarily dominate the entire field of cultural activity. They contribute in various ways to what we might call the transition of immanent fields of cultural practice.

In the case of keywords like *art* and *politics*, immanent notions actually function as veritable concepts in struggle, or nodal points in a social battle bereft of a final arbiter. This does not, however, mean that individual speakers can arbitrarily define all of their terms in any way that they choose, or

that they can capriciously skip between cultural contexts as in a game of anthropological hopscotch (in part because cultures do not function like secure, static boxes). On the contrary, since language is a collective practice, the use of terms contributes to the formation of a social archive. Indeed, the gradual sedimentation of social use produces what we might call, by appropriating and modifying Jean-Paul Sartre's vocabulary, a linguistic or conceptual practico-inert: a sedimented series of past practices that continue to have practical effects on conceptual use in the present.[18] This does not imply that there is a pure pole of active practice and another of inert institutionalization, but rather that linguistic and theoretical practices attest to an inertia by which there is a complex interactive exchange between the social archive and acts of speaking and thinking (which are at once constituted and constituting). For descriptive reasons, we can distinguish between the institutionalized practico-inert and the practico-inert of use. The former results from the official codification of language through dictionaries, grammar books, and education, whereas the latter is constituted by the unofficial sedimentation of practice that is part of our linguistic common sense, comprising a network of connotations, contextual relations, practical fields of application, and so forth. When Wittgenstein refers to what we would or would not say in particular instances, he is usually appealing to the practico-inert of use, which has largely been institutionalized ex post facto. In certain instances, his references to the language of *das Man* are problematic in their generality and seem to presuppose that every individual speaker has the same social archive of linguistic use. However, this is by no means always the case, and it is important to emphasize the extent to which the constitution of the practico-inert is itself the result of variable practices and the singular trajectories of social agents.

It is arguable that Wittgenstein primarily sought to abandon the misguided metaphysical quest for common properties in favor of a description of what I am here calling immanent notions, and more specifically the practico-inert of linguistic use: "What *we* do is to bring words back from their metaphysical to their everyday use."[19] In castigating efforts to explain or deduce phenomena by searching for what is supposedly hidden behind them, he austerely proclaims: "philosophy really *is* 'purely descriptive.'"[20] In

this regard, he runs the risk of reducing philosophic practice to the interminable, platitudinous task of drawing up an infinite inventory of linguistic use based on the social archive that forms the basis of linguistic common sense. If this is indeed the case, then Herbert Marcuse was surely right to lambaste as "one-dimensional thought" Wittgenstein's endeavor to develop a philosophy that "leaves everything as it is": "Paying respect to the prevailing variety of meanings and usages, to the power and common sense of ordinary speech, while blocking (as extraneous material) analysis of what this speech says about the society that speaks it, linguistic philosophy suppresses once more what is continually suppressed in this universe of discourse and behavior."[21]

The reduction of philosophy to the chary, conservative, and tedious task of drawing up an endless catalog of what exists recalls the well-known joke concerning a drunk who is searching for something beneath a streetlight. When a passerby asks him what he is doing, he replies that he is looking for his keys, which fell when he tripped over the curb. The passerby joins in the search, but after a quarter of an hour there is still no sign of the keys. "Where exactly did you trip?" asks the passerby. "About half a block up the street," replies the drunk. "Then why are you looking for your keys here if you lost them half a block up the street?" The drunk retorts: "Because the light's a lot better here!" The endeavor to simply describe linguistic use—in spite of certain benefits—runs the risk of becoming a task not dissimilar from this quixotic, inebriated search beneath a streetlight: it is definitely easier than other undertakings, but it is clearly limited since it is destined to leave things exactly as they are.

It is important to specify that Wittgenstein occasionally insisted on the need to describe not only the use of terms but also "the whole environment" and "ways of living."[22] And on at least one occasion he specified that his method "is not merely to enumerate actual usages of words, but rather deliberately to invent new ones, some of them because of their absurd appearance."[23] Nevertheless, just as he paid only a modicum of attention to the historicity and cultural variability of linguistic practices, he largely ignored at least an explicit engagement with what I propose to call interventionist concepts. The latter function as *idées-forces* that seek to displace the

established order of immanent conceptuality. They are incursions into the force field of cultural notions that prove that we are not simply condemned to reproduce—via what we might call the passive interventions in which we regularly participate willy-nilly—the dominant conceptual practico-inert or the status quo of discursive use. In many ways, it could actually be argued that Wittgenstein's own critique of metaphysical philosophy functions as just such an intervention, which seeks to redefine the very nature of philosophic practice. More germane to our immediate concerns here, we could cite the case of Cornelius Castoriadis's intervention into the field of politics and his attack on the idea of political *epistēmē* in the name of understanding politics as a collective process of social struggle whose very object is the institution of society as such. Jacques Rancière's polemical engagement with the field of aesthetics could serve as another example insofar as he aims at dismantling the rote interpretations of art history in the name of entirely reworking the dominant conceptual assumptions regarding the supposed nature of what is called modern art.

It is often falsely assumed that concepts can only play a truly interventionist role if they are axiomatically postulated as more or less transcendent elements irreducible to the situation at hand. In fact, some thinkers denigrate all of those who refuse philosophical fiats as if the choice were simply between the reproduction of the status quo and the sovereign imposition of a concept by intellectual decree. Let us briefly consider the work of two contemporary thinkers who have provided an ontological account of art—to take but this example—as a transhistorical phenomenon in terms of what I am here calling transcendent ideas: Alain Badiou and Cornelius Castoriadis.[24] The former explicitly identifies with the Platonic tradition and asserts that art has a transhistorical essence: it is a singular thought process of Ideas that serves to trace the effects of an event in the real. An event is a supplement to the situation that can be neither directly named nor represented by the means available within the situation itself. All true art, therefore, interrupts the given situation of aesthetic expression by acting on an event and ushering Ideas into the situation. This is what links Picasso's rendering of horses to the authors of the cave paintings at Chauvet-Pont-d'Arc, as Badiou claims in the preface to *Logics of Worlds*. In spite of the different

historical circumstances, the essence of art remains a constant because the paintings in both cases attest to the eternal Idea of a horse.[25] Although Castoriadis does not identify with the Platonist tradition and is more explicitly dedicated to historical research than Badiou, he nonetheless provides—somewhat surprisingly, given his other work—an ontological account of the transhistorical nature of art. He claims that the institution of society has always sought to produce a web of meaning suspended over what he calls Chaos, the Groundless, the Abyss.[26] Whereas religion has attempted to present the Abyss while simultaneously shrouding it, art—particularly in the form of the masterpiece—is properly speaking the "presentation of the Abyss (of Chaos, of the Groundless)."[27] More specifically, it gives form to the chaos underlying the cosmos by creating new worlds, while simultaneously reminding society that it lives on the border of the Abyss. All true art thereby opens a window onto chaos and "calls into question the established significations."[28] In spite of the fact that Castoriadis recognizes and insists on the social and historical specificity of cultural production as well as of some of the figures of the art world (such as the misunderstood genius, the avant-garde, and pure art), he nevertheless purports to isolate the universal and transhistorical essence of art as a window onto the chaos of being.[29] From the earliest cave paintings to Aztec statues, African masks, and European classical music, art has always and everywhere strived to escort humanity back to the border of the very Abyss from which it comes. "Every culture," writes Castoriadis, " . . . creates its own path toward the Abyss."[30]

These transcendent ideas of art do not properly transcend the immanent conjuncture in which they emerge. On the contrary, they are clear instantiations of a specifically modern European concept of art. As Paul Oskar Kristeller has argued, the modern system of aesthetics, in which the singular category of art serves as the general heading for the genres of painting, sculpture, architecture, music, and poetry, is a relatively recent, culturally specific phenomenon. "This system of the five major arts, which underlies all modern aesthetics and is so familiar to us all," he writes, "is of comparatively recent origin and did not assume definite shape before the eighteenth century, although it has many ingredients which go back to classical,

medieval and Renaissance thought."[31] Exploring the European tradition and examining the selective historicist assumption that the essence of art has remained a constant in spite of differing historical appearances, he demonstrates that "the Greek term for Art (*techné*) and its Latin equivalent (*ars*) do not specifically denote the 'fine arts' in the modern sense, but were applied to all kinds of human activities which we would call crafts or sciences."[32] He also explains that "there is no medieval concept or system of the Fine Arts": "if we want to keep speaking of medieval aesthetics, we must admit that its concept and subject matter are, for better or for worse, quite different from the modern philosophical discipline."[33] Finally, he notes that "the other central concept of modern aesthetics, . . . beauty, does not appear in ancient thought or literature with its specific modern connotations. The Greek term *kalon* and its Latin equivalent (*pulchrum*) were never neatly or consistently distinguished from the moral good."[34]

Explicitly drawing on the work of Kristeller, Larry Shiner has developed a detailed historical account of the new institutions of the fine arts.[35] He claims that all of the modern institutions, with the exception of the theater and the opera, date from the eighteenth century. He insists on the recent emergence of museums and public exhibitions, as well as of historical phenomena such as secular concerts, copyrights, literary criticism, and art history. While he admits that there were some important anticipatory signs, he insists on the strong connection between the new system of the fine arts and its institutions in the large sense of the term. He also emphasizes the way in which this system and its institutional apparatus produced a new conception of the artist and the work of art. The former was individualized as a creative genius, who delves into his or her imagination in order to give form—more or less freely—to original sensations and ideas. The work of art became a unique and self-sufficient creation bearing the indelible mark of its creator.

This modern, European idea of art, which Jacques Rancière has referred to as "art in the singular," developed in the eighteenth and especially the nineteenth century according to Raymond Williams: "The emergence of an abstract, capitalized Art, with its own internal but general principles, is difficult to localize. There are several plausible C18 uses, but it was in C19

that the concept became general."[36] Since that time, it is important to note that it has been applied to other time periods and cultural regions. James Clifford has highlighted, for instance, a taxonomic reconfiguration that took place around 1900, when "a large class of non-Western artifacts came to be redefined as art."[37] He thereby distinguishes, à la André Malraux, between art by destination and art by metamorphosis, and he foregrounds the importance of the phenomenon of cultural transition. Moreover, by emphasizing the historicity and cultural specificity of the exhibitionary system of art, Clifford points to its relative historical dynamism: "It has not reached its final form: the positions and values assigned to collectible artifacts have changed and will continue to do so."[38] It is important, however, to insist on the difference between emic and etic categories. Even though cultures are not static or well-delimited entities, we can heuristically distinguish between emic concepts, representations, values, and practices that are meaningful to the actor, on the one hand, and those that are proper to the observer and purport to be culturally neutral or etic. According to this terminology, my argument here is that art is an emic category though it is not reducible to its emic emergence but has been transferred or transplanted to other times and places (sometimes becoming emically enmeshed in new cultural practices). Inversely, my claim can be expressed as follows: there is no purely etic account of art, there is no a priori conceptual definition of the nature of aesthetics.

Rooted as they are in uncritical philosophical intuition and unquestioned cultural practices, the transcendent ideas proposed by Badiou and Castoriadis—like other such ideas, which are also found in Wittgenstein[39]—are largely determined by their sociohistorical conjuncture (and the practico-inert of conceptual use). They are dependent on the modern European singularization of the concept and practice of art and, more specifically, on the iconoclastic conception of art as a novel act of imaginative creation. Properly speaking, the transcendent ideas they put forth are immanent notions in disguise. They have their source in the immediate sociohistorical juncture, but they are hegemonically projected into the ethereal realm beyond, as if they could be axiomatically elevated above their theoretical force field. This is why it is appropriate to speak of the

pseudo-transcendence of crypto-immanent concepts: so-called transcendent ideas are actually faux transcendentals, or immanent concepts that an unbridled philosophic hubris attempts to pass off as transcendent. Rather than being the opposite of immanent concepts, transcendent ideas are the convoluted inversion of immanent notions that have become blind to themselves.

The dual position can help us reconfigure a given sociohistorical framework because it consists in simultaneously endeavoring to grasp an immanent conceptual network in all of its complexity and striving to intervene and displace it through specific leverage points concretely anchored in it. Interventionist concepts are primarily those notions that are formulated out of a keen awareness of a specific intersection of social forces but aim at shifting it in a particular direction (which can include the use of projected, pragmatic, or articulated universals, or even what we might call transcendental—as opposed to transcendent—ideas). Transcendent ideas lack leverage: they tend to be blind to their own determination by the immanent notional force field, and they are often hegemonically postulated with little or no grasp of the latter. Therefore, they slip back into the very conjuncture that they believe they are transcending. Interventionist concepts, on the contrary, are rooted in a diligent mapping of the plexus of immanent notions, which aims at discovering the specific points of leverage that can be used to displace the given conceptual order. Leverage, indeed, necessitates concrete points of anchorage within the sociohistorical matrix, and it also requires practical knowledge of how to use elements and forces against one another, how to make more from less, how to produce traction and gain sway by playing off of various points and structures of agency.

Using the heuristic distinction between immanent notions, transcendent ideas, and interventionist concepts, another way of formulating one of the fundamental theses in this book is that there are no transcendent ideas of art and politics. The latter are properly speaking immanent notions within particular cultures, whose field of use we can chart out within specific sociohistorical intersections by means of an analytic of aesthetic and political practices. An analytic does not presuppose the existence of an essential

property capable of conceptually unifying a given set of practices. Such a methodological orientation has far-reaching consequences for the question of art and politics. To begin with, it means abandoning the misguided search for *the* concept of art and *the* notion of politics as if there were a single transcendent idea connecting all of the practices referred to as 'artistic' or 'political,' whether it be within a particular era or throughout all time. The pragmatic or praxeological approach advocated here begins, instead, with the diverse practices labeled as 'artistic' or 'political' as well as with the processes of conceptualization that codify them. It abandons the quixotic quest for the unique ideas uniting all of these practices and instead concentrates on the practical social struggles for the definition of concepts. This does not, however, condemn us to simply describing the operative use of immanent notions. On the contrary, by recognizing that concepts are immanent to sociohistorical junctures, and are therefore modifiable, it invites us to actively intervene in order to participate in the ongoing social battles over what is called 'art' and 'politics.'

IMMANENT CONCEPTUALITY AND ACTS OF DENOMINATION

Finished, it's finished, nearly finished, it must be nearly finished.
(Pause.)
Grain upon grain, one by one, and one day, suddenly, there's a heap, a little heap, the impossible heap.

—CLOV (SAMUEL BECKETT'S *ENDGAME*)

Although this is not the place for an exhaustive analysis, a brief overview of some of the fundamental stakes of the sorites paradox can serve to clarify why it is inappropriate to assume that our concepts can be precisely determined and delimited according to common properties. The name *sorites* derives from the Greek *soros*, meaning 'heap,' and it is used to refer to a

puzzle and a series of homologous paradoxes that ensue from it. The puzzle has to do with the difficulty of determining the precise nature of an indeterminate concept such as a heap:

> Would you describe a single grain of wheat as a heap?
> No.
> Would you describe two grains of wheat as a heap?
> No.
>
> . . .
>
> Since you must admit the existence of a heap at some point, which grain of wheat allows you to draw the line?

This puzzle can also be inverted, beginning with the claim that one hundred thousand grains of wheat is a heap and working down by subtraction. The same troubling question remains: the removal of which grain of wheat makes it lose its status as a heap? Regardless of how the puzzle is presented, the fundamental problem is that, due to the indeterminacy of the concept of heap, it appears to be impossible to identify a single grain of wheat that could definitively differentiate a heap from a non-heap. The sorites paradox pushes this puzzle to the extreme:

> One grain of wheat does not make a heap.
> If one grain of wheat does not make a heap, then two grains do not.
> If two grains of wheat do not make a heap, then three grains do not.
>
> . . .
>
> If 99,999 grains of wheat to not make a heap, then one hundred thousand grains do not.
>
> ———————————
>
> One hundred thousand grains of wheat do not make a heap.

The premises of this argument appear to be true, and it relies on uncontroversial reasoning, employing only modus ponens and cut (which links together each of the sub-arguments resulting from a single application of modus ponens). However, the conclusion is intuitively false. A similar

paradox can also be arrived at by proceeding in reverse. If one is willing to admit that one hundred thousand grains of wheat make a heap, then it is possible to argue that one grain of wheat does as well since the removal of any one, single grain cannot make the difference between a heap and a non-heap. Whereas in the first version of the paradox no amount of wheat can ever make a heap, in the second version any amount of wheat necessarily makes a heap. If there are no heaps or if there are only heaps, we seem to be equally constrained in both cases: logical reasoning leads us to incontrovertible conclusions that are intuitively false.

Based on the vocabulary introduced above, it might be said that the sorites puzzle and paradox are founded on the assumption that the category of heap functions like a transcendent idea with an identifiable common property. However, if a heap is understood as an immanent notion rather than a transcendent idea, it is arguable that the paradox dissipates straightaway. Immanent notions are part and parcel of social practices, which include the collective activity of naming. General terms like *heap* do not require a common property, a transcendent essence, or a strict lexical definition in order to practically function in social exchanges. This does not mean that there is or has to be strict agreement regarding the identification of a heap of wheat. One person can refer to a certain amount of wheat as a heap according to his or her linguistic practico-inert, and another person can disagree, asserting that it is not a heap. There is no transcendent idea that could isolate the definitive feature of a heap once and for all and serve as an absolute arbiter. There are only immanent notions that are embedded in social practices, as well as interventions that attempt to modify the practico-inert of these concepts (leveraging them from their social point of anchorage).

According to this interpretation, which would of course need to be substantiated by a detailed engagement with the extensive literature on this subject, the sorites puzzle and paradox appear to result from transcendent conceptualism and the ahistorical, extra-social logicism that plagues much of formal logic. The latter, we must remind ourselves, is an abstraction from everyday social practice, and it is itself the result of a highly specific social exercise. Within the general field of linguistic practice, no strict determination

is necessary: we do not need to know exactly how many grains of wheat make a heap in order to be able to appropriately use the term. Words such as this are immanent to the practices of which they are a part, if it be the practice of farming or the practice of naming itself. Indeed, cases where we might imagine an exact definition of a heap are themselves unique social practices and only make sense within certain strictures, such as a scientific experiment in which it was decided that a heap would be defined by the existence of a precise number of grains of wheat. Far from confuting the argument for the immanent status of indeterminate concepts like heap, the establishment of these types of specialized conventions serves to further demonstrate the extent to which the meaning of terms is bound up with their social function.[40]

The same can be said of general concepts like art and politics. They have no common property or strict horizons that would allow us to determine once and for all their essential attributes. Therefore, the question of their precise identity cannot be based on an appeal to a definitive feature, nor can it be decided upon from a singular point in the social field. As in the more banal case of a heap of wheat, not everyone will agree on the precise moment at which art or politics can be said to exist. This does not, however, mean that these concepts are utterly vague. If there are no transcendent ideas uniting the totality of artistic and political practices, there are nonetheless immanent fields of conceptuality unique to specific sociohistorical conjunctures. These fields are the provisory and shifting results of complex forms of social and historical negotiation whose outer limits are not necessarily clearly defined. This is not only because social practices do not need strict borders in order to operate effectively. It is also due to the phenomena of transit, transfer, and transplant discussed above. Immanent notions only continue to survive if they have a social life, which imbues them with an inevitable dynamism.

The rejection of the ahistorical and extra-social formalism of transcendent conceptualism in favor of an analytic of immanent concepts does not simply constitute a naïve appeal to linguistic and conceptual common sense. To begin with, the very attempt to map out the plexus of immanent notions is an active topological intervention from a specific perspective. Secondly,

yes Raus le agin Borges
 map

acts of denomination constitute interventions insofar as they draw provisional conceptual lines in the shifting sands of social practice. This is in part because our concepts tend to be more abstract and generalizing than the practices that they index. Indeed, one of the fundamental difficulties inherent in the very process of naming is that our linguistic armature confronts multifarious and variegated practices with an extremely limited terminology. At the same time, however, this is precisely the source of its power and its capacity to develop leverage over a situation. For if it were as detailed and variable as the practices it seeks to name, it would by this very fact lose its topological purchase.

This is precisely the issue at stake in Jorge Luis Borges's "On Exactitude in Science." In this one-paragraph fable in the form of a literary forgery, the author recounts the problematic story of a map that came to cover the very territory it purported to represent: "the Cartographers Guilds struck a Map of the Empire whose size was that of the Empire, and which coincided point for point with it."[41] Even though this seems to be perfectly in line with the dictates of scientific exactitude, at least according to a certain positivistic understanding of technical accuracy, the tale recounts the historical discovery of the utter uselessness of such cartographic precision: "The following Generations, who were not so fond of the Study of Cartography as their Forebears had been, saw that that vast Map was Useless, and not without some Pitilessness was it, that they delivered it up to the Inclemencies of Sun and Winters."[42] The map, when it reaches its apex as perfect mimesis, masks as much as it reveals. It loses purchase on that which it attempts to grasp as soon as it sacrifices its power of distanciation. It might be said, at least in this case, that leverage emerges precisely in the gap between the infinite complexity of an immanent field and its representational organization through pragmatic intervention.

An act of denomination is, precisely, an incursion into the thicket of existence. It is the heuristic postulation of lines of demarcation within an endlessly intricate situation. Let us consider, in this regard, the important example of the modern, European concept of art discussed above. The use of such a category does not aim at isolating a single, essential idea

behind the totality of 'artistic' practices in a specific space-time. Instead, it seeks to provide a pragmatic label, in conceptual shorthand, for a Byzantine and dynamic practico-theoretical field, which itself is differentially distributed through the three dimensions of history (see below). Without wanting to overemphasize the parallel, it might be said that the European concept of art partially resembles what Max Weber calls an ideal-type, at least insofar as it is formed "by the synthesis of a great many diffuse, discrete, more or less present, and occasionally absent concrete individual phenomena, which are arranged according to . . . one-sidedly emphasized viewpoints into a unified analytical construct (*Gedankenbild*)."[43] There is no pure form of the modern concept of art precisely because there is no a priori idea of art. There are only a posteriori notions immanent to particular practices, which change and morph through space-time via metastatic transformations (see below). Therefore, there was never a moment of discontinuous rupture in which the idea of art more or less miraculously appeared, perfectly formed, on the historical scene. Instead, there is an extremely intricate process of ongoing social transformation that has been synthetically labeled through interventionist acts of designation, which propose a working topology to gain leverage over the situation at hand.

These acts—in this case as well as in others—do not follow strict dictates. As a matter of fact, they regularly confront the ship of Theseus paradox, which has to do with the status of identity over time. The central question raised by this paradox is at what point in time—if any—a ship, whose parts are gradually replaced, becomes another ship. What is the tipping point at which a quantitative change produces a qualitative shift? However, just as in the case of the sorites paradox, this aporia appears to be founded on the assumption that the identity of a particular phenomenon is rooted in a common property. As soon as we break with the illusion of transcendence by recognizing that there are no transcendent ideas guaranteeing our conceptual, terminological, or phenomenological delimitations, the paradox dissipates (although the dilemma of interventionist denomination remains). There is no such thing as ship *x* and ship *y*, each founded on a common feature or transcendent property. Instead, there is an infinitely complex temporal process within which acts of denomination intervene in an effort to organize

phenomena in particular ways. These acts do not carve nature at the joints, precisely because there are no a priori joints. They draw lines in the shifting sands of existence. Although they are rooted in the practico-inert of specific linguistic practices, they ultimately remain fallibilistic incursions that propose an operative topology to orient us in a dynamic and intricate process of ongoing transformation.

It is for all of these reasons that this book seeks to extend and develop one of Castoriadis's notable claims—"there is no science of politics"—by arguing that there is no *epistēmē* of art and other such general concepts.[44] There are only ongoing social struggles over meaning and values, as well as the institutionalized results of previous battles. Indeed, if there is no *epistēmē* of art and politics in the sense of an objective knowledge of their fundamental nature, it is precisely because the transcendent idea of art and politics is an illusion: they are dynamic social phenomena with no a priori being. Moreover, the very assumption that there should be, or needs to be, such knowledge merits the label of the epistemic illusion because no such requirement has ever been a prerequisite for the operative functioning of social practices. Instead of transcendent ideas, there are—or are not—various immanent notions of art and politics in changing sociohistorical conjunctures. It is this immanent field of conceptuality that allows us to advance the claim, for example, that *this* is art or *this* is politics. However, as we have seen, this does not mean that immanent notions are rigorously determined or that they have strict semantic borders. It also does not imply that we are condemned to relativist battles between more or less determined forms of *doxa* or popular opinion, as if the dissolution of the epistemic illusion were somehow equivalent to the fall of humanity into relativism, if not blind subjectivism. On the contrary, there is the possibility of cultivating what we might call a type of *phronesis* or practical knowledge by which we can at one and the same time come to terms with an inherited order of immanent conceptuality and intervene effectively within it. Such practical knowledge is not simply determined by a relative context. Instead, it is developed out of a reflexive effort to provide a topology of a given theoretical force field and find leverage points within it for developing interventionist concepts.

RADICAL HISTORY

Reality appears as a dynamic in which all fixed forms reveal themselves to be mere abstractions.

—HERBERT MARCUSE

In order to map the immanent practico-theoretical fields of aesthetics and politics, it is necessary to develop an alternative logic of history. To this end, let us start by distinguishing between three different orientations. Reductive historicism, to begin with, assumes that historical developments are rooted in a definable set of historical determinants. It understands historicism to be, most fundamentally, a form of rigorous determinism. Selective historicism recognizes the fluctuating nature of historical realities but postulates the existence of a fixed kernel behind historical change, usually in the form of a natural object of history. It is founded on a deep-seated assumption, which Friedrich Schiller expressed with particular precision: "something constant must form the basis of change [*dem Wechsel ein Beharrliches zum Grund liegen muß*]. There must be something that alters, if alteration is to occur; this something cannot therefore itself be alteration."[45] In terms of the vocabulary introduced at the beginning of this chapter, the presupposition, in conceptual terms, is that there must be a transcendent idea behind immanent notions. In the case of art, for instance, the assumption is that there is a constant, natural object—art itself—that simply takes on various external guises through the course of time. The history of art would thereby amount to a chronological description of these appearances, which never alter the deep essence of art itself, that is, the constant core that holds this very history together. This position is one of selective historicism because it arbitrarily selects what is part of history (the different countenances of art) and what is not (the essence of art itself).

Radical historicism dissolves the secure, extra-historical borders erected by selective historicism as well as the determinist foundationalism of reductive historicism. It maintains that all of our practices and our most

36

cherished concepts, values, and beliefs are fundamentally historical, but that this does not mean that they are somehow reducible to a unique set of historical determinants. It unleashes what Daniel Dennett has called, in a different context, a universal acid: it dissolves all of the supposedly fixed categories by unleashing the corrosive power of the sheer flow of time. It is for this reason, moreover, that Michel Foucault's distinction between an analytic and a theory proves particularly useful. A theory of power presupposes, according to Foucault, a substance or a metaphysics of Power, whereas an analytic jettisons the metaphysical assumption that there is a transhistorical or universal essence behind historical phenomena and proposes instead a circumstantial investigation into the various configurations and relations of power. The same fundamental strategy is appropriate for other practices, such as those that are of particular concern to us here: there is no art or politics in general, there are only immanent practices that are qualified as 'artistic' or 'political' in variable sociohistorical conjunctures.

In order to undertake an analytic of artistic and political practices, it is important to introduce a different logic of history.[46] A logic or order of history is not a method for organizing facts, nor is it a narrative that produces a nexus of meaning. Conceptually, it aims at avoiding the dual pitfalls of realism and constructivism. There are not facts on one side and their conceptual or methodological ordering on the other. Instead, the very existence of historical positivities depends on a specific practical mode of intelligibility. This is fundamentally what a logic or order of history is. Therefore, there is nothing purely epistemological or conceptual about it because it is always part and parcel of particular historical practices. Its knowledge is a practical knowledge, its *savoir* is always a savoir-faire. In breaking with the opposition between facts and methods, the notion of a logic of history replaces the polarization between the world (facts) and the mind (methods) by an examination of the configuration of givens. It might be helpful to invoke, in this regard, Thomas Kuhn's distinction between stimuli and data. In a series of remarkable analyses, he has shown that we never have direct experience of stimuli, or empirical reality in its brute form. The primary elements of our experience are data or givens. This does not mean, however, that we are free

to choose or invent the world as we see fit, but rather that the world given to us can only be *our* world as social beings, the world of our data.[47]

The alternative logic of history that I would like to propose is characterized by the heuristic distinction between three different dimensions. There is, to begin with, the vertical or chronological dimension of history. This is the only aspect that many people take into account, and it has led to a series of stale and abstract oppositions between continuity and discontinuity, epoch and event, which I will return to shortly. It is important to insist on the fact that there is not simply a single, homogenous temporality uniting all historical phenomena, but rather that the very nature, structure, and rate of time can vary based on the regions of history, various processes of development, and the phenomena in question. For instance, the rate at which the universe is expanding, the historical development of the modern concept of art, and the ticking clock of our own biological mortality all have varying levels of temporal intensity for us and are part of different scales of historical temporality. Furthermore, it is crucial to highlight the retentions, the reactivations, and the projections that animate history, making it into an intensive storm of temporalities functioning at variable rates rather than a simple progression of occurrences along a timeline. Finally, time itself, as we currently understand it, is a historical phenomenon that has emerged, changed, and developed 'over time' so to speak.[48]

History, however, is never reducible to the single dimension of time, which is in and of itself imperceptible. If there were no agents or objects of history, then we would be left with the ephemeral unfolding of abstract temporality. In addition to being situated in time, historical phenomena are always located in space: "Geography and chronology," wrote Giambattista Vico, "are the two eyes of history."[49] It is for this reason that it is absolutely necessary to take into account the horizontal dimension of history, or the geographic distribution of historical occurrences. It is precisely by highlighting this dimension that we can avoid the homogenization of historical space that is so common within the vertical conception of history. The latter lends itself to epochal thinking by occluding the geographic variations in historical phenomena in the name of synthetic blocks of time and homogenous units of practice, as if everything that was occurring was miraculously

linked through a singular spirit of the times. Implicitly calling into question the very notion of a *Zeitgeist*, the horizontal dimension of history foregrounds the variable geography of historical occurrences. It requires us to replace the debilitating logic of periods and epochs by one of phases and constellations that, as we will see, permit us to map out the spatial distribution of historical developments. Moreover, it should be noted that historical space is no less complex than historical time, meaning that there is no simple and homogenous spatial continuum that can be used to map all phenomena. There can be, for instance, proximities between far-off places and distances between contiguous locations, as space-times warp around the practices and activities that animate them.

While the horizontal and vertical dimensions of history allow us to break with the purely chronological conception of historical time, there nonetheless remains the risk of reducing each space-time to a monolithic block. It is therefore necessary to take into account the stratigraphic dimension of history. For within each particular chronotope, there are various strata that can be distinguished. For instance, to take the example of modern European art, it is important to underscore the fact that this particular concept and practice by no means dominates the entirety of aesthetic activities in our day and age. Not only is it centered in what is called the Western world, but even within this geographic region there are other strata of 'artistic' practice that operate within very different social frameworks. 'Lower arts' and crafts, folk traditions, vernacular customs, indigenous rituals, counterhistorical or atavistic practices, and other such activities—often problematically judged as parochial or anachronistic—are largely written out of the streamlined versions of the highroad of Art History, except for when they are appropriated by eminent artists. The stratigraphic dimension of history allows us to distinguish between different layers or features operative within the same space-time in order to avoid collapsing the variegated topography of historical developments into a singular plane.

By taking into account the three dimensions of history, it is possible to develop an alternative account of historical change, which definitively jettisons the hackneyed notions of continuity and discontinuity. Since historical transformation is always variably distributed through social space, it is no

longer possible to speak simply in terms of continuous epochs or discontinuous events, unless it is for purely pragmatic reasons, as conceptual shorthand. Periodic histories, like event-based narratives, are founded on a problematic logic of history, which privileges the vertical dimension of chronology at the expense of the geographic and social distribution of historical developments. Even in those histories that are attentive to the regional specificity of occurrences, there is a tendency to eradicate the social diversity of practices within specific regions in order to be able to discuss the area as a comprehensive totality. Generally speaking, there are thus two forms of historical compression that collapse at least one of the dimensions of history. Spatial compression consists in reducing the horizontal dimension of history to its vertical dimension by systematically subordinating the variations between different geographic regions to the grand march of History. Social compression occurs when the spatial dimension of history is taken into account, but at the expense of the diversity of social practices within each space-time.

To take but one example, Michel Foucault highlights, in *The Order of Things* and some of his early writings on literature, certain geographic differences between historical developments, but he nonetheless succumbs to a form of social compression on a number of fronts. For instance, he defines literature in the modern era in terms of a unique series of privileged authors, such as Sade, Mallarmé, Artaud, Bataille, and Blanchot. This allows him to formulate his thesis that literature functions as a twofold counter-discourse: it breaks with the classical framework of representation by reviving the brute being of language buried since the Renaissance, and it simultaneously resists the modern discourse of the human sciences by producing an intransitive language that leads to the 'death of man.' Although his choice to identify literature in general with a very specific tradition of transgressive literature is surely a polemical and provocative decision on his part, it nevertheless has the unfortunate consequence of excluding from literature as a historical discourse all of the prominent authors who cannot be easily aligned on his thesis regarding the literary death of man, including Hugo, Balzac, Stendhal, Zola, and many others. This social compression is precisely what allows him to produce a form of historical hegemony, passing off a particular tradition of transgressive literature for *la littérature* in general.

In resisting the historical hegemony operative in spatial and social com-pression, it is not sufficient to simply take into account the specificity of practices within the three dimensions of history. We also need to develop theoretical and methodological tools that help us break with the entrenched models of history, and in particular with the logic of epochs and events. The notion of a historical constellation is particularly appropriate for fore-grounding the unique distribution of historical phenomena in the various dimensions of history. For the description of a constellation allows us to pinpoint the precise geographic locales and social strata in which particu-lar historical developments take place. It thereby avoids homogenizing and hegemonic statements regarding the nature of a particular time period or geographic region. We might cite, as an example, Eric Hobsbawm's astute attempt to resituate Romanticism within the larger society: "since it domi-nated neither the cultures of the aristocracy, nor those of the middle classes and even less of the labouring poor, its actual quantitative importance at the time was small."[50] He underscores, in this context, the prominence of a con-stellation of non-Romantic aesthetic practices during what is schematically called the Romantic era:

> It is significant that the great majority of the characteristic, and virtually all the most famous, buildings of the period from 1790 to 1848 are neo-classical like the Madeleine, the British Museum, St. Isaac's cathedral in Leningrad, Nash's London, Schinkel's Berlin, or functional like the mar-velous bridges, canals, railway constructions, factories and greenhouses of that age of technical beauty. However, quite apart from their styles, the architects and engineers of that age behaved as professionals and not as geniuses. Again, in genuinely popular forms of art such as the opera in Italy or (on a socially higher level) the novel in England, composers and writers continued to work as entertainers who regarded the supremacy of the box-office as a natural condition of their art, rather than as a con-spiracy against their muse.[51]

It is important to note in this regard that a constellation does not pur-port to carve historical nature at the joints. As the term itself suggests, it is

a pattern that is perceived as such from a particular vantage point, and it is the result of drawing a series of lines to form a coherent topological scheme that does not necessarily exist in any purely objective sense. Since the delineation of a constellation is always undertaken from within a sociohistorical field, it is subject to collective negotiations. This means that the validity of a particular claim regarding the constellations of history, or other historical assertions for that matter, can never be objectively verified in any absolutely rigorous sense. At the same time, this does not reduce them to purely subjective affirmations. Insofar as they are part of a specific force field, historical assertions are both woven out of the social fabric and subject to public scrutiny. There is, therefore, the possibility of establishing a concrete objectivity, which is the result of a relative social consensus or the general agreement of particular historical communities. Such objectivity is, of course, open to revision, but the battles over it will ultimately be fought out in the social field. As a cultural practice, historical writing is both the result of specific sociohistorical developments (that it helps constitute as such) and the subject of collective debate.

Although the notion of constellation can be extremely useful for discerning various spatio-social patterns within history and describing particular conjunctures, it runs the risk of favoring slightly static visions of the past. In order to emphasize the dynamism of history and definitively break with the order of epochs and events, the concepts of historical phases and metastatic transformations are particularly useful. A phase, unlike an epoch, is always uniquely distributed in the three dimensions of history. It can therefore be mapped out as a dynamic constellation with shifting forms, thereby avoiding the pitfalls of the historical hegemony produced by the spatial and social compression of history. Instead of projecting particular historical phenomena over the totality of a time period or a geographic region, the notion of a historical phase allows us to map out the precise geographic and social distribution of particular developments. Just as the notion of a phase overcomes the debilitating historical logic of epochs, the concept of a metastatic transformation jettisons the logic of events insofar as they are conceived of as simple caesuras in a chronological timeline. A metastatic transformation always spreads or recedes in the three dimensions of history according to its

own unique distribution and tempo. It casts off the unfounded assumption that historical space is synchronized to such an extent that everything can change at one given moment, or even everything within a particular region or social nexus. Since historical transformation is never simply temporal, but also geographic and social (at least in the case of 'human' history), it is absolutely necessary to take into account its distribution in space and society. This is precisely the role of the concept of a metastatic transformation, which allows us to detail the points of alteration, their fields of influence, and their relative rhythms of expansion, but also the enclaves of resistance, the points of recession, the conflicts with counter tendencies, and so forth.

The logic of phases and historical metastases subverts the tiresome controversies over the precise dates of specific eras. Whereas an epoch is an abstract, temporal category, a phase always takes place in time, space, and society. Instead of simply beginning or ending at precise moments, it emerges in the three dimensions of history through a metastatic transformation. This alternative historical order also undermines the endless debates concerning the definitive nature of particular eras. Since there is no all-encompassing *Zeitgeist*, no *Geist* unifying the different units of historical *Zeit*, it does not make sense to purport to determine once and for all the supposed essence of a specific age. "The *Zeitgeist* is a mirage," Siegfried Kracauer appropriately pointed out, "and cross-influences are often counterbalanced by sundry inconsistencies."[52]

If the notions of era, epoch, age, event, historical turn, and so on still have any explanatory power, it is as pragmatic shorthand to index the vertical or chronological dimension of history. It is extremely useful to be able to avoid major conceptual detours every time that one wants to refer to a particular time of history. However, it must be remembered that they are only shorthand references to one dimension. In order to remain within a historical order that accounts for all three dimensions, the notion of historical conjuncture is particularly appropriate, for a conjuncture is a meeting ground between various phases and metastatic transformations. As a concept, it has the advantage of emphasizing the various lines of force, overlapping practices, and competing constellations within a particular space-time.

TOWARD A THEORY OF MULTIDIMENSIONAL AGENCY

Popular history, and also the history taught in schools, is influenced by
this Manichaean tendency, which shuns half-tints and complexities: it is
prone to reduce the river of human occurrences to conflicts, and the con-
flicts to duels.

—PRIMO LEVI

An analytic of aesthetic and political practices requires an alternative account of the modus operandi of practice itself. The standard philosophical dichotomies used to frame praxis tend to abstract from its constitutive complexities in the name of streamlined oppositions between thought and action, freedom and determinism, cause and effect, and so forth. Although these oppositions can be pragmatically useful in certain situations, they most often function as broad labels that serve to reduce the intricate play of forces in any field of practice to more or less stable ontological states or purified conceptual extremes.

It is therefore necessary to develop a theory of multidimensional agency in order to provide a more complex and nuanced map of the force field of action. It is very common to situate agency within the human subject, which then negotiates its will in relationship to exogenous variables. Such an approach mistakenly rigidifies the opposition between individual and society, inside and outside, idealism and materialism. Agency, however, is not a singular force reducible to a voluntary will confronted with the constraints of an external world. Instead, there are multiple tiers and types of agency that overlap and intertwine in an interactive and codetermining force field of activity. The environment, for instance, favors certain types of actions and prohibits or discourages others. The 'material' world does, therefore, have operative forms of agency (in the broad sense) by creating not only a realm of physical possibility but also a series of channels for action (and actions themselves) that guide, shape, funnel, and generally influence other tiers of agency. Institutions as well, in the widest sense of the term (including

44

cultural practices, languages, theoretical systems, and ritualized behaviors), establish historical catalogues of past activities that continue to have effects in the present. Like the environment, they are not static entities that are constituted once and for all. Instead, they are dynamic formations whose persistence is partially dependent upon repeated acts of reconstitution or reconfiguration. Practical or embodied intentions, to take another example, lead to what are assumed to be natural or instinctual actions, thoughts, and feelings, many of which are rendered possible by the environment—which is not simply external—and extant cultural institutions. We might also consider unconscious drives, which function as complex forces rooted in the temporal depths of the psyche, not to be confused with an isolated, individual point of agency. The psyche, as Castoriadis has convincingly argued, can only survive if it is always already a social psyche, which also means that it is a site of struggle between multiple, intertwined modes of agency, described by Freud in terms of the second topography of the ego, the id, and the superego. Concerted actions, to take a final example of a type of agency, are based on explicitly reflexive decisions and established strategies, but they are performed by social agents, meaning embodied nodal points in a nexus of relations that they help constitute. A concerted action is, therefore, devised according to learned strategies and coordinated with other actions.

Needless to say, different types of agency interact with one another, and none of them exists in a vacuum. Strictly speaking, the very act of heuristically labeling them extracts them from the fields of struggle within which they operate. Let us consider an example that, although fictional, sheds light on the intertwining network of various types of agency, as well as on what we might call the tiers, ranges, and sites of agency. In the famous dream sequence in *Sherlock Jr.* (1924), the projectionist, played by Buster Keaton, imagines that he walks onto the screen and becomes part of a film that he is showing. He quickly finds himself shuffled between rapidly changing sets that constantly contravene his actions. As he is walking down the street, for instance, the road abruptly becomes a precipice and he almost steps off into the abyss. When he walks back and then peers over the edge of the cliff, he suddenly finds himself leering over a lion, which causes him to hasten straight into what becomes—beneath his feet—a hole in the

desert. After clambering out of the hole and barely dodging a passing train, he sits down on a mound of sand for a rest, only to discover that the mound has become a rock in the ocean. When he decides to dive off of the rock into the water, he lands headfirst in a snowbank. Keaton thereby stages the relationship between competing forms of agency that interact in a dynamic field of changing relations. Within this sphere of interaction, there are different tiers, ranges and sites of agency. By a tier of agency, I mean the relative depth of the force in question. Deeper tiers are generally more recalcitrant to change, such as the passing train in relation to Keaton's body. A range of agency is its operative field of influence: the range of the environment extends beyond that of Keaton's actions (in accordance with a certain aesthetic logic of the gag). Finally, a site of agency is the particular locus from which it emanates, such as the lion or the train. In the sequence from *Sherlock Jr.*, the environment functions as a deeper tier of agency that drastically alters Keaton's embodied and concerted actions, which constantly recalibrate themselves in relation to shifting landscapes of competing agencies.

If agency is indeed multidimensional and the topography of the social field is constitutively variegated, then the endeavor to reduce events to singular or isolated causes is misguided. This is, however, one of the overriding tendencies favored by the ontological illusion and the talisman complex, which have a penchant for monocausal determinism insofar as they prescind the nature of art from that of politics and relate them only in terms of the potential of the former to more or less miraculously produce effects in the latter (or fail to do so). By flattening society into a deterministic structure and making agency into the property of privileged entities, they tend to compress the various dimensions of society into a binary framework separating the determinate cause from the determined consequence, the singularized agent from external results. This leads to the establishment of formulaic recipes according to which a particular work of art serves as the incontrovertible cause of a specific political consequence (or lack thereof). It is in this light that I would like to underscore three fundamental problems that continue to plague debates on the relationship between art and politics. The first is that of the autarchy of the work, or the reduction of the social phenomenon of art to the produced artifact, and the undue concen-

tration on the latter as the privileged locus of political potentiality. Such an approach tends to isolate the work itself—sometimes along with the artist and his or her intentions—from the complex social system of production, circulation, and reception. When these factors are taken into account, they are often reduced to monolithic structures as if there were simply one central system of production and circulation, with a relatively unvariegated field of reception. However, all three of these heuristically distinct dimensions vary based on time and place, and they are the scene of numerous agencies. The second problem is the widespread assumption that art history can be written in terms of the evolution from an era of heteronomy, in which art was dependent upon ritual, religion, and the court, to the autonomy of a unique social subsystem independent of other such subsystems. This streamlined, unidimensional history overlooks numerous factors that will be highlighted in the ensuing chapters, but it also fundamentally ignores the extent to which art itself is a social category. Indeed, the very distinction between art and non-art is part of a historically constituted cultural hierarchy, and the same is true for the categories of great art, authentic art, real art, high art, and so forth. For these and many other reasons, the very idea that art could be autonomous from society is an oxymoron: it is itself a social category. The third problem is that of binary normativity and the strict opposition between revolution and recuperation, according to which it is assumed that a work of art either has truly transformative potential or is simply a conservative element that further solidifies the Establishment. This framework is founded on a totalizing account of social phenomena, as if the latter had a single meaning, value, and role. However, as shared realities, works of art do not have a singular and total signification. Instead, they have a social meaning, which is an intricate mosaic of negotiated and renegotiated significations.

Numerous artists have themselves shed light on the Byzantine sociality of artistic work. Let us briefly consider a series of examples that shed light on the three social dimensions of aesthetic practice: production, distribution, and reception. Allen Ginsberg penned an imagined compromising dialogue with T. S. Eliot in which he questions the latter about "the domination of poetics by the CIA," reminding him of the impact of the

"subsidization of magazines like Encounter which held Eliotic style as touchstone of sophistication and competence."[53] Drawing on a number of substantiated links between the American Secret Service and the art world (see chapter 7), he directly calls into question the system of production, distribution, and reception that served as the crucible for literary modernism: "the C.I.A. [sic] in effect promoted and subsidized and organized and encouraged—put energy into—nourished—sustained artificially—the development of an ethos, language, set of thought-forms and economic-cultural presumptions."[54]

Hans Haacke's work has also explored the various agencies operative in the institutional modes of production, circulation, and reception of works of art. He famously sought to reveal the unsavory reality of real estate speculation within the ivory tower of the Guggenheim Museum in *Shapolsky et al.* The cancelation of this project and its later restaging in *Unfinished Business* at the New Museum simply further emphasized the importance of his intervention. *MetroMobiltan*, to take another example, foregrounded the symbiotic relations between museums and corporations, which collaborate in public relations campaigns whose goal is to manufacture and manipulate social consciousness as well as political reality. In front of an entablature that mimics the grandiose facade of the Metropolitan Museum, Haacke hung three banners. The central flag reproduced the one that hung in front of the museum in 1980, when Mobil sponsored the exhibit *Treasures of Ancient Nigeria*. It was flanked on either side by banners that presented two statements by Mobil in which the corporation admitted to the sale of supplies to the South African police and military during apartheid. The cornice above the banners bore a plaque with a quotation from a museum leaflet aimed at corporations, in which it was stated that the sponsorship of activities such as special exhibitions "can often provide a creative and cost-effective answer to a specific marketing objective, particularly where international governmental or consumer relations may be a fundamental concern." The photo-mural of a funeral procession of black victims of the South African police, partially visible behind the veil-like banners, constituted the final element in this complex collage suggesting that Mobil's collaboration with the Met in support of so-called primitive art was part of a public relations campaign

aimed at improving their corporate image and masking their ensanguined misdeeds in the land of 'the primitive.'

Thomas Struth has explored the reception of works of art by photographing the very real social dynamic operative in the encounter with institutionalized works. This never amounts to an unmediated confrontation with the work itself, but is rather an experience orchestrated by institutional framing, display mechanisms, precise spatial relations, specific historical narratives, the social rituals of museum attendance, the tourist industry, and so forth. In short, the entire complex of exhibitionary culture comes to bear on our so-called direct experience of the work itself.

As all of these cases illustrate, works of art can only be arbitrarily separated from their social inscription as potentially autonomous entities capable—or not—of producing political effects. If we admit that art is a social practice, it is necessary to recognize that works do not have univocal meanings or play ubiquitous social roles. Instead, they are the products of multiple forms of agency and the sites of diverse and ongoing negotiations that make them constitutively polyvalent (the same is true, moreover, of political actions). Hence, it is imperative to reject the implicit social univocity operative behind the supposed autarchy of the work, the autonomy of art, and binary normativity.

According to what we might call a substantialist social logic, art and politics are separate, clearly identifiable entities. Within this logic, it is ultimately of little import if each of these elements is judged to be autonomous or heteronomous, because both conclusions are founded on the same fundamental assumption: there is a coherent substance or transcendent element behind all artistic and political practices. The praxeological approach begins the other way around, namely, by exploring the complex, relational social logic of multiple practices in which the monolithic categories of art and politics appear, at worst, as abstract conceptualizations and, at best, as the result of interventionist acts of denomination. As soon as we jettison substantialist social logic, the question is no longer: what is the privileged link—if any—between art and politics? It is rather, how do the various dimensions of the motley practices referred to as artistic and political overlap, intertwine, and

interact? In this sense, praxeology abandons the preoccupation of categorical thought with *the* relation between Art and Politics in favor of mapping out—and participating in—the dynamic interaction between multidimensional social practices.

In order to flesh out these claims, let us briefly consider the work of Santiago Sierra and its relationship to a specific system of production, distribution, and reception. We can begin with the binary normativity that has beleaguered much of his reception: either he is considered to have produced the summum bonum of political art, or he is seen to be the quintessential sellout who creates spectacles of misery to enhance the market-driven art world and his own lucrative career. In both interpretations, his work is presumed to have a univocal meaning. However, one of the most interesting elements of his work is precisely the way in which it foregrounds—sometimes in spite of itself—the grey zone of politics and the lack of any a priori purity in political interventions.[55] The act of conferring visibility upon the invisible and exploited workers of globalized capitalism and power politics implicitly calls into question—as in the work of Alfredo Jaar—the dominant matrix of perception produced by the mass media, institutionalized education, and representative politics. It also breaks down the barrier between the art world itself and extreme forms of capitalist exploitation and oppression by forcing it into direct contact with the disenfranchised. For instance, in "Workers Who Cannot Be Paid, Remunerated to Remain Inside Cardboard Boxes," Sierra paid six political refugees from Chechnya to remain inside boxes for four hours a day in an art gallery. He also compensated 133 illegal street vendors, who were primarily immigrants, for allowing their hair to be dyed blond during the Venice Biennale in 2001. Such projects at least implicitly raise questions about the relationship between the privileged art world and the pervasive forms of inequality that this world tends to presuppose. However, they do not necessarily seek to change the dependence of the market-driven art world on the global inequities of neoliberal capitalism.[56] "There is no possibility," Santiago bluntly asserts, "that we can change anything with our artistic work."[57] As a matter of fact, the spectacular nature of his projects and their inherent shock value play directly into the marketing strategies of the programmed iconoclasm

integral to much of the art world. Finally, he often mimics—with a suspect form of ironic disdain—the exploitation of the global system by remunerating his subjects with comparable wages. For instance, he paid four prostitutes addicted to heroin the price of a shot of heroin to have a line tattooed across their backs. For these and other reasons, his work poses problems that should invite critical interrogation.

We need to recognize that a work of art has multiple dimensions and does not need to be judged as a whole (the same is true, mutatis mutandis, of theoretical work). The ensuing rejection of the binary normativity that encourages categorical and peremptory judgments such as 'this is good art' or 'this is bad art' does not simply lead, however, to irresolute banalities. On the contrary, it allows us to intervene in a much more precise and nuanced manner by factoring in the variegated topography of the social world. This requires maintaining the dual position: we must at one and the same time recognize that the social world is a battlefield of competing tiers and forms of agency *and* intervene in this theater of cultural warfare in the name of a particular orientation. In the case of Sierra, it is important to accentuate the ways in which one dimension of his work stages—wittingly or not—the grey zones of politics by revealing the extent to which any intervention occurs within a morass of relations in which the purified poles of authentic and inauthentic politics often reveal themselves to be highly problematic abstractions. Interpreted in this way, his work is neither the apex of contemporary political art nor the nadir of pseudo-political complicity with market forces. Instead, a certain aspect of his work serves as an interesting—though limited—reminder that we always begin politics in the middle, meaning that we cannot choose the overall social and historical framework of relations in which we intercede. This is why we need not decide if Sierra's projects have been successful across the board. Instead of submitting to the categorical dictates of binary normativity, we can and should recognize that the negotiation between multiple forms and sites of agency means that limited successes and partial failures are common in the grey zone. This in no way prohibits us, it should be emphasized, from making critical judgments or drawing clear lines of demarcation. The recognition of the grey zone does not preclude in the least forceful interventions.

This orientation requires rethinking the issue of political efficacy in the arts. The standard approach consists in judging the ability of isolated works to serve as catalysts for political action, broadly conceived, in a one-to-one causal relationship perfectly in line with the overall logic of the talisman complex. It tends to seamlessly coalesce with the formulaic, and largely instrumentalist, conception of art and politics, according to which stable equations authoritatively determine the true nature of a one-dimensional relationship, such as 'art is truly political when . . . ,' 'art is capable of having real political consequences when . . . ,' or 'art is not political when . . .' This conception is premised on the assumption that art and politics have clearly defined borders and, in certain cases, privileged points of encounter. This tends to lead to categorical judgments as well as a strict normative inventory separating true or authentic political art from work that is judged to be false or inauthentic.

Such an approach attempts to prescind works of art and political activities from their larger social inscription, as if they were unique objects or occurrences that could be easily separated and were the result of singular agencies. The praxeological orientation firmly rejects this social epoché, or this bracketing of the social, in order to study artistic and political activities in terms of a theory of multidimensional social agency, in which conjunctures of numerous determinants produce a force field of interaction with multifarious resultants. Rather than a one-to-one causal relationship between art and politics, there is an intertwined complex of agencies that are distributed through the three spheres of social praxis (creation, circulation, interpretation) and the three dimensions of history (the vertical dimension of time, the horizontal dimension of space, and the stratigraphic dimension of social distribution). In other words, instead of schematic causal formulas, there is a manifold of codetermining agencies that interact and produce a variable matrix of consequences, which are unequally distributed through the sociohistorical field. Therefore, there is no overall, singular result from works of art, as if they were univocal phenomena with a unique and determined effect. Indeed, partial successes and failures are to be expected when there are contending agencies in a variegated social topography.

Bertolt Brecht, whose work has often been lambasted for its simplistic didacticism and its detrimental instrumentalization of art, underscored the complexities of social efficacy in his writings. He pilloried the formulaic approach of authors like Georg Lukács who attempted to establish perennial equations between art and politics: "With the people struggling and changing reality before our eyes, we must not cling to 'tried' rules of narrative, venerable literary models, eternal aesthetic laws. We must not derive realism as such from particular existing works, but we shall use every means, old and new, tried and untried, derived from art and derived from other sources, to render reality to men in a form they can master."[58] Whereas the formulaic approach presupposes that there is one general recipe for all time or for a particular era, Brecht advocates a suppler, situational, and experimental orientation that takes its cues from the dynamism of the social and historical world, as attested to, for instance, by his three versions of *Galileo*. "For time flows on," he writes, "methods become exhausted; stimuli no longer work. New problems appear and demand new methods. Reality changes; in order to represent it, modes of representation must also change."[59] He even recognizes this to be the case for his own epic theater: "So is this new style of production *the* new style; is it a complete and comprehensible technique, the final result of every experiment? Answer: no. It is *a* way, the one that *we* have followed. The effort must be continued."[60] Moreover, he refers to what he calls the possibility of "partial success," which suggests that the peremptory opposition between triumph and failure ignores the variegated nature of social reception.[61] Though I do not want to unduly downplay the more programmatic and, at times, formulaic aspects of Brecht's theoretical writings, it is important to note that he nonetheless invites us in these and related passages to think political efficacy in situational and experimental terms within a grey zone of varying levels of partial success.

For these and other reasons, it is crucial to rethink the operative logic of political efficacy outside of the instrumentalist framework that tends to predominate by reifying a one-to-one relationship between an artistic work and a political effect. Just as the production, circulation, and reception of works of art take place within a conjuncture of determinants with multiple tiers, types, and sites of agency, the consequences of works of art need to be

traced out in terms of multifarious and dynamic resultants within a variegated social topography. Moreover, these resultants are always distributed in a unique and shifting phasal configuration within the three dimensions of history. The very meaning of 'efficacious' and its working criteria can change according to the specific juncture, and it is therefore important to foreground the variable status of efficacity itself, which is of course a social concept. In particular, we should be cautious not to identify political effects exclusively with political action per se. Politics, as the term is generally used, is not simply identifiable with action in the sense of what the French call *la descente dans la rue*, or mobilization in the street. If this were the case, then the majority of professional politicians and many activists would not be political actors in the true sense because they spend the lion's share of their time thinking, debating, writing, and making decisions. Furthermore, even action in the strict sense of the term is woven out of an aesthetic and theoretical fabric that makes sense of the action. The political efficacy of works of art should not, therefore, be immediately defined as the instrumental production of political action in a rarefied sense—as important as this may be—but should allow space as well for the reconfiguration of networks of cultural hegemony, of historical imaginaries, of frameworks of perception, of parameters of expression, of horizons of thought, and of general grids of sociopolitical possibility.

It is also worth highlighting, finally, that there are different forms of efficacy based on the types, tiers, ranges, and sites of agency. To take a political example, Johann Hari has pointed out that while the protests in the United States against the Vietnam War did not prevent the killing of approximately three million Vietnamese and eighty thousand Americans, they did achieve "more than the protestors could possibly have known."[62] When in 1966 Pentagon specialists presented a computer model to President Lyndon Johnson and argued for the use of nuclear weapons against the Vietnamese, he "pointed out the window, towards the hoardes of protesters, and said: 'I have one more problem for your computer. Will you feed into it how long it will take 500,000 angry Americans to climb the White House wall out there and lynch their President?'"[63] The same plan was presented to Richard Nixon in 1970, and "we now know from the declassified documents that the

biggest protests ever against the war made him decide he couldn't do it."[64] Therefore, in spite of the perceived failure of the protests to achieve their immediate goals, their range apparently reached a deep tier of agency by reformatting—as is often the case with protests—the very grid of present and future political possibilities: "Those protesters went home from those protests believing they had failed—but they had succeeded in preventing a nuclear war."[65] Hari concludes by pointing out that "protest raises the political price for governments making bad decisions."[66]

In conclusion, there is not one relationship between art and politics or one true form of political art. Instead, art and politics are immanent sociohistorical practices that have sundry modes of interrelation. Moreover, a work of art is not a unidimensional phenomenon with one value, meaning, or social consequence. It is a multidimensional nodal point in a force field of social relations. These can be heuristically mapped out in the three overlapping planes of social practice and the three intertwined dimensions of history. It is important to emphasize, however, that these are not simply determined structures. Instead, they index various domains in which there are multiple types, tiers, ranges, and sites of agency at work. One of the major limitations inherent in many of the established approaches to art and politics is that they seek to reduce these contending agencies to a simplistic social logic of determinism and freedom, individual and society, cause and effect, and so forth. By introducing a multidimensional account of social relations that aims at overcoming such abstract binaries, we can open space for rethinking the ground upon which debates concerning art and politics take place. Rather than being fixed entities with determinate causal relations between them, they are multidimensional and polyvalent social practices that are always negotiated between manifold agencies within shifting fields of intertwined determinants and resultants.

2

REALISM, FORMALISM, COMMITMENT

Three Historic Positions on Art and Politics

A CONSTELLATION OF ANALYTIC POSITIONS

Through the course of the twentieth century, myriad positions emerged on the relationship between art and politics. It is by no means my intention here to provide a summary of them or to construct a historical synopsis. On the contrary, I will chart out an important constellation of culturally specific texts—the majority of which are rooted in the tradition of European Marxism—in order to cull from them a topological overview of three prominent analytic positions on the relationship between art and politics: realism, formalism, and commitment. Since this chapter will focus on the work of three thinkers (Georg Lukács, Herbert Marcuse, and Jean-Paul Sartre), it is important to state at the outset that it will be less concerned with providing a global summary of their views than with foregrounding specific positions found within their writings. These are anchored in particular texts and have a certain amount of conceptual consistency, but they are not necessarily exhaustive of everything that Lukács, Marcuse, and Sartre have written on the subject matter.

It should also be noted, as a brief proviso, that there is nothing absolutely necessary in the choice of these authors. Other thinkers—such as Theodor Adorno, Roland Barthes, or Jean-François Lyotard—could perhaps have

been substituted for them. What is important for the purposes of the present analysis is to demonstrate the extent to which the position outlined in the preceding chapter seeks to part ways with the conceptual armature that structures one of the dominant debates on art and politics in the twentieth century. For in spite of the numerous differences between the three stances that will be analyzed, accentuated as they are by the various criticisms that these authors formulated of one another, there is a series of theoretical coordinates that tend to organize their debate. The goal of this chapter will therefore be to provide a nuanced and well-documented account of each of these positions while simultaneously foregrounding—for the sake of critical reflection—their shared theoretical coordinates.

THE TRUE ART OF POLITICS: LUKÁCS AND THE WELTANSCHAUUNG OF REALISM

The more the opinions of the author remain hidden, the better for the work of art. The realism I allude to, may crop out even in spite of the author's opinions.

—FRIEDRICH ENGELS

Karl Marx and Friedrich Engels never developed a systematic aesthetics, in spite of the fact that Marx at least twice planned a more sustained engagement with the arts. In 1841–42, he worked with Bruno Bauer on a critical assessment of Hegel's views on art and religion, and in 1857 he sought to comply with an invitation to write an encyclopedia entry on aesthetics. However, neither undertaking ever came to fruition. Moreover, virtually all of the canonical texts that currently constitute the foundation of Marxism were either unknown or unpublished until after the death of Marx in 1883. In the case of the major statements on the arts, most of them remained in manuscript form or in utter obscurity until the last third of the nineteenth or the first half of the twentieth century. *The German Ideology*, for instance, was

generally unknown until 1932 (except for a brief excerpt), and the *Economic and Philosophic Manuscripts of 1844* were only published in the 1930s, as well as most of the correspondence relevant to aesthetic issues. Maynard Solomon claims in this regard that "the only major debate in Marxist circles on any aesthetic question before the twentieth century was between Marx and Engels and Ferdinand Lassalle in 1859, and this had been restricted to a private correspondence which was not published until 1892 . . . and appeared in book form only in 1902."[1] The slow trickle of Marxist publications has been the intermittent source from which numerous authors writing after Marx have attempted to reconstruct a general Marxist view of aesthetics by drawing out the systematic implications from scattered and fragmentary passages.

Georg Lukács (1885–1971) was one of the first and certainly one of the foremost authors to formulate a systematic aesthetics based on the Marxist tradition.[2] Born into an aristocratic Jewish family in Budapest, Lukács evinced an early interest in the arts and published important books such as *Soul and Form* (1911) and *The Theory of the Novel* (1920, written around 1915). When he joined the Communist Party of Hungary in 1918, he largely abandoned aesthetics in order to concentrate on politics and revolutionary strategy. He published his highly influential *History and Class Consciousness* in 1923, followed the next year by an obliging self-criticism. After a tumultuous and complicated political career, which included working as the Commissar of Education in Béla Kun's short-lived Communist government, he effectively withdrew from the inner-party political arena at the end of the 1920s and commenced his work as a Marxist literary historian and aesthetician around 1930. In the ensuing decades, he published a prolific series of articles and books that developed a detailed defense of realism, including *Studies in European Realism, The Writer and Critic, and Other Essays*, and *The Historical Novel*. Despite certain criticisms of his work by the Zhdanovists, his writings continued to bear the marks of a withdrawal from the more utopian and interventionist elements of Marxism, which he had emphasized in the early 1920s, to a more orthodox position that was often seen to be at least partially compatible with the accepted categories of Soviet aesthetics.[3]

In what follows, I would like to focus on *The Meaning of Contemporary Realism* (1958), which brings together and develops many of the major

themes of his work since the 1930s. Marx and Engels had, of course, championed literary realism and praised the "graphic and eloquent pages" of fiction writers like Dickens and Thackeray, who had "issued to the world more political and social truths than have been uttered by all the professional politicians, publicists and moralists put together."[4] Similarly, Lukács sought to defend the classical heritage of realism, particularly but not exclusively in its nineteenth-century manifestations. In describing the primary task of realism, he cites one of Hamlet's well-known lines: "to hold, as 'twere, the mirror up to nature."[5] However, as he explains in his book from 1958: "every genuine realism, be it ever so rich in details when analyzed formally, is worlds apart from naturalism."[6] Whereas the latter is content to reproduce the infinite details of reality, true realism is always founded on a division between the essential and the extraneous. Unfortunately, the panegyrists of formalism have cast a shadow over this distinction, according to Lukács, by separating the pure form from the content of the work. They thereby efface "the real line of demarcation between realism and naturalism": "the presence or absence of a hierarchy in the human traits and situations that are configured. Therein a fundamental aesthetic principle expresses itself, which brings about a true parting of ways. Comparatively, the formal differences in the manner of writing are of merely secondary significance."[7]

It is surely for reasons such as these that Lukács speaks of "critical realism" in his publication from 1958. Far from simply providing a photographic reproduction of the surface of reality, critical realism produces perspective on the real by choosing its most revealing and essential features. It is precisely this lack of perspective that creates a surprising similarity between naturalism and avant-garde formalism:

> The removal of principles of choice, a removal that is founded on a world-view [*das weltanschauliche Entfernen der Prinzipien der Auswahl*], drives the style of avant-gardism in the direction of a naturalism, even when, at the same time, its external, formal characteristics seem to directly and fully contradict it. . . . Whereas in genuine selection, what is socially and humanly inessential is eliminated, in order thereby to simultaneously

accentuate meaningful elements, here the formal act of selection signifies a dismemberment and fragmentation of the real essence of man.[8]

Unlike naturalism and formalism, Lukácsian realism reveals the submerged forces of reality by relying on a principle of selection capable of producing perspective on the real. The mirror presented to nature, Hamlet explains in a qualification perfectly in line with Lukács's thinking, must draw lines of demarcation in order "to show virtue her own feature, scorn her own image, and the very age and body of the time his form and pressure."[9] Description and prescription, realism and normativity, are intimately intertwined.

It is precisely by shunning the superficiality of photographic verism and unearthing the deep nature of objective reality that realism serves political ends. In some of his work in the 1930s, the Hungarian philosopher describes this in terms of a pedagogical instrumentality according to which great realist literature is capable of modifying public opinion via popular education. "Through the mediation of realist literature," he writes, "the soul of the masses is made receptive for an understanding of the great, progressive and democratic epochs of human history. This will prepare it for the new type of revolutionary democracy that is represented by the Popular Front."[10] On the contrary, avant-garde literature, he claims in passages fiercely contested by authors like Bertolt Brecht, is incapable of teaching the masses because it imposes a limited and subjectivist vision of life. Lukács thereby rejects the distant analogy between formal innovation and revolutionary politics that plagues a certain conception of aesthetic modernity.

This does not mean, at least in principle, that he aims at making literature into a simple mouthpiece for an autonomous political project. To begin with, he formulates a critique of schematic literature that seeks to provide an aesthetic illustration of an existent theory.[11] He also attacked, in 1958, agit-prop and the reductive socialist realism promoted by Stalinist dogmatists, while nonetheless defending the true works of socialist realism and the need for an alliance between socialist and critical realists.

What is ultimately essential about the content of works of art for Lukács is the world image to which it attests, and its underlying philosophical anthropology: "The center, the core of this form-determining

content is always, in the end, man. Whatever may be the direct starting point, the concrete theme, the immediate goal, etc. of a literary composition [*eines literarischen Gebildes*], its innermost essence expresses itself in the question: what is man?"[12] There exist, for Lukács, two possible responses to this fundamental question. The first, which is that of the realist school, follows Aristotle in defining man as a "*zōon politikon*, a social animal."[13] The second is labeled "existentialist": "The ontological intention by which the leading writers of avant-garde literature determine the human essence of their forms [*Gestalten*] is the complete opposite. Briefly stated, 'man as such' is, for them, the individual existing from eternity, essentially solitarily, disconnected from all human relations and, a fortiori, from all social relations, existing indeed—ontologically—independent from them."[14] At base, what Lukács is interested in is the ontology inherent in an author's worldview, for it testifies to the existence of one of the two mutually exclusive conceptions of the relationship between humanity and the world. For the Aristotelians, humans are social animals situated in history and capable of distinguishing their concrete potentialities from those that are purely abstract. From the point of view of the existentialists, human beings are isolated from society and cut off from history, thrown into a chaotic and fragmented world in which they are lost in existential anguish: "Dissolution of the world and dissolution of man thus belong together: they increase and amplify one another. Their foundation is the objective absence of a structural unity in man [*Einheitlichkeit im Menschen*]."[15] In *The Meaning of Contemporary Realism*, it is this fundamental ontological difference that comes into relief behind the artistic opposition between realism and avant-gardism: realist literature is the product of an Aristotelian ontology, whereas avant-garde literature is a more or less direct consequence of an existentialist ontology.

We can now address the central issue of the politics of art in Lukács, and more specifically in his book from 1958. If he rejects *la littérature à thèse*, it is in part because he insists on distinguishing between conception and realization, or between the politics of artists and the politics of art. Hence, he does not defend committed literature but instead foregrounds how fiction, independently of the explicit intentions of the author, can put us in contact—or not—with the real of reality: "it is not here a question of a direct

political stance, but of the production of a worldview's atmosphere [*Weltan-schauungsatmosphäre*] as a general frame for the poetic reflection of reality [*die dichterische Widerspiegelung der Wirklichkeit*], the reflection of the present certainly above all, in which these elements of observation and evaluation of the world play a dominant role."[16] Writers' subjective worldviews and their possible commitments are thereby distinguished from the objective worldview that manifests itself perforce in their writings.[17]

This is particularly clear in the case of Honoré de Balzac, which perfectly illustrates Lukács's direct appropriation of Engels's position on the relationship between the politics of artists and the politics of art: "It is a curious result of this strange dialectic of history and of the unequal growth of ideologies, that Balzac—with his confused and often quite reactionary worldview—mirrored the period between 1789 and 1848 much more completely and profoundly than his much more clear-thinking and progressive rival [Stendhal]."[18] The political force of this conservative Catholic is not at all to be found in his intentions. In fact, it is precisely the gap between his political ideals and his literary project that made him a great realist: his indefatigable descriptions of reality compelled him to depict a world in contradiction with his own convictions. "What makes Balzac a great man," writes Lukács in a passage that echoes Engels's letter to Margaret Harkness in April 1888, "is the inexorable veracity with which he depicted reality even if that reality ran counter to his own personal opinions, hopes and wishes. Had he succeeded in deceiving himself, had he been able to take his own Utopian fantasies for facts, had he presented as reality what was merely his own wishful thinking, he would now be of interest to none."[19]

Against the backdrop of this general outline of one of the dominant analytic positions discernible in Lukács's writings on realism, let us now consider some of its limitations. To begin with, his categorical condemnation of the avant-garde is founded on a reduction of art, and more specifically literature, to *Weltanschauungen*, as if a sole and unique ontology lay behind the totality of avant-garde production. "This abolishing of reality [*Wirklich-keit*]," Lukács declares peremptorily, ". . . forms the fundamental theme

of avant-garde representation [*Darstellung*]."[20] The sheer complexity of the effective—in the sense of *wirklich*—history of the politicity of diverse avant-garde movements (from Russian constructivism to Surrealism, Mexican muralism, the Bauhaus, and others) is brushed aside in the name of a categorical verdict: *the* avant-garde is the bearer of an anti-humanist vision of the world. The entire complex history of art is thereby reduced—via an analysis of literature, and primarily novels[21]—to a philosophic battle between two worldviews: Aristotelianism and existentialism. Hence, the dynamism demanded by Lukács at an ontological level is appreciably lacking in his normative system, which suffers from a remarkable stasis, if not a simple dogmatism. Moreover, his hasty theoretical translation of literature into ontology raises serious hermeneutic problems. However, these do not prevent him from making peremptory judgments by definitively deciding on the value of particular writings, as if literature were in effect simply the faithful reflection of a well-determined vision of the world.

His condemnation of avant-gardism is not limited to a politico-ontological reprobation. It is also an aesthetic denunciation insofar as the avant-garde is responsible, on his account, not simply for the obliteration of traditional forms, but, much more broadly, for the destruction of literary form itself.[22] This is because realism, for him, is not simply "a style among various other styles, but rather the foundation of every literature [*die Grundlage einer jeden Literatur*]."[23] The avant-garde is hence an aesthetic aberration intent on destroying the natural vocation of literature and abolishing the essence of art.[24] It is in such passages that Lukács, in spite of his insistence on the historicity of aesthetics, shows signs of a certain form of essentialism and ultimately falls prey to the ontological illusion: art apparently has a more or less transhistorical essence, without however being completely ahistorical since it is a product of human beings, as Marx and Engels argued. Indeed, one of the all-embracing definitions he gives to art directly recalls the selective principle at work in realism, a movement that traverses the totality of history from Homer to Thomas Mann, as he often remarks: "art is an act of choosing the significant and essential, an act of omitting the insignificant and inessential."[25] This is unfortunately not the place for an engagement with the complex analyses of this problematic in Lukács's

massive *Die Eigenart des Ästhetischen* (1963), but it is perfectly legitimate to draw the conclusion that the Hungarian thinker, at least in works like *The Meaning of Contemporary Realism*, presents himself as the guardian of the essence of art as well as the defender of human values. His political and ontological stringency is thereby coupled with an aesthetic rigidity. In both cases, he relies on a categorical distinction between true and false forms of politics and art. His supposed knowledge of the more or less transhistorical essence of the latter corresponds to his presumably objective grasp of the true nature of political reality.[26]

Furthermore, according to his formulaic conception of the relationship between art and politics, genuine literature is an instrument in the service of authentic politics, and thus of the true understanding of the world. He thereby falls prey to the talisman complex by assuming the existence of certain autarchic works that are capable of more or less autonomously producing direct political effects. He largely brackets the question of the circulation and reception of works of art by relying on a presumed social univocity, as if each work were necessarily the vehicle for a sole and unique vision of the world, independently of its social inscription and the motley reactions of its spectators or readers. Instead of taking into account the variegated nature of aesthetic reception, Lukács performs a social epoché that excludes all other interpretations as misguided illusions that have failed to grasp the objective and singular truth of the work. Such univocity is not only a sine qua non condition for objective knowledge concerning the true nature of artistic works; it is also an integral part of the talisman complex: certain objects or practices are presumed to be bearers of a sovereign political power, much in the same way as talismans are understood as the autonomous vehicles of magical forces. Such an approach largely dismisses the complex variability of social dynamics in favor of a more or less monocausal determination: each work of art produces a singular political effect. Just as Lukács diminishes or even destroys historical dynamism in favor of a normative Manicheism, he effaces the social dynamic in the name of a univocal and more or less determinist conception of the politics of art. Works generally lose their status as sociohistorical entities by becoming the talisman-like reflections of two opposed worldviews.

Finally, realism's political efficacy ensues from the fact that it provides a faithful mirror of the true nature of history. At the heart of Lukács's aesthetic project, there is therefore the assumption that the Marxist framework provides an objective understanding of the fundamental structure of historical reality. This provides the foundation for his categorical judgments concerning the two opposed worldviews, for his definition of the nature of realism and of art in general, as well as for his description of the relation between art and politics. His entire undertaking thereby depends on a purportedly objective and scientific knowledge of the very essence of history.[27] This is what allows him to establish one of his central formulas: genuine literature is an instrument in the service of true politics, and hence of the veritable historical understanding of the world. Lukács's political and aesthetic stringency or even dogmatism is thereby bound up with a historical rigidity that is equally dogmatic: he purports to be able to reduce the force field of history to an objective essence and a singular trajectory oriented toward a unique end. It is precisely the swath of this trajectory that splits historical phenomena into two rival camps, separating the salvational works of art that promote this political telos from the damned works that do not.

AESTHETIC FORM: MARCUSE'S TRANSHISTORICAL SUBSTANCE OF ART

Only the transformed reality is the reality of art.

—HERBERT MARCUSE

The criticisms of Georg Lukács's aesthetics have been as numerous as they have been motley. In 1938, Ernst Bloch attacked his detached and generalist methodology, his a priori condemnation of formalism, and his dogged classicism. The same year, Bertolt Brecht—in a series of insightfully irreverent articles that would only be published after his death—inveighed against his unjustified concentration on the novel, his adulation of established

narrative models, and his simplistic distinction between form and content. At the end of the 1950s, Theodor Adorno lambasted with memorable virulence Lukács's bias for content, his peremptory aesthetic judgments, and his anti-modernist dogmatism: "for decades on end he laboured in a series of books and essays to adapt his obviously unimpaired talents to the unrelieved sterility of Soviet claptrap, which in the meantime had degraded the philosophy it proclaimed to the level of a mere instrument in the service of its rule."[28] Herbert Marcuse, to whose work we will now turn, rebuked Lukács's failed attempt to establish an external connection between literary works and social reality, his undialectical methodology, as well as his omission of the dimension of form, "which gives the societal content its specific artistic expression."[29]

In what follows, I will focus on Marcuse's final book, *The Aesthetic Dimension* (1978). This work brings together a number of fundamental themes in his writings on aesthetics, while also casting aside some of his earlier positions. Without providing a comprehensive overview of the relation between this book and his corpus as a whole, it should nonetheless be noted that he is generally more skeptical of contemporary aesthetic rebellion in this work. He no longer celebrates the desublimation of art and the attempt to merge it with reality in various forms of dissident art, nor does he praise the use of slang and obscenity as he had in the past. For all of these reasons, this book can be seen as a continuation of *Counter-Revolution and Revolt* (1972), in which Marcuse had already distanced himself from his earlier support of contemporary countercultural practices and desublimated art, most notably in *An Essay on Liberation* (1969).[30] Moreover, he defends the non-identity of art and reality, and hence the impossibility of any ultimate harmony between the two. In spite of the book's insistence on an aesthetic transformation of the senses à la Schiller and the early Marx, it abdicates the claim to be able to reconcile instincts and society, which was integral to the argument he had advanced in *Eros and Civilization* (1955).

The subtitle of Marcuse's book squarely situates it in relationship to Lukács: *Toward a Critique of Marxist Aesthetics*. Since his criticisms nonetheless remain within a Marxian framework, as he explicitly states himself,

it is important to specify the key ideas that he decries under the potentially misleading title "Marxist aesthetics": art is part of the ideological superstructure, authentic artwork expresses the consciousness of the ascending class, political content and aesthetic quality tend to coincide, the author needs to express the interests of the ascending class, the declining class can only produce decadent art, and realism is the most appropriate form of art.[31] Against this reductionist view of art, in which aesthetics is subservient, affirmative, and ideological, Marcuse asserts that art is an autonomous, negating, and productive force that is irreducible to its class origins and therefore eludes economic determinism. Art, on his account, does not need to be proletarian in order to be revolutionary, and bourgeois art is not by its very nature decadent and ideological. He thereby aims at displacing the political dimension of art from the economic base, the artist's class and ideological orientation, to the work itself and its particular aesthetic form: "The progressive character of art, its contribution to the struggle for liberation cannot be measured by the artists' origins nor by the ideological horizon of their class. . . . The criteria for the progressive character of art are given only in the work itself as a whole: in what it says and how it says it."[32] This is the first sign of what we might call the aesthetic autarchy of the work or an aesthetics of the isolated artifact, which Marcuse largely shares with Theodor Adorno's *Aesthetic Theory* (the sourcebook for *The Aesthetic Dimension*). For although the former's insistence on the specific character of works of art is laudable when compared to the reductionist determinism he lambastes, he valorizes the aesthetic form, as we shall see, on the basis of a social epoché by which he largely brackets the complex systems of production, distribution, and reception that constitute the social life of artworks.

Far from being reducible to a particular stage of the class struggle or a loutish form of Proletkult, art has, according to Marcuse, a "transhistorical substance": "its own dimension of truth, protest and promise, a dimension constituted by the aesthetic form."[33] The original German title of his book, *Die Permanenz der Kunst* (*The Permanence of Art*), which Marcuse judged to be "much too demanding/pretentious [*anspruchsvoll*]," has the advantage of going to the heart of matters.[34] It refers to the way

in which the very essence of art escapes history because it always and everywhere transcends and negates the status quo. Through the course of the book, he thus makes a number of references to "the permanence of art, its historical immortality," its "transhistorical, universal truths," and "the permanence of certain qualities of art through all changes of style and historical periods (transcendence, estrangement, aesthetic order, manifestations of the beautiful)."[35] As this last quotation illustrates, the beautiful, and more generally the universal aesthetic criterion of beauty, shares this transhistorical status, as does the category of great or authentic artwork: "throughout the long history of art, and in spite of changes in taste, there is a standard which remains constant. This standard not only allows us to distinguish between 'high' and 'trivial' literature, opera and operetta, comedy and slapstick, but also between good and bad art within these genres."[36]

Although aesthetic form, like autonomy and truth, "*transcends* the socio-historical arena," Marcuse nonetheless refers to it as "a socio-historical phenomenon."[37] "I do not claim in my little book that art is free from social determination," he firmly asserts in an interview in 1978, "but I do deny that the social determinants affect the very *substance* of the work."[38] Declaring that we learn "absolutely nothing" from Shakespeare's plays about the "real workings of the society" in which he lived, he proclaims that *Hamlet* cannot be adequately understood by social determinants: "'To be or not to be' transcends any kind of social determination."[39] This is yet another sign of an aesthetic autarchy of the work since he assumes that artworks have an extra-social and transhistorical substance. Indeed, his analyses tend to operate within a binary normative framework in which there are only really two options: social determinism or freedom, status quo or transcendence, sociohistorical reality or transhistorical art, Establishment or anti-Establishment, affirmation or negation. His references to the dialectical relationship between these two extremes, far from providing a way out of these reified polarizations, only further hypostatize them as being the only real possibilities. To return to the specific example evoked above, it is patently unclear why Shakespeare's plays do not reveal—even in a mediated fashion—at least *something* about the real social workings of

his cultural milieu, including for instance the social practice of playwriting, the historical state of the English language, the political situation of the times, the general state of gender, class, and race relations, and so on. The transhistorical substance of a work of art appears to refer to what distinguishes art from reality, this je ne sais quoi that transcends what is socially and historically determined. Marcuse thereby reveals his reliance on a widespread, partially romantic mythology regarding the undetermined and transhistorical nature of art.

He provides an important qualification of his position in the same interview from 1978: "Transhistorical means transcending every and any *particular* stage of the historical process, but not transcending the historical process as a whole. That should be evident, because we cannot think of anything under the sun that could transcend the historical process as a whole. Everything is in history, even nature."[40] This suggests that art is itself a product of history that emerged at a specific point in time. Indeed, this is precisely what Marcuse suggested in a lecture at the Guggenheim Museum in 1969, when he formulated a version of art history reminiscent of the work of other members of the Frankfurt School:

> The realm of forms: it is an *historical* reality, an irreversible sequence of styles, subjects, techniques, rules—each inseparably related to its society, and repeatable only as imitation. However, in all their almost infinite diversity, they are but variations of the *one Form* which distinguishes Art from any other product of human activity. Ever since Art left the magical stage, ever since it ceased to be "practical," to be one "technique" among others—that is to say, ever since it became a separate branch of the social division of labour, it assumed a Form of its own, common to all arts.[41]

In short, the Form of art emerged historically through a linear process of autonomization, but it has remained an invariable constant ever since.

Unfortunately, Marcuse hardly discusses this emergence, which poses fundamental problems for his approach. If art is indeed a social and historical practice that appeared at a particular point in time, then it is by no

means purely autonomous. Instead, it is a cultural activity unique to particular times and places. This, it seems, is precisely what Marcuse wanted to avoid because he clearly thought that it would lead to the dissolution of art into social reality, which is the only other option according to the binary framework that structures much of his work. It is for this reason, among others, that he posited a transhistorical substance of art and used it to describe art's historical dimension: "The essential historical quality of art is more and other than a mutation of fads and fashions; it is rather a transformation in which the substance of art persists in changing expressions."[42] This is an apposite summary of Marcuse's selective historicism: he chooses what is part of history ("changing expressions") and what escapes historical transformation ("the substance of art"). It is incumbent upon the selective historicist, I would argue, to vindicate his or her choice by demonstrating how the transhistorical elements are indeed beyond the pale of history, rather than simply being the result of socially conditioned choices and an anthropocentric timescale (in which being beyond the pale of history simply means existing for a few centuries).

Marcuse largely turned a blind eye to the social and historical factors conditioning his own conception of transhistorical art. In fact, far from truly surpassing his sociohistorical nexus, he posited a notion of transhistorical art that is clearly derived from the modern European concept and practice of art in the singular. His conceptualization not only depends on the unified category of the fine arts and on the modern concept of the individualized work of art, but it also relies extensively on the relatively recent understanding of art as rooted in iconoclastic creativity. As we saw in the analysis of faux transcendentals in the previous chapter, Marcuse was certainly far from being the only twentieth-century thinker to succumb to the anti-historical transubstantiation of current artistic practice, which transforms a parochial—namely, modern European—conception of art into a transhistorical constant.

One of the fundamental features of the transhistorical substance of art for Marcuse is its separation from reality: "an essential quality of art which remains through all its historical transformation is the difference between art and reality."[43] This diremption is the result of aesthetic form,

which "constitutes the autonomy of art vis-à-vis 'the given.'"[44] Form is not, however, opposed to content, not even dialectically according to Marcuse. "In the work of art," he writes, "form becomes content and vice versa."[45] He defines aesthetic form as "the result of the transformation of a given content (actual or historical, personal or social fact) into a self-contained whole: a poem, play, novel, etc."[46] In his lecture at the Guggenheim in 1969, he explicitly identified the very essence of Art with aesthetic Form, a theme that runs throughout *The Aesthetic Dimension*: "I shall use the term *Art* (capitalized) as including not only the visual arts but also literature and music. I shall use the term *Form* (capitalized) for that which defines Art as Art, that is to say, as essentially (ontologically) different not only from (everyday) reality but also from such other manifestations of intellectual culture as science and philosophy."[47] Aesthetic form is thus the source of artistic autonomy and of the separation between art and reality. It is the transhistorical essence of art per se.

It is precisely the essential difference between art and reality that gives the former its political power, according to Marcuse: as an act of sublimation, it forms a different reality than the one that is given and thereby negates the status quo.[48] If art continues to have an affirmative dimension for him insofar as it produces a reconciling catharsis, it nevertheless maintains a critical edge by breaking the monopoly of established reality:

Aesthetic sublimation makes for the affirmative, reconciling component of art, though it is at the same time a vehicle for the critical, negating function of art. The transcendence of immediate reality shatters the reified objectivity of established social relations and opens a new dimension of experience: rebirth of the rebellious subjectivity. Thus, on the basis of aesthetic sublimation, a *desublimation* takes place in the perception of individuals—in their feelings, judgments, thoughts; an invalidation of dominant norms, needs, and values. With all its affirmative-ideological features, art remains a dissenting force.[49]

It is, therefore, aesthetic form that not only defines art as such but also provides it with a critical function allowing it to contribute to the struggle for

liberation. Moreover, it is not so much art itself that has political power as the individual autonomous work: "The work of art can attain political relevance only as autonomous work. The aesthetic form is essential to its social function. The qualities of the form negate those of the repressive society—the qualities of its life, labor, and love."[50] Marcuse's isolation of the work of art and his identification of its inherent values is, of course, closely related to his bracketing of the social networks of circulation and reception.[51]

Moreover, the very idea that art would be political by maintaining the autonomy of aesthetic form suffers from the myth of a magical coalescence between artistic autonomy and political emancipation. Renato Poggioli, Nathalie Heinich, and others have debunked this myth by demonstrating that there is no necessary connection or clear historical correspondence between the dedication to aesthetic form and political progressivism. Poggioli adeptly writes:

> The hypothesis . . . that aesthetic radicalism and social radicalism, revolutionaries in art and revolutionaries in politics, are allied, which empirically seems valid, is theoretically and historically erroneous. This is further demonstrated, to some extent at least, by the relation between futurism and fascism, or again by the prevalence of reactionary opinions within so many avant-garde movements at the end of the last and the beginning of the present century.[52]

While it is certainly true that Marcuse does not simply praise aesthetic radicalism, as his derogatory comments on Duchamp's "pisspot" illustrate with striking clarity, he nonetheless favors intransitive works of art dedicated to form.[53] He even asserts that "aesthetic quality and political tendency are inherently interrelated," although "their unity is not immediate."[54] This formulaic approach to the relationship between art and politics ultimately runs the risk of being just as reductive as the vulgar Marxist paradigm that he decries. For in the place of economic determinism, he erects a system of formal determination: politically relevant works of art are those that are dedicated to aesthetic form.[55]

It is precisely the autonomy of art and aesthetic form that leads Marcuse to reject both politicized art and artistic commitment or *engagement*: "To ascribe the nonconformist, autonomous qualities of art to aesthetic form is to place them outside 'engaged literature,' outside the realm of praxis and production. Art has its own language and illuminates reality only through this other language."[56] In fact, he even refers to political art as "a monstrous concept" in a lecture he presented at the New York School of Visual Arts in 1967.[57] If the notion of political commitment in the arts has any real meaning for him, it has to be understood as commitment to autonomous form. In a revealing statement, he asserts that "the more immediately political the work of art, the more it reduces the power of estrangement and the radical, transcendent goals of change. In this sense, there may be more subversive potential in the poetry of Baudelaire and Rimbaud than in the didactic plays by Brecht."[58] This is one of the fundamental paradoxes of Marcuse's defense of artistic dedication to form, which equally plagues Adorno's arguments in *Aesthetic Theory*: art is more political the less political it is. Instead of subordinating aesthetics to politics, Marcuse maintains that it is precisely by obeying its own internal laws that art cultivates its veritable political potential as a transcendent truth separate from the reality of the status quo: the truly dialectical path from aesthetics to politics is the one that leads away from politics proper.

Art should not be explicitly politicized on Marcuse's account because it is always already political in a very specific sense. Giving his own idiosyncratic imprimatur to the talisman complex, he writes: "art has an internal, inherent social and political force and . . . therefore alone a politicization of art is unnecessary and damaging. Art has an inherent, internal political potential—first as indictment of the existing human condition: as an indictment of the existing mode of life and secondly, as the imagery of repressed and tabooed possibilities of freedom."[59] He even points to a fundamental aporia in the very effort to politicize art: "I want to anticipate the contradiction in the attempt to directly politicize art—if it is only in its alienation from its existing society that art can in fact communicate its contradictory, critical function, then the termination of this function, that is to say, the

taking back of the artistic alienation, would destroy . . . this very quality of art."[60] This core contradiction of the politics of art allows us to invert the statement made above: art is less political the more political it is. Regardless of its formulation, however, both of these contradictions point to the same fundamental problematic, which we will revisit in a different light later in the book: for art to be truly political, it has to maintain its distance from politics proper.

One of Marcuse's fundamental assumptions is hence that art and politics are separate domains with their own essential natures. "For art itself," he writes, "can never become political without destroying itself, without violating its own essence, without abdicating itself. The contents and forms of art are never those of direct action, they are always only the language of images, and sounds of a world not yet in existence. Art can preserve the hope for and the memory of such a world only when it *remains itself*."[61] In other words, it is precisely the autonomy of art from political reality—as well as its transhistorical status, which separates it from the historical given—that allows the former to intervene in the latter as an appeal to transcend the status quo.[62] This does not, however, mean that aesthetic autonomy necessarily produces direct political consequences. On the contrary, Marcuse not only insists on the separation between aesthetic form and political reality, but he also claims that their relationship is always indirect: "Art can never and never should become *directly* and immediately a factor of political praxis. It can only have effect *indirectly*, by its impact on the consciousness and on the subconsciousness of human beings."[63] There remains an unbridgeable gap between the aesthetic and the political,[64] and the true task of social transformation is political in nature:[65] "The realization, the real change which would free men and things, remains the task of political action; the artist participates not as artist."[66] He thereby maintains a strict separation between art and politics and—at least in certain texts—gives pride of place to political agency.[67] Ultimately, the autonomy of art leads to a fundamental contradiction: if art is politicized, it loses its power to transcend the status quo, whereas if it simply remains art, it is, by this very fact, severed from politics proper. This contradiction exists in various forms in all times and places, according to Marcuse, and its resolution "would mean the end of art."[68]

THE POLITICS OF PROSE: *ENGAGEMENT* IN HISTORY

A writer is committed when he tries to achieve the most lucid and the most complete consciousness of being embarked, that is, when he causes the commitment of immediate spontaneity to advance, for himself and others, to the reflective.

—JEAN-PAUL SARTRE

Jean-Paul Sartre was born in 1905 into a bourgeois family in Paris, and he first came to prominence for his literary writings and philosophic works rooted in the phenomenological tradition. Around the mid- to late 1940s, he evinced a growing interest in politics and quickly became one of the most notable defenders of artistic commitment or *engagement*. Although it would be a mistake to make his political awakening into a veritable about-face, as Thomas Flynn has argued, it is nevertheless clear that the adamant spokesperson for commitment in the postwar era had definitively turned his back on his prewar 'vacation from history.'[69] It is extremely revealing, for our concerns here, that Sartre's turn toward direct political involvement in the 1940s coincided with his dedication to providing a detailed history of modern French literature. He published *Baudelaire* in 1947, and his notes on Mallarmé most probably date from the same time period. At the hundredth anniversary of the revolution of 1848, he published *What Is Literature?* before undertaking his gargantuan *Saint Genet*. Through the course of the late 1940s and early 1950s, his numerous articles, editorials, and interviews on literature appeared in a variety of journals and were promptly collected in the *Situations* series. Although slightly less prolific in the field of literary history from approximately the mid-1950s onward, Sartre continued to write intermittently on literature and was working on the fourth volume of his existential psychoanalysis of Flaubert when he passed away in 1980. Emerging more or less simultaneously with his political *engagement*, Sartre's commitment to literary history would, like the latter, continue unabated until the end of his life.

Keeping this remarkable proximity between political commitment and literary history in mind, I would like to turn to his flagship publication, *What Is Literature?* In using this question for the title of an extended essay, Sartre anticipated an ontological response that would expose the very nature of literary discourse, hence his decision to begin by providing a typology of the arts that uses material and form as markers to distinguish between the different kinds of aesthetic production. Music and the fine arts, for example, use the raw materials of sound, color, or shape to create a feeling or an imaginary object. Poetry, as a literary art, does the same thing with words. Prose, on the other hand, uses the raw material of words as signs in order to produce meaning. Sartre thereby divides the literary arts between the poetic usage of words qua things and the prosaic use of words as means of communication.[70] The fact that poetry and prose share a common artistic material makes them both literary arts, but the poet repudiates communicative expression in the name of representation by using the physical aspects of words in the same way a painter uses color or a musician sound.

This typological classification of the arts, if not the title of the work itself, is the first indication that Sartre's analysis of literature runs the risk of succumbing to the ontological illusion. However, in the final footnote to the first section of *What Is Literature?*, he qualifies his position by explaining that there is a certain form of prose in poetry and vice versa. This suggests, in principle, that the strict delimitation of poetry and prose is actually a heuristic distinction within hybrid forms. Yet the mutual contamination of poetry and prose in any literary undertaking in no way implies the elimination of their essential differences, and it does not even mean that they are joined by a continuous series of intermediate states.[71] Sartre actually appeals to the *eidos* of prose and claims that, like poetry, its complex and impure structure nonetheless remains clearly delimited. This means that even if the forms of poetry and prose can be mixed in concrete literary works, their respective natures nonetheless remain in tact. The essential form (*eidos*) of prose is always and everywhere distinct from that of poetry.[72]

If he opens his book with an ontological typology of the arts, it is in order to clearly delimit the sphere of political commitment, which is limited to prose.[73] The fine arts fall outside the proper domain of *engagement*:

"one does not paint meanings; one does not put them to music. Under these conditions, who would dare require that the painter or musician commit himself?"[74] Furthermore, since poetry shares the modus operandi of the fine arts and remains foreign to the communicative "empire of signs," it is also situated, to a large extent, outside of the realm of commitment. Strictly speaking, it is the meaning communicated by a work of art that can be committed, whereas imaginary objects or feelings cannot be subjected to *engagement,* or at least not in the same sense.[75] Thus, Sartre's entire account of the politics of art, at least in this book, is in fact one of the politics of prose.

He organizes his analysis around three basic questions, which provide the tripartite structure of his book: what is writing? why write? for whom does one write? Since prose is inherently instrumental and aims at communicating a specific meaning, he defines writing as the act of unveiling a particular world or presenting an image of society. In the very act of disclosing an image of the world, prose writing simultaneously summons its readership to take responsibility for its situation and change certain aspects of it. "To write," Sartre claims, "is to make an appeal to the reader that he lead into objective existence the revelation [*le dévoilement*] which I have undertaken by means of language."[76] He thereby establishes a chain of equivalence leading from the act of writing to active social transformation: "to name is to show, and to show is to change."[77]

Before turning to the second question, let us pause to note that Sartre here merges prose writing with politics according to a formula that is particularly compelling for those with a literary penchant who prefer writing to other forms of participation in politics, as Anna Boschetti has astutely argued.[78] According to the mechanical equation that he establishes, to write is already to change the world because all prose apparently has a talisman-like property that directly induces a concrete reaction on the part of the reader. Moreover, even though Sartre deserves recognition for underscoring the crucial role of reception in the literary arts, the formula of art and politics that he establishes ultimately reduces readers' agency to the obligatory task of reacting to the world described in writing. The variability of reception and the motley interpretations of literary works, as well as the broad

gamut of actions available to readers, are largely sidelined in favor of under-standing prose as a straightforward call to action.

Sartre's response to his second question is partially contained within his answer to the first. The reason for writing is to reveal a world and summon the reader to assume responsibility for changing it. He thereby discards art for art's sake and deprecates those who argue that writing is a self-sufficient activ-ity. Prose necessarily addresses a reader and is in need of a readership in order to exist as art per se. His rejection of the notion that art is an isolated activity or a private matter of the soul sheds light on one of his most important claims: writing is a social process. The reason for writing must therefore be found in the dialectic between author and reader, between the artist and society.

For whom does one write? Since authors and readers are anchored in spe-cific situations, the prose writer always addresses a particular group of read-ers rather than an illusory universal reader. Moreover, in appealing to their freedom to modify the structure of society, the prose writer calls on their con-crete freedom instead of on any supposed abstract freedom. Since neither the author nor the reader can escape from their epoch, the former should embrace the parameters of his or her time period as being part of a shared condition. This does not, of course, imply accepting these parameters as natural givens or consenting to the norms that they establish. On the contrary, Sartre calls for a refined and lucid understanding of this shared condition that will lead both author and reader to a reflective awareness of their situation.

This means that *engagement* is always situational. There is no commit-ment in general, for Sartre, unless it is the commitment to freedom itself. No writer ever writes from the point of view of humankind, and no reader ever occupies the position of universal humanity. An author comes from a pre-cise economic background, has a particular nationality, a specific heritage, and so forth. The situation he or she shares with the reader is also structured by a concrete set of determinants. Thus, if commitment can be defined as an appeal to the freedom of the reader to assume responsibility for a shared world, it must not be forgotten that freedom *is not*, as Sartre was fond of saying. Freedom is won in precise historical situations: "each book proposes a concrete liberation from a particular alienation."[79] In *What Is Literature?* he celebrates novels by black Americans that express their hatred of the

whites because such novels are, on his account, an appeal to the freedom of their race.[80] However, he categorically condemns any novels that valorize anti-Semitism, inveighing most notably against Louis-Ferdinand Céline.

Since commitment is always situational, the structural conditions of politicized art depend, at least in part, on the historical context. This is surely one of the reasons why Sartre considered it of the utmost importance to provide a historical account of literature more or less at the same moment in time at which he began—as a literary and philosophic figure—to be directly involved in politics. With this in mind, let us take a few paragraphs to outline his account of literary history before considering some of its shortcomings.[81]

Although his writings on theater go back to the ancient Greeks, his comments in *What Is Literature?* begin with the twelfth-century repression of the literary arts by religious ideology. According to the brief overview that he provides, the *bonne conscience* or clear conscience of the medieval clerk, a specialist writing only for his associates, flourished on the deathbed of literature as writing served to perpetuate Christian ideology. Whereas the very act of writing and reading are now considered fundamental rights as well as natural means of communication, according to Sartre, they were technical activities in the Middle Ages, reserved for spiritual fathers and Church professionals.[82]

The worldly ideology of politics was added to the spiritual ideology of religion during the French classical age. The secularization of society, though still far from complete, extended the reading public outside the realm of clerical executives to include a distinct group of elites from the court, the clergy, the magistrature, and the affluent bourgeoisie. Since this restricted audience accepted the political and religious ideology of the times, the classical authors had nearly as clear a conscience as the medieval clerks, and literature remained under the yoke of the established order. Nevertheless, just as minor contestation in the name of God's will was possible before the seventeenth century, the mirror that writers of the classical age modestly held up to their public was at once captivating and unsettling for the view it gave of society. The work of art, almost in spite of authorial intention, called out to the freedom of its audience by presenting an image of society that rendered it unbearable.

A significant change occurred through the course of the Enlightenment. Whereas earlier writers were addressing a single and ideologically homogenous public, according to Sartre, authors of the eighteenth century saw their audience divide in two. A progressive, virtual public, at once desirable and slightly out of reach, was added to the detestable real public of conservative ideologues that had dominated previous ages. The ruling class had lost faith in their ideology but understood that the religious and political principles it had established were convenient tools for continuing their reign. The bourgeoisie, on the other hand, aspired to cast off the yoke of this now pragmatic ideology in order to promote their own worldview. The tension between these two groups of readers characterized the unique situation of Enlightenment writers, torn between the public consecration offered by the established order and the *Lumières* demanded by the rising bourgeoisie. This meant that literature, which had until then played a conservative role for an integrated society, became aware of its own autonomy and came to affirm its independence from the ideologies of both the church and the court. Literature came to be associated with what he calls *l'Esprit*, or the permanent power of critique and the freedom of negation in the name of truth. As 'Negativity,' literature liberated the Enlightenment writers from history and from the contingency of their situation by allowing them to use abstract, ahistorical reason to speak in the name of universal humanity.

The harmony between the oppressed bourgeoisie of the Enlightenment and the abstract, negative stage of literature's self-consciousness dissipated at the very moment at which they both obtained their respective goals. This unique chance in history was thus swiftly transformed into a lost paradise since the bourgeoisie, through the course of the nineteenth century, became the ruling class and introduced novel forms of oppression. It imposed its ideology of idealism, psychologism, determinism, and utilitarianism while superciliously demanding that authors help the bourgeois "feel bourgeois by divine right."[83] Literature thereby ran the risk of becoming the *bonne conscience* of the ruling bourgeoisie after having been the *mauvaise conscience* (bad conscience) of the privileged classes of the eighteenth century. This reversal meant the subordination of literature to the image that the bourgeoisie wanted to present of itself, a relationship that Sartre claims is equivalent to the assassination

of literature. The general rule he establishes in his discussion of previous centuries holds as well for this era: the death of literature occurs at the precise moment at which it loses its status as a "free appeal to free men."[84]

It is significant in this regard that he divides the nineteenth century into two distinct epochs separated by the revolution of 1848. The Romantic movement during the first half of the century continued to venerate aristocratic ideals and attempted in vain to restore the social dichotomy of the previous century. Even the writers who explicitly advocated a form of socialism were unsuspectingly espousing a by-product of their own bourgeois idealism, with perhaps the rare exception of Victor Hugo. Since these writers were still, to a large extent, living in the past and failed to accept the reality of the present, it was not until 1848 that a true break occurred. Authors began to reject not only the earlier forms of political and religious ideology, but also the recent ideology promulgated by the bourgeoisie. Literature and art came to be identified with the prodigal consumption of art for art's sake that brazenly trumpeted its emancipation from ideology. The only valid object for authors became writing itself, and literature thereby entered its reflexive period where it tested its methods, broke out of antiquated structures, experimented in determining its own laws, forged novel techniques, and became generally absorbed in the investigation of its own autonomy. The act of writing was removed from the utilitarian commerce of the bourgeoisie, and the author withdrew into the noble realm of the arts by negating everything worldly: "the extreme point of this brilliant and mortal literature is nothingness."[85]

However, literature's reflexive turn was haunted by a profound contradiction because the break with the bourgeois public was purely symbolic: "The writer boasts of having broken off all dealings with it, but by refusing the breakdown of classes from the bottom up [*le déclassement par en bas*], his break was condemned to remain symbolic."[86] In other words, at the very moment at which literature declared its freedom from all ideology, it revealed its complicity with an ideology disguised as its opposite. By participating in this masquerade and pretending to escape his or her situation, the modern author lives in bad faith, refusing to acknowledge for whom he or she is really writing. This fundamental contradiction is at the heart of the collective pathology that dominates literature from 1848 to the First

World War. Sartre describes the psychological maneuvers involved in terms of a process of identification often found in autistics: "the sick person who needs the key of the asylum in order to escape . . . comes to believe that he himself is the key. Thus, the writer, who needs the favor of great men to shirk his class [*se déclasser*], ends up by taking himself for the incarnation of the entire nobility."[87] The parasitic writers of the Second Empire and early Third Republic invented a false aristocracy of letters to mask the bourgeois audience they simultaneously needed and despised.

The dialectical process of literary autonomy that began with the Enlightenment conception of literature as critical negativity thereby led to the post-1848 notion of literature as the absolute negation of everything worldly. The final stage in this process was attained by Surrealism in the interwar period. Whereas the *poètes maudits* negated the world and refused to accept their situation, the surrealists forced negativity into the last bastion that had survived the absolute negation of their immediate predecessors. They wrote in order to consume and annihilate literature itself. They posited the luxury of self-destruction as the noble beauty of their anti-art and embraced absolute irresponsibility. However, this was only one more form of subterfuge used to hide their parasitic relationship to the bourgeoisie and was thereby a symptom of their continued pathology. All said and done, their apparently revolutionary impulse was in fact premised upon maintaining the social order that they needed in order to create the illusion of rebellion. In analyzing this symbiosis, Sartre comes to the conclusion that the surrealist iconoclasts were actually the opposite of revolutionaries who aim at definitively changing class structure. Indeed, it is only in a classless society, he argues, that a truly revolutionary and utopian literature can emerge: "actual literature [*la littérature en acte*] can only measure up to its full essence in a classless society. Only in this society could the writer realize that there is no difference of any kind between his *subject* and his *public*, since the subject of literature has always been man in the world."[88] Political action is therefore necessary in order to allow the true essence of literary prose to flourish.

Although Sartre tends to use general terms such as *la littérature*, his overarching model in *What Is Literature?* is clearly the history of French

literature. Not only are the vast majority of his examples taken from the French cultural tradition, but his chronological delimitation of literary epochs is unmistakably based on the history of France. This explains some of the political events chosen to delimit historical eras, and it also sheds light on why three of the most important periods in literary history happen to correspond to moments when the French tradition exerted a visible influence over the rest of Europe: the classical age under Louis XIV, the Enlightenment of the *philosophes*, and the modern period starting in 1848. It also explains why epochs that were arguably dominated by other European countries are generally ignored or marginalized, such as the Italian Renaissance or the Romantic era in Germany and Great Britain. The analysis of historical space is almost exclusively restricted to France and to particular traditions within its borders. However, this space is presented as totalizing and universal, and the eras he delimits function as relatively homogenous blocs with almost no exceptions.[89] Sartre answers the question "what is literature?" by primarily providing a response to the question "what is French literature?" He thereby presents a near paradigmatic example of historical hegemony: a particular historical development (French literature) is passed off for a universal phenomenon (*la littérature*).[90]

It is, of course, undeniable that Sartre conceives of literature as a social function that has undergone a series of changes based on the historical transformation of society. Nonetheless, these modifications never alter the fundamental condition of literature as a free appeal to the freedom of humanity. This condition can be put in danger, as it was by the triumph of the bourgeoisie in the latter half of the nineteenth century. It can even be directly negated, as was the case with surrealist anti-literature, according to Sartre. The fact remains that it is the very substance of literature that defines these historical deviations. Thus, while it is true that the essence of literature is historical in the sense that it only exists in specific temporal conjunctures, its historicity must not be confused with actual alterations in the meaning of literature. The same is true of Sartre's typology of the arts. Poetry and prose, for example, have played various roles in the historical development of literature, but their essential differences remain the same because of what might be called their universal condition. Even the notions of author and reader have

retained, according to Sartre, certain fundamental characteristics in spite of the important changes they have undergone since the Middle Ages.

This selective historicist postulation of a universal literary condition behind all historical changes is closely allied with two other notable features of his analysis: reductive historicism and organic conceptualism. The reductivism inherent in *What Is Literature?* is apparent in Sartre's tendency to discuss each historical era as if he were isolating the fundamental conditions that govern all literary production at a particular point in time. These conditions are, of course, historical and change with each major epoch of political history, but they nonetheless serve to determine the total historical situation within which writers were working. This means that Sartre assumes an epochal homogeneity that allows him to discuss the general state of literature at a particular point in time.[91]

Moreover, in tracing the self-conscious evolution of literature since the Middle Ages, he relies on a series of organic concepts: literature, poetry, prose, author, reader, and so forth. These are not only general terms that purport to summarize the total situation of a particular epoch, but they operate as animate concepts that organically develop through various stages. Each notion functions like a historical actor by behaving and thinking in much the same way as an individual person or a for-itself. The analogy that Sartre thereby establishes is not simply between macrocosmic and microcosmic levels of history, but rather between the modus operandi of totalizing concepts such as literature and individual historical agents. Literature acts, thinks, decides, becomes self-conscious—following its own proper entelechy—much like an individual, with the important difference that its subjectivity is universal and that each action or thought appears to encompass the totality of individual decisions at a particular point in time. Furthermore, the historical stages literature has gone through are themselves defined by a conceptual apparatus that is readily identifiable as the theoretical system Sartre uses to analyze human subjects. It is clear, for example, that the most essential components of this analysis are facticity and freedom, being and nothingness. Literature, as a social function, is always situated in a particular context and the stages of its development are based on the given facts of its situation as well as its particular response to them.

Whereas it remained under the yoke of religious and then political facticity from the Middle Ages through the seventeenth century, the Enlightenment marked the moment at which it assumed its responsibility as a free historical agent and negated the ideologies inherent in its particular situation. Although the new ideology it promoted would later reveal its historical falsity, this is perhaps the closest literature came to a positive social critique and to a successful mediation between facticity and freedom. By 1848, this relative paradise had been definitively lost, and literature tended toward the opposite extreme of bad faith. By a process of absolute negation, it affirmed its total freedom from the situation and took refuge in art for art's sake and surrealist anti-literature. Just as pre-Enlightenment literature had declined to take full advantage of the minimal freedom it had, post-Enlightenment writing refused to recognize the minimal constraints of its historical situation by blindly affirming its absolute freedom from facticity. Commitment in the current era, so it seems, must seek to rejuvenate the Enlightenment sense of situated negativity by reworking the bourgeois arguments of the eighteenth century for the anti-bourgeois end of a classless society.

ONTOLOGIES OF ART: REALISM, FORMALISM, COMMITMENT

We must deny the hypothesis that the relation between avant-garde art (or art generally) and politics can be established a priori. Such a connection can only be determined a posteriori.

—RENATO POGGIOLI

The analytic positions outlined by Lukács, Marcuse, and Sartre in certain of their works form part of one of the important constellations in the twentieth-century controversy on art and politics. Although there is still much that can be learned from these authors and they should be studied seriously, I will conclude, for pragmatic and heuristic reasons, on a negative note by

critically reflecting on the theoretical coordinates that tend to govern their debate (in spite of all of the significant differences between them and their mutual criticisms of one another). In different ways and to varying degrees, all three thinkers fall prey to the ontological illusion and the assumption that there is a more or less transhistorical essence of art and, perhaps to a lesser extent, politics. Moreover, since they presume to have privileged access to and understanding of this essential nature, they equally succumb to the epistemic illusion by assuming that sociohistorical agents can have rigorous knowledge of more or less transhistorical constants.

All three of these thinkers also show signs of a formulaic methodology by purporting to isolate a single, privileged link between art and politics: realism as the art that unearths the deep forces of true political history (Lukács), aesthetic form as the negation of the status quo (Marcuse), prose as an appeal to the freedom of the reader to change the world (Sartre). In each case, a singular relationship is established such that other possible relations are judged inauthentic, invalid, or compromising. The implicit methodological message is that there is only one true relationship between art and politics. The structural monocausality of this one-to-one relation is in part due to an instrumentalization of aesthetics founded on an opposition between true political art—*the* correct instrument—and the false politics of art. All three philosophers thereby remain plagued by a binary normativity in which valid or successful art, which follows the prescribed formula, is strictly opposed to the illegitimate art that ignores it.

The formulaic relation between art and politics is largely founded on the talisman complex and the assumption that works of art have an innate power to effect political change. This can be through the perpetuation of the correct worldview (Lukács), the transcendence of the established reality (Marcuse), or the natural function of prose as a description that is simultaneously a transformation of society (Sartre). The talisman complex tends to presuppose an aesthetics of the isolated artifact in which it is the work of art in and of itself that has a political power. A social epoché thereby reduces the politics of art to the transformative force supposedly inherent in a solitary talisman-like object or activity, which is purportedly able to produce— often monocausally—political consequences. Even Sartre's description of

the role of the reader runs the risk of reducing the act of reception to a passive reaction before the true source of agency (the creative act of writing), thereby only partially overcoming the social epoché.

Finally, all three thinkers rely on problematic historical schematizations in order to provide accounts of the concrete encounters between art and politics. They all evince signs of selective historicism, if not an outright transhistoricism in certain cases, by assuming that the history of the arts is founded upon certain structural invariants. There are also clear traces of reductive historicism, at least in Lukács and to a certain extent in Sartre, insofar as they assume that the totality of historical phenomena can be reduced to a strict set of epochal determinants. Historical hegemony and organic conceptualism are also problems that afflict some of the work of these writers in various ways, and the problematic historical thesis regarding the autonomy of art will need to be revisited in the chapters to come. Since the relationship between art and politics is always framed by a historical account in the work of these authors (and, for that matter, in the writings of many others, both within and outside of the Marxian tradition), the attempt to reconceptualize this very relationship requires a radical rethinking of history. This was precisely one of the goals of the previous chapter, and it will continue to be one of the central themes in the ensuing analyses.

PART II

VISIONS OF THE AVANT-GARDE

3

THE THEORETICAL DESTINY
OF THE AVANT-GARDE

THE END OF ILLUSIONS

In our day and age, it is widely assumed that the more grandiose historical
encounters between art and politics have proven to be unsuccessful. Such a
failure has apparently revealed the extent to which the aesthetic dreams of
ushering in new forms of sociopolitical life were as much based on puerile
delusions as the mumbo jumbo of yesteryear's political radicals. This histori-
cal thesis, at least in certain sectors, tends to frame the very field of artistic
and political possibilities. "In politics," writes Thierry de Duve, "revolutions
engendered the Terror and the Gulag, and we no longer have faith in their
project of emancipation. In art, the notion of the avant-garde is no lon-
ger acclaimed [*n'a plus bonne presse*], and revisionism is now the order of
the day."[1]

If we unpack this thesis, it is indeed arguable that in the realm of the
arts, to begin with, a prominent historical consensus has come to impose
itself with the force of an indisputable given. If it be on the left or on the
right, among art historians or philosophers, if it be considered a cause for
celebration or regret, nearly everyone agrees that the historical avant-garde
of the early twentieth century has failed. Like many other forms of aesthetic
rebellion, the very institutions against which it had revolted were able to

recuperate it. In spite of the critical efforts of the neo-avant-garde at mid-century and beyond, the same historical dialectic purportedly transformed its negativity into the stabilizing positivity of the establishment, and art history continued its homogenizing march, dialectically enriched by the very attempt to contravene it. It therefore matters little if the neo-avant-garde is understood as the veritable rebirth of the avant-garde or simply the tail end of a long funeral procession, for its fate is widely judged to be identical with that of its predecessor. Today, the avant-garde has the dubious distinction of having twice failed. In the current age of colossal corporate museums and the global art market, the very appeal to the avant-garde or neo-avant-garde strikes many as the result of a puerile longing based on the myth of an outside that no longer exists, or never in fact existed.

It must not go unnoticed that there is a partial historical synchrony between the perceived failure of the avant-garde—as well as of other forms of aesthetic rebellion—and the supposed disintegration of the political grand narratives of the communist and socialist traditions. In the last third of the twentieth century, a seemingly endless number of voices have prophetically proclaimed that the utopian project of radical social transformation has been proven to be illusory. The era of the end of aesthetic myths largely coincides, therefore, with the age of the termination of political fantasies: the avant-garde and radical socialism are twin illusions. The political vanguard shares a common destiny with the aesthetic avant-garde: their early utopian fervor paradoxically served to reveal—via a dialectical inversion—the supposedly indisputable historical fact that there is no alternative to the systems in place.[2]

Our epoch is thereby implicitly framed as an enlightened age in which the delusions and superstitions of yesteryear no longer have any purchase. The presumed collapse of utopian projects, if they be aesthetic or political, paradoxically serves to confirm the progress of our own knowledge. In other words, the thesis on the failure of artistic and political endeavors judged to be utopian is itself premised on an utterly utopian conception of epistemic progress and the assumption that we can now establish definitive knowledge regarding the successes and failures of history. We thereby presume to have arrived at a meta-utopian epistemological plateau from which we

can overlook and judge all previous—and future—utopian undertakings. Regardless of the specific formulation of the end of illusions thesis, it must not therefore be lost on us that the true utopia, as it appears at the ultimate end of history, is epistemological and historiographical rather than aesthetic or political: we now supposedly know, unlike our benighted predecessors, that the course of history cannot be changed by radical art or revolutionary politics. This theoretical utopia serves to put a definitive end to all other utopian aspirations and practices by purporting to have attained absolute knowledge concerning what is historically possible.

CONTEMPORARY CRITICAL THEORY: THE ABANDONMENT OF AESTHETICS AND THE RETREAT OF RADICALISM

To provide a detailed account of the end of illusions thesis, it would, of course, be necessary to meticulously explore the various intellectual constellations that have contributed to it, as well as the motley political, economic, and social forces that have actively promoted it. For the sake of providing one specific case study, whose implications will transcend the particular instance analyzed, this chapter will concentrate on the troubling state of contemporary critical theory and, more specifically, on the flagship publication by Peter Bürger, *Theory of the Avant-Garde* (1973).[3] This book continues to serve as one of the central reference points in current debates on the avant-garde, and many of its critics still accept much of its methodological orientation. In order to situate and introduce its central claims, it will be useful to begin with a brief overview of the evolution of Frankfurt School critical theory and its relationship to the omniscient defeatism of the end of illusions thesis.

It is well known that the early members and associates of the *Institut für Sozialforschung*, which was nearly named the *Institut für Marxismus*, were very concerned with the relationship between aesthetics and radical political transformation, as evinced by the work of figures like Theodor Adorno,

Walter Benjamin, Max Horkheimer, and Herbert Marcuse. Jürgen Habermas, who is often recognized as the major figure in the second generation of critical theory, distanced himself from the primarily Marxist orientation of the early Frankfurt School. Although his relationship to Marx is complicated, we can, for the purposes of this brief discussion, take our bearings from a revealing text from the mid-1980s on the exhaustion of utopian energies where he asserts that "the utopian accents have moved from the concept of labor to the concept of communication."[4] He goes on to insist on "the abandonment of the methodological illusion that was connected with projections of a concrete totality of future life possibilities," which leads him to the conclusion that "the utopian content of a society based on communication is limited to the formal aspects of an undamaged intersubjectivity."[5]

It is not only in the realm of politics that Habermas has given his own unique imprimatur to the end of illusions thesis. He has also provided a distinctive and derisively crystalline formulation of this thesis regarding the avant-garde aspiration to link art and life: "But all those attempts to level art and life, fiction and praxis, appearance and reality to one plane . . . all these undertakings have proved themselves to be sort of nonsense experiments. These experiments have served to bring back to life, and to illuminate all the more glaringly, exactly those structures of art which they were meant to dissolve."[6]

Although a detailed investigation would be necessary, it is certainly arguable that the end of illusions thesis has taken a firm hold over much of third-generation critical theory, leading to two important tendencies: the abandonment of aesthetics and the retreat of radicalism. Regarding the former, it is remarkable that a significant number of the current representatives of Frankfurt School critical theory have neglected the question of aesthetics. If it be Rainer Forst and Axel Honneth in Germany, or Seyla Benhabib, Nancy Fraser, and Thomas McCarthy in the United States, many contemporary critical theorists have sidelined the question of aesthetics in favor of moral and political philosophy. Peter Uwe Hohendahl has underscored this methodological reorientation: "In the official transition from Habermas to Axel Honneth, who was recently appointed Habermas's successor at the University of Frankfurt, the aesthetic question, which was so prominent

in the work of Adorno and Benjamin, has been moved to the background."[7] Such a shift in focus, it should be noted, turns its back on the resolutely interdisciplinary approach of the first generation of the Frankfurt School. There are, of course, important exceptions, as we will see. However, in conformity with the widespread academic specialization of the contemporary intellectual world, critical theory has generally come to mean, at least in certain circles, a theory focused primarily on moral, political, and social issues. A clear separation between art and the sociopolitical realm is more or less implicitly accepted, and many contemporary critical theorists thereby abandon the project of a total analysis of society that would include aesthetics and the culture industry.

A retreat of radicalism has accompanied the general abandonment of aesthetics. The political orientation of the major representatives of third-generation critical theory is notably less transformative than that of first-generation figures. It would, of course, be a mistake to unduly identify the latter with a revolutionary agenda across the board. Indeed, it is arguable that they were often plagued by certain conservative tendencies. However, the radical high points of the first generation of critical theory stand in stark contrast to the work of many of the representatives of the third generation. With few exceptions, the more recent critical theorists are generally more concerned with improving democratic debate and various institutional mechanisms rather than with radically altering the very structure of society, politics, and economics through revolutionary struggle.

Although the abandonment of aesthetics and the retreat of radicalism are characteristics of a certain form of neo- or post-Habermasian critical theory, if not of much of Habermas's own work, there are numerous exceptions to this general tendency.[8] Regarding the engagement with aesthetics, let it suffice to cite, in the current context, the work of Peter Bürger, Christoph Mencke, and Martin Seel in Germany, that of Jay Bernstein and Peter Osborne in the Anglophone world, or that of Jean-Marc Lachaud and Rainer Rochlitz in France. There are surely many others who are equally worthy of mention. The list of those dedicated to revolutionary politics would certainly be much shorter, but there are still thinkers who identify simultaneously with Frankfurt School critical theory and transformative

politics. Although a detailed analysis would be required before drawing any definitive conclusions, it certainly appears that some of Nancy Fraser's work is at least slightly closer to the transformative heritage of the first generation than the work of many of her contemporary interlocutors.[9]

These exceptions, as well as others that could be cited, do not necessarily call into question the working hypothesis that I would like to advance: the relationship between aesthetics and transformative politics no longer imposes itself as a crucial and central object of analysis for contemporary critical theory. On the contrary, it is frequently assumed that they can be studied in isolation, or that the question of aesthetics can simply be abandoned, as well as that of revolutionary politics. Even those who are interested in examining the relationship between art and politics often develop, as we will see in the case of Peter Bürger, melancholic accounts of their historical divorce that underscore the impossibility of any reconciliation in the current conjuncture. In many ways, contemporary critical theory thereby runs the risk of partaking in and contributing to the historical imaginary of the end of illusions, according to which the aesthetic dreams of an art capable of transforming society are as illusory as those of the utopians who mistakenly thought that they could actually change the course of history.

With this in mind, we can now turn to Bürger's *Theory of the Avant-Garde* and his own explicit historical contextualization of his project. It is clearly rooted in the tradition of Frankfurt School critical theory, but he situates it more precisely in terms of a post-1968 melancholy and the sobering realization that "all revolutions have failed": "When I conceived of *Theory of the Avant-Garde* . . . the impulses that the May events had awakened had already been arrested."[10] Appealing to Walter Benjamin's writings on constellations, he asserts that May 1968 shed a new light on the historical avant-garde, thereby making his project possible: "The second event . . . illuminates the first. This constellation underlies *Theory of the Avant-Garde*. From the standpoint of the utopia of 1968, whose failure was already unambiguously sketched out, the author read the historical avant-gardes and saw the failure of the May '68 movement prefigured in them. . . . The author does not need to deny that it is an image marked by melancholy."[11] Based, therefore, on Bürger's own reflexive historical understanding of his project, it is

the supposed political failure of the movements of May '68 that illuminated the failure of avant-garde artistic projects. The end of political illusions, in other words, retroactively shed light on the end of aesthetic illusions.

In turning to Bürger's history of the demise of avant-garde delusions, it is important not to lose sight of the fundamental stakes of our analysis, which far surpass his particular argument. The overall goal of this chapter and the next is to call into question our supposed historical knowledge in order to rethink the avant-garde today by definitively breaking with the historical order that frames it within an all too well determined destiny.

THEORY OF ARTISTIC AUTONOMY

In order to understand Bürger's central thesis, let us begin with the historical typology that he uses in order to explain the emergence of what he calls the historical avant-garde movements (Dadaism, early Surrealism, and the Russian avant-garde after the October Revolution).[12] Three principal elements organize this typology: the function, the production, and the reception of works of art. In the era of sacral art, to begin with, art functions as a cult object produced collectively within religious institutions and destined for a communal reception. Courtly art constitutes the first step in the emancipation of art from the world of the sacred. Although its reception is still collective, it is produced by individuals and aims at representing figures of authority and courtly society. It is only in the third age of bourgeois art that production is individualized along with reception. Whereas art was an integral part of the life praxis of the faithful and of courtly society in preceding eras, its function changes significantly in the bourgeois culture that emerges at the end of the eighteenth century. Isolated from life, it comes to function as the "objectification of the self-understanding of the bourgeois class" without playing a veritable social role.[13] The separation of art from life praxis thereby becomes one of the dominant characteristics of bourgeois art and constitutes what Bürger calls its autonomy as "a distinct social subsystem," following in part the work of Max Weber and Jürgen Habermas.[14]

His overall typology reads, therefore, as a trilogy that recounts the history of the emancipation of art: the sacral era of cult objects is succeeded by the courtly age that liberates art from religion, which is followed in turn by the bourgeois period and the emancipation of art from all social functions. It is precisely for this reason that he refers to autonomy as an "ideological category": it "joins an element of truth (the apartness of art from the praxis of life) and an element of untruth (the hypostatization of this fact, which is a result of historical development as the 'essence' of art)."[15]

In spite of the connotations inherent in Bürger's vocabulary, it is extremely important to note that the so-called autonomy of art, and what he also refers to as the institution of art (*Institution Kunst*) in bourgeois society, does not result from the institutionalization of art in modern museums, academies, universities, and so forth. He is very clear regarding this point in a long passage in a collection of essays written in the late 1970s and early 1980s:

In the sociology of literature and art, the concept of the "institution of art" is occasionally employed to denote social formations [*Einrichtungen*] such as publishers, bookstores, theaters, and museums, which mediate between individual works and the public. "Institution of art" will not be used in this sense here; the concept rather refers to the epochal functional determinants [*die epochalen Funktionsbestimmungen*] of art within the bounds of society. I will not contest the possibility of a sociology of instances of mediation. . . . Only, this sort of empirical sociology of instances of mediation is not likely to illuminate the social function of art and its historical transformation. Adding investigations of individual instances cannot replace theoretical coordinates [*Theorierahmen*], which alone can form the basis for research on the social function of art. . . . We can treat as the *institution of art* those notions [*Vorstellungen*] about art (its functional determinants) which are generally valid in a society (or in individual classes or ranks).[16]

In *Theory of the Avant-Garde*, he describes the institution of art in terms of the emergence of "a systematic aesthetics as a philosophical discipline in

which a new concept of autonomous art is developed."[17] The supposed separation between the social subsystem of art and society as a whole derives directly from this new concept: "with the constitution of aesthetics as an independent sphere of philosophical knowledge, this concept of art comes into being, *which has as a result* that artistic production is divorced from the totality of the life [*Lebenstotalität*] of social activities and comes to confront them abstractly."[18]

These and other such statements reveal an operative idealism that openly belies Bürger's critique of idealist aesthetics as well as his express appeal to materialism: "its author understood *Theory of the Avant-Garde* as, primarily, an attempt at laying the foundations for a materialist cultural science."[19] In the "Postscript to the Second German Edition," he attempts to justify this apparently contradictory position by asserting that aesthetic theories, although they represent the most advanced ideas of an era, are not limited to the field of philosophy because they also dominate the minds of those who intervene in institutions in the material sense of the term. However, he does not propose in the least to change the relation of determination between ideas and institutions. On the contrary, he incongruously invokes as a defense of his apparent materialism the fact that he concentrated on "ideas about art in their most developed form" (notably those of Kant and Schiller).[20] What is more, as his precious few examples performatively illustrate in their own right, there is actually only one idea of art: "the singular term 'institution of art' highlights the hegemony of *one* conception of art in bourgeois society."[21] This partially disguised idealism is thus, in fact, a staunch idealism founded on a monolithic conceptualism: a single concept of art serves as the functional determinant for the totality of artistic theories and practices in the modern age.

This methodological idealism is seconded by what we might call a hermeneutic idealism, upon which some of his more severe critics have remarked. Marjorie Perloff goes to the heart of matters when she writes: "Bürger's theses are buttressed by precious few concrete examples, and no wonder. If the avant-garde exists only to call into question art as an institution, there is no point characterizing the actual work of Picasso or Picabia, Breton or Broch. Bürger, for that matter, seems to have much less interest

in what the avant-garde produced than in family quarrels with Gadamer and Horkheimer, Benjamin and Adorno."[22] Benjamin Buchloh has perhaps been Bürger's most persistent gadfly, repeatedly recalling the concrete ways in which the complexities of artistic practices in the twentieth century are irreducible to the monolithic conceptual structures of a theoretician who maintains a safe, and even sterile, distance from art history.[23]

In all fairness, it must be noted that Bürger does have a consistent response to such criticisms:

> There are, of course, differences between futurism, Dada, surrealism and constructivism. . . . A history of the avant-garde movements would have to represent these differences, which can be demonstrated by tracing the intellectual altercations between the various groupings. Theory pursues other goals; thus *Theory of the Avant-Garde* tries to make visible the historical epoch in which the development of art in bourgeois society can be recognized. To this end, it needs to undertake generalizations that are set at a much higher level of abstraction than the generalizations of historians.[24]

He invokes the same distinction between history and theory in his introduction to *Theory of the Avant-Garde*, asserting that his book does not aim at providing a historical account founded on specific interpretations of works of art: "the examples from literature and the fine arts to be found here are not to be understood as historical and sociological interpretations [*Deutungen*] of individual works but as illustrations of a theory."[25] He thereby proposes a theoretical distinction between two distinct practices: history relies on historical and sociological interpretations, whereas theory marshals illustrations that "serve to give concreteness to statements that make a more sweeping claim to general validity."[26] Although such a delimitation might appear to vindicate his project against his art-historical critics, it actually provides yet further proof of his deep-seated idealism. For his fundamental assumption is that there are theoretical constructions capable of grasping a historical field in its "contradictoriness" such that the crystalline waters of theory are not muddled by the unsettling investigations into the

multifariousness of concrete particulars. Indeed, according to a rather suspect strategy of selective exemplarity, he accepts and even highlights particular instances that illustrate his theoretical constructs while simultaneously dismissing any counterexamples as nothing more than historical and sociological interpretations. This means, at least in theory, that no specific examples would ever be able to confute his conceptual edifice because the latter is situated at a higher level of abstraction. He thereby establishes an idealist system of defense resembling a castle in the sky.

Let us return, in this light, to the question of the institution of art. It is clear that what Bürger understands by this expression is a theoretical institution. And this is for good reason: material institutions such as the modern museum, national libraries, modern theatres and operas, or the publication industry in no way serve to illustrate his conceptual thesis on the separation between art and society. On the contrary, it is arguable that they reveal the extent to which there was a slow and complex reconfiguration of the relations between art and society in which the former came to play an important role in the struggles surrounding the constitution of national identities. Let us take a single example, which is particularly appropriate for Bürger's concentration on the visual arts: the modern museum. Theodore Ziolkowski identifies its prototype in an example that is directly connected with Bürger's field of analysis: the *Altes Museum* in Berlin, which was designed by Karl Friedrich Schinkel and built between 1823 and 1829, when his friend, G. W. F. Hegel, was giving his famous lectures on aesthetics at the University of Berlin. According to Ziolkowski:

> Schinkel's museum in the Lustgarten embodied an institution that had never before existed: a museum dedicated exclusively to art (and specifically including painting as well as sculpture), intended primarily for the education of the nation, located in such a manner as to make a statement about the equality of art vis-à-vis church and state, designed in such a manner as to suggest the religious power of art, displayed in such a manner as to emphasize the autonomous integrity of the work of art, and organized in such a manner as to reveal the historical development of art as a central phenomenon of human culture.[27]

Like many other historians and theorists—ranging from Benedict Anderson and Eric Hobsbawm to Dominique Poulot and Larry Shiner—Ziolkowski insists on the strong connections between this new institution of art and the emergence of modern nation-states as well as the establishment of national, cultural *patrimoines*. Instead of simply separating art from society, institutions like the modern museum helped facilitate more direct access to works of art by creating a public space in which the cultural past was often staged in such a way as to train and educate the citizenry of emerging nation-states. It is, of course, important to add—against Bürger's assertion—that no institution has a single and unique social effect. Institutions have variable consequences, and one of these, in the case of the modern museum, was to create a site for the possibility of a relatively new and important bond between 'art' and 'society.'

It is true that Bürger is partially correct to insist on the historical novelty of aesthetics and art in the singular, which was discussed in chapter 1. However, he does not sufficiently recognize the extent to which the singularization of the idea of art is bound up with material institutions that are intertwined with the social and cultural practices of developing nation-states. It is by no means my intention here, it should be noted, to oppose a vulgar materialism to Bürger's de facto idealism. On the contrary, it is essential to remind ourselves that the opposition between concrete examples and theoretical constructs is itself an abstraction: there are never pure, brute facts on the one hand and ideational systems on the other. They are always intertwined in diverse and complex ways such that the very distinction between them remains purely heuristic. Therefore, it makes just as little sense to appeal to an idea of autonomous art that is supposed to trickle down into institutions and practices as it does to exclude the conceptual dimension of human praxis in the name of a vulgar materialist account of institutions.

THE VERITABLE DESTINY OF THE AVANT-GARDE

Let us now turn to the theoretical history that Bürger adumbrates against the backdrop of the so-called autonomy of art at the end of the eighteenth

century, which is in fact the idea of the autonomy of art that he finds in Kant and Schiller. This new conceptualization, according to Bürger, does not exclude straightaway heteronomous aesthetic practices whose contents are still political. During the first half of the nineteenth century, a discrepancy exists, therefore, between the idea of autonomous art and the heteronomous content of individual works. It is only during the second half of the century that the separation between art and life praxis comes to occupy the very content of works of art. This transformation reaches completion in aestheticism at the end of the nineteenth century, when "art becomes the content of art."[28]

Autonomy qua idea of art, which comes to serve as the content of artistic works, is the necessary condition for the historical emergence of the avant-garde: "The European avant-garde movements can be defined as an attack on the status of art in bourgeois society. What is negated is not an earlier form of art (a style) but art as an institution that is removed from the life praxis of men [die Institution Kunst als eine von der Lebenspraxis der Menschen abgehobene]."[29] It is thus aestheticism that finally reveals social inefficacy as the essence of art in bourgeois society and thereby provokes the self-critique of art that is the avant-garde. The latter negates the autonomy of art and endeavors to reunite it with life. Proposing "a radical break with tradition," Dadaism, early Surrealism, and the Russian avant-garde share a common objective: "the destruction of art as an institution [Zerstörung der Institution Kunst]."[30] The negative intention of the avant-garde leads not only to an assault on the function of art in bourgeois society but also to an attack on the individual production and reception that are proper to it. Bürger cites as examples the negation of individual creation in Marcel Duchamp's ready-mades and André Breton's attempt to negate individual reception by proposing "recipes" that allow every reader to write his or her own "automatic texts."[31] If it be at the level of function, production, or reception, the avant-garde intention is always and everywhere the same: to destroy the institution of art in bourgeois society.

This destructive impulse goes hand in hand with a new understanding of the work of art. Posing a direct challenge to the organic unity of part and whole in previous artwork, the inorganic work of the avant-garde

produced heteroclite assemblages of cacophonous elements. Yet, as illustrated by the case of Cubism, the simple creation of a montage of desultory fragments does not immediately qualify as an avant-garde work of art. It is also necessary to have the intention to call into question art as such, that is to say, the idea of art. Bürger ultimately proposes, therefore, a dual definition of the avant-garde: it is at one and the same time the intention to destroy the institution of art and to create inorganic works.[32] Such a definition is one of the first signs that the avant-garde was destined to fail: how can art be abolished through the production of works of art?

Indeed, the very failure of the avant-garde was due to the success of one of its intentions: by creating works that were recognized as art, it was actually integrated into the exact same institution that it sought to destroy. According to the Marxist logic of recuperation, the revolt against art as institution was absorbed by the very institution that was the object of rebellion. It is for this reason, moreover, that the neo-avant-garde is constitutively inauthentic according to Bürger: it "institutionalizes the *avant-garde as art* and thus negates genuinely avant-gardiste intentions."[33] The a priori failure of the neo-avant-garde thereby echoes the a posteriori downfall of the historical avant-garde. Bürger seems to have taken his inspiration from Karl Marx's famous and oft-cited lines: "Hegel remarks somewhere that all facts and personages of great importance in world history occur, as it were, twice. He forgot to add: the first time as tragedy, the second as farce."[34] The tragedy of the avant-garde reappears—and can only reappear—on the historical stage as the farce of the neo-avant-garde.

Before examining some of the fundamental historiographical problems plaguing Bürger's thesis, it is important to show that his position is slightly more complicated. In point of fact, the avant-garde adventure of the early twentieth century is profoundly contradictory, for the separation between art and life is the sine qua non condition for a "critical cognition of reality."[35] That is to say that an art that fully integrates itself into the praxis of life would lose its critical capacity. Since the era of the historical avant-garde, this has been illustrated by the culture industry, which has effectively eliminated the distance between art and life by what Bürger calls a "false

sublation [*Aufhebung*]."[36] Hence, the downfall of the avant-garde is not simply a de facto occurrence. It is a de jure failure founded on the very principles of its formation:

> The historical avant-garde movements negate those determinations that are essential in autonomous art: the disjunction of art and the praxis of life, individual production, and individual reception as distinct from the former. The avant-garde intends the abolition [or sublation] of autonomous art [*die Aufhebung der autonomen Kunst*] by which it means that art is to be integrated into the praxis of life. This has not occurred, and presumably cannot occur, in bourgeois society unless it be as a false sublation [*Aufhebung*] of autonomous art.[37]

This is the veritable destiny of the avant-garde: a determined, theoretical fate based on the necessary concatenations of its inner concept. Agency is largely removed from history in the name of an idealist determinism: nothing can escape the destiny of the Idea of the avant-garde in bourgeois society. "The history of concepts," Bürger avers in a revealing passage, "can show how the individual aspects of a concept, which unfold theoretically as a necessary interrelationship, have formed themselves historically."[38]

Given what he calls the "the experience of the false sublation of autonomy," he comes to ask "whether a sublation of the autonomy status [*Aufhebung des Autonomiestatus*] can be desirable at all, whether the distance between art and the praxis of life is not requisite for that free space within which alternatives to what exists become conceivable."[39] In *The Institutions of Art*, he provides a definitive response—founded apparently on conceptual principles—to this rhetorical question: "the opposition to life-praxis is the condition enabling art to perform its critical function, even as that condition prevents the critique from having any practical consequences."[40] The conditions of possibility of critical art with practical implications thereby coincide with its conditions of impossibility. Avant-garde art is theoretically destined to critically fail: either it dissolves art into life praxis and loses its critical function, or it maintains its distance from life at the expense of not having practical consequences.

As we have seen, this failure, inscribed as it is in the very concept of the avant-garde, is tied to the remarkable success of inorganic works of art.[41] Political defeat was the price of artistic triumph. This was a Pyrrhic victory if ever there was one, for the artistic achievement of the avant-garde was nothing short of the *Aufhebung* of the avant-garde intention to *aufheben* the very institution of art.

CRITIQUE OF THE HISTORICAL ORDER
OF THE AVANT-GARDE

Bürger proposes a periodic history organized solely around the chronological or vertical dimension of history. He dispenses with the horizontal dimension, meaning the distribution of practices in space, in the name of chronological linearity. He defends, moreover, a primarily discontinuist thesis insofar as he purports to be able to clearly distinguish between three artistic epochs and diverse moments of bourgeois art. Each period is determined by a uniform conceptual order within a grandiose story of autonomization that takes the form of a progressive trilogy leading from the sacred objects of an enchanted world to courtly art and finally the autonomous art of bourgeois society. It is against this backdrop that the historical avant-garde is understood as both the moment of historical self-consciousness of the autonomy of art as well as a daring venture to reenchant art by transforming it back into an integral part of life praxis. Its ultimate failure in its sociopolitical endeavors thereby serves as a formidable lesson to anyone who wants to alter the course of history: it is impossible to change the structure of historical development, that is, its ideational framework, and art only has a single role to play in each time period. In the bourgeois society of the modern age, it is perforce autonomous, and it is a myth to think that it can be authentically reconnected with life. The theoretical dialectic of autonomy integrates all of the moments of negation, revolt, and refusal into a single, unifying totality. The avant-garde thereby ultimately functions as the work of the negative that enriches, confirms, and brings to a self-conscious end the inexorable process of autonomization.

In spite of Bürger's apparent attempt to break with teleology and evolutionism, he ends up producing a rectilinear, totalizing, and unidirectional history rooted in reductive determinism. By proposing a so-called dialectical conception of history and constantly invoking contradictions and a lack of historical synchrony, he deploys a suspect strategy for maintaining a unilinear history at a macroscopic level while providing himself with the means for responding to counterexamples at a microscopic level. This is why, at least in this case, dialectical history functions like a theodicy: the affirmation that the historical process is contradictory permits the recuperation of any and all counterexamples within the framework of a single, totalizing historical development. Like Ptolemy, Bürger engages in intellectual acrobatics in order to preserve the general structure of the movement of history by adding as many epicycles as necessary in order to integrate the totality of 'empirical facts' within a single and unique process of Ideas. Consider, for instance, his response to the claim that the modern age has been marked by the commercialization of aesthetics: "It is one of the tricks of the dialectic of autonomy and heteronomy that this very radicalized claim for autonomy in art, which aestheticism formulates, coincides historically with the subjection of the aesthetic to the valorization interests of capital."[42] Concrete instances of artistic heteronomy, when run through Bürger's dialectical machinations, actually serve to confirm the autonomy of art. His methodological orientation presupposes, moreover, as is often the case with dialectical histories, a theoretical mastery of the objective course of history, an intellectual authority of such a rare pedigree that no historical data could ever call it into question. This is how he ultimately establishes a reductive historicism. By purporting to know the true movement of history at work behind temporal appearances, he reduces the totality of historical phenomena to a supposedly objective reality: the dialectical process of the autonomization of art. In short, his dialectic of history functions as a form of methodological subterfuge allowing him to explicitly abjure teleology and evolutionism while clandestinely recuperating the very same historical order that they depend upon, thereby producing a vertical, totalizing, unilinear, unidirectional (at least in bourgeois society), objective, and determinist history.

His analysis of the avant-garde depends, moreover, on a monolithic conceptualism. Each of his major concepts—autonomy, the institution of art, aestheticism, the avant-garde, and so on—is endowed with a theoretical uniformity by purporting to synthesize a set of extremely complex practices. Let us begin with the central issue of autonomy. Bürger presents it as an epochal concept, meaning a notion that serves to capture the fundamental characteristics of an age in a singular ideational framework. The guiding methodological assumption is that historical eras are reducible to singular concepts and that the goal of theoretical reflection is, in part, to identify the appropriate notions for each age. In Bürger's case, he aligns a series of epochal concepts—autonomy, aestheticism, the avant-garde, the neo-avant-garde—in order to provide what he takes to be a coherent theoretical framing of art-historical developments since the eighteenth century. In such an undertaking, he has to establish a nearly impermeable historical filter that allows him to be highly selective in choosing the illustrations of each epochal concept in such a way as to preserve its unified hegemony. It is worth considering, in this regard, his massive dismissal of committed art through the course of the nineteenth century. He authoritatively claims, in order to illustrate his thesis, that "the predominance of *one* (autonomous) concept of art is demonstrated by the struggle against committed art which is waged on several fronts."[43] In one fell theoretical swoop, he purifies nineteenth-century artistic developments of all of those—from Hugo, Dickens, and Zola to Whitman, Courbet, and many others—who were interested in directly relating art to what he calls social and political life praxis: "Ever since the aesthetics of autonomy was institutionalized, attempts to link up with the Enlightenment's concept of literature and to include cognitive and moral questions in art have been fought by writers and critics (examples would be the rejection of Zola's naturalism and of Sartre's *littérature engagée*). . . . In fully developed bourgeois society 'autonomy' and 'use' of art have increasingly come to oppose each other."[44] Indeed, he defines modern art as such in terms of autonomy: "'Art' in the modern sense of the word refers to those artistic practices loosened from moorings to real life."[45]

The autonomy thesis does not only purge artistic history in order to structure it in terms of hegemonic epochal concepts, thereby abolishing

both the complex geography of historical developments and the social tensions operative in various space-times. It also attempts to draw theoretical lines in the sand by delimiting art as such from other fields of practice, thereby making it into a transcendent, monolithic idea rather than an immanent sociohistorical notion and a concept in struggle. Art, it might be said, is only autonomous insofar as it functions for Bürger as a rarified and purified idea. Aesthetic practices are, for their part, intertwined with other practices, and their delimitation as such is the result of ongoing social struggles. As mentioned above, there are important links between nineteenth-century artistic practices and the novel institution of the art museum, as well as the constitution of the cultural heritage of emerging nation-states. This is one indication among others that the "institution of art" in this sense by no means emerged as an autonomous sphere but was rather entwined with important social, political, and historical transformations.

It is worth indicating some of the other historical elements that suggest that Bürger's thesis could actually be reversed: rather than art becoming autonomous from society in the modern age, it underwent a significant popularization or democratization, for lack of a better term. It is not my intention to make such an argument, at least insofar as it would run the risk of replacing one epochal concept by another. Instead, I simply want to briefly foreground various aspects of aesthetic practices in the nineteenth century that demonstrate some of the reasons why the autonomy thesis is fundamentally untenable (this is equally true of the heteronomy thesis, which is just as schematic). To take a few important cases, it is clear that the rise of the modern novel and other relatively recent aesthetic developments are linked in various ways to increasing literacy rates and the slow expansion of mass education. They are also tied to a long series of industrial and technological changes. Works of art not only became reproducible on an unprecedented scale through technological advances such as photography, electrotyping, cheap paperbacks, and so on, but they also entered into novel networks of rapid circulation, stimulated in part by the railways. A mass market for artistic goods developed, which significantly changed the social distribution of works of art. According to Eric Hobsbawm:

Few societies have cherished the works of creative genius (itself virtually a bourgeois invention as a social phenomenon . . .) more than that of the nineteenth-century bourgeoisie. Few have been prepared to spend money so freely on the arts and, in purely quantitative terms, no previous society bought anything like the actual amount of old and new books, material objects, pictures, sculptures, decorated structures of masonry and tickets to musical or theatrical performances. (The growth of population alone would put this statement beyond challenge.)[46]

The arts were thereby firmly intertwined with various sociocultural practices and became part of the everyday socialization of citizens through phenomena such as newspapers, periodicals, books, decorative objects, photographs, museums, public concerts, and theatrical performances.

Bürger sometimes qualifies his position by referring to the "relative independence" of art and recalling that, as a social subsystem, it nonetheless remains part of society as a whole.[47] Moreover, his theory regarding the failure of the avant-garde suggests that it is impossible to link art to life praxis *within* bourgeois society.[48] In principle, if society were to change, then the role of art could perhaps be altered as well. However, this is apparently such a distant possibility—"all revolutions have failed," he categorically asserts—that he does not seem particularly concerned with it.[49] Instead, he focuses the majority of his intellectual energy on defending the autonomy thesis. In fact, he explicitly spurns two of the suggestions advanced in the preceding paragraph regarding art's relationship to socialization and to the market economy. To begin with, he admits that "nothing appears to contradict the idea that art is set up as an autonomous institution in bourgeois society more than the fact that works of art in this very society are pressed into service as instruments of schooling [*Erziehung*] and socialization."[50] However, he hastily circumvents this problem by appealing to a principled relation of determination: "works of art can be pressed into service as instruments of schooling precisely because of their autonomous status."[51] According to a dialectical legerdemain, autonomy is the necessary condition of possibility for social use. He regularly relies on such unsubstantiated declarations at key moments in his counterarguments. A similar petitio principii

characterizes his rejection of what he calls the "economic approach."[52] He claims, following Gerhard Leithäuser, that there are "formal prescriptions" for art in bourgeois society but not "actual prescriptions" that would extinguish artistic independence, because otherwise there would be no distinction between autonomous art and the culture industry (which apparently is the case for the "economic approach").[53] However, it is precisely the existence of such a distinction that must be proven, rather than simply assuming that it exists and peremptorily declaring that "commodity aesthetics presupposes an autonomous art."[54]

Let us pause to consider in this light the central case of Friedrich Schiller, who is apparently responsible, along with Immanuel Kant, for the novel concept of the autonomy of art.[55] Now it is true that Schiller partially relies on Kant's *Critique of the Power of Judgment* to develop his conceptualization of beauty: "Beauty gives no individual result whatever, either for the intellect or for the will; it realizes no individual purpose, either intellectual or moral; it discovers no individual truth, helps us to perform no individual duty, and is, in a word, equally incapable of establishing the character and clearing the mind."[56] Indeed, he explicitly castigates the "self-contradictory" idea of didactic and moral art on the grounds that "nothing is more at variance with the concept of Beauty than that it should have a tendentious effect upon the character."[57] However, this insistence on beauty's freedom from utilitarian ends nowise means that the aesthetic condition is not propitious for the development of political freedom, as well as of knowledge and morality. According to the historical account he provides in *On the Aesthetic Education of Man* (1794–95), "the essential bond of human nature" has been "torn apart," leading to ruinous conflict that has "set its harmonious powers at variance."[58] Since the age of reason and Enlightenment has proved incapable of restoring this lost "unity of human nature," he claims that something else is necessary in order to overcome the barbarism of his age: "The way to the head must lie through the heart. Training of the sensibility [*Ausbildung des Empfindungsvermögens*] is then the more pressing need of our age, not merely because it will be a means of making the improved understanding effective for living, but for the very reason that it awakens this improvement."[59] Aesthetics is thus understood as the indispensable bridge capable

of linking the two impulses of humanity: the sensuous drive of physical existence and the formal penchant of rationality. And it is precisely in this regard that Schiller advances a general argument regarding the social role of art. Far from being purely autonomous, the fine arts are explicitly described as an "instrument" for the improvement of the "moral condition" and hence the political sphere: "we must indeed, if we are to solve that political problem in practice, follow the path of aesthetics, since it is through Beauty that we arrive at Freedom."[60] In fact, he denigrates all other attempts at political and social reform, insisting on the need for an aesthetic *Aufhebung* capable of restoring the unity of humanity: "we must continue to regard every attempt at reform as inopportune, and every hope based upon it as chimerical, until the division of the inner Man has been done away with (*aufgehoben*), and his nature has developed with sufficient completeness to be itself the artificer (*Künstlerin*), and to guarantee reality to the political creation of Reason."[61]

It is therefore a grave mistake to interpret Schiller's claim regarding the purposelessness of beauty as an argument in favor of the autonomy of art. If beauty, on his account, should not be controlled by external constraints or subordinated to tendentious ends, it is precisely because its freedom has propitious political effects. In fact, art plays a privileged salvational role at the core of Schiller's argument: by reestablishing the unity of human nature through an *Aufhebung* of its two fundamental but opposed impulses, it leads toward freedom.[62] To use Bürger's somewhat problematic vocabulary, we might say that if art is autonomous in relationship to individual ends, it is precisely in order to be heteronomous when it comes to establishing political freedom. This is why Schiller actually identifies "the most perfect of all works of art" with "the building up of true political freedom."[63] Indeed, he defines freedom as the successful *Aufhebung* of man's conflicting impulses, which can only occur in aesthetics: "As soon, that is to say, as both the opposite fundamental impulses are active in him, they both lose their sanction, and the opposition of two necessities gives rise to *freedom*."[64] This reestablished unity helps lead as well to truth, morality, and the fulfillment of humanity.[65] The freedom of the aesthetic impulse of play is thus in no way "autonomous" from social, political, moral, and epistemological concerns. On the contrary, aesthetics functions as the privileged path to a new humanity and a new society.

It is not only that Bürger constructs a faulty image of Schiller as one of the first thinkers of the autonomy of art when, in fact, Schiller attempted, if anything, to think art's redemptive relationship to society in terms of an aesthetic *Aufhebung* equivalent to political freedom. It is also that his description of the historical avant-garde as the endeavor to overcome the distinction between art and life comes dangerously close to Schiller's own depiction of art as the unity of life and form. It should be noted, in this regard, that the author of *On the Aesthetic Education of Man* had an expansive conception of art. When he discusses "beauty for her own sake," for instance, he explicitly refers to the aestheticization of daily life that breaks away from the "fetters of exigency" through adornment, furniture design, and architecture.[66] In more or less the same context, he also refers to the gleam of freedom in the purposeless displays of the animal world, from the swarming of insects in the sunlight to the melodious warbling of songbirds.[67] We should not, therefore, confuse his discussion of art and aesthetics with a restricted understanding of a social subsystem of institutionalized fine art and literature. More germane to our discussion here, he defines aesthetics in terms of the *Aufhebung* of life and form:

> The object of the sense impulse, expressed in a general concept, may be called *life* in the widest sense of the word. . . . The object of the form impulse, expressed generally, may be called *shape*, both in the figurative and in the literal sense. . . . The object of the play impulse, conceived in a general notion, can therefore be called *living shape*, a concept which serves to denote all aesthetic qualities of phenomena and—in a word— what we call *Beauty* in the widest sense of the term.[68]

Just as in Bürger's argument concerning the avant-garde, he claims that this unity of opposites can never be perfectly realized. Indeed, the equilibrium of reality and form "always remains only an idea, which can never be wholly attained by actuality. In actuality there will always be a preponderance of one element or the other, and the utmost that experience can achieve will consist of an oscillation between the two principles."[69] He does not, however, think that there is an inevitable failure inscribed within the very nature of this undertaking.

Bürger's monolithic conceptualism is equally apparent in his account of aestheticism and the historical avant-garde. Regarding the former, it is at once surprising and revealing that he does not provide any extended analysis of historical examples of aestheticism, a term that functions in his text as an ideational construct with little or no material content. He thereby avoids discussing the complex ways in which what is called aestheticism was, in part, a progressive attempt, on behalf of figures as diverse as William Morris and Oscar Wilde, to aestheticize everyday existence. The following description of aestheticism by Fiona MacCarthy, for instance, equates it very precisely with the endeavor to link art to life praxis, which Bürger of course takes to be one of the defining attributes of the avant-garde's anti-aestheticism: "One of the main tenets of aestheticism was that art was not confined to painting and sculpture and the false values of the art market. Potential for art is everywhere around us, in our homes and public buildings, in the detail of the way we choose to live our lives. . . . In its essence aestheticism was a movement for reform and the project to infiltrate beauty into everyday life."[70] This description perfectly echoes one of Oscar Wilde's memorable descriptions of Dorian Gray: "to him Life itself was the first, the greatest of the arts, and for it all the other arts seemed to be but a preparation."[71]

Concerning the avant-garde itself, it might be said that it is by no means this constellation of movements that was doomed to failure, but rather Bürger's own theoretical undertaking. For it is impossible to establish a single epochal concept for the entirety of aesthetic practices qualified as avant-garde in the early twentieth century. As Benjamin Buchloh has appropriately explained: "*Any* theorization of avant-garde practice from 1915 to '25 . . . must force the vast differences and contradictions of that practice into the unifying framework of theoretical categories, and is therefore doomed to failure. One wishes that Bürger had expressed some awareness of how patently absurd it is to reduce the history of avant-garde practices in 20th-century art to *one* overriding concern."[72] While Bürger has occasionally attempted to nuance his account,[73] he nevertheless purports to be able to distinguish between those movements that were authentically avant-garde and those that remained peripheral (Cubism, for instance). He defines the unity of the avant-garde in terms of the uniformity of its intention, and thus

as an intellectual phenomenon that is extremely difficult, if not impossible, to verify. Moreover, in his description of the avant-garde work of art, he establishes the same fundamental uniformity by defining it as inorganic. He thereby founds both facets of his definition of the avant-garde on the same monolithic conceptualism: just as there is only one avant-garde intention, there is only one avant-garde work.

Methodologically, he relies on a transcendental hermeneutics according to which a single principle or set of principles is supposed to determine the totality of artistic practices. These principles correspond to a sequential series of epochal concepts in such a way that each concept purportedly governs the aesthetic practice of an entire era. The possibility that multiple practices might inhabit the same time frame is either simply excluded or incorporated into a strictly periodic history through the rhetorical appeal to the dialectics of history (which only serves to maintain the governing principles of an era by admitting certain "contradictions"). Moreover, there is a parallel purification of historical space by which certain privileged locations become representative of epochal trends at the expense of others. For instance, the early work of the Vienna Secession, the rise of Mexican muralism, and the central role of the Bauhaus in Germany would have all been viable candidates for the elaboration of a more complex geography of avant-garde activities, but they are generally left out of Bürger's account. Finally, the author of *Theory of the Avant-Garde* not only reduces the vertical dimension of chronology to a rectilinear progression of conceptual orders while turning a blind eye to the horizontal dimension of geographic diversity; he also excludes the stratigraphic dimension of the diverse social practices inhabiting the same space-time, thereby excising important art-historical developments.[74] Consider, for instance, French Impressionist Cinema, which overlapped spatially and temporally with French Dadaism and Surrealism, and was arguably one of the most significant avant-garde film movements. However one might try to classify the work of Abel Gance, Jean Epstein, Marcel L'Herbier, and others, it is obvious that they were not attempting to abolish the very idea of autonomous art. Therefore, it is patently unclear how their work could be integrated into Bürger's thesis on the historical avant-garde, and it appears that it suffered from exclusion

due to either expediency or lack of awareness. The case of French Impressionism also raises the issue of the complex social intertwining and overlapping between what are referred to as relatively discrete movements. To take but one such example, Luis Buñuel worked as an assistant director to Jean Epstein on *The Fall of the House of Usher* (1928), and he made two important Surrealist films in collaboration with an artist known primarily for his paintings, Salvador Dalí: *Un chien andalou* (1928) and *L'âge d'or* (1930).

Bürger not only purifies and filters individual space-times in order to establish overarching conceptual principles for an entire era. He also tends to overlook the truculent tensions that animated many of the avant-garde movements. He generally downplays, for instance, all of the significant conflicts within and between Dadaism, Surrealism, and the Russian avant-garde. To cite only a few examples, one of the clashes apparent in early Dada, according to Martin Gaughan, was "between Ball's inclination to the spiritual and the more aggressively non-metaphysical approach of Huelsenbeck and Tzara. For the older man art might still have a salvationary role, for the two younger men it was an assault weapon."[75] In the case of Surrealism, some critics talk about two or more movements, or at least a split between two rival groups, affiliated respectively with André Breton and Georges Bataille. Furthermore, in the late 1920s and the early 1930s, there were a number of important political disputes that polarized the Surrealists. André Breton had joined the French Communist Party in 1927, along with Louis Aragon, Paul Éluard, and Pierre Unik. With the evolution of the Stalinist Communist Party and its proletarian policy, Aragon eventually renounced Surrealism in favor of communism, and Breton did the opposite, while nonetheless maintaining strong ties to Leon Trotsky and the non-Stalinist revolutionary left. Dalí, for his part, was expelled from the group in 1934 because of his alleged sympathies for the Hitler regime.[76]

Bürger's response to such criticisms would most likely consist in reiterating that he is doing theory rather than history. However, as we have already seen, there is no hard and fast distinction between the two. History is itself a theoretical endeavor, and there is no such thing as brute empirical facts. The latter always function as 'givens' within a conceptual assemblage. Bürger's own assemblage is one in which the vertical dimension of chronology is

reduced to a rectilinear sequence of determinate epochal concepts, and he occludes both the horizontal and the stratigraphic dimensions of history. Moreover, he relies on a transcendental hermeneutics in order to isolate the governing principles of an entire set of practices, and thus of a complete historical era. For all of these reasons, it should now be clear that the critique of his work in this chapter is not a simple appeal to 'material facts' that belie his claims. On the contrary, it aims at going to the heart of the matter by focusing on the historical logic operative in his work. In order to rethink the avant-garde, we must not content ourselves with reviewing the historical record. We need a new historical order.

4

TOWARD A RECONSIDERATION
OF AVANT-GARDE PRACTICES

*It is perhaps best not to think of the avant-garde as a clear-cut
entity that passes through time, simply changing its costumes
through the nineteenth and twentieth centuries. It is . . . better to
think of the avant-garde less as an entity . . . and more as a social
process latent within the culture of modern societies.*

—GAIL DAY

In order to rethink the avant-garde in the current conjuncture, it is necessary to formulate an alternative logic or order of history that takes into account the vertical dimension of chronology, the horizontal dimension of geography, and the stratigraphic dimension of social practices. Such a logic encourages us to think in terms of historical constellations and metastatic transformations—that is to say, changes of variable rhythm that are unequally distributed through sociohistorical space—instead of trying to reduce history to a singular process of development. This alternative historical order jettisons not only teleology (and ateleology) but also dialectical history in its diverse guises. Insofar as human history necessarily has a geographic and social dimension, it is irreducible to a unique trajectory, as contradictory and convoluted as it might be. There is no such thing as a single system of determination at work in each time period or behind the totality of history. On the contrary, there are conjunctures of determinants that vary according to space-time, social strata, and various forms of sociohistorical agency. There are also multiple temporalities and conflicting social constellations that inhabit each moment. History is not, therefore, determined by

more or less transcendent principles from a single locus of agency. It is a force field animated by various immanent forms of agency and normativity in which everything is by no means determined in advance.

It is equally necessary to jettison the privilege accorded to artistic production by taking into account the complex social logic of avant-garde practices, where it is a question not only of production, but also of the circulation and reception of works of art. The dual definition of the avant-garde proposed by Peter Bürger in *Theory of the Avant-Garde*, as we saw in the previous chapter, primarily—although not exclusively—centers on artistic production: the intention to abolish art by creating inorganic works of art. This presupposes the existence of a unified will at work within the historical avant-garde, which is by no means self-evident. To take but a single example, André Breton did not describe Surrealism in his first manifesto (1924) as an attempt to abolish art by introducing a radical break with tradition.[1] On the contrary, he explained that it is the expression of the "real functioning of thought," whose trace can already be found in great writers of the past such as Dante, Shakespeare, Sade, Baudelaire, and many others.[2] Far from abolishing art, Surrealism aims, in this case, at returning to the veritable source of all real art. In fact, it is not unrelated to the important avant-garde practice that might be generically labeled as the *return to origins*, which can manifest itself in such diverse 'backward looking' activities as the engagement with what is called primitivism, the revalorization of craft practices, or the revitalization of Greek and Roman mythology. According to an involuted temporality, the way forward—far from being a radical break with tradition—is actually through the past.

Regarding works of art, Bürger's distinction between organic and inorganic is much too general to be decisive in all cases. It is, moreover, founded on a transcendental hermeneutics that aims at establishing a single governing principle for the totality of avant-garde practices. One could argue, for example, that the literature of fragments is inorganic and dates back at least to the end of the eighteenth century, but that Marcel Duchamp's *readymades* are organic insofar as the part and the whole constitute a coherent ensemble. This is equally true of his imagined "reciprocal ready-mades," such as using "a Rembrandt as an ironing board!"[3] Certain avant-garde

practices, like that of Duchamp, actually foregrounded the social insertion of objects in such a way that the work is not only the object per se but rather its social staging, meaning its circulation and reception. In other words, social inscription becomes a question for such artists rather than serving as the stable frame for the presentation of their work, hence the importance of analyzing the ways in which avant-garde practices sometimes become properly sociological by producing works that intervene in systems of distribution and reception. Indeed, one of the objectives of a certain type of avant-gardism is precisely to transform the very nature of artistic production: instead of creating works for an established institutional framework, the very process of production integrates the institutions of distribution and reception. Vladimir Tatlin's proposed *Monument to the Third International* could be cited as another poignant example of an organic avant-garde work, due to its precise combination of geometric forms and temporal rhythms of movement into a towering symbol of modernity. Like Duchamp, Tatlin was concerned, moreover, with the very framework of aesthetic distribution and reception, as attested to by his conceptualization of the tower as a new venue for the circulation of sounds and images.

It is equally important to call into question the debilitating binary normativity opposing institutional inertness to artistic vitality, the culture industry to authentic art. The social world is more complex than this Manicheism would have us believe, and institutionalization is not necessarily equivalent to the neutralization of art.[4] It is not simply that there are diverse establishments and variable forms of institutionalization, but also that the inscription within an institution can allow for the circulation of works, as well as the staking out of positions in relationship to the institution itself. The vulgar Marxist logic of recuperation is founded on the uniformization of social effects, as if the simple fact of institutionalization necessarily led to a consistent transformation: a loss of critical agency through the neutralization of artistic effects. It is actually the very logic of recuperation that often neutralizes art by making it into a simple object exploited by institutions instead of examining the diverse ways in which aesthetic practices aim at intervening in existing organizational structures in order to reconfigure them or produce alternative institutions.

Returning to Duchamp's *ready-mades*, we should ask ourselves if it is always a matter of simply choosing between resistance and recuperation. Since they integrate the network of distribution and reception into their very logic of production, it is possible to interpret *ready-mades* as an interrogation into the institutional frame and its effects on the very notion of art. The intervention in the institution is hence absolutely necessary and is actually part of the artistic act as such. That is to say that the *ready-made* is irreducible to the object per se and only makes sense insofar as the work is understood as an act, the *opus operatum* as a modus operandi: the fact of introducing certain objects into the established system of distribution and reception. The simple rejection of the institution on the part of the artist would be completely illogical in this case, for the institution is part of the mise-en-scène that is the work of art qua act. In short, rather than being opposed to the inner vitality of the art object, the institution is in this case part and parcel of the work itself. For these reasons, among others, a more nuanced account of social normativity is required that overcomes the simplistic opposition between rule and transgression, the institution and its outside.

Let us consider, more broadly, the relationship between various avant-garde practices and institutions in order to debunk the historical myth of a simple opposition between the two. There is a long list of avant-garde attempts to establish new institutions or work within existing structures. In the broadest sense of the term *institution*, we might reference the innumerable avant-garde publications, as well as the creation of alternative spaces and events, such as those important for Dadaism: Cabaret Voltaire, the Galérie Dada, the First International Dada Fair, and various gala events (including the one organized in 1923 at the Théâtre Michel, which instigated Man Ray's *Le retour à la raison*). In the more restricted sense of institution, an early example is to be found in the Vienna Secession, which established the House of the Secession in 1898 under the motto "To the age its art, to art its freedom." It worked closely with the Viennese government, at least in the early years, on various projects including the creation of a Modern Gallery: "Modern artists won painting and architectural commissions and teaching posts. Not only some of Austria's major public buildings but even her

postage stamps and currency were designed by Secessionists."[5] To take an example from a very different cultural context, Mexican mural painting was also partially supported by the institutional mechanisms of the state and successfully brought art into the larger social environment. In this regard, the general history of avant-garde cinema could also be cited as an example of an aesthetic undertaking intimately bound up with the development of a whole series of institutions, such as theaters, journals, and ciné-clubs.

Individual artists identified with the avant-garde also helped establish institutions. For instance, Johnannes Itten set up a private art school in Vienna, Władysław Strzemiński aided in founding the Sztuki Museum in Łódź, Poland, and El Lissitzky sought to establish the living museum as a new type of institution and exhibit.[6] El Lissitzky had been influenced by Kazimir Malevich's Union of the New Art, founded in 1919 under the acronym UNOVIS.[7] Wassily Kandinsky, to take a rather famous case, participated in the creation of the Institute of Artistic Culture (Inkhuk) and was named the director of the Museum of Pictorial Culture in Moscow before founding the Russian Academy of Artistic Sciences. Moreover, he was sent to teach at the Bauhaus, arguably one of the most important avant-garde institutions of the twentieth century. Founded in 1919 by the architect Walter Gropius, it brought together such famed artists as Kandinsky, Malevich, Lissitzky, Theo van Doesburg, Naum Gabo, and Paul Klee. Similar to institutions such as VKhUTEMAS (Higher State Artistic and Technical Workshops) in Russia, the Bauhaus sought, in part, to link avant-garde art and design with contemporary industry.

If Peter Bürger and some other theoreticians have sidelined or ignored these institutions, it is likely because such endeavors to link art and life praxis through industrial design largely succeeded: they clearly overstepped the boundaries of museums and galleries by merging aesthetics with everyday existence. The Bauhaus, according to Eric Hobsbawm, "set the tone of both architecture and the applied arts of two generations" by deliberately turning away from "the old arts-and-crafts and (avant-garde) fine arts tradition to designs for practical use and industrial production: car bodies (by Gropius), aircraft seats, advertising graphics (a passion of the Russian constructivist El Lissitzky), not forgetting the design of the one and two million Mark

banknotes during the great German hyper-inflation of 1923)."[8] Predecessors such as Art Nouveau, Art Deco, and the Arts and Crafts movement, in conjunction with important institutions like the *Maison de l'art nouveau, La société des artistes décorateurs,* and Morris & Co. also helped connect art and industry, design and quotidian life.[9]

Avant-garde aesthetic practices are therefore irreducible to the simple binary opposition between the dormancy of institutions and the vitality of art. Such a dichotomy is founded on a long series of assumptions that needs to be dismantled without simply falling prey to a blind embrace of institutions. To begin with, art is largely reduced to the visual arts according to the museum-based model, to which I will return below. Institutionalization is taken to be the enemy of spontaneous artistic creation as well as its sociopolitical potential, thereby occluding the ways in which certain institutions—not only museums and galleries, but also theaters, libraries, and publishing houses—can allow for the circulation of works of art, thereby increasing their social impact. Moreover, it is often assumed that there is a homogenous reception as soon as a work of art is institutionalized, as if everyone necessarily reacts in the same way simply because of a particular social framing device. This points to the fact that the opposition between resistance and recuperation is largely founded on a productivist aesthetics centered on the purity of the act of creation. Furthermore, a certain avant-garde conception of iconoclasm radically reduces the complexity of social norms by assuming that rules are singular axioms that are respected or broken. Yet, if the development of artistic practice has shown anything, it is not simply that there are always new rules to be broken. It is that rule breaking has become a norm and that the infringement of a convention is very often rooted in a second-order normativity governing the very act of breaking rules. "Like any artistic tradition, however antitraditional it may be," Renato Poggioli aptly remarks, "the avant-garde also has its conventions."[10] Rather than simply opposing the rigid strictures of institutionalized art to the freedom of avant-garde creation, we therefore need to be attentive to the second-order normative structures that orient avant-garde practices in various ways by dictating objectives and strategies. It is surely in this light that we should understand Poggioli's provocative statement that

"the stereotype is only the modern form of the ugly."[11] He thereby suggests that avant-garde practice is governed by the norm according to which traditional and entrenched conventions must be overcome for their own sake. Indeed, he writes that "the conventions of avant-garde art, in a conscious or unconscious way, are directly and rigidly determined by an inverse relation to traditional conventions."[12]

This complex relationship between avant-garde practices and institutions is one sign among others that it is necessary to develop a historical logic capable of providing an account of the various social constellations operative in what is generically labeled *the* avant-garde. There is not actually a single avant-garde, nor is there a unique avant-garde practice. There are diverse and overlapping constellations of artistic activities that various social agents identify as avant-garde. Calling into question the essentialism inherent in the assumption that there is one avant-garde does not, however, lead to the dissolution of the avant-garde into an infinite multiplicity of heteroclite elements. We do not have to choose between synthetic conceptual unity and sheer empirical chaos. The avant-garde exists as a concept in struggle, a sociohistorical notion immanent to a certain number of specific practices. Originally a military term referring to the front lines of an advancing group of troupes, it came to be used in a figurative sense to refer to the world of art and culture—with a few rare exceptions—in the nineteenth and especially the twentieth century in Europe.[13] It is therefore part of a very specific conjuncture of determinants (without, however, being reducible to a single core determination). This is one of the reasons why it is absolutely crucial to dispose of the idea of a unique and rectilinear history of the avant-garde as a quasi-homogenous phenomenon with a determined destiny, in the name of an analytic of diverse avant-garde practices and their constellational distribution in the three dimensions of history.

In this light, let us reconsider some of the assumptions regarding the emergence of the diverse avant-garde practices in the early twentieth century. Peter Bürger's narrative of discontinuity, in which the avant-garde constitutes a radical historical break, is as problematic as the opposite assumption that history is continuous, which is to be found, in part, in Clement Greenberg's schematization of the avant-garde.[14] The very idea that history

could be either continuous or discontinuous is based on the faulty presup-
position that it is reducible to its chronological dimension and that this
dimension functions like a simple thread that is either severed or unbroken.
However, as soon as we take into account the three dimensions of history,
absolute continuity or discontinuity become impossible. The notion of a
metastatic transformation allows us to overcome this opposition by think-
ing in terms of changes that are unequally distributed through space-time
and social strata. Such a transformation is a dynamic reconfiguration that
morphs at variable rates in the three dimensions of history. This means, in
part, that *the* avant-garde was never born, nor does it simply die or fail all
at once. Avant-garde aesthetic practices emerge metastatically in diverse
sociohistorical constellations. The inquiry into the reasons for their emer-
gence requires a logic of historical determination that jettisons the mono-
causal etiology in which, for instance, the avant-garde is the result of art
becoming self-conscious and realizing its autonomous status in bourgeois
society. Rather than a largely internal account of art's arrival at self-aware-
ness, we need to think in terms of a conjuncture of determinants in which a
constellation of factors specific to a particular space-time facilitates certain
developments while also leaving a margin of maneuver for various types of
sociohistorical agency.

The conjuncture of determinants favoring the metastatic emergence and
subsequent transformation of avant-garde practices varied considerably
according to the three dimensions of history and the specific forms of agency
at work. Speaking in very general terms, however, we can highlight—in no
particular order—the following factors, which are by no means exhaustive:
unprecedented industrialization and urbanization, the First World War
and what is called the end of empires, the Russian Revolution, the inter-
war rise of fascism, the development of modern technology, relatively new
forms of mechanical reproduction and mass entertainment (photography,
illustrated periodicals, the phonograph, the radio, the cinema, and so on),
increased internationalization through new modes of travel and commu-
nication, demographic expansion,[15] the evolution of the market economy
as well as of the art market, the solidification of modern institutions such
as the museum and the modern educational apparatus, alternative networks

of communal interaction between artists, the development of the relatively new artistic persona of the iconoclast, and novel forms of artistic as well as theoretical agency. No single factor prevailed, and they combined in various ways depending on the precise conjuncture and the operative modes of agency. The avant-garde was not simply the result of individual or collective motivations internal to the art world. Art has not been on a gradual path toward self-consciousness, nor is it an autonomous system. On the contrary, the practices identified as artistic (a label that continues to be negotiated and contested in the social field) are intertwined in complex ways with other practices. It is difficult to imagine, for example, what is referred to as avant-garde architecture without the industrial developments allowing for the extensive use of glass, steel, and concrete. The dependence of avant-garde photography and film on certain technological innovations is equally clear, although it would be a grave mistake to reduce these developments to a brute technological determinism.

The tendency to insist on avant-garde production frequently casts a shadow over important historical changes in the social circulation and reception of the arts. Among the exceptions to this general rule, Clement Greenberg famously argued that there is a close sociohistorical link between kitsch and the avant-garde. The former is "a product of the industrial revolution which urbanized the masses of Western Europe and America and established what is called universal literacy."[16] The latter, according to Greenberg, is the privileged art of the educated elite, which distinguishes itself from the masses by refusing the crass philistine products of kitsch. Although Greenberg's account is somewhat schematic, he points to the ways in which the industrial marketplace, urban popular culture, and the nascent mass media helped transform the social framework of artistic production and circulation. Eric Hobsbawm has also highlighted important demographic changes that significantly modified the structures of artistic reception, thereby favoring the emergence of avant-garde aesthetic practices: "With the collapse of the dream of 1848 and the victory of the reality of Second Empire France, Bismarckian Germany, Palmerstonian and Gladstonian Britain and the Italy of Victor Emmanuel, the western bourgeois arts starting with painting and poetry therefore bifurcated into those

appealing to the mass public and those appealing to a self-defined minor-ity."[17] He goes on to argue that the situation was not the same in all the arts, but that there was nonetheless a 'cultural revolution' in certain sectors: "with the triumph of city and industry an increasingly sharp division grew up between the 'modern' sectors of the masses, i.e. the urbanized, the literate, and those who accepted the content of the hegemonic culture—that of the bourgeois society—and the increasingly undermined 'traditional' ones."[18]

Greenberg's account of the avant-garde, which certainly has important limitations, has the advantage of touching on an additional factor that deserves mention. He refers to "a superior consciousness of history—more precisely, the appearance of a new kind of criticism of society, an historical criticism."[19] This 'superior consciousness' is the result of a series of signifi-cant developments, including the collection and ordering of artifacts from the past in modern museums and archives, as well as the establishment and consolidation of historical narratives with the formation of modern art his-tory.[20] Moreover, the temporal framework of modern aesthetics has also been marked by the emergence of a utopian order of history in which—to speak in very broad terms—the future becomes an open horizon of possi-bilities rather than being enclosed within the cyclical patterns of a natural-ized history.[21] In this modern historical order of the arts, in which temporal inscription has become integral to artistic practices and the future remains open, there is an immanent, operative concern with the history that *will have been written.* This is surely one of the factors at work in the various and sundry attempts to artistically intervene in such a way as to leave an indel-ible mark on the unfolding of history, thereby situating practices in terms of an understandable narrative regarding past events and preparing for the future history of art. This unique temporal framework of future perfect his-tory is structured around the awareness that the future will be archived as a past, that it *will be* what it *will have become* in history's future. "The initiators and followers of an avant-garde movement," writes Poggioli, "were con-scious of being the precursors of the art of the future."[22] The proliferation of manifestoes and the self-promotion of artistic schools and movements, to take but two examples, are surely linked to the battle being waged over the history of the future.

The precise configuration and operative agencies of this conjuncture of determinants varied according to time, space, and social strata. They contributed in different ways to the emergence of a series of constellations of avant-garde practices. By constellation, I mean a heuristically coherent group that, far from dominating the totality of space-time, is unequally distributed in the three dimensions of history. Therefore, a plurality of overlapping constellations can and often do inhabit the same historical conjuncture. This is one of the reasons why *the* avant-garde does not and cannot function as an epochal concept. To begin with, it was largely a Western phenomenon: "the non-European avant-garde barely existed outside the western hemisphere, where it was firmly anchored to both artistic experiment and social revolution."[23] Secondly, avant-garde practice by no means dominated European art in the early twentieth century: "to say that the new avant-garde became central to the established arts," writes Hobsbawm, "is not to claim that it displaced the classic and the fashionable, but that it supplemented both."[24] Thirdly, there was a wide disparity between the various avant-garde constellations. As Benjamin Buchloh remarks, for instance: "At the same time that Heartfield and Lissitzky were engaged in the most radical and consequential assault on the institution of art during the late '20s and '30s, Vlaminck and van Dongen—former members of the Fauve avant-garde—were selling what Paris then thought to be the best contemporary painting, but what was in fact the most menial art ever to leave the studios of the 'avant-garde.'"[25] To cite another example, one of the important constellations of avant-garde art was linked to a revival or reinvention of classicism: "Avant-garde artists as different as Picasso, the Fauve André Derain, Futurists like Gino Severini and Carlo Carra, all turned to classical themes enacted in more or less stable pictorial space. The 'metaphysical' painter Giorgio de Chirico went so far as to conclude his essay 'The Return to the Craft' with the ringing declaration, in Latin: 'Pictor classicus sum.'"[26] Rather than there being one avant-garde or a single constellation of practices, there are a number of overlapping and sometimes conflicting configurations of avant-garde activities.

SOCIAL EFFICACY BEYOND THE BINARY

Art . . . is a method of organizing our shared life in general.

—DECLARATION OF THE INTERNATIONAL FRACTION OF CONSTRUCTIVISTS
OF THE FIRST INTERNATIONAL CONGRESS OF PROGRESSIVE ARTISTS

Global judgments of success or failure require social univocity, and they are based on the assumption that a phenomenon like the avant-garde can have a single and homogenous result. This supposition is, in turn, founded on a social epoché by which the sheer diversity of social consequences is bracketed in order to establish a single omnipresent upshot for each action or group of actions. Such an elimination of the social, in conjunction with a cosmotheoretic knowledge of history, is a necessary prerequisite for individual judgments concerning the singular—but totalizing—social effect of the avant-garde.

In the case of Bürger's thesis on the failure of the avant-garde, its effects are ultimately due to a conceptual conundrum. The avant-garde intends to accomplish a task that is logically impossible: to abolish art by producing inorganic artwork. As we saw in the preceding chapter, failure is thereby inscribed in the very conceptual matrix of the avant-garde. It is assumed, moreover, that there is a single intention that animates the entire history of the avant-garde, as if social movements functioned analogously to individuals and had unified intentions. The social epoché employed at the level of reception to reduce avant-garde movements to a single consequence is equally mobilized at the level of production: all of the variable aims and objectives of the myriad of avant-garde artists in the early twentieth century are reduced to the sole and unique intention of abolishing art as an ideational institution. Bürger thereby assumes that a single spirit unites all of the aesthetic practices that he identifies as avant-garde: the spirit of the same misguided and naïve intention.

Renato Poggioli provides an alternative account that, in spite of its limitations, foregrounds the possibility that a sacrificial method undergirds the

avant-garde, which participates in a dynamic tradition of perpetual turn-over. According to this tradition, the avant-garde's failure qua integration into the norm is precisely its mode of success: "The avant-garde is condemned to conquer, through the influence of fashion, that very popularity it once disdained—and this is the beginning of its end. In fact, this *is* the inevitable, inexorable destiny of each movement: to rise up against the newly outstripped fashion of an old avant-garde and to die when a new fashion, movement, or avant-garde appears."[27] The overall victory of the avant-garde in general is, in fact, made up of the dynamism of its own individual disappointments. As in fashion, success is failure: "the whole history of avant-garde art seems reducible to an uninterrupted series of fads."[28] It is for this reason that Poggioli poignantly attacks the thesis on the supposed end of the avant-garde: "If there has been an overcoming, it consists of the felicitous transition of the avant-garde in the strictest sense to an avant-garde in the broad sense; of a defeat in the letter and a victory in the spirit of avant-gardism."[29] The avant-garde has not only succeeded in imposing a new spirit of constant overcoming, but it has also effectively imposed a new temporality on the arts: "avant-gardism has now become the typical chronic condition of contemporary art."[30] The punctual failures of avant-garde movements, understood as their normalized integration into the popular realm of recognized art, ultimately contribute to the overall success of avant-garde temporality as the dominant chronological modality of the art world. "'*Avant-gardism*,'" write Fred Orton and Griselda Pollock, "has become the pervasive, dominant ideology of artistic production and scholarship. It instates and reproduces the appearance of a succession of styles and movements often in competition and each one seemingly unique and different in its turn. . . . The illusion of constant change and innovation disguises a more profound level of consistency."[31]

In evaluating the consequences of avant-garde practices, many theorists rely almost exclusively, like Bürger, on a museum and canon model. However, it is patently unclear how the thesis of the end of the avant-garde would work when applied to other arts, such as architecture and design. What would it mean for the latter to destroy their autonomous status and become part of life praxis (to use Bürger's vocabulary)? Are not architecture

and design, at least insofar as we consider actual buildings and objects in use, always already part of life praxis? What could it possibly mean for avant-garde architecture and design to fail to link art and life? It seems that it would imply that buildings and designed objects would fall out of use or prove to be structurally unsound. If this is indeed the case, then any avant-garde buildings or designed objects actually in use would stand as potent symbols of the blatant success of the avant-garde. Given the triumph of the International Style, to take an important example of architecture that is still—in spite of criticisms—ever present in the urban landscape of industrialized modern cities, wouldn't we have to draw the conclusion that avant-garde architecture has been extremely successful in marrying art and life praxis? Moreover, if we take our historical bearings from what are often considered pre-avant-garde developments like Art Nouveau, Art Deco, and the Arts and Crafts Movement or from avant-garde movements like Constructivism, De Stijl, the Bauhaus, organic architecture, and others, could it not be argued that the cutting edge of modern industrial design has been extraordinarily successful in transforming the aesthetic experience of everyday life?[32] It should be quite obvious from these questions that the undue concentration on institutionalized art and canonized literature in the restricted sense produces a very limited account of avant-garde practices. It also favors the conclusion that art has not succeeded in abolishing the institution of art, which should come as no surprise when one focuses on institutionalized art. In the case of Bürger, his general tendency to occlude the industrial design aspect of various avant-garde movements suggests, moreover, that he implicitly relies on the idealist dichotomy between art and industry, which is precisely one of the oppositions attacked by movements such as Constructivism and the Bauhaus. In fact, by maintaining the border between institutionalized art and industrial design, he begins with the very conceptual dichotomy that so many avant-garde practices sought to overcome: the modern social hierarchy privileging the spiritual endeavors of the fine arts over and against the applied arts of architecture and design. He thereby predetermines the 'failure' of the avant-garde precisely because he tends to ignore the very practices that 'succeeded,' if we use this rather schematic normative vocabulary. This is ultimately because he relies on a

concept of art that is itself founded on a social hierarchy between arts and crafts, the spiritual and the material. He thereby obfuscates the fact that the concept of autonomous art is already, in and of itself, a social product: far from being separate from life praxis, the very notion of art—including the idea of autonomous art—is part and parcel of a specific social reality and cultural hierarchy.

In analyzing the constellations of avant-garde aesthetic practice, it is absolutely necessary to break with the museum-based model of canonized art and literature, which tends to facilitate rectilinear histories. Indeed, there is a long-standing inclination to concentrate on art history and then project it onto the other arts. Such an orientation is particularly detrimental to the attempt to map the constellations of avant-garde practice in the early twentieth century because there was such an intense mixture of what are called artistic genres. As Poggioli appropriately points out: "the experimental aspect of avant-garde art is manifested not only in depth, within the limits of a given art form, but also in breadth, in the attempts to enlarge the frontiers of that form or to invade other territories, to the advantage of one or both of the arts."[33] Early avant-garde cinema is an excellent example thereof, and there are numerous cases of extensive collaboration between artists, writers, composers, choreographers, photographers, and so on.

Another problem with the account of the failure of the avant-garde found in authors like Bürger is that the etiology is essentially internalist, assuming that if the avant-garde ceased to exist, it is due to internal reasons since art is autonomous in bourgeois society. However, if there were indeed significant pockets of recession in avant-garde practice after the massive developments of the early twentieth century, this cannot simply be explained in terms of the conceptual failings of the avant-garde. On the contrary, it is necessary to examine the ways in which aesthetic practices are intertwined with social, political, economic, and technological factors. For instance, the Nazi rise to power led to the closure of the Bauhaus and a general end to the avant-garde, at least within Germany. The same might be said of Stalinist Russia, if not of Russia as of Lenin's famous decree in the early 1920s.[34] The effects of the Great Depression should also be factored into any account of the partial downturn in avant-garde production, as well

as various technological changes. The introduction of sound cinema is a case in point insofar as it rendered some of the more extreme modes of formal experimentation 'impractical'—as witnessed by the general demise of Dadaist film and French Impressionist cinema—while nonetheless allowing for the continuation of more sober cinematographic techniques in a certain form of Surrealism, as well as the development of new experiments with sound (such as in René Clair's films).[35]

For all of these reasons, the univocal categories of success and failure are inappropriate for discussing the legacy of the avant-garde. Since there is not a single homogenous avant-garde practice, let alone a unique avant-garde intention or single spirit, it is mistaken to think that it could succeed or fail once and for all. Instead, there are a plurality of immanent activities that can be charted out in terms of overlapping and sometimes conflicting constellations, which morph in variable metastatic transformations through the three dimensions of history. These are not aligned on a single front line against the institution of art or founded on a radical break with the past, nor are they so many free practices of creation opposed to the rigidity of established conventions. There are, in what is generically referred to as the avant-garde, sundry attempts to introduce novel modes of production, circulation, and reception that give variable content to an immanent concept in struggle, in certain cases by working with, or developing, institutions of various sorts. Avant-garde practices are often related to an effort to rework the social status of art and its position in a matrix of political, economic, and technological relations. In this regard, the avant-garde engagement with architecture and industrial design is extremely important since it aims, in part, at dismantling the hierarchy of art over craft by bringing aesthetics into everyday existence (with great 'success' in certain cases). At the same time, the very category of avant-garde art is coextensive, at least in select instances, with a social distinction in the networks of circulation and reception based on the separation between the avant-garde and the arrière-garde or mass entertainment. It is for this reason that the task of rethinking avant-garde practices needs to be undertaken not only in relationship to aesthetic production, but also concerning the specific social matrices of distribution and reception. It is also worth noting that many

avant-garde practices accept, implicitly or explicitly, a novel mode of historicity in which the present is recognized as a future past, and historical accounts come to serve as unique forms of aesthetic legitimation. This mode of future perfect historicity is, moreover, linked to a temporal and normative framework of more or less programmed iconoclasm (which has also largely 'succeeded' in the contemporary art world). The historicity of avant-garde practices is thus not unrelated to their sociality, and both dimensions must be taken into account. In this regard, it should be noted that the results of avant-garde interventions cannot be determined by logical deduction or cosmotheoretic foresight because the social field is the site of numerous types and points of agency, which can change over time. They are incursions in a variegated social topography that have multiple and sometimes conflicting consequences.

PART III
THE POLITICS OF AESTHETICS

5

THE SILENT REVOLUTION

Rancière's Rethinking of Aesthetics and Politics

PASSAGE À L'ENVERS

The circuitous response to the question "what is literature?" in the introduction to *Mute Speech* (1998) is one of the best introductions to Jacques Rancière's rather complex methodology, which breaks in important ways with the work of his predecessors and charts out new territory for thinking art and politics. The concept of literature, he claims, is at once absolutely self-evident and radically undetermined. Rather than invoking this paradox as a Heideggerian justification for investigating the essential question of our age, Rancière uses it as a vehicle for analyzing the intellectual constructs at work in the various attempts to isolate the nature of literature. The empirical approach, for example, accepts the self-evidence of the historical conventions that establish a well-circumscribed catalogue of literary works. This positivistic attitude is countered by a theoretical definition that posits the existence of a literary essence irreducible to the simple bibliographical delimitations inherent in textual classification. Instead of searching for a passage between the Scylla of positivism and the Charybdis of speculation, Rancière is interested in the historical conditions that render such a choice possible. In other words, he refuses to give a straightforward answer to the question "what is literature?" in order to resituate the question

itself in its historical context and examine the various factors that determine possible responses.

One of the guiding presuppositions at work in the attempt to define literature is that aesthetic history can and should be divided between works of art and the philosophic reflection on the nature of aesthetics. In order to thwart this erroneous assumption, Rancière painstakingly demonstrates that these domains are in fact coextensive and that it is impossible to separate theoretical claims from artistic practice. In the introduction to *Mute Speech*, he provides a brief analysis of this relationship in terms of the dispute between John Searle and Gérard Genette. On the one hand, he agrees with Genette's claim that the literary status of a play like *Britannicus* is not simply due to the pleasure it produces and that literature cannot be reduced to Searle's notion of arbitrary aesthetic judgment. However, he refuses to accept Genette's counterclaim that *Britannicus* is a literary work because of its specific genre. According to Rancière, such a conclusion would have been incomprehensible for Racine's contemporaries. *Britannicus* was strictly speaking a tragedy, and it was therefore classified as poetry and not literature. In fact, the term *littérature* referred to a particular form of knowledge and was not used as a subdivision of written works in the same way that it is today. Thus, if Genette considers *Britannicus* to be a literary work, it is only due to the status retrospectively conferred upon it by the Romantic age, that is, by a new idea of art and literature. For Rancière, the concept of art is always embedded in a regime of perception that determines what is visible as art or literature in a specific context. Ideas are not autonomous reflections on preexisting empirical content; they are part of the historical configuration in which artistic practices appear. The mistake that Genette makes—the same could be said mutatis mutandis of Searle—consists in applying a contemporary concept of literature to a work of the classical era as if the historical trajectory of ideas could be separated from the historicity of literary forms.

In spite of appearances, Rancière is not simply reiterating the importance of the hermeneutic distance separating classical tragedy from modern times. While it is true that he brazenly discredits universal definitions of

literature by resituating them in their historical matrix, his own methodology aims neither at a fusion of horizons nor at the conclusion that insurmountable epistemic limits forever divide the past. On the contrary, he analyzes the ambiguous status of literature in contemporary discourse in order to elucidate the artistic and conceptual constructs that determine the space of possible statements regarding the nature of literary works. If literature is, for him, neither a conventional category of classification nor the written incarnation of a literary essence, it is because this very choice is itself predetermined by systems of perception, action, and thought that he refers to as artistic regimes.[1] Thus, when he finally provides his own working definition of literature, he carefully sidesteps the wearisome debates on the nature of literariness and the precise limits of genre classification. Strictly speaking, literature refers to the historic mode of visibility that produces a split between two possible forms of writing and their corresponding theoretical formulations: the consecration of the incomparable essence of literary creation and the demystification of the metaphysics of art in the name of either positivistic criteria of classification or arbitrary aesthetic judgment. The paradox inherent in the contemporary idea of literature is thereby explained in terms of the unique system of perception and thought introduced by what he will call the aesthetic regime of art.

Rancière's examination of the historical underpinnings of the question "what is literature?" ultimately aims at specifying the conditions that predetermine its ambiguous response. He then integrates this entire network of questions and responses within the historical relationship between rival poetic systems. This allows him to demonstrate that the paradoxical notion of literature is in fact a constitutive element of the silent revolution in the meaning of the term *literature* between the belles-lettres tradition and the expressive poetics that has come to prominence in the modern era. It is in part because this revolution can be consecrated as an absolute or fall into silent oblivion that literature functions as a homonym in contemporary discourse. All said and done, the only valid response to the question "what is literature?" thus consists in a genealogy of the historical conditions that produced both the question and its contradictory responses.

HISTORICAL TRIPTYCH OF ART AND POLITICS

A tacit accord exists between the aesthetic regime of art and Rancière's own historical and hermeneutic methodology. Rather than searching for the hidden meaning behind appearances, he elucidates the conditions that produce both appearances and the reality that they either conceal or disclose. The interpretive lenses of the ethical regime of images and the representative regime of art both rely on a dichotomous structure that presupposes a split between representation and its external support. In the case of the ethical regime, images and words refer back to an original archetype, whereas the representative regime assumes that appearances are symptomatic of hidden meanings.[2] The exteriority presupposed in both cases is called into question by the aesthetic regime of art. Referring to Giambattista Vico's landmark interpretation of Homer as one of the founding moments of this regime, Rancière claims that his hermeneutic procedure consisted in isolating the immanent conditions that produced Homeric poetry.[3] Vico decided to read Homer as a witness to a particular state of language and thought within which his own discourse was embedded. Far from celebrating the work of an innovative lyricist as did the Aristotelians, he considered Homer a poet only insofar as his conscious contribution was irremediably fused with unconscious influences and his voluntary decisions were wed to the involuntary developments of his historical epoch. In the terms Rancière uses to describe the aesthetic regime of art, logos became indiscernible from pathos.

In much the same way, Rancière's genealogy of aesthetic forms avoids establishing a normative paragon of artistic production or elucidating the secret meaning concealed within works of art. He is primarily interested in the modes of perception, action, and thought that are immanent in specific forms of artistic practice. It is for this reason that his distinction between two meanings of the term *aesthetics* is of the utmost importance for understanding his work.[4] In its broad sense, aesthetics refers to the distribution of the sensible (*partage du sensible*) that functions as the immanent set of conditions for artistic production as well as the system of perception and thought that makes an object or action visible as art. This general definition

has the advantage of extending aesthetics beyond the field of art in the traditional sense to include the coordinates of perception and action in the domain of politics. In order to understand this unique attempt to theorize the aesthetics of politics, it is necessary to begin by analyzing aesthetics in the restricted sense, that is, one of the three regimes of art akin to the three hermeneutic paradigms touched upon above.[5]

Although Rancière carefully avoids overly systematic accounts of the main characteristics of the three regimes of art, certain salient features are readily visible. The ethical regime is based on the distribution of images—not to be confused with art in the contemporary sense—and their arrangement with regard to the ethos of the community.[6] This distribution, at least in the exemplary case of Plato's *Republic*, is organized around two primary reference points: the origin of images (the model copied) and their destination (the purpose they serve in the community). The representative regime of the arts emerges out of Aristotle's critique of Plato and establishes a series of axioms that were eventually codified in the seventeenth and eighteenth centuries. To begin with, the principle of fiction posits that the essence of a poem is not to be found in its metric regularity but can be strictly defined as the fictional imitation of actions, which presupposes a specific space and time for fiction. The generic principle or principle of 'genericity' (*principe de généricité*) organizes artistic production in a hierarchy of genres that corresponds to the hierarchy of possible subjects. The principle of decorum or appropriateness (*principe de convenance*) serves to adapt forms of expression and action to the subject matter represented and to the proper genre. Finally, the principle of presence or contemporaneity (*principe d'actualité*) privileges the act of speaking and the pedagogical ideal of efficacious rhetoric. These four axioms by no means exhaust the representative regime, and they themselves are in fact dependent upon an entire logic of the sensible ranging from the ubiquity of binary oppositions and hierarchical systems of organization to the omnipresence of cause and effect relationships. However, the advantage of the four principles that Rancière outlines in the first chapter of *Mute Speech* is that they provide precise reference points for understanding the transformation ushered in by the aesthetic regime of art: the primacy of language supplants the principle of fiction; the equality of represented

subjects replaces the hierarchical distribution of genres; the indifference of style with regard to content undermines the principle of appropriate discourse; and the model of writing supersedes the ideal of speech as act. As is the case with the ethical and representative regimes, the changes introduced by the aesthetic regime of art should not be understood in terms of simple historical alterations in the nature of artistic production. In moving from one regime to another, the entire distribution of the sensible is at stake, namely, the "system of relations between *doing, seeing, saying* and *sensing.*"[7]

This is one of the reasons why parallels can be seen between the three regimes of art and the three forms of political philosophy that Rancière outlines in chapter 4 of *Dis-agreement* (1995). Hasty assimilations are undoubtedly doomed to failure, but the historical reference points and dominant logic of each regime are immediately identifiable. To begin with, Platonic archi-politics is the attempt to found a community on the integral manifestation of its logos in sensible form. The spirit of the law in the republic is infused into the ethos of its citizens and incorporated as a living *nomos* that saturates the entire community. Everyone has a designated place and an assigned role. The principle of *sōphrosunē* supplants the freedom of the *dēmos* and serves to regulate the activities of individual citizens in relation to their role in the organization of the communal body. Given Rancière's definition of politics (*la politique*) as the polemical intervention—driven by the verification of absolute equality—in the system of perception and discourse established by the police (*la police*), archi-politics eradicates *la politique* in the name of *la police.*[8] Aristotelian para-politics commits the same error in the opposite direction. Instead of simply replacing politics with the police, it purports to incorporate the former within the latter by translating egalitarian anarchy into the constitutional order. The *dēmos*, or the people who have no part in the distribution of the sensible, are mimetically transformed into one of the parties of political litigation. Such a conversion, as natural as it may seem to modern theories of sovereignty and the para-political tradition of social contract theory, conceals the fact that the equality of the *dēmos* can never be adequately accounted for within the police order. This inherent falsity of para-politics constitutes the deep truth of meta-politics: an absolute wrong undermines every attempt at instituting political justice

and equality. As a science of suspicion whose only access to truth is through the veil of ideological falsity, Marxist meta-politics repeatedly denounces the distance separating social reality from the dubious pretenses of rights and representation. It thereby oscillates between a nihilism that condemns the speciousness of all politics and a radicalism of "true politics"—the communal incarnation of the truth of social reality—that is strictly homologous with Platonic archi-politics. This epistemological configuration is also one of the dominant features of contemporary liberalism. However, the identification of politics with the management of capital is no longer, for liberal democracies, the shameful secret hidden beneath the mask of ideology; it is the truth that legitimates the consensual system of post-politics.

Archi-politics, para-politics, and meta-politics all identify politics with the police. The three forms of political philosophy thereby abolish the central antagonism between absolute equality and the police order that characterizes Rancière's understanding of *la politique*.[9] The Marxist meta-political notion of class provides a poignant illustration of this operation. To begin with, Rancière explains that the concept of class acts as a homonym that hesitates between two extremes. In the police order, the proletariat refers to a group of individuals whose origin or occupation bestows upon it a collective identity. In the realm of politics, the same term acts as a mode of subjectivization that interrupts social categories and breaks the established molds of classification. Marxist meta-politics transforms this radical antagonism between politics and the police into an opposition, within the police order, between the false forms of political representation and the true embodiment of social reality.

For Rancière, political categories such as the proletariat, minorities, women, or the *dēmos* refer to an unmanageable excess, a "suspensive existence" with regard to the body politic. They are not the true social reality behind ideological appearances. Strictly speaking, they are democratic subjects demonstrating their virtual power of declassification by instituting polemical communities where the wrongs of the police order are at stake. This is one of the reasons why politics is not, for Rancière, a specific sector of activity found in certain places and at particular times, carried out by select individuals. Politics exists any time the account of parts and shares

within society is disturbed by the intrusion of those who have no part in the established order. In his discussion of democratic subjectivization, he often makes reference to the paradoxical slogan on a well-known poster from May 1968: "We are all German Jews!" In a certain sense, all of the terms used to refer to those who have no part in the communal distribution of the sensible are equivalent insofar as they refer to a paradoxical excess that cannot be contained within regulatory categories.[10] The universal presupposition of subjectivization—absolute equality—does not, however, amount to a simple distribution of rights and responsibilities within society. In fact, the very notion of "social equality" is contradictory because equality can only be actualized in polemical communities that are relentlessly transformed by political subjects. Equality, it might be said, is an activity rather than a state of being, an intermittent process of actualization rather than a goal to be attained once and for all.

If aesthetics is understood in its broad sense as a distribution of the sensible rather than the domain of artistic practice in the restricted sense, then the realm of the political (*le politique*) is fundamentally aesthetic in nature. It is the meeting ground between a police distribution of the sensible and the democratic incursion, in the name of equality, that disrupts the perceptual categories of a community. In partitioning the sensible, political systems decide who or what has a part in the community and how these parts are distributed. The task of politics (*la politique*) consists, in part, in producing communal forums for dispute by demonstrating the gap between the visible and the invisible, the sayable and the unsayable, the audible and the inaudible. While Rancière avoids systematizing the three political and aesthetic regimes outlined above, he nonetheless delineates three distinct distributions of the sensible: a hierarchical system founded on the ethos of the community, a representative regime of appropriate and adequate forms, and an ambiguous realm that vacillates between nihilism and the glorious incarnation of truth. However, it would be a grave mistake to conclude from the loose outline of these regimes that Rancière is postulating a totalizing logic that aims at systematizing cultural and political history. Fortunately, his work has overcome the pathological fear of Hegel found in some of his compatriots—a fear that often verges on a form of *Angst* induced by the

haunting specter of metaphysics—without falling prey to the trite impulse of a return to Hegelian systematics. All said and done, Rancière generally avoids establishing an abstract, tripartite system of art and politics by analyzing the three regimes of art as immanent constellations that only exist in relationship to one another through historically specific forms.

AESTHETIC GENEALOGY

In a revealing interview, Rancière candidly admits his indebtedness to Michel Foucault: "The genealogy of the concept of literature that I have attempted in *La Parole muette* [*Mute Speech*], or in my current work on the systems of art, could be expressed in terms close to Foucault's concept of episteme."[11] However, he is quick to add that he is not concerned with establishing the limits of thought for a particular era and that he is "much more sensitive to crossings-over, repetitions, or anachronisms in historical experience."[12] The question of historical methodology, moreover, is ultimately tied for Rancière to the polemical role played by equality, a concept that has little theoretical pertinence for Foucault. Given that one of the common reference points that they both share is the set of methodological changes introduced by the Annales School, this may serve as a useful starting point for examining the explanatory power of Foucault's epistemes and Rancière's artistic regimes.

Elucidating Foucault's relationship to his immediate predecessors in historiography would require a long and detailed study extending well beyond the scope of the present chapter. It is, however, worth emphasizing that the choice between historical continuity and discontinuity is misleading. It is a mistake to affirm that Foucault either entirely accepted or categorically rejected the methodology of the Annales School. The most obvious reason for this is that the Annales School itself has not consistently maintained a single doctrine accepted by all of its members at every stage of its long history. The early endeavors by Marc Bloc and Lucien Febvre to overcome historical positivism and the limits of political history while avoiding the

pitfalls of abstract German-style historiography have undergone numerous metamorphoses and given birth to diverse trajectories in the historical sciences. Furthermore, the dominant personalities in the second generation of the Annales School made important decisions regarding their methodological heritage. Economics and demography became privileged tools of analysis, totalizing geohistory tended to replace the chronicle of human lives, and the primary focal point became the classical age. Without adding the further complication that Foucault himself played a major role in the development of the third generation of the Annales School, let it suffice to conclude that the notion of a historical "school" can only be taken as pragmatic shorthand to refer to a long and intricate history.

Moreover, Foucault's own intellectual jabs and feints make it difficult to isolate one fixed historical method, or even three methodological formulas that would correspond to each of the supposed periods of his corpus (archeology, genealogy, problematization). Whether he is referring to his historical studies as experiments, calling his delimitations provisory, qualifying his historical claims, refining his notion of discontinuity, referring to himself as a journalist, or reformulating the basic stakes of his entire project in terms of his present concerns, Foucault's critical reflection on his own theoretical enterprise often leaves his reader with the impression that *this* is in fact the only constant in his work. To take one example among many others, in the introduction to *The Archeology of Knowledge*, he begins by making reference to a set of methodological characteristics readily identifiable with certain tenets of the Annales School: the quantification of the past, the extension of history beyond the restricted domain of politics, the multiplication of levels of historical analysis, the use of the notion of *mentalités* to transpose the history of ideas outside the domain of individual consciousness, and the expansion of historical epochs beyond the short duration of political events. At almost the same time that these developments were occurring in the historical sciences, Foucault asserts that a separate group of thinkers (Bachelard, Canguilhem, Guéroult, and Serres) were studying ruptures and discontinuities that undermined the mythological model of continuous development in the history of ideas. Although Foucault is often presented as an advocate of historical discontinuity and is usually integrated

into the latter tradition, he affirms in *The Archeology of Knowledge* that these two methodological changes emerged out of the same fundamental problem of historical documentation. They both shared the common enemy of memorial history, whose aim in interpreting documents was to reconstruct the past by resuscitating its mummified voices for the ear of humanity's collective consciousness. They were allies in reversing this tendency and transforming documents into "monuments," that is, sets of documentary mass that could be organized into relational networks and anchored in precise historical laws. Thus, he actually situates the crucial theme of discontinuity within the overall framework of monumental history that unites the archeological history of ideas with the Annales School. His own rejection of the early Annales School concept of collective mentalities does not, therefore, imply extending the interpretive grid of discontinuous epistemes to every field of investigation. The quantifiable history of demography, economic systems, social formations, technology, and climate can methodologically justify epochs of long duration (*longue durée*). However, recent scientific and intellectual history is no less justified in dismantling the long series inherent in the idea of human progress and the teleology of reason.

The manner in which Foucault divides history into individual series and then parcels out diverse strata within them is crucial to the notion of an episteme. Perhaps the most widespread understanding of this term is that it refers to totalizing systems of discursive order that break down and reassemble themselves at epoch-changing moments in history. Although Foucault occasionally suggests that this is the case, his use of a particular form of serial history produces a very different image of epistemes. Organized as they are in chronological series, they do not simply constitute periodic blocks that purport to encompass the sum total of discursive activity at a given point in time. The establishment of temporal sequences—such as the Renaissance, the classical age, and the modern age—is in fact dependent on isolating individual strands and series within the total field of discursive production. In *The Order of Things*, for example, he concentrates primarily on the parallel trajectories of three unique strands within the general series later defined as the human sciences: the analysis of wealth, natural history, and general grammar that become political economy, biology, and philology

in the modern age. Given these parameters, nothing excludes the possibility of additional strands and series that would not abide by the same historical laws. Indeed, Foucault clearly delineates literature as a 'counterdiscourse' whose internal logic opposes the modern epistemic order of the human sciences. The chronological schema remains roughly the same since literature in its modern sense was born upon the ashes of the belles-lettres tradition around the end of the eighteenth century. However, modern literature discards the classical paradigm of representation in order to revive the brute being of language buried since the Renaissance. Liberated with modern times from the law of an initial discourse, literature folds back upon itself as an intransitive language whose only law is to affirm its own glorious being. As Foucault mentions on numerous occasions, the unique status of literary language is incompatible with the existence of man, which is integral to the human sciences. Thus, instead of corroborating the famous historical thesis on the birth of man, literature acts as an anachronistic counterdiscourse that contravenes what many consider to be Foucault's central thesis on the modern age in *The Order of Things*.[13]

The position that Rancière takes with regard to his predecessors in historiography is indicative of his rejection of certain features of Foucault's archeology of knowledge. To begin with, he fully accepts the importance of situating new history in its context and understanding it as a specific mode of discourse that emerged in the modern age with the dawn of the human and social sciences. As a novel discipline, it was inseparably connected to the unique conjunction of three developments in the nineteenth century: the rapid expansion of scientific rationality, the emergence of modern literature, and the various waves of democratic revolution that swept across Europe. This historical configuration determined the contradictions inherent in the discursive contract signed by new history, which was at once scientific, literary, and political in nature.[14] The advocates of new history purported to unveil the rational order hidden behind appearances while arranging this order into narrative form by using characters and plot. The political dimension of new history only served to intensify this conflict between its scientific and literary requirements. Just as the homonymous *dēmos* was in constant struggle with the established laws of the community, the multitude of

historical voices was in irremediable tension with the historical regularities established to incorporate them.

Rancière's poetics of knowledge consists in analyzing the discursive procedures by which a particular form of knowledge attempts to establish itself as a mode of truth within the parameters set by its historical framework. In the case of new history, he studies the methods employed by its main proponents to mitigate the contradictory nature of its discursive contract. However, the dominant feature of new history is precisely the impossibility of definitively eradicating its double contradiction. As a discipline unique to the modern age, it is unavoidably trapped between science and literature, on the one hand, and between representation and democratic excess, on the other. Therefore, history as a discipline is not a unified discursive series but rather the meeting ground of contradictory forces. The idea of a serial history of disciplines that are organized into discourses and counterdiscourses remains foreign to Rancière's historiography insofar as disciplines such as new history are simultaneously discourses and their own counterdiscourses. Furthermore, since new history is in the grips of a contradiction that saturates the art, literature, and politics of the nineteenth century, the cultural and intellectual developments of the modern age cannot be reduced to a more or less homogenous epistemic formation.

Rancière's implicit refusal of the disciplinary units and epistemic consistency necessary for Foucault's brand of serial history is inseparable from his explicit rejection of chronological sequences. Indeed, one of the starkest contrasts between epistemes and regimes is apparent at the level of historical delimitation. Despite the numerous provisos and qualifications, the end of the eighteenth century nonetheless remains a fundamental turning point for Foucault, especially in his early work. Rancière, on the other hand, avoids conflating his three regimes of art with precise historical epochs. Although the aesthetic regime is unique to what Rancière loosely refers to as the modern era, the ethical and representative regimes date at least since the ancient Greeks. This does not mean that each regime comes into existence as a fully constituted set of rules that then endlessly repeats itself through history. On the contrary, a regime is a malleable system of action, perception, and thought that takes on historically specific forms and does

not exist in complete isolation from the other regimes that share its historical conjuncture. One of the reasons for this is that, regardless of the apparent order of succession in their overall logic, each regime is made up of autonomous elements that have their own unique historicity. Thus, an individual regime functions neither as a historical epoch nor as a unified aesthetic framework that transcendentally determines the limits of possible action and thought. Many cultural, intellectual, and political forms are in fact hybrids made up of components from different regimes or conflicting elements within a single regime. For Rancière, the specificity of the modern age—strictly speaking a misnomer—is not to be found in its epistemic order or in the struggle between fully elaborated cultural constructs. The 'age' of democratic revolution is caught in an irresolvable tension between diverse elements from the representative and aesthetic regimes of art, and these factors function independently of chronological sequences such as classicism and modernism.

The paradigm proposed by Rancière has the advantage of almost entirely sidestepping the belabored debates on historic continuity and discontinuity. The founding presupposition of these disputes is that history itself is made up of unified temporal series that either remain constant or undergo transformations that establish new sequences. These series do not have to correspond to the sum total of activity for a particular epoch, but they purport to isolate a precise domain at a given point in time. The portrait of literary history that Foucault outlines in his early work is a perfect example. As a distinct discursive series, modern literature is given its birthright by a radical event that is usually situated around the turn of the nineteenth century with the writings of Sade and Hölderlin. Within this chronological sequence, Foucault establishes a chain of exemplary cases that renew, through the course of history, the inaugural transgression of literary language: Nietzsche, Mallarmé, Roussel, Artaud, Bataille, Blanchot, and so forth. La littérature is thereby condensed into a well-circumscribed dimension of history and identified with an extremely specific cultural heritage. Foucault combines the event-based delimitation of a chronological sequence with a delineation of historical space that reduces literature to a limited set of authors and a particular geographic region for each moment

on the historical time line. The result of this operation is the compression of the historical space of literary production into a consistent series that masks significant aspects of European cultural history. Rancière's account, on the contrary, attempts to broaden the spectrum of analysis in both directions. Given his dismissal of facile chronological delimitations, he returns to Plato, Aristotle, Cervantes, Vico, Voltaire, and many others to chart the emergence and transformation of diverse elements that will have an influence on 'modern' literature. He also argues that if the nineteenth century did in fact introduce a relatively novel configuration of aesthetic forms, then the much-ignored literary significance of social realism has to be taken into account as one of the forerunners in this process. This indicates his concern with salvaging the breadth of historical space and resuscitating the voices of authors like Hugo and Balzac that many postwar French thinkers, like Foucault, had largely disregarded. If the diversity of cultural production at any given moment in time is taken into account, it is de facto impossible to reduce the silent revolution of literature to a dramatic event signaling a new chronological sequence in history.

Rancière's innovative historical methodology also allows him to critically assess the relevancy of the almost endless speculation on the nature of modernism and postmodernism.[15] In addition to rejecting naïve claims to historical beginnings and ends, he judiciously exorcizes two mythical paradigms of artistic modernity. The first reduces the developments of the aesthetic regime of art to an anti-mimetic revolution in which individual artistic forms affirm their uniqueness by exploring the power inherent in their specific medium: pigment and two-dimensional space for painting, intransitive language for literature, non-expressive systems of sound for music. The second paradigm, as equally deficient and widespread as the first, identifies forms specific to the aesthetic regime of art with the concrete manifestation of the modern destiny of humanity. Referring to this historical model as modernatism (*modernitarisme*), Rancière details a few of the diverse guises under which it has operated: Schiller's aesthetic state; the system of idealism outlined in an early rough draft by Hegel, Hölderlin, and Schelling; the Surrealist investment in the authenticity of artistic revolution after the disappointment of political insurgency; the Heideggerian thesis

that explains the failure of modernism in terms of the fatal destiny of the forgetting of being. According to Rancière, the crisis of art identified with the postmodern era is itself proof that aesthetic modernity—if this term has any precise historical meaning—has not been adequately accounted for by these two models. If it had been, then they would have been able to explain the following factors: the breakdown of the evolutionary trajectory outlined by numerous modernist projects and the return of the repressed (figurative painting and perspective in contrast to the modernist explosion of two-dimensional abstraction, curved space and ornamentation in the face of architectural functionalism, and so on), the emergence of new forms of three-dimensional artistic expression that have invaded the exhibition space underlying modernism (video art, pop art, installation, performance), the production of hybrid forms that disregard the borders of recognizable genres of artistic practice as well as the sociohistorical delimitations inherent in the notion of the avant-garde or modernist innovation. The introduction of the term *postmodernism* partially reveals the insufficiencies inherent in the modernist attachment to the notion of a proper domain of art subdivided into a determined set of distinct practices that each evolves according to an internal teleology. Rancière's rejection of this model does not, however, fall prey to the temptation to establish postmodernism as a separate historical epoch. The fact that the inadequacies of the two paradigms of modernism outlined above have become more visible over the last fifty years simply proves that they gravely miscalculated the potential of the aesthetic regime of art.

The concept of modernism is not only ineffective as a historical description of a distinct epoch and as a category of aesthetic production; it also tends to obscure, according to Rancière, the relationship between art and politics by confusing two distinct notions of the avant-garde. The strategic conception of avant-gardism maintains that a renegade group of iconoclasts surpasses the mass of institutionalized artists and cuts a swath of innovation by interpreting the signs of its own tradition. The aesthetic conception of the avant-garde, which is the only one that makes sense in regard to the aesthetic regime of art, is oriented toward the future and founded on the artistic anticipation of a world in which politics would be transformed

into a total life program. Rather than being defined in relationship to the time-honored past that it is trying to overcome, the avant-garde is here understood as the attempt to invent tangible forms and material figures for a life to come. Each of these two conceptions is rooted in a different idea of political subjectivity: the archi-political concept of a party that embodies the essential conditions for historical change and the meta-political notion of a global subjectivity that prepares for the material manifestation of a virtual community. The modernist vision of the relationship between art and politics is thus related to the historical confusion between an archi-political and a meta-political notion of the avant-garde. Rancière, although he is interested in charting the transformations of these two notions of avant-gardism, clearly rejects the link they establish between aesthetics and politics. One of the central questions that needs to be addressed, therefore, concerns the precise modality of the historical relationship between politics (*la politique*) and the aesthetic regime of art.

IMMANENCE AND HOMONYMY

Although Rancière dismisses the idea of an event-based sea change separating the classical and modern ages, the aesthetic regime of art nonetheless introduces an unprecedented distribution of the sensible. From Michelet's use of mute witnesses and the anonymous mass of historical documentation to Balzac's convocation of the silent language of things, he carefully charts a silent revolution in the structure of signification whereby the muted multitude takes on a voice of its own. The exteriority of meaning inherent in the logic of the ethical and representative regimes is thereby replaced by a horizontal plane of signification where meaning saturates the immanence of things themselves rather than transcending them. This aesthetic reconfiguration of the sensible parallels the political revolutions of the nineteenth century and the various attempts to open up the governmental and social order to the anonymous voices of the people. However, there is an inevitable risk in both cases that the act of incorporating these voices

will actually eradicate their 'impropriety' by reducing them to categories of social division or by silencing them in order to speak in their name. The silent revolution of immanent meaning thereby remains inseparable from a second major characteristic of the aesthetic regime of art: the indiscernibility of opposites and the ambiguous nature of homonyms. The voices that interrupt the aesthetico-political order risk being heard at the expense of being silenced since their recognition by the established system of the sensible often causes a nearly imperceptible transformation. Thus, the aesthetic regime of art replaces the depth of living speech and embodied words with a plane of immanence where the voices of the muted masses interrupt the distribution of the sensible by constantly hesitating at the border of silence. This hesitation is indicative of a unique figure of thought, action, and perception whose inherent contradiction dominates the aesthetic regime of art. The proper-improper (*le propre-impropre* or *l'impropriété propre*), as *dēmos* or democratic literarity, quietly disturbs the ordered distribution of the sensible by introducing the impropriety of homonyms.[16]

As Rancière is well aware, the immanence of meaning and the indiscernibility of opposites are two of the prevailing themes in the philosophy of Gilles Deleuze, including in his work with Félix Guattari. Without seeking a term-for-term correspondence, an apparent theoretical proximity is readily identifiable. In addition to Deleuze's well-known conceptualization of the plane of immanence and the role of indiscernibility in his work on film and painting, it is worth highlighting Rancière's appropriation of the notions of territorialization and deterritorialization, their shared concern with the Proustian notion of literature as a foreign language within language, and their common interest in registers of the sensible that elude representation. In order to provide a concrete example of this proximity, let us take the case of Deleuze's landmark publication on Foucault in 1986. In this book, he describes Foucault's archeology of knowledge as a historical investigation of the stratified matrix of the sayable and the visible in which the primacy of discourse only serves to emphasize the inalienable autonomy of the non-discursive domain of the visible. With the publication of *Discipline and Punish*, Foucault sought to definitively overcome the risks of a rigid dualism by interpreting each of these domains as multiplicities. Moreover, he added to

the archeology of the sensible an analysis of the heterogeneous forces that disturb the stratification of the sayable and the visible by interrupting them from the outside (*le dehors*). What Deleuze calls "relations of force" constitute a third form of multiplicity that is in a state of constant transformation and becoming, a power that deterritorializes the archive of the sensible order. In his later work, Foucault explored the manner in which the outside folds in upon itself to create zones of subjectivization. Just as the internal constitution of the self remains an operation of the outside, a duplication of the *dehors* that preserves its radical difference, the actualization of forces in the stratification of the sensible is an act of simultaneous integration and differentiation. In both cases, the singularities of the outside are duplicated by an act of differential repetition. This is where Deleuze locates Foucault's logic as it has been actualized through the course of his oeuvre: the concepts of knowledge, power, and the self designate a threefold problematization of thought organized around four diagrammatic zones (the stratified zone of the sayable and the visible, the strategic zone of relations of force, the subjective zone of the fold, and the outside of radical singularities).

Based on this brief outline, a conceptual propinquity between Deleuze's Foucault and Rancière's historical methodology is apparent in the following set of themes: historical archives of the visible and the sayable that stratify the formless singularities of the outside, forces that interrupt the distribution of the sensible by deterritorializing the order of perception, and modes of subjectivization by which the outside is simultaneously integrated and preserved qua outside. For readers seeking a facile interpretive lens, it appears that Rancière's conceptual framework is a differential repetition of Deleuze's Foucault. However, the reason for enumerating these characteristics is not to enter into banal debates over whether Rancière is ultimately Deleuzian or to establish theoretical slogans that reduce their relationship to commodifiable catchwords. With regard to our current concerns, Rancière's critical assessment of the conceptual machinery put in place by Deleuze provides a unique opportunity for specifying the role of immanence and the contradictions of indiscernibility in the work of both thinkers.

Historically, Rancière situates Deleuze in the logical trajectory of the aesthetic regime of art and identifies his anti-representationalism with the

accomplishment of the "destiny" of aesthetics.[17] In criticizing representative constructs such as narration, illustration, and figuration, Deleuze defines works of art as heterogeneous elements that introduce a contradictory zone in which the sensible surpasses its own limits and manifests a particular mode of thought. This heteroclite form of the sensible is essential to the framework of the aesthetic regime of art insofar as it participates in the contradictory identification between thought and the sensible, logos and pathos, consciousness and the unconscious. Francis Bacon's method of defiguration, as analyzed by Deleuze, is therefore structurally equivalent to Flaubert's systematic dismantling of the grammatical and semantic edifice of traditional narrative. The goal in both cases is to render the power of a work of art identical with the pure power of the sensible qua idea, thereby cleansing it of its representational qualities. However, Rancière repeatedly demonstrates the paradoxical nature of this enterprise, especially in the field of literature: books cannot be written with the purified substance of the sensible, and modern literature—the same could, in theory, be said of Bacon—inevitably has recourse to representational constructs, fabricating fables that purport to produce an effect analogous to the effect of the pure sensible.

If Rancière inscribes Deleuze's writings on art and literature within the destiny of the aesthetic regime, it is because he attempts in vain to eradicate this paradox by freeing aesthetics from the constraints of representation. His insistence on the purity of the sensible ultimately condemns his work to a series of selective interpretations whose final goal is to illustrate the existence of a purity that has been repeatedly disproven by history. According to Rancière, Deleuze's clear-cut distinction between representation and the pure sensible transcends the specificity of the works he analyzes and masks their internal contradictions, as is the case, for example, with his repeated efforts to cleanse Proust's writing of organic models. This attempt to isolate the inorganic material of art attests to a fundamental misapprehension of the logic of the aesthetic regime and its paradoxical relationship to the representative regime of arts.[18] Furthermore, Deleuze's purified aesthetics is founded on a performative contradiction that serves as additional proof that the sensible cannot elude the fables of representation. Rather than concentrating

on the material dimensions of the works he studies, Deleuze focuses almost exclusively on representative elements such as character and plot. In analyzing the power of indetermination and metamorphosis, he provides examples of their symbolic manifestation in the stories of Gregor Samsa and Bartleby instead of demonstrating their materialization in words. Even his repeated references to literature as a foreign language within language rely on referential descriptions rather than material transformations of discourse itself. The evocation of Gregor's "painful whimpering," for example, describes a change in the sensible rather than indicating how such a change manifests itself in the very substance of language.[19] In Rancière's criticisms of Deleuze's contribution to film theory, he demonstrates that the same contradiction plagues his endeavor to differentiate between the movement-image and the time-image.[20] Lacking any clearly identifiable correlate in the realm of the sensible, Deleuze distinguishes between these two types of images with regard to the allegorical content he reads into them, depending on the perspective that he privileges (either the natural philosophy of the movement-image or the philosophy of mind identified with the time-image). In his analysis of film, as with literature, he inevitably relies on allegorical fables and symbolic forms of representation. There are two reasons for this performative contradiction, according to Rancière. The first is quite simple: what he is looking for does not exist. The second reason is that his philosophic project is based on a clear distinction between the register of representation and the anti-representational logic of difference. He is unable to accept what Rancière refers to as the contradictory relationship between the representative and aesthetic regimes of art.

At the risk of oversimplification, it might be said that the initial signs of a conceptual proximity between Rancière and Deleuze are everywhere countered by a practical distance. Although the theoretical motifs of immanence and indiscernibility are essential for understanding Rancière's conception of the aesthetic regime of art, he is less interested in establishing a transcendental logic of immanence read allegorically through particular works than in studying the sensible logic immanent in the works themselves and their general context. This historical sensitivity and his rejection of illustrative hermeneutics unmistakably distinguish him from Deleuze's use of history as a rhizomatic

plane of immanence structured by a bivalent economy of representation and difference, or being and becoming. Refusing to accept the transcendental distinction between these two registers, Rancière purports to demonstrate both the empirical falsity of Deleuze's abstract logic and his inability to accept what is perhaps the fundamental contradiction of modern times.

SILENT CONTRADICTIONS

One of the reasons for situating Rancière's work in relationship to two of his prominent predecessors has been to outline the unique position he holds within his immediate historical conjuncture. His relationship to Deleuze's theoretical framework and Foucault's historical methodology also reveals a tension inherent in his own project that might be described as a hesitation between two extremes. For the sake of argument, let us begin with the first of these two extremes and a series of problems connected with it. Like a number of his contemporaries, Rancière acknowledges an indebtedness to the neo-Kantian tradition and, more specifically, to the historical transcendentalism that Deleuze and others have highlighted as an essential feature of Foucault's work.[21] This tendency is further confirmed by his implicit suggestion that the three regimes of art constitute the sum total of possible distributions of the sensible. They are identified with three essential moments in history—Plato, Aristotle, and the Romantics—as if the internal logic of this historical trio was sufficient for explaining the totality of intellectual and cultural developments since the ancient Greeks. All said and done, the geographic, historical, social, and disciplinary limits of these regimes remain largely undetermined. While it can be presumed that they are valid essentially for the European tradition, Rancière rarely restricts them to a specific cultural heritage.[22] He also implies that the chronological gulf separating the ancient Greeks from the Renaissance was dominated by the ethical and representative regimes, though few studies to date have demonstrated this. Finally, he suggests that the three regimes of art have no disciplinary limit and that they span the totality of theoretical and cultural production

at any given moment in history. Concerning the 'modern age,' for example, he makes numerous references to fields other than literature, philosophy, and film but has yet to publish a sustained discussion of areas such as music, architecture, and modern science.

The issue of exemplarity and historical transformation can be added to the general problem of delimitation. If Rancière is indeed postulating his regimes as more or less transcendental historical conditions of possibility, then he needs to explain why the works he has chosen give privileged access to these conditions and are not simply a convenient sampling of examples that conform to a predetermined model, or fodder for a form of historical hegemony where the particular is passed off as a universal. Regarding historical change, it remains unclear why the only fundamental transformation since the ancient Greeks, meaning a change that has given birth to a new distribution of the sensible, occurred approximately at the end of the eighteenth century. Rancière occasionally suggests that the development of regimes has its source in their internal logic or their historical 'destiny,' but this type of explanation risks eradicating the social dynamic of history in the name of an idealist evolution of aesthetic forms in the broadest possible sense of the term.

Whatever the response to this problem might be, the question of historical transformation cannot be separated from Rancière's postulation of absolute equality as a universal in politics. Although he claims that his understanding of aesthetics is thoroughly historical in nature, the contradictions that dominate the aesthetic regime of art bear a striking resemblance to those surrounding his notion of equality. In fact, democratic literarity appears to function as a historical element of universal value loosely equivalent to the artistic manifestation of equality.[23] If this is indeed the case, then not only do democratic literarity and the politics of equality share the transhistorical value of equality, but the contradictory task of working toward this impossible ideal constitutes one of the salient features of modern art and politics in general. This normative dimension to Rancière's historical descriptions explains why his analyses tend to gravitate around a unique system of values, but the justification of this strategy is rarely made explicit. Furthermore, it remains uncertain whether the logic of contradiction, as

one of the doxic coordinates of much of contemporary French thought, is sufficient for explaining the totality of activity in the social sphere or isolating the specificity of politics and modern art.

These historical and methodological complications are counteracted by an opposite tendency in Rancière's work. Rather than insisting on a unique formula throughout diverse historical formations like Deleuze or postulating historical a priori à la Foucault, he focuses on the particular combination and organization of elements within bodies of work when compared to the plurality of possible amalgamations.[24] In this regard, his regimes of art act as immanent conditions that only exist in actual historical configurations. In other words, the individual components that make up a particular regime do not transcend history as an abstract set of totalizing principles. Strictly speaking, they are indiscernible from the works they inhabit. This unique form of immanent critique, which consists in analyzing cultural particulars as coextensive with artistic regimes, has the advantage of overcoming almost all of the problems raised above. Since the three regimes of art are immanent in all of the material that Rancière has studied, and certain forms have shown a propensity for repetition, it is probable but not necessary that these regimes extend beyond the geographic, historical, social, and disciplinary limits of his general field of research. In principle, it is also possible that other distributions of the sensible exist in the cultural domains, historical time periods, and traditions that have thus far escaped his analysis.

The problems of exemplarity and historical change are resolved in much the same way. Since his particular case studies are not individual instantiations of general rules, they do not serve as examples of transcendental historical principles. On the contrary, any axioms that he establishes are immanent in specific works and practices. Even if certain elements are prone to repetition, they never remain untainted by the particular configurations within which they appear. As immanent causes, they determine their effects only insofar as they are simultaneously determined by them. Furthermore, since Rancière avoids postulating a transcendental set of historical laws or even an exhaustive list of immanent axioms,[25] artistic regimes remain open to change and to the production of novel aesthetic forms. It is partially for this reason that the end of the eighteenth century does not constitute a

historical rupture and that no single cause sparked the onset of the modern era. This is not to say that it is impossible to establish patterns within the history of artistic regimes, only that these patterns are always manifest in particular forms and never exist in a pure, abstract state. Finally, as regards the question of normativity, it must not be forgotten that Rancière has forsaken the naïve ideal of objective history without falling prey to absolute relativism. His writings are strategically anchored in their own historical conjuncture, and the apparent universality of their normative dimension is inseparable from his attempts to intervene in the current distribution of the sensible. The supposed transcendental value of equality and democratic literarity is in fact immanent in a particular historical struggle.[26] If equality is the "only universal," as he is fond of saying, its universal status is derived neither from human nature, nor from any other founding principle. It is strictly speaking a polemical universal presupposed by contentious interventions in the police order. In other words, it is a relational universal that only exists in concrete acts of struggle rather than an abstract universal resting on an a priori foundation. This is as much the case for Rancière's own writings on equality as for the works and practices he has studied.

The relationship between these two methodological tendencies creates a visible tension within Rancière's work. His inclination toward historical transcendentalism is relentlessly undermined by a historiography of immanence founded on the analysis of specific aesthetico-political formations. His affirmation of the universal value of egalitarian excess is repeatedly translated into militant histories that intervene in the field of cultural particulars. In short, his regimes of art are themselves homonyms that hesitate between two extremes: necessary transcendental determinants and possible immanent conditions. The first of these two tendencies reveals an apparent proximity to the hermeneutic paradigm of symptomatology that Rancière outlines most notably in *The Aesthetic Unconscious* (2001). According to this framework, the exegesis of individual works is premised on organizing them into a general system of operations whose every detail can be explained in terms of a series of "deep conditions." In the case of history, this amounts to isolating the fundamental structures that not only explain the totality of historical phenomena but also elucidate the mistakes inherent in all of

the merely apparent truths of history (such as the two models of aesthetic modernity or the three forms of political philosophy). The second tendency in Rancière's work does not, however, reproduce the opposite hermeneutic paradigm, which consists in privileging the existence of radical singularities that escape rational explanation. On the contrary, it introduces a significant shift in historical logic that displaces the long-standing opposition between rational explanation via causal necessity and the sublime confrontation with the unrepresentable, absolutism and relativism, universality and particularity, generality and specificity, logos and pathos. By constructing a relational logic of immanence that abandons the hierarchical system of appearance and truth, Rancière outlines a novel methodology for cultural and intellectual history that escapes the age-old struggle between transcendental historical claims and the appeal to the absolute specificity of individual elements. Instead of viewing history from above or complacently denouncing any claims that extrapolate from the microcosmic atoms of the past, Rancière proposes an immanent logic of history that aims at establishing a topography of autonomous axioms of perception, which only exist in the combinatory forms attested to by concrete historical formations. In other words, he forsakes the privileged positions that purport to have direct access to either macrocosmic or microcosmic truths of history in order to analyze conceptual networks from a select point within them and elucidate both their modes of operation and their combinatory processes. This does not, however, amount to restricting artistic regimes to the horizons of individual works, nor does it mean that regimes are somehow situated between the universal and the particular. Strictly speaking, this second tendency in Rancière's work definitively breaks with an entire logic of historical perception and introduces a novel configuration of the sensible.

6

PRODUCTIVE CONTRADICTIONS

From Rancière's Politics of Aesthetics to the
Social Politicity of the Arts

CONCEPTUAL CUL-DE-SAC

Jacques Rancière has earned a much-deserved reputation as an intellectual maverick who has sought to entirely rethink the relationship between aesthetics and politics. In many ways, his contribution to date might be understood as a veritable Copernican revolution since he has inverted the standard approach to the very question of how these two phenomena relate to one another. Instead of beginning with the assumption that they are separate entities and then searching for a privileged point of intersection, he asserts that art and politics are actually consubstantial as distributions of the sensible. This means that politics, for him, is fundamentally an aesthetic affair—and vice versa—since it is, above all, a matter of establishing and modifying a sensory matrix that delimits the visible from the invisible, the sayable from the unsayable, the audible from the inaudible, the possible from the impossible. "Art and politics," he writes, "are not two permanent and separate realities about which it might be asked if they *must* be put in relation to one another. They are two forms of distribution of the sensible, both of which are dependent on a specific regime of identification."[1]

The reader familiar with this fundamental thesis—what I will call the Consubstantiality Thesis or Thesis 1—will perhaps be surprised to discover that Rancière constantly calls it into question. He reminds his reader, again and again, that aesthetics does not truly coincide with politics because it does not produce political subjectivization, that is to say, dissensual acts that disturb the hierarchies of the given police order in the struggle to verify the presupposition of equality through the construction of a *we*.[2] In fact, art—and particularly literature—tends to distance us from politics proper and hinder its development by producing "desubjectivization."[3] In this regard, art and politics not only part ways, but they actually tend to be mutually exclusive: politics proper extricates itself from the desubjectivization of aesthetics, and art tends to act as a meta-political bulwark against politics proper (thereby implicitly maintaining the police order). Rancière's second elementary thesis—the Differentiation Thesis or Thesis 2—is hence that aesthetics and politics are distinct domains that are incongruous with one another.[4]

The recapitulation of these two theses facilitates the formulation of a core contradiction that is arguably *the* contradiction of Rancière's work on aesthetics and politics because it sums up both the force and the limitations of his project to date. This contradiction is in many ways the productive contradiction—to use his own vocabulary—that has allowed him to generate some of the most interesting recent work on art and politics while at the same time trapping his project between two extremes: the abstract identification of aesthetics and politics and the concrete reification of the border separating them. These extremes, as we will see, foreclose the possibility of thinking the social politicity of aesthetic practices. The contradiction in question can be succinctly summarized as follows: Rancière regularly affirms the consubstantiality of aesthetics and politics (T1) while constantly reminding us that there is no clear correspondence between them (T2). In short, art and politics are consanguineous (T1) only insofar as they never intermingle in any concrete and determined way (T2). Unpacking the core elements of this contradiction will help us come to terms with his profound rethinking of art and politics as well as the deep impasse to which it leads.

TITILLATING TAUTOLOGIES AND
SOBERING DEMARCATIONS

Rancière is not known for the crisp clarity of his definitions and distinctions. On the contrary, his sibylline style prides itself—for reasons that will become clear—on indetermination and equivocality. In the case of the contradiction highlighted above, it is precisely the ambiguity of the terms *politics* and *aesthetics* that allows him to navigate between two apparently incompatible registers.

Let us begin with the word *politics*. Although he never, to my knowledge, distinguishes between them, Rancière works with at least three different definitions of this term. Politics is understood, most generally, to be an overall distribution of the sensible: "the configuration of a specific space, the delimitation of a particular sphere of experience, of objects established in common and coming from a common decision, of subjects recognized as capable of designating these objects and arguing about them" (D1).[5] More specifically, however, he defines politics proper as a dissensual act of subjectivization that intervenes in the police order, that is, the given distribution of the sensible, by calling into question the 'natural order of bodies' through the verification of the presupposition of equality and the attempt to construct a collective subject of enunciation. In other words, political activity actually "reconfigures the distribution of the sensible" (D2).[6] Finally, he occasionally refers to politics (*la politique*) as the meeting ground between police procedures and the process of equality (politics proper, according to D2), an encounter that he more often calls *the political* (*le politique*) (D3). It is primarily the first meaning of the term *politics* that is operative in the Consubstantiality Thesis, whereas it is the second that is at work in the Differentiation Thesis. If there were some clear continuity between these competing definitions, the ambiguity on this point might be understood as a clever attempt to underscore the proximity between two notions of politics. However, this does not seem to be the case,[7] and it leads us—in classic Rancièrian style, so to speak—to yet another contradiction that must be dealt with before moving on to the

THE POLITICS OF AESTHETICS

question of aesthetics: the contradiction of politics and the police that is at the core of the Consubstantiality Thesis.

The first definition of politics is, strictly speaking, a contradictory identification between politics and what Rancière calls the police. Compare the following definitions:

> It [politics] is a partition of the sensible, of the visible and the sayable, which allows (or does not allow) some specific data to appear; which allows or does not allow some specific subjects to designate them and speak about them.[8]

> It [the police] is an order of the visible and the sayable that makes it such that a certain activity is visible and another is not, that a certain form of speech is heard as discourse and another as noise.[9]

In spite of the clear proximity—if not outright identity—between politics (D1) and the police as distributions of the sensible (particularly in his more recent writings), Rancière first introduced these terms in stark opposition to one another. Indeed, in the passage just cited from *Disagreement*, he goes on to write that he reserves the term *politics* (D2) for the activity that is "antagonistic" to the police because it "breaks the sensible configuration in which parties and parts or their absence are defined, and it does so by a presupposition that, by definition, has no place in this configuration: that of a part of those who have no part [*une part des sans-part*]."[10] The contradiction of politics and the police emerges between these two incompatible definitions. Politics is, on the one hand, the set of self-evident sensory coordinates that define modes of being, doing, making, perceiving, and speaking, which he also calls the police (D1). It is, on the other hand, the precise opposite of the police because it is an intervention in the distribution of the sensible that disturbs the self-evident sensory order (D2). If we relate this contradiction to the fundamental contradiction of aesthetics and politics, we arrive at one of the central problems of Rancière's project: the Consubstantiality Thesis is rooted in the first definition of politics as a general distribution of the sensible,

in other words, in the contradictory identification between politics and the police. This reveals that what is perhaps Rancière's most well-known claim actually means the opposite of what it appears to signify: aesthetics is in fact consubstantial with the distributional framework of beings, discourse, and perception, which is—according to the second definition of *la politique*—the very opposite of politics, that is, the police. Instead of art and politics being consanguineous, the former is pitted against the latter as the faithful companion of the police order of self-evident sensory facts. In a certain light, this could perhaps be taken as a sign for how to extricate Rancière from the contradiction between Thesis 1 and Thesis 2 since it suggests that the latter—in which aesthetics and politics are largely opposites—is the position he ultimately wants to maintain. However, it is by no means clear that he desires to simply identify aesthetics and the police order since he regularly claims the opposite by asserting the consubstantiality of aesthetics and politics.

Let us now turn to aesthetics. Once again, it is possible to distinguish between at least three different definitions. To begin with, Rancière occasionally uses the term simply to refer to the distribution of the sensible in general (D1). More often than not, however, he defines aesthetics as a particular distribution of the sensory order (D2): "It [aesthetics] strictly refers to the specific mode of being of whatever falls within the domain of art, to the mode of being of the objects of art. In the aesthetic regime, artistic phenomena are identified by their adherence to a specific regime of the sensible, which is extricated from its ordinary connections and is inhabited by a heterogeneous power, the power of a form of thought that has become foreign to itself."[11] Lastly, he occasionally uses the term to refer to what is called, in common parlance, the general realm of art, which is identifiable and circumscribable in terms of the recognizable practices of literature, painting, film, and so forth (D3). It is the first definition that is at play in the Consubstantiality Thesis, whereas the second is mobilized in the Differentiation Thesis. Unlike in the case of politics, there is no outright contradiction between these two definitions since they can simply be understood as a general and a specific understanding of aesthetics. It is between D2 and D3 that a contradiction emerges, particularly in Rancière's most recent work. On the

one hand, he defines aesthetics as a problematic entity with undetermined limits because of the ambiguous relation between art and life (D2): "The aesthetic regime . . . simultaneously establishes the autonomy of art and the identity of its forms with the forms that life uses to shape itself."[12] On the other hand, he understands aesthetics (D3) as a circumscribed domain distinct from other fields, such as politics. Here we encounter what we might call the contradiction of aesthetics, which plagues the Differentiation Thesis insofar as it depends on a reification of the realm of art (D3) that directly contradicts Rancière's definition of aesthetics as a field with problematic horizons (D2). Aesthetics is suddenly disambiguated as a domain distinct from politics proper. However, if this is indeed the case, then aesthetics is simply domesticated as a particular *manière de faire* (way of doing and making) distinct from other *manières de faire*, meaning that it is resituated within the representative regime in which the arts remain clearly discernible practices. Thus, the Differentiation Thesis, in order to prove the distinct nature of aesthetics and politics, actually has to destroy aesthetics proper (D2), namely, the specific distribution of the sensible of the aesthetic regime in which the identity of art remains problematic.

Moreover, the same is true of politics insofar as Rancière has to circumscribe its specific domain even though he regularly insists that there is no 'proper' of politics (in part because any definition of the nature of politics remains open to the possible impropriety of political disagreement and dissensus). This reveals what we might call the contradiction of politics: if the proper of politics is to be improper, to have no proper place or identity but rather to disturb the given distribution of the sensible (D2), it nonetheless needs to be properly distinguished from other activities such as aesthetics by a minimal constitutive identity that allows it to be recognizable as *politics proper* (even if this identity is nothing more than the impropriety of dissensual acts).

It is worth underscoring a final series of complications. In Thesis 1, politics and aesthetics are defined tautologically—and at a significant level of abstraction—as distributions of the sensible. Instead of being a concrete proposal that can be evaluated according to tangible criteria, Rancière establishes this identification as if by philosophical fiat. Although it is a rich and interesting proposition, which sometimes plays itself out in powerful

and insightful analyses, if it is simply based on a tautological definition of abstract concepts, nothing can preclude anyone else from marshalling rival definitions and advancing similar blanket assertions by declaring, for instance, that aesthetics is consubstantial with ethics or that politics is the same thing as morality, or the culinary arts and horseback riding for that matter (aren't these all ways of distributing the sensory order in some general sense?). The level of abstraction is such that Rancière's tautological definition runs the risk of losing all purchase on the specificities of political and aesthetic practices, and he actually suggests this himself by generally reverting to Thesis 2 as soon as he begins analyzing particular, concrete instances of art and politics.[13]

With this in mind, let us now turn to the arguments advanced in *Le spectateur émancipé*. More than any of his other works to date, he explicitly emphasizes in this book the political efficacy of aesthetics as a force of dissensus (a slight but important variation of T1):

The aesthetic rupture thereby set up a singular form of efficacy [*efficacité*]: the efficacy of a disconnection, of a rupture of the relation between the productions of artistic know-how and defined social objectives, between sensible forms, the meanings that can be read in them, and the effects that they can produce. We can say this differently: the efficacy of a dissensus. . . . It is in this way that art, in the regime of aesthetic separation, happens to touch upon politics.[14]

These and other such claims are constantly curtailed by reminders of the clear limits between art (the domain of *this* and *I*) and politics (the realm of *we*) (T2). If aesthetics "touches upon" politics, it is obviously not politics proper in and of itself. Moreover, it only comes in contact with it in an undetermined and ambiguous manner:

The forms of aesthetic experience and the modes of fiction thereby create an unprecedented landscape of the visible, new forms of individualities and of connections, different rhythms of apprehension of the given, new scales. They do not do this in the specific manner of political activity,

which creates forms of *we*, forms of collective enunciation. But they form the dissensual fabric from which are cut out the forms of object construction and the possibilities of subjective enunciation proper to the action of political collectives. If politics properly speaking consists in the production of subjects who give voice to the anonymous, the politics proper to art in the aesthetic regime consists in the elaboration of a sensible world of the anonymous, of modes of *that* and of *I*, from which emerge the proper worlds of political *we's*. But inasmuch as this effect passes via the aesthetic rupture, it does not lend itself to any determinable calculation.[15]

Moreover, if aesthetics is in fact able to produce a dissensual fabric that can then be used by political subjects, the latter remain undetermined by aesthetics itself, and Rancière suggests on numerous occasions that it is up to political actors to capitalize (or not) on aesthetic possibilities.[16] This is indeed one of the closest encounters between art and politics, and it is under the rubric of aesthetic dissensus that Rancière has provided some of his most compelling and precise arguments. Nevertheless, he continues to remind his reader that there is no fluid confluence between aesthetic dissensus and political dissensus. In one of his boldest claims, he asserts that the politicized art of those who purport to venture out into the real world or provoke public mobilization is condemned to either disappear as art (by becoming indiscernible from politics) or remain within the museum space, forever cut off from the real world. In *Aesthetics and Its Discontents*, he formulates this contradiction as the "founding paradox" and the "originary contradiction" of the politics of art—more specifically, the meta-politics of art—in the aesthetic regime: "The solitude of the work bears a promise of emancipation. But the fulfillment of the promise is the elimination of art as a separate reality, its transformation into a form of life."[17] The 'politics of aesthetics' therefore finds itself divided between two extremes: "An art that is political on the stipulation that it maintains itself pure of all political intervention is opposed to the art that does politics by abolishing itself as art."[18] In short, either art is political by abandoning art, or it is political precisely insofar as it remains distinct from politics. This fundamental contradiction ultimately means that the singularity of art and the specificity of politics remain incompatible:

The contradictory attitudes that today are drawn from the grand aesthetic paradigms express a more fundamental undecidability of the politics of art. This undecidability is not the result of a postmodern turn. It is constitutive: aesthetic suspension [*le suspens esthétique*] immediately lends itself to being interpreted in two senses. The singularity of art is linked to the identification of its autonomous forms with forms of life and with political possibilities. These possibilities are never fully implemented except at the expense of abolishing the singularity of art, that of politics, or both together.[19]

This argument is problematic at a number of levels. To begin with, Rancière appears to suffer from a crypto-essentialism when he suggests that art is detached from politics inasmuch as it is recognized as art, as if these were necessarily mutually exclusive domains: *either* art is in the real world of politics *or* it is only in the realm of aesthetics. Indeed, he regularly refers to the domain of art and fiction, on the one hand (D3), and the field of "the real," on the other, thereby reifying an opposition that by no means goes without saying.[20] This is visible in his repeated references in works like *Le spectateur émancipé* to art trying to leave its place by moving outside into the real (D3), which themselves contradict his assertion that there is no 'real' outside of art (D2) but only folds in the sensory fabric where the politics of aesthetics and the aesthetics of politics "join and disjoin."[21]

Unfortunately, his critique of the meta-politics of art and the various attempts to bring art into the 'real world' appears to suffer from the same problem that he has highlighted in the work of many of his predecessors: the use of painting and the museum-based model of art as the paradigmatic framework for art history. It is worth citing, in this regard, a few poignant cases that lie outside the purview of the museum-based model. How can aesthetics and politics be distinguished, for instance, in protest songs, revolutionary chants, or national anthems? When a girl began singing "We Shall Overcome" during a police raid on a meeting to discuss the emerging black freedom movement at Highlander Folk School in Tennessee in 1960, where did the song end and the political act begin?[22] To take another example, how can one easily distinguish between the writer and the political activist, for instance, in Harold Pinter's famous Nobel lecture "Art, Truth

and Politics," in which he severely lambastes Western imperialism but also discusses his own literary works and reads an excerpt from Pablo Neruda's "I'm Explaining a Few Things"? Isn't it precisely due to the intertwining of art and politics that the CIA made a concerted effort to prohibit Neruda himself, a communist sympathizer, from obtaining the same prize in 1964? Indeed, René Tavernier, serving as an activist for the CIA's Congress for Cultural Freedom, prepared a report on Neruda's political commitments, which was circulated to select individuals, in which he argued that it was "impossible to dissociate Neruda the artist from Neruda the political propagandist."[23] Furthermore, it is essential to remind ourselves that the world of museums and galleries is itself clearly bound up with the real world of politics in very significant and concrete ways, as artists such as Andrea Fraser and Hans Haacke have acutely argued.[24] This does not, of course, mean that we are condemned to accept the ubiquity or utter consubstantiality of aesthetics and politics, but rather that they are immanent notions and practices rather than entities separated by a definitive dividing line.

Let us return to the core of matters before considering the crucial issue of causality and indetermination: abstractly and conceptually (D1), politics and aesthetics are consubstantial (T1) for Rancière, but concretely and specifically (D2), there is no direct correspondence between them (T2). He tends to oscillate between these two levels in ambiguous crescendos and decrescendos that create zones of indetermination, ultimately suggesting that these two positions are vaguely compatible. The abstract identification in Thesis 1 is based on defining aesthetics and politics tautologically as empty emissaries of the same central concept: the distribution of the sensible. This titillating tautology reveals its inner vacuity as soon as Rancière descends to the specific level of cultural particulars and discovers, on the contrary, that art and politics are more or less discordant (T2). However, this sobering discovery is itself dependent on the reification of the horizons of entities that, according to D2, have no proper identity. In short, it appears that politics and aesthetics can only be identified if they are defined so abstractly that they lose all specific content, and they can only be separated if they are reified to such an extent that they are alienated from the very impropriety that makes them 'distinct.'

CAUSALITY OR INDETERMINATION

The Consubstantiality Thesis is founded on an abstract tautology that is as interesting and provocative as it is vague. Unless it is grounded in a more specific account of the correspondence between the sensory order of aesthetics and the political fabric of society, it remains a very intriguing proposition with limited purchase on specific practices.[25] Given the more concrete nature of the Differentiation Thesis, I would now like to explore its internal logic in greater detail. If aesthetics does not foster politics proper for Rancière, it is primarily because there is not a causal relationship between works of art and political activity: art does not directly produce political subjectivization. I take it that Rancière is drawing our attention to one aspect of a much larger problem: the talisman complex. This complex has its basis in the naïve belief in the innate power of works of art to instigate social and political change. In certain cases, this relationship of determination might be taken to be a one-to-one causal relation, although other forms of determination are possible. The core of the issue, however, is the supposition that a work of art has an inherent, independent essence, as if it were an autonomous entity with its own inner force. The talisman complex is therefore closely related to the ontological illusion, or the idea that art and politics have identifiable natures and that we can determine once and for all where they do or do not overlap.

I will return to the talisman complex and the ontological illusion in a moment, but, for the time being, it is important to foreground the fundamental conceptual opposition at work in the Differentiation Thesis: the polarization between causality and indetermination. If art and politics part ways for Rancière, it is because there is no causal relationship between them: their rapport is one of indetermination. Moreover, it is precisely insofar as it is undetermined—and a force of indetermination—that aesthetics can perhaps have interesting political implications for him. Thus, he invites his reader to abandon causal determination in favor of indetermination at two different levels of his analysis.[26] This dual valorization of indeterminacy is founded on the assumption that if there is no necessary link

between art and politics, then the connection must perforce be undetermined, and that it is precisely this indetermination that can help us establish a tentative and precarious association between art and politics.[27] In addition to the fact that this does not necessarily follow, we should highlight in passing that Rancière obviously succumbs to the valorization of indeterminacy that has plagued many of the leading members of the French intellectual vanguard.[28] It is worth reminding ourselves in this regard that indetermination can be as politically dangerous as it can be beneficial because politics does not obey our conceptual categories or our fetishized notions (in spite of what many conceptual authorities would like to have us believe).

Before examining in greater detail the limits of the binary logic of causality and indetermination, let us consider the examples that Rancière provides of a productive proximity between a certain form of aesthetics and politics. These examples, as I have already mentioned, are very few and far between. The overwhelming majority of his specific interpretations of authors and artists actually criticize the innumerable faulty and failed attempts to link art and politics. In fact, his positive examples are so rare that he often returns to a privileged set of paradigmatic cases. One of the examples that he is very fond of citing is that of a jobber, Gabriel Gauny, who describes gazing out of a window while he is working on a floor. For Rancière, this is a patent case of indetermination. On the one hand, Gauny is determined by an entire sensory framework imposed by the dominant order, a framework that dictates ways of seeing, speaking, acting, and thinking, as well as a specific distribution of space and time. However, when he gazes out of the window during his workday, he breaks with this dominant order; he creates a fissure within the system of determination by appropriating the privileged activity—spectatorship—of the aesthete. This does not change the fact that he is exploited by the capitalist system. However, for Rancière, "working class emancipation is the possibility of making for oneself ways of speaking, ways of seeing, ways of being that break with those that are imposed by the order of domination."[29] Gauny's gaze, which escapes the determined sensory registers of experience, is therefore an example of the way in which "aesthetic" indetermination—to use the vocabulary that has become much more prevalent in Rancière's recent writings on Gauny—can be political in a certain sense. This is an interesting

point, particularly as it is developed in *The Nights of Labor* with the description of the way in which Gauny constructed an alternative space-time: "The absence of the master from the time and space of productive work turns this exploited work into something more: not just a bargain promising the master a better return in exchange for the freedom of the worker's movements but the formation of a type of worker belonging to a different history than that of mastery."[30] Unfortunately, however, Rancière tends to frame the discussion of Gauny within a rather stark opposition between Marxian determinism and his own brand of indetermination: either we see in him a mystified worker trapped in the illusory ideology of internal emancipation by which he blindly remains within the system of exploitation, or we follow Rancière in finding in his account of a gaze out of the window the powers of indetermination that are emancipation proper. These extremes are unnecessary, and they cast a long shadow over the multiple levels of determination and agency at work: exploitation is not necessarily total domination of the sensory order, and there are varying degrees of emancipation from systems of thought, perception, and action. Fortunately, in *The Nights of Labor*, Gauny's description of his gaze is situated in the larger context of the newspapers of the French Revolution of 1848 and various attempts to distribute and redistribute the space-time of work. In some of Rancière's more recent writings, however, Gauny's case is presented as an example of emancipation proper, if not politics itself (the ambiguity on this point appears to be willfully maintained). Indeed, this is arguably one of the closest encounters between aesthetics and politics in Rancière's corpus.

Yet, we cannot overlook the fact that the supposed coalescence between the two does not actually appear to be one at all, in spite of the lexical indetermination cultivated by Rancière.[31] Gauny's gaze and his description of it do not directly produce politics proper (D2) by creating a *we* of collective enunciation. It is true that Rancière suggests that his personal experience would take on a collective meaning in the revolutionary context of 1848, like the multiplicity of other "micro-experiences of repartitioning the sensible."[32] However, Gauny's account of his gaze is constructed first and foremost out of the *I* (or the *he*, since his account is in the third person) of the jobber and the *that* of the window: "Before taking on this collective meaning

in a revolutionary context, it was the product of both the joiner's individual experience and his personal appropriation of the power of writing."[33] In redistributing the sensory order, his experience appears to be primarily 'aesthetic' (D1), and the possibility of implementing new forms of political subjectivization is explicitly situated at a different level: "That verification [of equality in the appropriation of the perspective gaze] contributes . . . to the framing of a new fabric of common experience or a new common sense, *upon which new forms of political subjectivization can be implemented*."[34] We would surely be justified in referring to Gauny's experience as a form of "aesthetic dissensus" insofar as it attempts to "reconstruct the relationship between places and identities, spectacles and gazes, proximities and distances," but it is not a type of political subjectivization in and of itself.[35] This is the point at which we see that when it comes to aesthetics and politics proper, never the twain shall meet. Even when undetermined forms of aesthetics disturb the sensory fabric, they do not directly produce political subjectivization and collective forms of enunciation, as is indeed much clearer in Rancière's other positive examples, drawn from the work of Roberto Rossellini, Alfredo Jaar, Sophie Ristelhueber, Pedro Costa, and so on. Instead, they act as modes of sensory dissensus that could perhaps lend themselves to political developments (this is—in an important decision— left up to the agency of political subjects for Rancière). However, they are most definitively not politics: "Aesthetics has *its own politics* just as politics has *its own aesthetics*."[36] This ultimately means that even the positive examples of an apparent coalescence between art and politics are not the merging of aesthetics (D1 or D2) and politics proper (D2), but rather a redistribution of the sensory order via aesthetic dissensus that is only political in the general and abstract sense of a configuration—or reconfiguration—of the sensory order (D1 with the important qualification of possible reconfiguration): "art and politics are attached to one another [*tiennent l'un à l'autre*] as forms of dissensus, operations of reconfiguration of the shared experience of the sensible."[37] Aesthetics in the strict sense (D2) and politics proper (D2) never actually overlap in any determined and concrete sense for Rancière.

Furthermore, he explicitly states that it is not primarily works of art or particular messages that are political, but rather the construction of a unique

arrangement of space and time (proper to the aesthetic regime): "Art is not political first and foremost by the messages and the feelings that it conveys regarding the order of the world. Neither is it political by the manner in which it represents society's structures, the conflicts or identities of social groups. It is political by the very distance it takes with respect to these functions, by the type of time and space it establishes, by the manner in which it delimits this time and peoples this space."[38] This suggests that the aesthetic dissensus linking art to politics in the general sense of a distribution or redistribution of the sensible (a minor variation of D1) is less dependent on individual works of art and political strategies than on the institutional system of exhibition, which could itself clearly benefit from a more in-depth analysis by Rancière, who tends to make provocative statements in passing.[39] If art and politics cross paths in some sense, it is less, therefore, because the arts are, in general, distributions of the sensible (D1), or because individual works of art in a generic sense (D3) are vehicles for political messages or representations. It is primarily because aesthetics is a specific distribution of the sensible (D2) that produces a neutralized space-time in which cause and effect are disconnected.[40] This is the privileged locus for the close encounters between aesthetics (D2) and politics in the general sense (D1), a locus in which there is still no direct causal link between aesthetics and politics proper (D2).

Ultimately, Rancière tries to force our hand and make us choose between abstract principles when we do not in fact need to do so. In trying to establish a stark contrast between his writings and the work of his predecessors, he draws a sharp line between causal determination (art causes politics, workers are determined by ideology, and so on) and indetermination (art has an undetermined relationship to politics, workers can produce zones of indetermination, and so forth). The abstract categories of causality and indetermination are so far removed from concrete social practices that they do very little to capture the specificities of aesthetic and political activities. In fact, they tend to distract from the social dynamic at work in history, which is neither rigorously determined nor totally undetermined. Sociohistorical practices such as 'art' and 'politics' do not abide by the black and white logic of conceptual delimitation. They are necessarily inscribed in time and in a field of social action: there is no work of art in itself or politics proper that would

somehow be separate from material production, institutional inscription, social struggles, theoretical negotiations, and so forth. Therefore, they remain irreducible to universal conceptual attributes such as 'determined' or 'undetermined.' To a certain extent, it might be said that both of these practices are determined in various ways and with varying levels of determination, and that they are also undetermined in certain key respects. In point of fact, the abstract conceptual opposition between determination and indetermination does little or no justice to the variegated field of forces that play a role in sociohistorical practices. Instead of having to choose between causality and indetermination, we need to develop a logic of practice capable of describing and explaining the complex constellation of forces at work in the practices labeled 'art' and those identified as 'politics.' Such a logic of practice needs to make room for overdetermination, causal variability, degrees of determination, levels of agency, and so on, because social practices such as art and politics are never rigorously determined or absolutely undetermined.

ART AND POLITICS AS SOCIAL PRACTICES

Rancière appears to have opened the door to a radically new conceptualization of the relationship between aesthetics and politics qua distributions of the sensible (T1). However, as we have seen, he leads us to a door that he has locked and bolted from the inside, leaving art and politics proper cut off from one another (T2). Furthermore, we have underscored the ways in which each of these theses leads in turn to a harrowing series of paradoxes. The Consubstantiality Thesis has its basis in the contradiction of politics and the police: aesthetics and politics are only consanguineous if the latter is defined as a given distribution of the sensible, or what Rancière calls the police (which is, in principle, the very opposite of politics). The Differentiation Thesis leads to the contradiction of aesthetics and the contradiction of politics proper: aesthetics and politics are only clearly demarcated insofar as the former is disambiguated as a specific field distinct from life and the latter is given a proper identity that alienates it from its constitutive impropriety (according

to which the very 'nature' of politics is one of the open-ended questions of political activity).[41] It appears, then, that either aesthetics is identified with the police as a system of self-evident sensory facts (T1), or it is disambiguated as a specific *manière de faire* distinct from politics proper and thereby resituated within the representative regime of the arts (which denies the ambiguity that aesthetics shares with *la politique*) (T2). In short, either aesthetics is identified with the police, or it is eliminated along with politics.

Although there might be room in Rancière's conceptual edifice to find at least partial solutions to some of these problems, such interstitial work is likely to prove less productive in the long run than a complete reassessment aimed at exiting this impasse and obviating all of its requisite contradictions. To this end, I would like to argue in favor of abandoning unnecessary conceptual abstraction and the hypostatization of art and politics—as well as the cult of ambiguity—in the name of understanding them as sociohistorical practices that can and have been linked in various ways. Art and politics have no *eidos*. They are concepts in struggle that vary according to the social setting and historical conjuncture. Strictly speaking, there is no such thing as art or politics in general, that is, invariable entities that undergo only superficial changes through the course of time. As Rancière has forcefully demonstrated in the case of aesthetics, art in the singular is the invention of what he calls the aesthetic regime of art, which is only approximately two hundred years old.[42] Similarly, I would argue that there are numerous and varied political cultures that have more or less incompatible understandings of the very nature of the political and its stakes. In other words, instead of art and politics being general or universal ideas that have undergone various iterations through time, they are immanent notions in struggle that are operative (or not) in various cultural matrices. Rather than concepts transcending the totality of social practices and describing them as if from the outside, they are inseparable from the concrete practices that produce them (hence the difficulty of talking about them with singular terms).

If the search for the definitive link between politics and aesthetics is in vain, it is not because these two terms are actually synonyms for the distribution of the sensible. It is because there are no definitive categories of politics and aesthetics. There are only rival definitions, competing practices,

and more or less compatible artistic orders and political cultures. The politics of aesthetics is ultimately based on the ontological illusion, that is to say, on the idea that politics and art are circumscribed phenomena with identifiable common properties and that the relationship between these entities can be definitively determined. If the conclusion that is reached is that politics and aesthetics are consubstantial, or that they never actually meet in any determined way, the same exact assumption is at work. Against the politics of art understood in this sense, I would like to argue in favor of analyzing the social politicity of aesthetic practices. Instead of purporting to define the nature of art and politics as well as the status of their relationship or non-relationship, the study of the social politicity of the arts seeks to come to terms with—and participate in—the complex negotiations within and between various aesthetic activities and assorted political agendas. It breaks with the fundamental assumption that works of art have an inherent politicity and that we can determine, once and for all, the political valence of an artistic project as an isolated element. It also rejects the widespread inclination to define the politics of art only in terms of the authentic works of art and the correct political agenda, not recognizing the important ways in which the politicization of aesthetic practices operates in various and sundry ways. Furthermore, the study of the social politicity of art jettisons the widespread proclivity to think the politics of aesthetics within the framework of the visual and literary arts, leaving aside the role of architecture, urban planning, public art, design, music, and so forth.

It is important to recognize that works of art are not talismans with inherent powers. They are social phenomena with a production logic, a set of propositions, strategies, assumptions, and potentialities. This does not, however, mean that we are condemned to acquiesce to the pervasive thesis that works of art are open to an infinite number of equally valid interpretations. The recognition that there is no *epistēmē* in politics and art (to slightly extend one of Castoriadis's important claims) does not force us to join in the 'postmodern' celebration of infinite interpretation. On the contrary, if there is no apodictic knowledge of art or politics, it is because they are collective phenomena whose 'being'—if such vocabulary is even adequate—is negotiated in the social field. On my account, therefore, there are no a priori limits between art

and politics that make the connection between them impossible. As imma-
nent pragmatic notions bound up with specific practices, their horizons are
instead part of ongoing social battles that no individual can halt by philo-
sophical fiat. In the break with the politics of aesthetics, there is thus a shift
in emphasis from artistic product qua object of knowledge to the relation-
ship between aesthetic production and circulation in the social field as well
as reception by a dynamic public contending over the meaning and values of
cultural artifacts.[43]

One of the core problems in Rancière's project is that he largely—
although not entirely—removes art from its social inscription in his anal-
ysis of its relationship to politics (and thus to its social insertion). The
conclusions that he arrives at reveal the roadblock that he has implic-
itly erected: either art and politics are related to each other in a purely
abstract manner as distributions of the sensible, or they part ways as two
distinct activities. One of the primary reasons for this parting of ways is
the criterion of success that he establishes for truly political art, which he
attributes to the representative regime of the arts: it must directly cause
political action. However, as collective endeavors with multiple factors at
work, social practices do not follow the monocausal logic of determination
operative in the classic example of causality: one billiard ball striking
another. The idea that an independent work of art, in the traditional sense,
would directly produce political action not only hypostatizes art and poli-
tics as distinct entities, but it establishes a criterion of success that is based
on a faulty understanding of social practice. As a matter of fact, it is not
the work in and of itself as an isolated artifact that directly produces polit-
ical consequences.[44] It is the life of the work, with its various strategies and
propositions, as it is received, interpreted, circulated, and mobilized for
motley ends. More precisely, it is the social life of works of art—including
their production, distribution, and reception—that has political valence,
not the solitary works themselves, as if they were magical talismans capa-
ble (or not) of sparking off changes by the preternatural power of their
own internal chemistry.[45] Rancière's criterion of success for political art
therefore actually guarantees its failure precisely because it is based on
the assumption that an artistic work could—in and of itself—directly

provoke political action in the strict sense of the term. Rather than attrib-
uting this failure to the nebulous indetermination of the aesthetic regime
of art and then fleeing into abstract tautologies in order to save the cher-
ished consubstantiality of art and politics (T1), it is essential to break with
the internal logic of the talisman complex in all its guises in order to think
through the social politicity of aesthetic practices. This will allow us, in
turn, to reconsider the social works of art that directly perform political
actions (such as some of Gianni Motti's work). According to Rancière,
these are inevitably unsuccessful insofar as they either lose their status as
art or alienate themselves from politics. Even the most radical attempts
to artistically stage political actions are destined to fail on his account.
In this case, the failure is not due to the indetermination of aesthetics
but, on the contrary, to the strict determination that separates art from
politics (T2).

There is no set recipe for the correct relationship between the social
categories of art and politics; there is no panacea or ultimate equation.
There are experiments in the social world with various consequences.
There are choreographies, mises-en-scène, and propositions within works
of art as well as underlying possibilities. Their politicity manifests itself in
their inscription in the social field, and it cannot therefore be determined
once and for all by ontological deduction. This does not, however, pre-
clude the possibility of making strong arguments regarding the political
dimensions of various works of art. On the contrary, it necessitates it. The
criteria of success equally vary based on the operative value systems and
social objectives. If we take art and politics as they have generally been
understood in the larger European world since approximately 1800, we
can identify a series of nodal points for encounters between them. This
is obviously not the place for a full-scale investigation, but it is nonethe-
less important to chart out, if only briefly, a field for further research (a
domain largely foreclosed by Rancière's binary logic of consubstantiality
and differentiation, causality and indetermination). In no particular order,
the following points of interaction between artistic and political practices
deserve further exploration.

POLITICAL PEDAGOGY AND PERCEPTION MANAGEMENT

From nineteenth-century realism to contemporary documentaries, art can and often does serve to inform the public regarding various social, moral, and political issues.[46] It can also participate in the management of the collective perceptual framework of citizens by reaffirming the dominant model of visibility, contradicting it, or proposing other vistas (à la Liu Bolin). To briefly summarize the potential of art to function as a form of political pedagogy, we can take our cue from a few lines of William Carlos Williams's "Asphodel, That Greeny Flower," which Alfredo Jaar is fond of citing:

It is difficult
to get the news from poems
yet men die miserably every day
for lack
of what is found there.[47]

FICTIONALIZED PERSPECTIVE ON THE REAL AND SATIRICAL INTERVENTION

From the work of Franz Kafka, George Orwell, Eugène Ionesco, and Harold Pinter to films such as *Level 5*, *Brazil*, and *Children of Men*, fiction can be a powerful tool for attempting to tap into the real of reality in a world whose apparent reality might mask more than it reveals. Likewise, satire has long been an important tool for political criticism, and the satirical can at times be pushed to the point of intervention and revelation, as in the work of the culture-jamming activists The Yes Men.

SOCIAL AND POLITICAL IMAGINARY

Art can act as a vehicle for the dominant social and political imaginary operative in a particular society, but it can also attempt to dismantle it to

various degrees. The work of Wafaa Bilal serves as an interesting case of an artist trying to destabilize various features of the contemporary American political imaginary, particularly regarding the war in Iraq. Brian Jungen's critical commentary on the contemporary cult of sports icons and the gods of consumer culture could be taken as an example of the way in which art can counter (or solidify) the core social representations of a given culture. As is the case with the other points of intersection, art can often span the two schematic extremes of critique and confirmation of the status quo, and the case of Andy Warhol might be interpreted as one in which the horizons between criticism and complicity often remain ambiguous.

CULTURAL HEGEMONY

Works of art can, in spite of the author's explicit intentions, reinforce cultural hegemony by exercising an influence over ideas, feelings, and institutions through consent rather than via domination (as Edward Said has argued in the wake of Antonio Gramsci). Art thereby contributes to a cultural order of sensibility that attunes us to the world and provides us with means of expression. At the more overtly manipulative level of ideological power games, Frances Stonor Saunders has provided an insightful account of the disturbingly central role played by the CIA, and particularly the Congress for Cultural Freedom, in the international Kulturkampf during the Cold War (see chapter 7).

COLLECTIVE IDENTITY AND COUNTERHISTORIES

From the development of nation-states and their national music and literatures to the Négritude movement, black American culture, and beyond, art can act as a powerful framework for collective identity by producing a shared reservoir of sounds, images, and stories that make sense of 'who we are as a people' or 'who we can be as a people.'[48] The modern museum and certain forms of public art—as well as the canonization of national artistic and literary traditions—have helped substantiate the role of aesthetics in collective identity formation by establishing a shared past and cultural

reference points. Art can also produce powerful counterhistories that aim at dismantling the dominant national narratives and reconfiguring their operative categories or assumptions (as in *Heart of Darkness* or *Beloved*). Finally, aesthetic production is often a rallying pole for movements of political solidarity and collective mobilization, which include such elements as murals, posters, flags, and banners, as well as shared dress codes, common insignias, and popular songs.

CRITICAL INTERVENTION OR COMPLICITY

Art can reify a given state of affairs or break with it in order to bring alternative worldviews into focus. This intervention can be sensory and perceptual, as in Jean-Luc Godard's juxtaposition of Vietnamese and American films about the Vietnam War or Banksy's graffiti interventions on the Israeli 'security fence.' However, it can also be more conceptual and theoretical, for instance in John Pilger's ongoing critique of Western imperialism. Its objects of criticism can be political in the common sense of the term, but they can also be specific to the political establishments of the art world, as in Hans Haacke's canceled exhibition at the Guggenheim Museum in 1971, where he proposed to unveil the inner complicity between the art world and the vicious powers of the business world. On the side of institutional complicity, there are of course many artists whose obvious agenda is to defend the political status quo by providing the art establishment and other institutions with precisely what they are seeking. Claire Bishop has argued, for instance, that this is the role of relational aesthetics as it manifests itself in the work of artists like Rirkrit Tiravanija: "Tiravanija's microtopia gives up on the idea of transformation in public culture and reduces its scope to the pleasures of a private group who identify with one another as gallery-goers."[49]

INTERSECTION

It is possible for art to serve as a forum to advance directly political projects. When Wafaa Bilal asked each visitor to his exhibit to donate $1 to the group

Rally for Iraq in order to help finance scholarships for Americans and Iraqis who had lost their parents in the war, his exhibit became a venue for political fundraising. Similarly, when Gianni Motti invited the Kurdish community of Paris to express their demands at the opening of the exhibition "Hardcore" (2003), the Palais de Tokyo became a stage for collective protest.

INTERROGATION

Art is capable of raising questions about the world we are living in and staging inquiries aimed at proposing possible solutions or soliciting responses from the public. Godard's *La chinoise* could be taken, at least in part, as an interrogative film exploring the question: what is the sensory materiality of Marxist-Leninist discourse in France in the late 1960s, and what are its implications?

TRANSFORMATION OF SENSE AND EXPRESSION

Works of art can offer alternative modes of perception, as in the way in which Victor Hugo, Leo Tolstoy, and others constructed a new form of visibility in which the *misérables* and the 'little people' of history came to occupy center stage instead of being silenced, caricatured, or relegated to the wings. They can also propose alternative forms of expression, such as in Hugo's stalwart defense of linguistic equality in poems like "Reply to a Bill of Indictment":

> . . . Till 1789,
> The language was the State: words well or ill born,
> Lived in castes, with their own compartments . . .
> Enter the villain—me. I asked myself,
> "Why must A always step aside for B?"
>
> . . .
>
> I blew a revolutionary wind.
> I dressed the old dictionary in liberty's colors:
> Away with peasant words and senator words![50]

COORDINATION OF COLLECTIVE BODIES AND STYLIZATION OF SOCIAL EXISTENCE

Haussmann's widening of the Parisian boulevards to allow for easy troop deployment and inhibit the construction of revolutionary barricades reveals the ways in which projects in urban planning—like architecture and other arts, as Benjamin and Foucault have argued—sculpt the social body, establish relations of power, and distribute the sensory order in very direct ways. Art is thereby capable of producing a political geography and a more or less stable set of social relations. At a slightly more personalized level, aesthetics in the broad sense—from fashion and marketing to furniture design and cookware—also functions as a stylization of social existence. As Stuart Hall argues, "through design, technology, and styling, 'aesthetics' has already penetrated the world of modern production. Through marketing, layout, and style, the 'image' provides the mode of representation of the body on which so much of modern consumption depends."[51]

POLITICAL PROPOSITIONS AND SOCIAL EXPERIMENTS

Art can celebrate political developments or propose an alternative world and purport to help bring it about, as was the case with a significant portion of Communist art, Futurism, and Nazi artwork such as Leni Riefenstahl's *Triumph of the Will*. Art can also foster experiments with alternative social and political structures or new modes of collective interaction. Le Corbusier's *Unité d'habitation* could be taken as such an experiment, and movements like Fluxus have emphasized the social and participatory dimension of artistic experimentation.

This is neither an exhaustive list nor a set of fixed categories. There is surely significant overlap between many of these points of interaction. Moreover, there are obviously works of art that cut across several of them at once. My objective in this brief overview is simply to indicate, in summary fashion, some of the broad and multifarious ways in which the immanent social

practices of politics and aesthetics, far from being well-delimited autono-
mous entities, concretely overlap and intersect. It is by no means my inten-
tion to suggest that their encounters are so ubiquitous that the pragmatic
distinction between them no longer makes sense. Moreover, it is important
to insist on the ways in which these forms of interaction depend on the
circulation and reception of works of art. There is no politics inherent in
art, although there can certainly be propositions and possibilities at the level
of production. And for art to be political, it does not have to directly cause
political action in any rarified sense. Aesthetic practices qua social prac-
tices participate in sculpting collectivities in more or less direct and active
ways. They can inform, satirize, indoctrinate, train, give a sense of belonging,
intervene, mobilize, raise questions, transform perception and expression,
organize collectivities, and propose experiments. Strictly speaking, there is
no work of art in isolation since a work only works and functions as art inso-
far as it has a social existence. Its politicity is never, therefore, inherent only
in its production logic as a given aspect of its inner reality. Unlike the poli-
tics of aesthetics, which tends to focus on the production of works of art—
and, more specifically, the *product* of art—at the expense of distribution and
reception, the study of the social politicity of artistic practices recognizes
that works of art are collective phenomena that are politicized precisely
through their production, circulation, and reception in the social world.

PART IV
THE SOCIAL POLITICITY OF AESTHETIC PRACTICES

7

THE POLITICITY OF 'APOLITICAL' ART

A Pragmatic Intervention into the Art of the Cold War

PRAGMATIC INTERVENTIONISM
AND AESTHETIC HERMENEUTICS

An analytic of practice aims at providing an anti-essentialist account of a sociohistorical conjuncture of practices. This is a necessary task, but it is not in and of itself sufficient, for there is the risk of reducing philosophy to a purely descriptive endeavor. It is for this reason, among others, that it is essential to maintain the dual position of describing and intervening. Indeed, this position consists in recognizing, to begin with, that description is a specific form of intervention, and that an intervention, in order to gain leverage over a situation, requires a refined and minute grasp of the situation itself. This is why the type of intervention in question might best be described as a pragmatic intervention: it charts out a field of practice and pragmatically intercedes in order to leverage it in a particular direction.

What follows might be called, more specifically, a hermeneutic intervention, and its objective is to displace recent debates on the relationship between art and politics in Cold War America. Interventions of this sort are not somehow separate from the politics of art. Instead, they are part and parcel of the social politicity of aesthetic practices, for the political dimension of

art is not reducible to the sovereign force of the work itself and its talisman-like properties. The politicity of a work of art is to be found in its social life and the complex interaction between the multiple types and tiers of agency that participate in various ways in its production, circulation, and reception.

The aesthetic hermeneutics deployed in this chapter aims at avoiding the binary opposition between artistic intention and social context by multiplying the levels of analysis in relation to the various layers of operative agency. It will implicitly rely on the distinctions developed in previous chapters between the three dimensions of history (the temporal juncture, the geographic bearings, the social strata) and the three aspects of social practice (creation, distribution, interpretation). However, it will primarily concentrate on developing a theory of variegated social agency that jettisons the cumbersome oppositions between individual and society, freedom and determinism, autonomy and heteronomy, aesthetic autarchy and contextualism. The social life of works of art, it will be argued, plays itself out in intricate encounters between numerous tiers and points of agency.

KULTURKAMPF AND THE CIA: A CASE STUDY IN THE SOCIAL POLITICITY OF 'APOLITICAL' ART

> One of the extraordinary features of the role that American painting played in the cultural Cold War is not the fact alone that it became part of this enterprise, but that a movement which so deliberately declared itself to be apolitical could become so intensely politicized.
>
> —FRANCES STONOR SAUNDERS

There is a widespread proclivity to reduce art history to a linear chronology of innovations in style, thereby severing artistic developments from their constitutive social inscription. When the larger social world is taken into consideration, it is often presented in terms of an external context that serves as the backdrop for autonomous aesthetic production. This intention-

alist and formalist approach to art history is particularly pronounced in the case of avant-garde movements, whose historical framing tends to emphasize aesthetic novelty in terms of advancing steps in a linear sequence of unique inventions or iconoclastic interventions. The presumed autonomy of aesthetic production is frequently accompanied, moreover, by the supposed autarchy of artwork, which reduces the relation of art and the social realm of politics to the ability—or inability—of works of art to produce more or less direct consequences in the 'outside world.' It is thereby assumed that art can only have an external relationship to politics. Indeed, since art is considered autonomous, it is only the talisman-like power of individual works that can forge—or fail to forge—a bridge between the sphere of aesthetics and the exogenous realm of politics.

It is with this in mind that I would like to turn to the historical accounts of the rise of Abstract Expressionism in postwar America. According to Serge Guilbaut, the standard versions of the history of this movement have largely ignored its resonances with the dominant ideology of the time:

> Until now, most studies of the art of this period have dealt with either the aesthetics of action (Margit Rowell, Harold Rosenberg) or the formal qualities of the work, focusing exclusively on the medium and stylistic influences (Clement Greenberg, William Rubin, Michael Fried, Irving Sandler). By contrast, I examine the political and cultural implications of the period. My central thesis is that the unprecedented national and international success of an American avant-garde was due not solely to aesthetic and stylistic considerations, as both European and American commentators frequently still maintain, but also, even more, to the movement's ideological resonance.[1]

Polemically assailing the thesis of the autonomy of aesthetics, he appeals to the methodological tradition of the social history of art, affiliated most notably with the work of Timothy J. Clark. "The history of American art can be written only if society is not divided up into isolated cells," writes Guilbaut, "only if the mediations among social, economic, cultural, and symbolic facts are not obliterated."[2]

Published in 1983, his controversial work, *How New York Stole the Idea of Modern Art*, is part of what is now called the revisionist account of Abstract Expressionism. Beginning in the mid-1960s, a number of publications called into question various assumptions concerning the supposedly autonomous rise to prominence of the American avant-garde and the widely discussed displacement of the artistic center of gravity from Paris to New York. The role of governmental support, and particularly clandestine manipulation, played a particularly prominent role. In April 1966, *The New York Times* published a series of five articles that explored the work of the Central Intelligence Agency, America's first peacetime intelligence organization. The third of these articles discussed the promotion of false front organizations and the secret transfer of CIA funds to help finance the Congress for Cultural Freedom, as well as scholarly research, publications, radio broadcasts, research centers, and numerous other cultural and intellectual endeavors.[3] 1966 and 1967 were the watershed years as revelations in journals like *Ramparts* concerning the CIA's covert operations in the world of culture and elsewhere contributed to a veritable deluge of disclosures.

In May 1967, Thomas W. Braden provided an insider's account of the Agency's promotion of American culture in the international Kulturkampf with the Soviet Union. According to Frances Stonor Saunders's flagship publication *Who Paid the Piper?* (1999), the former supervisor of cultural activities at the CIA "volunteered hitherto secret information which would never have been uncovered by other means—solid proof to end all the ambiguities (and the possibility of any more denials)."[4] He recounted the shadowy story of the birth of the International Organizations Division and defended the policy of going behind the back of Congress in order to funnel financial support into the non-Communist left and various cultural endeavors: "Back in the early 1950's, when the cold war was really hot, the idea that Congress would have approved many of our projects was about as likely as the John Birch Society's approving Medicare."[5] Braden explained the logic behind such clandestine operations by lionizing the power of culture in the battles of the Cold War: "I remember the enormous joy I got when the Boston Symphony Orchestra won more acclaim for the U.S. in Paris than John Foster Dulles or Dwight D. Eisenhower could have bought with a hundred

speeches."[6] He also brazenly asserted the urgency of working with the non-Communist left in the fight against the spread of Communism: "The fact, of course, is that in much of Europe in the 1950's, socialists, people who called themselves 'left'—the very people whom many Americans thought no better than Communists—were the only people who gave a damn about fighting Communism."[7]

Christopher Lasch's 1968 article, "The Cultural Cold War," provided a summary of the revelations to date as well as of the unabashed efforts to weather the crisis until it became obvious that there was simply too much evidence for CIA involvement in the world of culture. He audaciously drew what appears to be the only logical conclusion:

> For twenty years Americans have been told that their country is an open society and that communist peoples live in slavery. Now it appears that the very men who were most active in spreading this gospel were themselves the servants ("witty" in some cases, unsuspecting in others) of the secret police. The whole show—the youth congresses, the cultural congresses, the trips abroad, the great glamorous display of American freedom and American civilization and the American standard of living—was all arranged behind the scenes by men who believed, with Thomas Braden, that "the cold war was and is a war, fought with ideas instead of bombs."[8]

It was not until the 1970s that *Artforum* finally opened its pages to these forms of critical interrogation, and it published two notable articles. In 1973, Max Kozloff impugned the implicit assumption of the autonomy of aesthetics operative in so many accounts of postwar art in the United States: "The most concerted accomplishments of American art occurred during precisely the same period as the burgeoning claims of American world hegemony. It is impossible to imagine the esthetic advent without, among several internal factors, this political expansion."[9] The following year, Eva Cockcroft examined the central role of private patronage in the American art world. Emphasizing the important fact that "the U.S. museum, unlike its European counterpart, developed primarily as a private institution," she

foregrounds the influence of the corporate model in which boards of trustees, "often the same 'prominent citizens' who control banks and corporations and help shape the formulation of foreign policy," are the ones who "ultimately determine museum policy, hire and fire directors, and to which the professional staff is held accountable."[10] More specifically, she focuses on the central role of the Museum of Modern Art in funding and supporting— like the CIA—a tendentious version of art history aimed at promoting the 'free art' of a supposedly free society.[11] Indeed, her article outlines the very close ties between the Rockefellers' institution and the major players in American power politics. Nelson Rockefeller himself, who had notoriously ordered Diego Rivera's murals removed from the walls of the Rockefeller Center because they depicted Lenin, had vacated the MoMA presidency between 1940 and 1946 to work as President Roosevelt's Coordinator of the Office of Inter-American Affairs.[12] The art section of the government's wartime intelligence agency for Latin America also served as a home to René d'Harnoncourt, who later became the director of MoMA. William Paley, who was the president of CBS and one of the founding fathers of the CIA, was on the members' board of MoMA's International Program. The Chairman of the Museum's board of trustees, John Hay Whitney, worked for the Office of Strategic Services during the war, served on Truman's 'psy-war' planning unit, and allowed his charity to be used as a CIA conduit.[13] Julius Fleischmann was also on MoMA's board of trustees and served as the president of the CIA's Farfield Foundation. Before joining the CIA in 1950, Thomas W. Braden himself "had been MoMA's executive secretary from April 1948 to November 1949."[14] His wife, Joan, also worked for Nelson Rockefeller.

"Throughout the early 1940s," writes Cockcroft, "MoMA engaged in a number of war-related programs which set the pattern for its later activities as a key institution in the cold war. Primarily, MoMA became a minor war contractor, fulfilling 38 contracts for cultural materials totaling $1,590,234 for the Library of congress, the Office of War Information, and especially Nelson Rockefeller's Office of the Coordinator of Inter-American Affairs."[15] There was thus extensive overlap between MoMA's work and the covert operations of the CIA. This is not because there was a formal agreement

between the two, as far as we know, but instead because such an agreement "simply wasn't necessary," according to Saunders.[16] Cockcroft explains this operative consensus in the following terms:

> The functions of both CIA's undercover aid operations and the Modern Museum's international programs were similar. Freed from the kinds of pressure of unsubtle red-baiting and super-jingoism applied to official governmental agencies like the United States Information Agency (USIA), CIA and MoMA cultural projects could provide the well-funded and more persuasive arguments and exhibits needed to sell the rest of the world on the benefits of life and art under capitalism.[17]

The precise relationship between MoMA, the CIA, and Abstract Expressionism remains a subject of much debate. Anti-revisionists, as they have come to be called, claim that the connections are more tenuous than revisionists like Cockcroft and Saunders.[18] Moreover, MoMA's support for Abstract Expressionism was apparently more ambivalent, and there were numerous competing agendas among the staff and the board of trustees.[19] It only fully embraced the movement in the mid- to late 1950s. There has also been an attempt to correct the statistical and historical record regarding the representation of Abstract Expressionism in various exhibits as well as the sources of funding. At the level of historical correctives, the antirevisionists have sometimes made valuable contributions to this debate, and they have argued for the relative paucity of concrete evidence for direct links between Abstract Expressionism and the American Secret Service. However, none of them, as far as I know, has denied that the CIA was secretly involved in funding culture and the arts. On the contrary, most of them openly admit it. This fact has now been well established through direct testimony by members of the CIA and the release of internal documents.

The revisionists maintain that there was a strategic coalescence between the cultural agendas of the CIA and MoMA, which appears to have congealed around 1947, following the failure of the State Department's traveling exhibition *Advancing American Art*. Aimed at confuting Soviet assertions that the United States was a cultural wasteland, this

government-funded exhibit included a selection of seventy-nine 'progres-sive' works and was scheduled to travel through Europe and Latin Amer-ica.[20] In spite of its early success, the exhibit was ferociously contested in the United States and eventually canceled, signaling an early victory for philistines of the likes of George Dondero. This Republican from Mis-souri neurotically declared modernism to be part of an international con-spiracy. "Modern art is Communistic," he bombastically asserted, "because it does not glorify our beautiful country, our cheerful and smiling people, and our material progress."[21] In the era of Joseph McCarthy's hysterical reprobation of anything unorthodox, it became increasingly clear that the US Congress was unlikely to promote American avant-garde art. In fact, Secretary of State George C. Marshall declared that there would be "no more taxpayers' money for modern art," and the State Department issued a directive ordering that no American artist with Communist associations be exhibited at government expense.[22] In 1953, the chief spokesperson for the US Information Federation of Arts, A. H. Berding, went so far as to proclaim that "our government should not sponsor examples of our cre-ative energy which are non-representational."[23] The intellectuals at the CIA, many of whom had been recruited from the premier Ivy League schools and culturally trained in the values of modernism, tended to see things differently: "Where Dondero saw in Abstract Expressionism evi-dence of a Communist conspiracy, America's cultural mandarins detected a contrary virtue: for them, it spoke to a specifically anti-Communist ideology, the ideology of freedom, of free enterprise. Non-figurative and politically silent, it was the very antithesis to socialist realism."[24] Certain members of the CIA thereby resolved to go behind the back of Congress, and they worked with the private sector to promote an agenda that seam-lessly coalesced with the work of the Rockefellers and MoMA.

The discrepancy between Congress and the CIA illustrates the extent to which the US government did not function as a monolithic institution but was rather the scene of competing agendas. President Truman was notori-ous for his disdain of modernism, as were Republicans like McCarthy and Dondero. However, within Congress, there was no unanimous consensus on the relationship between modern art and communism. Jacob Javits, who

became a senator in 1957 when McCarthy and Dondero completed their terms in office, was one of the few members of Congress whose opposition to Dondero's assaults is a matter of public record. "The very point which distinguishes our form of free expression from communism," he explained, "is the fact that modern art can live and flourish here without state authority or censorship and be accepted by Americans who think well of it."[25] Dwight D. Eisenhower, who took the presidential helm in 1953, also "recognized the value of modern art as a 'pillar of liberty.'"[26] According to Michael Krenn, the Department of State generally came to share the belief, notably expressed by President Roosevelt on the eve of World War II, that art was taking on a larger and more significant role in the world.[27] Immediately following the war, "the department, ably assisted and much encouraged by vocal segments of the art profession, embarked on a bold new initiative designed to bring American art—particularly modern art—to the world."[28] Krenn has provided a detailed historical account of the complex force field of negotiations between diverse governmental agencies and private institutions—including internal debates—regarding the political patronage of the arts. His work aims in part at recontextualizing the covert operations of American Cold War cultural diplomacy in relationship to the overt international programs run through the State Department, the United States Information Agency (USIA), the Smithsonian Institution, and the American Federation of Arts. Needless to say, this is an extremely important part of the historical equation that must not be obscured by undue concentration on the clandestine activities of the Secret Service.

It is equally important to note that there were important disagreements within the CIA itself, as attested to by Braden's account of Allen Dulles's decision to overrule Frank Wisner in order to establish the International Organizations Division.[29] Founded in 1950, the IOD followed a series of "obvious" rules, according to Braden: "Use legitimate, existing organizations; disguise the extent of American interest; protect the integrity of the organization by not requiring it to support every aspect of official American policy."[30] This new organization served to provide a better institutional base for the psychological warfare programs promoting America's cultural achievements. In Braden's words:

We wanted to unite all the people who were artists, who were writers, who were musicians, and all the people who follow those people, to demonstrate that the West and the United States was devoted to freedom of expression and to intellectual achievement, without any rigid barriers as to *what you must write* and *what you must say* and *what you must do* and *what you must paint* [Braden's emphasis], which was what was going on in the Soviet Union.[31]

The divergence between Dulles's CIA and the majority position in Congress came to a head in late 1952, when McCarthy became suspicious of Braden's organization upon learning that it had subsidized pro-Communist groups. "This was a critical moment," writes Frances Stonor Saunders, "McCarthy's unofficial anti-Communism was on the verge of disrupting, perhaps sinking, the CIA's most elaborate and effective network of Non-Communist Left fronts."[32] The Agency had to recede even further into the background and diligently maintain the clandestine nature of its operations, thereby staving off detection of its undercover cultural endeavors until the mid-1960s.

The centerpiece of the CIA's underground campaign was the Congress for Cultural Freedom, which was run by the undercover agent Michael Josselson from 1950 until 1967:

At its peak, the Congress for Cultural Freedom had offices in thirty-five countries, employed dozens of personnel, published over twenty prestige magazines, held art exhibitions, owned a news and features service, organized high-profile international conferences, and rewarded musicians and artists with prizes and public performances. Its mission was to nudge the intelligentsia of western Europe away from its lingering fascination with Marxism and Communism towards a view more accommodating of "the American way."[33]

The reach of the CCF was extremely broad, and Saunders draws the conclusion that "whether they liked it or not, whether they knew it or not, there were few writers, poets, artists, historians, scientists or critics in post-war

Europe whose names were not in some way linked to this covert enterprise."[34] Hugh Wilford, whose book *The Mighty Wurlitzer* was written as a partial corrective to Saunders's account, nonetheless corroborates many of its key elements. Indeed, he even goes so far as to claim that the CCF evolved into "one of the most important artistic patrons in world history, sponsoring an unprecedented range of cultural activities."[35] It covered travel expenses for its international meetings, made donations for literary prizes and fellowships via CIA conduits like the Farfield Foundation, organized art exhibits and cultural festivals, and was involved in book contracts through publishing houses like Frederick A. Praeger. It also secretly supported literary magazines such as the Anglo-American monthly *Encounter*, which was a creation of the CCF, and the *Partisan Review*, which Wilford describes as "the principal literary vehicle of the New York intellectuals and one of the most influential little magazines of the twentieth century."[36] Ironically, all of the honorary presidents of the CCF were well-known philosophers, including Bertrand Russell, Benedetto Croce, John Dewey, Karl Jaspers, and Jacques Maritain. There is still some debate over how many people knew that the CCF was a CIA front organization, and at what time they became aware of it. Jason Epstein, one of the founders of *The New York Review*, has asserted that by the mid-1960s everyone basically knew who was funding the Congress.[37]

In the environment of the cultural Cold War, it seems that Abstract Expressionism constituted an "ideal style" for the propaganda activities of the American Secret Service: "It was the perfect contrast to 'the regimented, traditional, and narrow' nature of 'socialist realism.' It was new, fresh and creative. Artistically avant-garde and original, Abstract Expressionism could show the United States as culturally up-to-date in competition with Paris. This was possible because Pollock, as well as most of the other avant-garde American artists, had left behind his earlier interest in political activism."[38] Many of the New York artists had worked for the Federal Arts Project, which was part of Roosevelt's New Deal. They produced subsidized artwork and were generally involved in left-wing politics. However, they tended to follow, according to Serge Guilbaut, the political trajectory epitomized by Dwight Macdonald, moving from conventional Marxism to Trotskyism

and then various forms of anarchism: "Painters such as Rothko and Got-
tlieb, Pollock and Motherwell . . . followed the same course."[39] Clement
Greenberg had provided the theoretical framework for this political con-
version, and Guilbaut argues that he served in many ways as the crucial
lynchpin linking Trotskyism to the embrace of a more or less apolitical form
of aesthetic modernism: "Greenberg carried Trotsky's defense of a critical
art that remained 'faithful to itself' one step further, maintaining that while
the avant-garde did indeed do critical work, it was criticism directed within,
toward the work of art itself, toward the very medium of art, and intended
solely to guarantee the quality of the production."[40] Referencing in particu-
lar the publication of "Avant-Garde and Kitsch" in 1939, Guilbaut claims
that Greenberg established an elitist modernist position that broke with the
overt politicization of art in the name of formalist avant-gardism, a position
that appealed to many of the emerging artists in the New York School.

As noted above, there is still debate concerning the CIA's promotion of
Abstract Expressionism, in part because the historical record is perforated
by many lacunae and the long leash policy of the American Secret Service
aimed at making these holes difficult to fill.[41] In 1995, Saunders broke the
story of a former CIA case officer who explicitly stated that the agency rec-
ognized a unique opportunity in the New York School:

"Regarding Abstract Expressionism, I'd love to be able to say that the
CIA invented it just to see what happens in New York and downtown
SoHo tomorrow!" he joked. "But I think that what we did really was to
recognise the difference. It was recognised that Abstract Expressionism
was the kind of art that made Socialist Realism look even more styl-
ised and more rigid and confined than it was. And that relationship was
exploited in some of the exhibitions."[42]

According to Saunders, the CCF organized "several exhibitions of
Abstract Expressionism during the 1950s. One of the most significant,
'The New American Painting,' visited every big European city in 1958–59.
Other influential shows included 'Modern Art in the United States' (1955)
and 'Masterpieces of the Twentieth Century' (1952)."[43] Although the latter

exhibit did not include works by the Abstract Expressionists, she contends that the display of European masterpieces culled from American collections sent a clear postwar message: "modernism owed its survival—and its future—to America."[44] Indeed, James Johnson Sweeney, a curator as well as an associate of the CIA-backed *Partisan Review* and an advisor to MoMA (who provided the art exhibit for the CCF's festival "Masterpieces of the Twentieth Century"), boasted that he had chosen works for the festival that "could not have been created nor whose exhibition would be allowed by such totalitarian regimes as Nazi Germany or present-day Soviet Russia and her satellites."[45] Saunders also claims that there is evidence for CIA support of the following exhibits: "Twelve Contemporary American Painters and Sculptors" (1953–54), "Young Painters" (1954), and "Antagonismes" (1960). Hugh Wilford has corroborated some of these claims by arguing that the CIA's "principal front man in the cultural Cold War," Julius Fleischmann, donated large cash prizes to the "Young Painters" show.[46] For "Antagonismes," the American participants were "chosen by MoMA and the costs met by the Farfield and another CIA conduit, the Hoblitzelle Foundation."[47]

It is important to recognize that even if CIA patronage of Abstract Expressionism did not extend beyond what the sparse historical record—in its current form—allows us to assert with confidence, it is obvious that there was a larger policy of psychological warfare aimed at promoting 'artistic freedom' as a Cold War symbol for the supposed cultural and political liberty of the United States. For instance, the American Secret Service clearly supported contemporary music, epitomized by Nicolas Nabokov's intention to "counter, composer by composer, Stalinism in the arts" in the program established for the CCF-backed festival of the arts "Masterpieces of the Twentieth Century."[48] "The political, cultural and moral meaning of the Festival and its program should not be overt," according to Nabokov's proposal, but "it should be left to the public to make its inevitable logical conclusions. Practically all the works [to be] performed belong to the category branded as 'formalist, decadent and corrupt' by the Stalinists and the Soviet aestheticians, including the works of Russian composers (Prokofiev, Schostakovish [sic], Scriabine and Strawinksy [sic])."[49]

The CIA's penchant for certain forms of what is generically labeled modernism—visible as well in its support of literary figures like Eliot and Pound—was founded on its surreptitious use of purportedly autonomous art as a cultural symbol for the 'free world.'[50] However, the high art sensibilities of the cultural mandarins were not a constant, as authors such as Hugh Wilford and Richard Burstow have pointed out. To begin with, they were surprisingly reluctant to extend their patronage to the American musical avant-garde, including the work of Milton Babbitt and John Cage.[51] Wilford points to evidence that "the CIA's own tastes in the realm of the performing arts were far from high modernist": "Classical symphonies, Broadway musicals, even the jazz of Dizzy Gillespie, all were used by a large array of U.S. government bodies . . . in an attempt to persuade music lovers around the world that America was no less hospitable to the aural arts than the literary and visual."[52] The Boston Symphony Orchestra played a particularly central role in CIA sponsorship. Its first European performance, when it went to Paris to play Stravinsky's *The Rite of Spring* in the CCF's "Masterpieces" festival, was paid for by a grant of $130,000 from the International Organizations Division, arranged by Thomas Braden.[53] Wilford also references the case of dance, which in general "did not feature prominently in the CCF's international program": "American ballet tended to be promoted abroad by the overtly government-funded President's Emergency Fund (which echoed the CCF's approach to music by neglecting avant-garde dancers such as Merce Cunningham in favor of more traditional fare)."[54] In a revealing letter written in 1955 to Nelson Rockefeller by Frank Wisner, the Assistant Director of the CIA's Office of Policy Coordination, the latter argues against sending the New York City Ballet to Moscow on the grounds that it would surely suffer from Russian prominence in this area.[55] Instead, he recommends presenting musical shows such as *Oklahoma, Carousel, Kiss Me Kate*, or the Ice Capades. He also suggests the possibility of sending jazz orchestras or the BSO, and he reasserts the importance of showcasing 'negro' talent (to contravene criticisms of American racism).[56] Wilford also highlights a cache of anonymously written letters discovered among C. D. Jackson's papers, which reveal "a CIA agent based in Hollywood's Paramount Studios who is engaged in an astounding variety of clandestine

activities on the Agency's behalf."[57] The American Secret Service not only sought to influence Hollywood film production, but it occasionally undertook cinematic projects, such as the animated version of George Orwell's *Animal Farm* (1954).[58] By manipulating the storyline, Orwell's anti-totalitarian narrative was ironically transformed into a covert weapon of Cold War propaganda.[59]

MULTIDIMENSIONAL SOCIAL AGENCY

Any analysis of political influence in the cultural realm can tend to undermine the actual legitimacy of the culture as culture, and the intricacies of the semi-autonomous, contingent development of cultural-intellectual activity. Arguments are often reduced to an emphasis either on the autonomy or the dependence of art, neither being particularly satisfactory for the broadening of historical understanding.

—GILES SCOTT-SMITH

The ongoing debate between the revisionists and the anti-revisionists tends to operate within the binary framework of a series of polar oppositions such as determinism and freedom, dependence and autonomy, society and the individual, contextualism and aesthetic autarchy. Whereas the revisionists seek to reveal the social and contextual elements that have determined artistic production, the anti-revisionist counteroffensive generally aims at foregrounding the freedom of individuals in their artistic production and the liberty of institutions in their aesthetic judgments. Fortunately, the authors involved in this debate have sometimes refused a simplistic opposition between absolute determination and complete freedom. However, many of them tend to remain within a binary social logic in which total determination is disproven by individual instances of freedom, and complete liberty is contravened by cases of exogenous control.

Instead of relying on the strict polarization between the knights and pawns of the Cold War, it is crucial to recognize that there are different modes, levels, ranges, and points of agency. The vocabulary of agency should not be unduly identified with that of freedom, which suggests the existence of a rarified or purified state, a zero-point of originary activity. Regarding CIA involvement in the art world, the modes of agency might best be described as financial control and encouragement, institutional support, covert lobbying, and other types of clandestine manipulation. These modes of agency are, of course, bound up in complex ways with an entire political, economic, and social force field. Moreover, since these were underground activities, there was an attempt to construct a deep and undetectable tier of agency, whose consequences were palpable but whose sources were unknown. The range of agency depended on individual cases, but it is extremely important to underscore the fact that financial and institutional encouragement does not mean that the CIA co-opted the agency of all of the parties involved, or that its reach stretched deep into the social agency of all of the artists and intellectuals affected. Instead, it attempted, at least in part, to quietly coerce them in such a way that they felt like they were acting naturally. Obviously, it did not always succeed in attaining its goals. For instance, Wilford cites an important example of "the limits of CIA manipulation in the face of commercial and domestic political pressure": the director and studio head at Paramount refused to play up "the negro angle" by planting "black actors on the golf links in *The Caddy* for fear they might upset southern white moviegoers."[60] The author of *The Mighty Wurlitzer* draws the conclusion that "the CIA might have tried to call the tune, . . . but the piper did not always play it, nor the audience dance to it."[61] This is equally true of overt governmental patronage of the arts (as well as of political censorship). The acceptance of funding by no means necessarily negates the agency of those who accept it, and financial strings have a specific range of agency. According to Michael Krenn, there was a regular push and pull between governmental support and political control: "When artists and art organizations felt that the government was trying to censor or control the art, they rebelled. When the State Department, the USIA, or, to a lesser extent, the IAP, came to believe that art (or artists) was

sending a wrong or ineffective message, their eagerness to support the initiative quickly faded."[62]

All of this points to the importance of developing an account of the multiple sites of agency operative in any conjuncture. As we have seen, the strict opposition between the Establishment, on the one hand, and free artists and intellectuals, on the other, ignores the complex social topography of these relations. Within what is generically called the government, there are numerous institutional agencies, which do not necessarily agree: Congress, HUAC, the Executive Branch, the State Department, the USIA, the AFA, the CIA, the CCF, the FBI, and so forth. Inside each of these organizations, there is also a multiplicity of points of view, as attested to by the internal struggles within Congress and the CIA. Moreover, these manifold sites of agency share the social field with an entire series of other points of agency, including museums, galleries, curators, art collectors and dealers, the art market, art critics, art theorists and historians, and the art critical apparatus (publications, documentaries, lectures, courses, and so forth). These multiple sources of action enter into intricate, dynamic negotiations over time, and they are irreducible to the dualisms of establishment and antiestablishment, determinism and freedom, in spite of the fact that there may be hegemonic unification or ideological complicity in certain instances.

Let us consider, in this light, a few concrete examples, beginning with a case that clearly illustrates the tiers and ranges of agency. Theodor Adorno is notorious for his condemnation of committed literature and his defense of aesthetic autonomy (which should not be confused with art for art's sake). In one of his well-known essays, he lambastes Georg Lukács for his support of Soviet-style realism, to which he opposes "art's own autonomous status," asserting that "social truth thrives only in works of art autonomously created."[63] In an ironic twist of fate, it so happens that this essay was published in *Der Monat*, which was "a journal created by the US Army in West Germany and financed by the Central Intelligence Agency."[64] Max Horkheimer was dubious of the journal's orientation, but Adorno, at least according to Rolf Wiggershaus, "had so little sensitivity to the anti-communist 'freedom' jargon that he published articles in *Der Monat* just as he did elsewhere."[65]

What Adorno appears to have overlooked is the extent to which the very category of autonomy is not autonomous, meaning that it is not somehow separate from the sociopolitical force field of cultural power dynamics. In fact, as Saunders has pointed out, the concept of autonomy was itself integral to the Cold War agenda of the US Secret Service: "That's built into the very first provision of the CIA involvement, which is that autonomy, not just the semblance of it, but autonomy should be preserved because autonomy is going to give the greatest credence to the independence of these organizations."[66] She adds, of course, that this autonomy was strictly circumscribed, but that the illusion of its purity was nonetheless a central part of the equation. It is highly revealing, in this regard, that the Congress for Cultural Freedom itself defended the autonomy of art on grounds not unrelated to those of Adorno: "In order to oppose a world in which everything serves a political purpose, which is for us unacceptable, it was necessary to create platforms from which culture could be expressed without regard to politics and without confusion with propaganda, where the direct concern would be for ideas and works of art in themselves."[67] It is precisely this type of argument that led them to support certain artists whose 'autonomous' work was admired by Adorno.

This does not mean that Adorno was simply the unwitting pawn in an intricate Cold War plot, nor does it signify that his arguments were delivered to him prepackaged by the CIA. It certainly does not imply that all of his work on aesthetics can be dismissed as convenient propaganda in the cultural Cold War. Instead, it suggests, to begin with, that his attack on Lukács and socialist realism, as well as his appeal to aesthetic autonomy, happened to coalesce extremely well with the Cold War agenda of the American Secret Service. This should invite us to critically reflect on the sociopolitical inscription of theoretical practices, as well as question autonomy discourse and the motley forces operative in its production and circulation. It is important to recognize that this discourse, like the category per se, is not itself autonomous from the very force field in which it emerges. Of course, it is certainly true that a social agent cannot control everything in his or her conjuncture, and the CIA backing of *Der Monat* and various forms of 'autonomous' art by no means usurps all of Adorno's theoretical

agency. However, he can nonetheless be held to account for not recogniz-
ing and engaging with—even after the fact—some of the powerful forms
of agency at work in his sociopolitical conjuncture. He can also be held
responsible for turning a blind eye to the contradictory nature of the very
category of autonomy in favor of what ultimately appears to be, at least in
certain instances, a naïve understanding of the autarchy of cultural artifacts.

 The critique of aesthetic autonomy is one of the themes in the next
example to which I would like to turn: Emile de Antonio's documentary on
postwar American art, *Painters Painting* (1972). Instead of simply concen-
trating on the art objects as such, or an exogenous context for that matter,
the film unearths and explores the struggles between the multiple tiers and
points of agency operative in the supposedly simple act of painters paint-
ing. The opening sequence establishes, in many ways, the aesthetic logic of
the entire film. Beginning with a series of nine vertical lines reminiscent
of Robert Rauschenberg's *White Painting* (1951), as well as the geomet-
ric stripes of Frank Stella, Daniel Buren, and other 'formalists,' the cam-
era slowly zooms out to reveal that these vertical bars are actually part of a
facade. A carefully constructed panning shot then seamlessly reframes this
Mondrian-like building—the headquarters of the monopolistic Ma Bell—
in the urban landscape of the Empire City. This visual reinscription of so-
called formalist painting within the specific social, economic, and historical
conjuncture of postwar America—and, more specifically, New York—is fur-
ther reinforced by the voiceover prologue by Philip Leider, who recounts a
brief history of American painting:

> The problem of American painting had been a problem of subject matter.
> Painting kept getting entangled in the contradictions of America itself.
> We made portraits of ourselves when we had no idea who we were. We
> tried to find God in landscapes that we were destroying as fast as we
> could paint them. We painted Indians as fast as we could kill them, and
> during the greatest technological jump in history, we painted ourselves as
> a bunch of fiddling rustics. . . . Against the consistent attack of Mondrian
> and Picasso, we had only an art of half truths, lacking all conviction. The
> best artists began to yield rather than kick against the pricks. And it is

exactly at this moment, when we finally abandoned the hopeless con-
straint to create a national art, that we succeed for the first time in doing
just that.

A rapid, horizontal tour de force of a circumambulatory pan through an
art gallery then cuts to a shot of the horizontal stripes of Jasper Johns's *Flag*,
and a slow zoom in serves to complete the inverse mirroring of the open-
ing sequence as another voice-over discusses the problematic of specifically
American painting. This aesthetic logic of reframing (a painting within a
cityscape) and of displacement (zoom out to zoom in, pan left to pan right,
vertical to horizontal lines) dominates the entire film as de Antonio regu-
larly resituates what is seen in relationship to the invisible forces outside of
the frame. He thereby invites the spectator to inquire into the constructed
nature of the perceptible as well as the powers operative in such a construc-
tion and its possible displacement.

He conducts interviews with artists in their studios, often situating their
work in relationship to its immediate material context of production. He
also integrates interviews and documentary footage with art critics, cura-
tors, art collectors, spectators, and an art dealer. The film thereby explores
the institutional, economic, and social matrix of the artists in question, as
well as the critical apparatus that presents them to the broader public. This
implicit rejection of the autarchy of isolated aesthetic artifacts does not,
however, lead him to devalue the agency of the artists involved. This is par-
ticularly interesting in the case of their political agency, which has often
been considered very subdued or secondary in the New York School. In
his conversation with Helen Frankenthaler, de Antonio inquires into the
gender dynamic and sexual politics in painting. He also raises the issue of
politics at numerous points in his exchange with Andy Warhol, and they
discuss his depiction of the men on the FBI's most wanted list (later discov-
ered to be individuals who were not, in fact, fugitives but simply ordinary
citizens). Barnett Newman provides perhaps the film's most explicit refer-
ence to the political dimension of art when he asserts: "there's no question
that my work and the work of the men I respect took a revolutionary posi-
tion, you might say, against the bourgeois notion of what a painting is as an

object, aside from what it is as a statement, because, in the end, you couldn't even contain it in any ordinary bourgeois home."

Before exploring the political dimensions of this film in greater depth, it is worth further contesting the somewhat monolithic image of the New York School as apolitical by recalling that this constellation of artists included some who, in the vagaries of their individual itineraries, showed signs at one point or another of a direct investment in progressive politics. Newman was a self-professed anarchist, and he made an effort to give his canvases a radical political meaning, in part through the theoretical lens of Wilhelm Worringer. After the police crackdown on the Democratic National Convention in 1968, he participated in an exhibit in a Chicago gallery that functioned as a collective protest. His own contribution, a large frame of steel coated in red paint and laced with barbed wire, recalled not only the barbed wire used to encircle the convention hall in Chicago, but also the death camps in Europe and Russia. Similarly, Robert Motherwell painted his series *Elegies to the Spanish Republic* to mourn its defeat, and Clyfford Still also showed signs of an explicit political orientation in some of his artwork, as did Jackson Pollock and others in their early years.[68] However, it is arguably Ad Reinhardt who was the most explicitly dedicated to the organized left throughout his career: "A lifelong socialist, he joined the Artists Union immediately after college, and drew cartoons and designed covers for the *New Masses* and *P.M.* long after other modernists had abandoned the left. During the 1940s he continued to support leftist art groups like the United American Artists and the Artists League of America."[69] Reinhardt's paintings nonetheless remained abstract and did not seek to represent or reflect leftist political ideologies. In fact, he emphasized the political importance of non-representative works, claiming that illustrative pictures, even with progressive political content, did not "threaten but actually could only support their bourgeoisie standards [sic]. Actually, the illustrative picture that pretended to be more than illustration or decoration prohibited a more profound appreciation of art on the part of the spectator by not demanding a firsthand and comprehensive participation (and preparation) for its meaning."[70] His doctrine of 'art-as-art' was surely not unrelated to his stalwart condemnation of the commercialization

of the art world, as well as to his brutal attacks on his former friends: he described Rothko as "Vogue magazine cold-water-flat fauve," Pollock as the "Harpers Bazaar bum," and Newman as "the avant-garde huckster-handicraftsman and educational shopkeeper."[71] Reinhardt was thus keenly aware of the ways in which economic, entertainment, and political interests had saturated the art world and debased art for its own sake.[72] This is particularly apparent in his political cartoons, which are sometimes ignored or overlooked as peripheral to his main body of artistic work, revealing the extent to which the very category of artwork is always already a social category (largely distinct from and superior to, in this case, cartoons). In one of his most elaborate drawings, *FOUNDINGFATHERSFOLLYDAY* (1954), he satirically condemned the entire social network of artists, museums, dealers, and publications that produced what is perceived as the New York art world. His *How to Look* series was also a virulent intervention into the institutional and ideological matrix framing our experience of art. To take but one poignant example, *How to Look at Art and Industry* (1946) established a parallel between Socrates's death upon drinking poison and the death of any American artist who accepted to enter into a painting competition sponsored by the Pepsi-Cola Company. The quotation from the New Testament beneath his reworked engraving of the death of Socrates leaves no doubt as to the nature of his critical condemnation: "For the love of money is the root of all evil."

De Antonio largely shared Reinhardt's concern with the framing of aesthetic experience. *Painters Painting* not only situates the viewer in the complex tapestry of social, institutional, political, and economic relations integral to the New York art world from 1940 to 1970, thereby recalling Reinhardt's scrupulously detailed *FOUNDINGFATHERSFOLLYDAY*. It also mobilizes a subtle use of the image and soundtrack to carefully construct a film about the overall framing of postwar New York painting. To begin with, de Antonio is transparent about the fact that he is not proposing a survey or a purportedly objective account of the art scene or, for that matter, of an identifiable art historical movement such as Abstract Expressionism. Instead, the framework of *Painters Painting* is highly personal, although it is by no means as idiosyncratic as Jonas Mekas's *Walden* (1969). De Antonio tended

to interview those artists whom he knew or whose work he appreciated, and he ignored figures who did not interest him as much (Adolph Gottlieb, Donald Judd, Franz Kline, Robert Morris, Mark Rothko, Cy Twombly). Moreover, through the course of the film, he regularly highlights the involvement of his camera crew in the staging of the interviews and the overall construction of the film. For instance, the recording crew and de Antonio are often visible, the strike of the clapboard is shown, unmatched sound and image tracks are occasionally used, and behind-the-scenes elements like de Antonio's call to cut the opening exchange with Warhol are integrated into the film itself. The director clearly wanted the process of cinematic production to be part of the final product. In his autobiographical film, *Hoover and I* (1989), he resolutely states over the whirring camera: "This film, although it probably won't be seen by many people, is an attempt at subversion. This film is a film of opposition. I'm glad we're hearing the sound. Why should the process of any art not be included in whatever that art is?" This inside-out technique by which the framing devices, which normally remain imperceptible, are themselves incorporated into the film recalls the work of Bertolt Brecht, as well as Jean-Luc Godard's integration of Brechtian realism into film. "It mustn't be forgotten," writes Godard in a passage that calls to mind the work of de Antonio, "that film has to, today more than ever, keep as its rule of conduct this idea of Bertolt Brecht: 'realism is not how true things are but how things truly are [*le réalisme, ce n'est pas comment sont les choses vraies, mais comme sont vraiment les choses*].'"[73] By showing the invisible elements that construct and frame what is visible, de Antonio produces a hyper-realism that shows "how things truly are," that is to say, a realism premised on unveiling the very artificiality of the real as it is aesthetically presented. True realism, it might be said, does not simply purport to portray the real or "true things" as given facts. Instead, it unearths the constructive mechanisms that produce what is perceived as the real, thereby simultaneously displaying the artificiality inherent in traditional verism.

De Antonio's process-oriented technique invites the viewer to concentrate on the forces that are staging what is seen, as well as on everything that remains outside of the perceptible frame. This is not an instance of formal commitment, meaning the dedication to formal innovations that are

analogically linked to politics in diverse ways. Instead, this appears to be a case of aesthetic transformation in the precise sense of a modification of the horizons of the visible and the audible that encourages the spectator to become reflexively aware of the sensory framing of experience in the broad sense of the term. This cultivates, at least potentially, a critical sensibility in the viewer and a heightened attentiveness to the systemic scaffold producing and maintaining 'the real.'

It is certainly regrettable that de Antonio did not explicitly reference the CIA's clandestine involvement in the world of art and culture in postwar America. Even though the revelations were just beginning to come out in the mid- to late 1960s, his political orientation made him uniquely suited to raise the question of the relationship between the success of the New York School and Cold War ideology, which he did not do in the film. However, his insistence on framing devices and on the sensory matrix that undergirds the perceptible—highlighted in the long final sequence in which Larry Poons fastidiously frames one of his paintings—invites the spectator to critically reflect on the invisible forces operative in staging and presenting what is perceived as reality. Given the covert nature of CIA activity, this is a particularly interesting strategy because it cultivates—at least potentially—a critical attitude rooted in a systemic perspective. Regardless of what is actually known, it invites the spectator to be wary of the imperceptible forces that are often operative in a power matrix like that of Cold War America.

The film does include, however, an intense exchange at MoMA when a member of the radical Artists' Workers council angrily questions John B. Hightower, MoMA's director, about the possibility of the museum serving artists rather than the Rockefellers. Hightower calmly replies, with the self-assured voice of aristocratic progeny: "I'd say the chances are probably pretty slim." There is also a behind-the-scenes comment by Leo Castelli as he is talking on the phone and explaining to his interlocutor that he is participating in de Antonio's film. Reflexively touching on the political nature of the project, he explains: "He's making a film like the McCarthy film [*Point of Order*] without McCarthy, about the art world." Despite the fact that de Antonio openly admitted to feeling conflicted over his decision to make a film about purportedly apolitical artwork that had been seamlessly

integrated into the machinery of the elitist corporatocracy,[74] it is interest-
ing to note that he retorted to one of his critics: "*Painters Painting* is more
political than you seem to think. Art is power."[75]

My argument here is not that this film should be taken as a privileged
or exemplary case of good political art. Instead, it is that from the vantage
point that I have developed here, there are signs of a particularly interesting
artistic strategy for resisting the pernicious but largely concealed forces at
work in the undercover Kulturkampf. By developing a critical awareness,
de Antonio encourages a reflexive attentiveness to the obscure underworld
of power politics. It is not surprising, in this regard, that he criticized Rob-
ert Redford's plans to play Woodward in *All the President's Men*: "Redford
thinks he's against the CIA. But I'm not against the CIA, I'm against the
system that produced the CIA. . . . Watergate is a nice soft issue because it
focuses on a man and not a system. Redford views Watergate as an aberra-
tion, whereas in my view Watergate is inherent in the system."[76] The reflex-
ive awareness that he cultivates is thus clearly oriented toward a systemic
analysis that focuses on the overarching framework that produces certain
events or occurrences.

Let us conclude this analysis by underscoring a particularly interest-
ing case in which de Antonio appears to have mobilized framing devices
outside of his films in order to displace the attention of the American
Secret Service. As we know from his film *Mr. Hoover and I*, he had a ten-
thousand-page FBI file, and the CIA also had thousands of pages on his
activities. In 1975, he announced in an interview that he was planning to
make a film on Philip Agee, the renegade CIA agent who had turned his
back on the American Secret Service and published *Inside the Company:
CIA Diary*. Although de Antonio's designs were apparently sincere, in spite
of his playful and sardonic references to the possible participation of Jane
Fonda and Robert Redford, the film was never made. Within weeks of the
interview, de Antonio began recording his clandestine meetings with the
Weather Underground, the radical collective that was in hiding and on
the FBI's most wanted list. Was his stated plan to make a film on Agee a
framing device aimed at throwing the Secret Service off of his trail so that
he could arrange private meetings with revolutionary fugitives and make

Underground (1976), in which he brought the muzzled message of these subversive dissidents to the big screen? Was this an ironic way of getting back at the true masters of deceit?[77] Given his attentiveness to framing devices and to the work of aesthetic displacement, as well as his cultivation of a systemic critical sensibility, this would not be surprising in the least.

AESTHETIC AGENCY IN SOCIAL FORCE FIELDS

The case of American art during the Cold War clearly showcases the severe limitations of the product-centered approach to the politics of aesthetics, which reduces the latter to a political power supposedly inherent—or not—in isolated, talisman-like objects or practices. Louis Menand is absolutely correct in this regard to laud the revisionists' attack on the widespread assumption that "the conditions of a painting's production and reception are irrelevant to its significance as art."[78] "Everything was shaped by Cold War imperatives after 1945," he writes, "because everything is always shaped by circumstance."[79] It is, of course, ironic that an art movement that was largely perceived to be apolitical became "a prime political weapon," and this plainly illustrates the need to take into account the complex networks of production, circulation, and reception when examining the politicity of aesthetic practices.[80] Moreover, it is important to highlight that, in the words of Menand, "the 'apolitical' interpretation of abstract painting derived, quite self-consciously, from a politics."[81] Indeed, it was precisely the separation between art and politics that perfectly served political ends, revealing the extent to which the very theoretical and hermeneutic endeavor to prove or defend this separation was ironically bound up with very concrete political forces operative in the art world. Eva Cockcroft went to the heart of matters when she boldly asserted: "They [the Abstract Expressionists] also contributed, whether they knew it or not, to a purely political phenomenon—the supposed divorce between art and politics which so perfectly served America's needs in the cold war."[82]

The preceding analysis calls into question the ontological and epistemic illusions, the supposed autonomy of art, the isolation of the aesthetic artifact, and the talisman complex. It should be clear from the investigation as a whole that the politics of art cannot be limited to the political—or apolitical—dimension of individual works of art. We need to account for their inscription and circulation in the social world. Moreover, overcoming the social epoché that has plagued much of the debate on the politics of aesthetics also requires the development of a multidimensional social theory in which it is recognized that there are various modes, tiers, ranges, and sites of agency. As we have seen, the monolithic categories of autonomy and heteronomy, individual freedom and political conspiracy, are unsuited for making sense of the intricacies of social relations and the complex chemistry of multiple forms and points of agency. Indeed, the binary normativity inherent in the opposition between art and the establishment is too crude to take into account the manifold of conflicting agencies at work. CIA funding and covert governmental manipulation, to return to these examples, did not negate in toto the agency of those who were affected by such machinations. These constitute tiers of agency with concrete effects that have specific ranges. As we have seen in the case of Reinhardt, de Antonio, and others, they did not control the totality of aesthetic production but instead functioned as coercive powers in a much larger force field of agencies.

8

RETHINKING THE POLITICS
OF AESTHETIC PRACTICES

Advancing the Critique of the Ontological Illusion
and the Talisman Complex

ONTOLOGICAL ILLUSION

The common starting point for reflections on the relationship between art
and politics is a series of three central questions: What is art? What is poli-
tics? What is the relation between art and politics? This *terminus a quo* is
apparently so self-evident that there has been very little critical reflection
on what this series of questions actually entails. While it is true that the
responses have varied widely, they nonetheless tend to share the same meth-
odological framework, which might be referred to as a descriptive ontol-
ogy: they purport to provide an account of the being of art and politics
as well as the nature of their relationship. The guiding assumption is that
art and politics have essential identities that can be definitively described.
Modifying the level of analysis or the terms of relation does not necessar-
ily change the methodological orientation. In other words, if the initial
question includes 'what is literature?' 'what is film?' or 'what is democracy?'
the same basic methodological framework is operative. This is equally true
in the case of an individual work of art or a particular instance of poli-
tics. At base, it is a matter of responding to the question *ti estin*—what is

(an entity)?—with an ontological description of the nature of a particular object, activity, or relationship.

This common-sense starting point, as we have seen in previous chapters, runs the risk of orienting the entire discussion of art and politics around competing definitions of their nature and rival accounts of their privileged meeting ground (or lack thereof). Such a *terminus a quo* is based on the ontological illusion, which is to say, the myth according to which art and politics have fundamental identities that can be defined once and for all. Moreover, the relation between them is often thought in causal terms: a particular work of art or type of artwork provokes a specific political action (or not). Such a relationship makes sense within the framework of the talisman complex, according to which the politics of art amounts to a political force inherent in works of art that is supposedly capable of producing political consequences through a nebulous, paranormal alchemy. The talisman complex tends to center the entire discussion of art and politics on the productive side of art by focusing primarily on the art object or artistic activity as such, occasionally linking these to the particular artistic intentions imbued within them. It thereby brackets, to a greater or lesser extent, the intricate system of forces operative in the production and social distribution of works of art, as well as in their reception by a public. The political dimension of art is thus reduced to the supposed power of a particular talisman-like object or practice. It should be emphasized, moreover, that this complex also frequently prevails in the various attempts to delegitimize political art or reveal the vacuity of particular instances of politicized work, as if the fact that a specific work or group of works did not instigate a political transformation was in and of itself an indictment of its politicity, if not of political art in toto.

Consider, for instance, the various and sundry claims made regarding the supposed failure of Pablo Picasso's *Guernica* (1937), which was famously painted in the wake of the destruction of the Basque town during the Spanish Civil War. In 1948, Jean-Paul Sartre raised the rhetorical and sardonic question: "does anyone think that it won over a single heart to the Spanish cause?"[1] If the answer is clearly 'no' for him, it is in part because paintings do

not express unambiguous meanings that could galvanize spectators. Instead, they present imaginary objects and feelings that cannot be clearly committed to a political cause, as we saw in chapter 2. Theodor Adorno, in spite of his truculent and unrelenting criticisms of Sartre's conception of commitment, nonetheless shared his view on *Guernica* and sought to extend it to the work of Bertolt Brecht: "Sartre's candid doubt about whether *Guernica* had 'won a single person to the Spanish cause' certainly holds true for Brecht's didactic drama as well."[2] These types of categorical judgments are largely founded on the assumption that the politics of art amounts to the potential for individual works to function as autonomous and sovereign sources of political transformation. In sharp counterdistinction to this approach, which is dependent upon the supposed autarchy of the isolated work of art, I maintain that it is essential to examine the complex and diverse ways in which aesthetic practices are intertwined with the social fabric and its political struggles. In the case of Picasso, for instance, it should be remembered that he provided direct financial support to the Spanish Republic and Republican exiles:

> *Guernica* was given to the Spanish Republic by Picasso, and he also conferred the 150,000 francs he had received for expenses to the fund for Republican exiles. The fund also benefited from the proceeds of the many charitable exhibitions of *Guernica* and its related works, and from the sale of the limited folio edition of *Songe et mensonge de Franco*. It has not been confirmed that Picasso actually financed the purchase of warplanes as has been alleged. Instead, he donated milk for the children in Barcelona. He signed numerous declarations in support of the Republic and became involved with several refugee relief organizations. He participated in fund-raising efforts such as exhibitions and auctions to benefit Spanish refugees, and was particularly active in securing the liberation of Spanish intellectuals from French internment camps. Mercedes Guillén, the wife of the Spanish sculptor Balthazar Lobo, recalled how helpful Picasso was in obtaining green cards for Spanish exiles.[3]

These were not simply individual acts of Picasso the citizen that could somehow be separated from those of Picasso the artist. They were actions rendered possible, in part, by his social status as an artist and the relative popularity as well as the financial success of *Guernica* and other works. Picasso himself recognized the fundamental impossibility of separating the artist from his or her social and political being: "What do you think an artist is? An imbecile who only has eyes if he is a painter, or ears if he's a musician, or a lyre at every level of his heart if he's a poet, or even, if he's a boxer, just his muscle? On the contrary, he is at the same time a political being, constantly alive to heart-rending, fiery or happy events to which he responds in every way."[4]

The peremptory judgments issued by Sartre and Adorno effectively illustrate the role of the interpreter within the framework of the ontological illusion and the talisman complex, which is to identify *the* politics of art, to determine *the* political effects of artistic endeavors once and for all. The guiding assumption is that art and politics are separate entities, and that each artistic object or practice has its own proper politics that can be objectively identified as such. The fundamental hermeneutic presupposition is hence that there is an *epistēmē* of art and politics, a strictly determined knowledge regarding the political efficacy or inefficacy of particular works. Moreover, it is widely assumed that the task of the interpreter is simply to describe what exists in the nature of things, so to speak. There is often, therefore, a short-circuit between subjectivity and objectivity insofar as the supposedly objective political effects of art are determined based on the subjective experience or point of view of the interpreter. In the worst cases, this leads to a complete uniformization of artistic reception via hermeneutic hegemony: a singular experience of a work of art or a specific judgment is hegemonically imposed as a general or even universal experience or judgment without considering the variability operative in the social reception of works of art.

The talisman complex often leads to the identification of a privileged meeting ground between art and politics or a prototypical form of political art. One can think, for instance, of Sartre's decision to focus on prose

writing as the only art form capable of being truly committed because it uses words to produce meaning. As we saw in the second chapter, he thereby restricts the entire discussion of artistic commitment—at least in *What Is Literature?*—to prose writing, whereas he holds music, painting, and poetry to be outside the field of commitment in the true sense of the term. One might also consider Georg Lukács's valorization of realism as the literary form capable of truly mirroring the deep forces of reality at work behind the fleeting appearances of the world. He thereby rejects what he refers to as the introversion of formalism and the extraversion of naturalism, neither of which are interested, according to him, in the social totality and the essential, subterranean mechanisms of historical development. Both thinkers end up producing relatively schematic formulas: *this* art is truly political and *that* art is not. Aside from a few important exceptions, which usually occur nonetheless within a rather rigid class determinism, there is little attempt to consider works of art as social objects in the sense of being polyvalent phenomena with a multiplicity of dimensions, nodal points in a complex of social relations that are irreducible to a single or definitive relationship.

The ontological illusion and the talisman complex are ultimately rooted in a social epoché: an individual thinker purports to determine the very being of art and politics, as well as the nature of their relationship, by setting aside their sociality and establishing a fixed, univocal determination of social phenomena. In other words, the social is bracketed by a transcendent, categorical determination of the nature of art and politics from a subjective point of view in the social field, which purports to grasp the objective nature of things. This ultimately leads to a fundamental impasse: if what we call politics necessarily has a social dimension, and the ontological illusion and talisman complex bring about a bracketing of the social, then they foreclose the possibility of actually thinking the political dimension of works of art, that is to say, their social politicity. More so than an impasse, this might be best described as a cul-de-sac insofar as the various authoritative statements on the particular political nature of works of art are destined to endlessly turn in circles around one another.

For claims cannot be mediated by an account of the social distribution and reception of works of art, nor can they be reinserted in a broader description of the ongoing social struggles over the supposed nature of art and politics.

This social epoché reduces works of art to a singular, atomistic existence and usually situates them in a binary normative framework in which there are only two possibilities: either a work of art helps advance a particular political agenda or it hinders it. There are thus only two viable judgments, and the task of the critic often becomes one of drafting a long list of authentic and inauthentic works. Such an approach excludes the complexity and variability of social phenomena such as works of art, which—instead of acting like fixed talismans with a single and unique power—can and do have variable effects at different levels that are irreducible to the simple opposition between positive and negative. For instance, it appears that R. W. Fassbinder, who is often presented as the quintessential German dissident, had at least some partial supporters on the right as well as among conventional members of the film industry. Indeed, he defended accepting money from conservatives in order to make complex politico-psychological films that do not allow for the easy identification of good and evil so common to moralizing political films. "If someone objects, as some of my friends do," Fassbinder brazenly declared, "that you shouldn't make films with the money of rightists, all I can say is that Visconti made almost all his films with money from rightists. And always justified it with similar arguments: that they gave him more leeway than the leftists."[5] Fassbinder is an excellent example not only of the ways in which works of art qua social phenomena are irreducible to the binary normative framework of good and evil, but also of the ways in which artists themselves have at times sought to undermine this very framework. To take but a single example, it is worth recalling how Fassbinder attacked—from the left, so to speak—mainstream feminism and gay rights advocates in *The Bitter Tears of Petra von Kant* (1972). In making a film about lesbian relationships, he adapted the story of Midas to the stage by focusing on a successful fashion designer who turns everything around her into petrified

objects through the ice-cold touch of her passion for possession. By staging the caustic sadomasochistic battles between Petra and the women in her life, Fassbinder audaciously contravened and ultimately deconstructed the essentialism operative in the acquiescent models of social-engineering multiculturalism, in which works of art are used to construct positive role models that supposedly break with the negative stereotypes of mass culture.

The compression and uniformization of the social dimension of works of art via a social epoché are often closely linked to a reductive conception of history, if not an outright exclusion of historicity through a historical epoché. In extreme cases, art and politics are presented as transhistorical or ahistorical constants, as if they had existed as discrete phenomena since time immemorial. When history is taken into account, as in much of the Marxist and neo- or post-Marxist tradition, for instance, it is often reduced to its vertical or chronological dimension. The horizontal dimension of the geographic distribution of events is thereby forgotten in favor of a more or less homogenous conception of periodic blocks of time, as if there were a *Zeitgeist* unifying all of the developments of a particular moment. Moreover, the complex strata of various social formations and practices tend to be occluded in favor of a more or less monolithic vision of society. By excluding both the horizontal dimension of geography and the stratigraphic dimension of social practice, historicity is thereby reduced to supposedly univocal blocks of time.

RETHINKING ART AND POLITICS

In order to reopen the question of the relations between art and politics in a new light, this book has sought to break with the ontological illusion in all of its forms: there is no being of art and politics, and there is no essential and unique relationship between them. In direct opposition to the conceptualist assumption that there is a fixed notion of art and politics, it maintains the position of radical historicism: art and politics have

no stable natures but are differentially constituted sociohistorical practices. Radical historicism, as we have see in previous chapters, should be carefully distinguished from reductive historicism, which consists in bringing all historical phenomena back to a fixed set of determinants. If everything is in history (radical historicism), this does not mean that everything can be explained by a series of historical determinants as if history were only a form of destiny (reductive historicism). The adjective *radical* indexes, among other things, the dynamic role of different forms of agency in history and the fact that historical developments are never absolutely and strictly determined. It also refers to the dissolution of the very objects of history: if history is radical, it is precisely insofar as its objects are only provisory formations in the torrent of time. It is for this reason that it is also important to distinguish the intransitive history of radical historicism, in which there are no absolute or fixed objects behind historical mutations, from the transitive history of selective historicism, which purports to separate the chaff of changing appearances from the true wheat of invariable entities. Art and politics are not simply historical in the sense that they have undergone changes over time. They are radically historical insofar as there is no being or essence that unifies them across time and space. Whereas historical theories of art and politics tend to be founded on selective historicism and the assumption that these are natural objects with their respective histories, the analytic of aesthetic and political practices begins the other way around, by exploring the complex set of relations that are labeled *art* and *politics* at diverse points in time and in variable geographic and social settings. This does not imply, of course, that there are not identifiable phenomena and immanent notions within a particular sociohistorical conjuncture. It simply means that these are not historical constants, but are rather the result of intricate sociohistorical negotiations and their institutional sedimentation. This is one of the reasons why radical historicism goes hand in hand with radical sociologism: all human phenomena develop in a social matrix, but this does not mean that they are reducible to a particular state of the social.

This book proposes, in nuce, to jettison the ontological illusion that undergirds much of the debate on art and politics in favor of a radical

historicist analytic of practice, according to which 'art' and 'politics' are recognized as sociohistorical concepts in struggle. Instead of searching for the privileged point of intersection or the natural link between them, it recognizes that various relations are constructed and dismantled in the social sphere through a series of ongoing battles (and that the critic plays a crucial role in these struggles). It is for these reasons, among others, that it has been crucial to reject the talisman complex, which reduces the politics of art to the supposedly inherent power of artistic objects and practices to provoke political consequences. Objects of art in their traditional sense do not have, in and of themselves, an innate political power.[6] They might very well be imbued with a particular political agenda or orientation, and they might embody strategies for transformation that should be seriously engaged with and diligently unpacked. However, this does not mean that they have a political force that can be identified once and for all as being part of their constitutive nature.

The critique of the talisman complex has required overcoming the social epoché. Instead of according pride of place to aesthetic products and their autonomous political force, an analytic of aesthetic practices focuses on the social dimension of these practices by studying not only the works themselves but also the complexities of their production, their distribution in society, and their reception by a public. In short, it is a matter of examining works of art as social phenomena instead of as isolated atoms with a supposedly innate political power. It is, of course, still necessary to analyze in detail the works themselves by studying their aesthetic logic, their propositions and strategies, their implicit political implications, and their potentialities. But these should be seen as part of the collective existence of works of art, and more specifically the social dimension of production. The latter also includes the sociohistorical conjuncture, the set of operative practices in this juncture, the cultural field of possibility, the social and economic forces at work, the material conditions of production, the artist's training and acquired dispositions, and everything else that goes into the act of producing particular works of art. To take a single example of the relevancy of this dimension to the

politicity of aesthetic practices, we can note that it is rather one-sided to critically dismantle the particular political agenda manifest in various Hollywood films if the product is not situated in relationship to a system of production in which, for instance, the Pentagon has played a central role by bartering military expertise and extremely expensive military equipment against the right to censorship. "Millions of dollars can be shaved off a film's budget if the military agrees to lend its equipment and assistance," writes David L. Robb in his book *Operation Hollywood*.[7] "And all a producer has to do to get that assistance," he goes on to write, "is submit five copies of the script to the Pentagon for approval; make whatever script changes the Pentagon suggests; film the script exactly as approved by the Pentagon; and prescreen the finished product for Pentagon officials before it's shown to the public."[8]

In addition to production, it is equally necessary to consider distribution and reception. Regarding the first of these terms, it is important to foreground the real social circulation of works of art by studying their accessibility, their cultural framing, the institutions that present them, and so forth. For instance, it is clear that the modern museum, which began to emerge around the end of the eighteenth century, has played a key sociopolitical role by making art—in principle—more accessible to the masses, solidifying and codifying a cultural heritage and shared conception of the past, and also linking national artistic traditions to the cultural identity of emerging nation-states. An institution like the museum has, moreover, played a significant role in the articulation of various aesthetico-political rejections of establishment art and bourgeois institutions since at least the end of the nineteenth century. To take a more specific example of a very different nature concerning the political dimensions of aesthetic distribution, it is interesting to note that John Pilger's documentary *The War on Democracy* (2007), which is in part an attack on the new political imaginary of the 'War on Terror,' was never distributed in the United States. Pilger writes that a major New York distributor said to him, "You will need to make structural and political changes. Maybe get a star like Sean Penn to host it—he likes liberal causes—and tame those anti-Bush sequences."[9]

Finally, concerning reception, it is imperative to recognize that works of art do not play univocal roles in the social matrix. They necessarily have a multidimensional social existence insofar as they are subject to different interpretations and points of view, but also to variable historical junctures, cultural contexts, and modes of social framing. We might take our cue—up to a certain point—from a statement made by Jean-Paul Sartre: "there is no art except for and by others [*il n'y a d'art que pour et par autrui*]."[10] In order for a work of art to function as such, it needs to circulate in society and have its own proper social existence, as limited as this may be. In so doing, it takes on a life of its own by being understood in various ways, put in relationship to different works, placed in sundry contexts, and so forth. This social life often extends well beyond the immediate conjuncture of emergence of the object or practice in question, which can frequently transit between different times and places.

This brings us to the role of the critic and interpreter. Rather than simply describing, from the sidelines, the politics supposedly inherent in isolated works of art, the critic plays a crucial role in the politicity of works by entering into the sociopolitical struggle over their reception. In addition to drawing out potentialities, the critic can also formulate arguments and politicize the work in various ways and according to a particular orientation. We should not assume, however, that the work is thereby necessarily sullied and debased, for the battles of interpretation are part of the social life of the work itself. This does not mean that there are not better or worse interpretations, but rather that this very distinction is negotiated through social institutions—in the broad sense—and the conflicts around them. Another way of putting this, as we have seen, is by extending one of Castoriadis's claims regarding politics: just as "there is no science of politics," there is no *epistémé* of art; there are only open-ended collective struggles over signification and value, as well as the sedimented consequences of past conflicts.[11] This is one of the reasons why it is essential to forsake the hermeneutic hegemony that consists in trying to pass off a personal interpretation for a universal attribute of a particular work or, in the language just evoked, making an informed opinion into a form of infallible

scientific knowledge (which does not mean that interpretation is infinitely open). The same is true, it must not be forgotten, of the interpretation of theoretical texts, and those advanced in this book as a whole are self-conscious interventions. They sometimes rely on the heuristic device of oppositional framing by pragmatically juxtaposing what might appear to be an absolutely true and a decidedly false view on the politics of art, but these are ultimately descriptive interventions and topological schematizations from a particular vantage point that aim at gaining traction in a specific sociohistorical conjuncture.

The dual position seeks to resolve these and other related problems. On the one hand, it is necessary to recognize the plural nature of artistic reception and abandon the naïve and self-serving belief in artistic *epistēmē*. On the other hand, such a recognition should by no means hinder us from intervening in the field of social negotiation in the name of a particular politicization of aesthetic practices (or, mutatis mutandis, a specific theoretical interpretation). In place of hermeneutic hegemony, we need pragmatic interventionism: the role of the interpreter is to intercede in a particular conjuncture to directly participate in the production of an artwork's politicity by formulating informed opinions on its political valence. This requires that we acknowledge the multiple dimensions of works of art in their social existence, and that we break with the simple binary normativity that has beleaguered a significant portion of the debate on art and politics by reducing it to categorical judgments opposing good and bad political art. The social inscription of artistic works is much more complicated than this schematic framework would lead us to believe.

We might consider in this regard Georg Lukács's attempt to make Honoré de Balzac's own political position and artistic intentions secondary to his unique brand of realism, which coalesced on his account with Marx's description of the history of capitalism, as we saw in chapter 2. Even if Balzac did provide a detailed portrait of the wretched social transformations caused by modern capitalism, it is difficult to deny that his work was read and appreciated by the bourgeoisie, and interpreted along more conservative

lines. In other words, his works were intertwined with diverse publics and various political orientations, and this reveals the extent to which they were not politically univocal, in spite of what Lukács might want to have us believe by identifying the true politics of Balzacian realism.

We could also consider one of Theodor Adorno's passing statements in a letter to Walter Benjamin in 1936: "The laughter of the audience at a cinema—I discussed this with Max [Horkheimer], and he has probably told you about it already—is anything but good and revolutionary; instead, it is full of the worst bourgeois sadism."[12] Here we have a case of the reduction of social reception to a univocal political meaning, as if everyone laughing in the cinema were manifesting the same fundamental trait. It is, of course, important to emphasize that this is only a passing statement made in a personal letter and that Adorno did not maintain this methodological orientation throughout his entire corpus. For instance, he occasionally invoked the split consciousness of the cultural consumer capable of seeing through the products of the culture industry while nonetheless indulging in them.[13] Nevertheless, in this particular proclamation he does purport to have access to *the* effect of laughter in the cinema per se (via, we can presume, his personal experience of individual films), thereby collapsing the density of the social fabric into a singular and monolithic framework of reception. He thus judges for everyone and in the place of everyone else. There is no attempt in this passing statement to take into account the multifaceted topography of the receivers of cultural production. Moreover, Adorno's operative normative categories clearly reveal the binary value system at work. There are apparently only two possibilities: either laughter at the cinema is good and revolutionary, or it is bad and reactionary. He excludes the possibility of variegated and differentiated forms of reception in favor of an overarching conclusion concerning the political meaning of laughter at the cinema in general. This is why the problem with his assessment is not its cultural conservatism but its method. Indeed, the opposite claim would have been equally problematic. The core issue is the extent to which abstract conceptualizations attempt to reduce social phenomena to

a single concept and unique value, as if they had a singular meaning. This presupposes *epistēmē* concerning the definitive nature of a multifaceted social event. Although this is by no means the place for such an investigation, it is certainly worth asking whether or not Adorno's assessment of jazz succumbs to the same series of problems.

CONCLUSION

Let us return to the core of matters and provide working labels for the two general positions we have been discussing. For the sake of argument, and without unduly rigidifying this heuristic distinction, the first might be generically referred to as *the politics of art* insofar as it is founded on the ontological illusion according to which each of these entities has a fixed being and a privileged relation that can be definitely described via the distinguished lens of *epistēmē*. The politics of art concentrates on the supposedly unique power of isolated talisman-like artifacts to produce—in a more or less monocausal fashion—political effects and generally assumes that the role of the interpreter is to authoritatively make claims regarding the nature of art in general or the singular political meaning of particular works. Rather than separating art from its social inscription, rarifying politics as a discrete element, and then searching for their supposedly privileged link, I have sought to break with the politics of art in this sense in favor of examining and participating in the social politicity of aesthetic practices. This has meant undermining the ontological illusion and the talisman complex by a radically historicist analytic of practice, which reveals that there is no being of art and politics or privileged relation between them. Instead, these are sociohistorical concepts in struggle. It has therefore been absolutely essential to abandon the social epoché that has acted as a bulwark against understanding the social politicity of works of art in order to analyze three heuristically distinct social dimensions of aesthetic practices: production, distribution, and reception. This has not

condemned us, however, to simply describing these various dimensions from the sidelines, so to speak. On the contrary, occupying the dual position has allowed us to simultaneously recognize the polyvalent status of artwork and pragmatically intervene in the sphere of collective negotiations with strong arguments concerning the political elements operative in various aesthetic practices. This displacement from what we are here calling the politics of art to the social politicity of aesthetic practices has sought, in general, to open novel space for rethinking the complex relationships between what is schematically referred to as 'art' and 'politics.'

CONCLUSION

Radical Art and Politics—No End in Sight

RADICAL HISTORICIST PRAXEOLOGY

One of the primary objectives of this book has been to modify the groundwork for debates on art and politics. It has sought to combat what is arguably the fundamental assumption that has beset many of the previous controversies on this issue: that art and politics are distinct entities definable in terms of common properties, and that—if they do interact—they have privileged points of intersection, which can be determined once and for all in terms of stable formulas. This common-sense supposition is rooted in an illusion of transcendence insofar as it is presumed that there are more or less fixed characteristics that unify our terms, concepts, and practices in such a way as to guarantee their meaning. Against this substantialist and ontologizing approach to art and politics, this book has argued for a relational and praxeological account that begins the other way around by examining specific cultural practices without presupposing a conceptual unity behind them. Such an orientation is radically historicist in the sense that it recognizes that all of our practices—be they linguistic, theoretical, aesthetic, or political—are historically constituted and that they are necessarily part of a temporal dynamic. In fact, any of the supposed identities produced within this dynamic are only temporary formations. Hence,

in the grand scheme of things, the labels used to classify various practices, or even identify practice as such, are contingent. Radical history thereby proposes a significant departure from the extant debates on art and politics by maintaining that there is no art or politics in general, nor a singular relation between them. There are historically constituted and constituting practices in immanent force fields of action where activities labeled as artistic or political—if they do exist—form sites of social struggle.

The praxeological orientation of a radical historicist analytic of practice changes the very nature of the questions that are raised. The problem is no longer 'what is *the* relationship between art and politics?' It is 'how do the diverse aspects of practices identified as aesthetic and political overlap, intertwine, and sometimes merge in precise sociohistorical conjunctures?' Instead of distinct entities whose relations can be described in terms of fixed recipes, there are variably constituted aesthetic practices with a dynamic social politicity. This does not mean that they have an inherent politics, but rather that they are socially inscribed loci of struggle between competing forces identified as political, be it at the level of their production, their distribution, or their reception. One of the concrete tasks of this book has therefore been to chart out specific manifestations of the social politicity of aesthetic practices while simultaneously intervening in order to try to gain leverage over the very battlefield where these take place.

Part 1 juxtaposed the approach advanced in this book as a whole with some of the fundamental methodological assumptions that have framed a significant portion of the twentieth-century debate on art and politics, ranging from the ontological and epistemic illusions to the social epoché, the talisman complex, binary normativity, historical compression, and reductive and selective historicism. Against this backdrop, part 2 then sought to reopen the question of the avant-garde in a new light by critically dismantling the end of illusions thesis and mobilizing an alternative historical order and theory of social agency. Part 3 analyzed the major contribution of Jacques Rancière to contemporary debates on aesthetics and politics in order to both come to terms with his important work and underscore its limitations. Finally, part 4 proposed a detailed case study of the social

I use the term for [handwritten marginal note]

politicity of purportedly apolitical art and further developed some of the central arguments made in the book as a whole.

Instead of a sequential narrative or developmental thesis, this work has juxtaposed and superimposed a series of circumscribed investigations into the historical encounters between artistic and political practices. The preceding parts thereby form a palimpsest with multiple entrance points and various levels and objects of analysis. The individual layers can be read separately, but they ultimately permeate and inform one another through reciprocal resonance. The book's overall structure seeks to performatively resemble, therefore, a radical history of overlapping and intertwining constellations that form a dense palimpsest devoid of rigid borders.

THE SOCIAL AGENCIES OF RADICAL HISTORY

A radical historicist analytic of aesthetic and political practices aims at charting out immanent force fields of activity without presupposing the existence of transcendent ideas, transhistorical constants, or sociocultural invariants. This does not mean that the concepts and practices of art and politics are infinitely variable, nor does it imply, for that matter, that they are reducible to a fixed set of epochal determinants. Indeed, one of the tasks of this book has been to propose a logic of history that allows us to map historical developments in terms of three axes: the chronological dimension of time, the geographic dimension of space, and the stratigraphic dimension of social practice. This historical order goes hand in hand with an alternative account of historical change in terms of metastatic transformations that are unequally distributed through the three dimensions of history and develop according to specific rhythms of progression and regression within distinct foyers of alteration. Moreover, it provides us with the tools necessary for charting out specific constellations of practices within historical phases that are uniquely disseminated in social space-time. In this regard, one of the central arguments has been that instead of transcendent ideas or transhistorical practices (such as Art and Politics), there are only specific conceptual

3 axes: time, space, social prac. [handwritten marginal note]

historical change in above [handwritten marginal note]

networks and practical fields of activity that are—or are not—immanent to particular constellations of social practice situated in the three dimensions of history. These are properly speaking contingent precisely insofar as they are the result of arbitrary historical developments, but they impose themselves with the force of necessity in specific conjunctures.

Radical history, qua intransitive history, not only dissolves supposedly natural objects into the three dimensions of history. It also shuns the determinism of reductive or reductionist historicism by emphasizing the important role played by the multiple types, tiers, and sites of agency that animate sociohistorical force fields. These are irreducible to the binary oppositions between freedom and determinism, individual and society. Indeed, the very idea of a force field suggests that there are numerous agencies at work, with different levels of determination and variable ranges. In the case of what is called aesthetics, it is therefore a mistake to search for a singular political valence inherent in artistic objects or practices as such, as if it were necessary to perform a social epoché in order to discover the one true politics at the talisman-like core of an isolated aesthetic artifact. Instead, it is important to examine the overlapping constellations of the often conflicting and rival agencies at work in all three of the heuristically distinct social dimensions of artistic practices: production, circulation, and reception.

The social politicity of aesthetic practices is woven out of diverse forms and sites of agency that participate in ongoing struggles. Since these are inscribed in an open-ended history and the social life of works of art can be quasi-perennial (which is not the same thing as eternal), what is often called the 'politics of art' is in fact a politics without end. It cannot be determined once and for all by ontological deduction. The immanent force field of various struggles can be mapped out in order to provide an operative, topological understanding of the dynamics involved and attempt to gain leverage over them. It is also possible to intervene in this force field in order to make strong arguments regarding the political relevancy of certain aesthetic practices. It is not, however, possible to halt all debate and draw definitive conclusions that are valid across the board because the social politicity of aesthetic practices is part of interminable battles between multiple forms,

tiers, and sites of agency. Rather than putting an end to these struggles, this book has sought to develop an alternative historical order and social logic in order to both map and intervene in them. It is very important to emphasize, in this regard, that it does not lay claim to the true and invariable nature of history and society (although it has sometimes pragmatically relied on oppositional schematizations for the sake of argument). It recognizes that its propositions form an intervention, meaning a situated and anchored attempt to intercede in the current conjuncture and leverage it in the direction of a radical historicist analytic of practice.

NO END IN SIGHT

The introduction to this book opened with a problematization of the typical point of departure for debates on art and politics, and it proposed a significant departure from it. It therefore makes sense to conclude by focusing on the question of ends and returning to one of the underlying issues of this work as a whole: the status of the widespread consensus that the era of revolutionary politics and radical art—if it ever truly existed—is definitively behind us. Such a view implicitly presents our age, as we saw in chapter 3, as the enlightened era of the end of political and artistic illusions. Whereas our benighted predecessors might have been naïve enough to believe that they could actually change the course of history through artistic and political interventions, we now supposedly know that such fatuous endeavors were foolishly misguided.

The end of illusions thesis is founded on a reductionist historicism that levels the social field of agency. It reduces history to destiny, thereby negating—in advance—the possibility that agents could alter the predestined course of historical development. According to the implications of this thesis, the true end of history is not a political or aesthetic utopia. It is an epistemological and historiographical meta-utopia in which we are capable of definitively knowing—through a form of absolute knowledge attained at the end of history—the entire spectrum of historical possibility.

The radical historicist orientation does not propose to counter the end of illusions thesis by defiantly insisting on the existence of an essential link between art and politics, or more specifically between radical art and revolutionary politics. Instead, it attacks the theoretical coordinates that the end of illusions thesis shares with its structural opposite: the substantialist ontology that presumes that there are two separate entities—art and politics—that may or may not be linked by privileged points of intersection. By displacing this substantialist ontology in favor of a sociohistorical praxeology, radical history seeks to change the very terms of the debate. Rather than there being clearly definable entities that can or cannot be linked, there are immanently constituted and constituting practices—and modes of conceptualization—that intertwine and overlap in diverse ways within a variegated social topography.

Radical history subverts the reductionist historicism of the end of illusions thesis as well as its leveling of social agency. It recognizes that there is not a single plane of determination, but that the immanent field of practice is the site of multiple types and points of agency, with variable ranges and levels of determinacy. It is therefore impossible to establish once and for all the true or authentic relationship between aesthetic and political practices. This is not simply because there is not a single relationship; it is also because the variable relations between aesthetic and political practices are fought out in open-ended social battles. There is ultimately no end of history when the latter is understood as radical history.

NOTES

1. FOR A RADICAL HISTORICIST ANALYTIC OF AESTHETIC AND POLITICAL PRACTICES

1. Ludwig Wittgenstein, *The Blue and Brown Books: Preliminary Studies for the "Philosophical Investigations"* (New York: Harper and Brothers, 1958), 1. Wittgenstein dictated these working notes, which were not destined for publication, to his students at Cambridge, and he had stenciled copies made.

2. Ibid., 19–20. See also Ludwig Wittgenstein, *Philosophical Investigations*, trans. G. E. M. Anscombe (Oxford: Blackwell, 1997), 31–32.

3. Wittgenstein, *The Blue and Brown Books*, 27.

4. Ibid., 17.

5. "Here the term 'language-*game*,'" Wittgenstein writes, "is meant to bring into prominence the fact that the *speaking* of language is part of an activity, or of a form of life [*Lebensform*]." Wittgenstein, *Philosophical Investigations*, 11; see also ibid., 81.

6. Wittgenstein, *The Blue and Brown Books*, 25; see Wittgenstein, *Philosophical Investigations*, 39.

7. Wittgenstein, *The Blue and Brown Books*, 17. This does not, of course, mean that these primitive language games are incomplete parts of a language that are later systematized.

8. Wittgenstein, *Philosophical Investigations*, 11; see also ibid., 8 and 39.

9. Ludwig Wittgenstein, *Lectures and Conversations on Aesthetics, Psychology, and Religious Belief*, ed. Cyril Barrett (Oxford: Blackwell, 1967), 1. Wittgenstein himself did not directly write any of these lectures. They were compiled from students' notes, which he did not review.

10. Ibid., 1.

11. Ibid., 8; see also ibid., 9 and 32, as well as Wittgenstein, *Culture and Value*, ed. Georg Henrik von Wright in collaboration with Heikki Nyman, trans. Peter Winch (Malden, Mass.: Blackwell, 1998), 89, 91, 98.

12. Wittgenstein, *Lectures and Conversations on Aesthetics*, 34; see also ibid., 8–9, 12, 30.

13. See ibid., 9.

14. Wittgenstein, *The Blue and Brown Books*, 28.

15. Wittgenstein, *Philosophical Investigations*, 33; see also ibid., 34.

16. Ibid., 33; see also ibid., 36; and Wittgenstein, *The Blue and Brown Books*, 19.

17. This working typology is partially inspired by Maruška Svašek's distinction between transit and transition in Svašek, *Anthropology, Art and Cultural Production* (London: Pluto, 2007).

18. Although the term *practico-inert* is borrowed from Sartre's *Critique of Dialectical Reason*, I am not using it in strict conformity with his thought.

19. Wittgenstein, *Philosophical Investigations*, 48.

20. Wittgenstein, *The Blue and Brown Books*, 18; see also ibid., 125, as well as Wittgenstein, *Philosophical Investigations*, 47, 50.

21. Wittgenstein, *Philosophical Investigations*, 49; Herbert Marcuse, *One-Dimensional Man* (Boston: Beacon, 1964), 175.

22. Wittgenstein, *Lectures and Conversations on Aesthetics*, 7, 11.

23. Wittgenstein, *The Blue and Brown Books*, 28.

24. I have developed more comprehensive accounts of both of these authors in the following articles: Rockhill, "Recent Developments in Aesthetics: Badiou, Rancière and Their Interlocutors," in *The History of Continental Philosophy*, ed. Alan Schrift, vol. 8, *Emerging Trends in Continental Philosophy*, ed. Todd May (Durham: Acumen Press, 2011), 31–48; and Rockhill, "Eros of Inquiry: An Aperçu of Castoriadis' Life and Work," in *Postscript on Insignificance: Dialogues with Cornelius Castoriadis*, by Cornelius Castoriadis, ed. Gabriel Rockhill, trans. Gabriel Rockhill and John V. Garner (London: Continuum, 2011), ix–xxxix.

25. For a poignant and incisive critique of Badiou's Platonist aesthetics, see Rancière, *The Politics of Literature* (Cambridge: Polity, 2011), 183–205; and Rancière "Aesthetics, Inaesthetics, Anti-Aesthetics," in *Think Again: Alain Badiou and the Future of Philosophy*, ed. Peter Hallward (London: Continuum, 2004), 218–31.

26. See Castoriadis, *The Castoriadis Reader*, ed. and trans. David Ames Curtis (Oxford: Blackwell, 1997), 315; Castoriadis, *Domaines de l'homme* (Paris: Éditions du Seuil, 1986), 521; Castoriadis, *Figures of the Thinkable*, trans. Helen Arnold (Stanford: Stanford University Press, 2007), 171.

27. Castoriadis, *Domaines de l'homme*, 347.

28. Castoriadis, *La montée de l'insignifiance* (Paris: Éditions du Seuil, 1996), 75.

29. See Castoriadis, *Fenêtre sur le chaos* (Paris: Éditions du Seuil, 2007), 25; Castoriadis, *Domaines de l'homme*, 344.

30. Ibid., 347.

31. Paul Oskar Kristeller, *Renaissance Thought and the Arts: Collected Essays* (Princeton: Princeton University Press, 1990), 165. See also R. G. Collingwood, *The Principles of Art* (London: Oxford University Press, 1958), 5–7.

32. Kristeller, *Renaissance Thought*, 166.

33. Ibid., 177–78.

34. Ibid., 166.

35. See Larry Shiner, *The Invention of Art: A Cultural History* (Chicago: University of Chicago Press, 2001). See also Dominique Poulot, *Musée, nation, patrimoine, 1789–1815* (Paris: Éditions Gallimard, 1997) and the following works by Nathalie Heinich: *Du peintre à l'artiste: artisans et académiciens à l'âge classique* (Paris: Les Éditions de Minuit, 1993); *Être artiste: les transformations du statut des peintres et des sculpteurs* (Paris: Klincksieck, 1996); and *L'élite artiste: excellence et singularité en régime démocratique* (Paris: Éditions Gallimard, 2005).

36. Jacques Rancière, *The Politics of Aesthetics*, ed. and trans. Gabriel Rockhill (London: Continuum, 2004), 23; Raymond Williams, *Keywords: A Vocabulary of Culture and Society* (New York: Oxford University Press, 1983), 41.

37. James Clifford, *The Predicament of Culture: Twentieth-Century Ethnography, Literature, and Art* (Cambridge, Mass.: Harvard University Press, 1994), 196.

38. Ibid., 226.

39. See, for example, his references to great art and the creative genius, such as his discussion of what appears to be the common property of all great art in Wittgenstein, *Culture and Value*, 43: "Within all great art there is a WILD animal: tamed. . . . All great art has primitive human drives as its ground bass."

40. One question worth exploring is whether or not the social function of 'heap' in formal logic is as a transcendent idea.

41. Jorge Luis Borges, *Collected Fictions*, trans. Andrew Hurley (New York: Penguin, 1998), 325.

42. Ibid.

43. Max Weber, *Sociological Writings*, ed. Wolf Heydebrand (New York: Continuum, 1994), 264. Weber claims that "the construction is merely a technical aid which facilitates a more lucid arrangement and terminology." Weber, *From Max Weber: Essays in Sociology*, ed. H. H. Gerth and C. Wright Mills (New York: Oxford University Press, 1958), 324.

44. Castoriadis, *Postscript on Insignificance*, 11.

45. Friedrich Schiller, *On the Aesthetic Education of Man in a Series of Letters*, trans. Reginald Snell (New York: Continuum, 1990), 61–62.

46. This section develops themes that I have explored in detail in *Logique de l'histoire: pour une analytique des pratiques philosophiques* (Paris: Éditions Hermann, 2010).

47. "A given world, whether everyday or scientific," writes Kuhn, "is not a world of stimuli." Kuhn, *The Essential Tension* (Chicago: University of Chicago Press, 1977), 309.

48. See Norbert Elias, *Time: An Essay*, trans. Edmund Jephcott (Cambridge, Mass.: Blackwell, 1992).

49. Giambattista Vico, *New Science*, trans. David Marsh (London: Penguin, 1999), 12.

50. Eric Hobsbawm, *The Age of Revolution, 1789–1848* (New York: Vintage, 1996), 270.

51. Ibid., 261.

52. Siegfried Kracauer, *History: The Last Things Before the Last* (Princeton: Markus Wiener, 1995), 183.

53. Allen Ginsberg, "T. S. Eliot Entered My Dreams," *City Lights Journal* 4 (Spring 1978): 61, 63.

54. Ibid., 63.

55. Although I am borrowing the vocabulary of the "grey zone" from Primo Levi's *The Drowned and the Saved*, I am not using it in strict conformity with his analysis.

56. On this issue, see Andrea Fraser, "From the Critique of Institutions to an Institution of Critique," *Artforum* 44, no. 1 (September 2005): 278–83.

57. Cited in Katya García-Antón, "Buying Time," in *Santiago Sierra: Works, 2002–1990* (Birmingham, UK: Ikon Gallery, 2002), 15.

58. Bertolt Brecht, "Against Georg Lukács," in *Aesthetics and Politics*, by Theodor Adorno, Walter Benjamin, Ernst Bloch, Bertolt Brecht, and Georg Lukács (London: Verso, 2002), 81. See also Brecht, *Brecht on Theatre: The Development of an Aesthetic*, ed. and trans. John Willett (New York: Hill and Wang, 1997), 68.

59. Brecht, "Against Georg Lukács," 82.

60. Brecht, *Brecht on Theatre*, 135.

61. Brecht, "Against Georg Lukács," 74.

62. Johann Hari, "Protest Works: Just Look at the Proof," *Independent*, October 29, 2010.

63. Ibid.

64. Ibid.

65. Ibid.

66. Ibid.

2. REALISM, FORMALISM, COMMITMENT: THREE HISTORIC POSITIONS ON ART AND POLITICS

1. Maynard Solomon, ed., *Marxism and Art* (Detroit: Wayne State University Press, 1979), 187.

2. The exposé that follows draws extensively on my study of Lukács, entitled "Critique de la doxa moderniste: pertinence contemporaine et limites méthodologiques," in *L'actualité de Georg Lukács*, ed. Pierre Rusch and Ádám Takács (Paris: Archives Karéline, 2013), 111–33.

3. For Lukács's later criticisms of Zhdanov, see, for instance, his preface to *Writer and Critic, and Other Essays*, ed. and trans. Arthur D. Kahn (New York: Universal Library, 1974).

4. Lee Baxandall and Stefan Morawski, eds., *Marx and Engels on Literature and Art* (St. Louis: Telos Press, 1973), 105; see also ibid., 112 and 115.

5. William Shakespeare, *Hamlet*, in *The Norton Shakespeare*, ed. Stephen Greenblatt (New York: Norton, 1997), p. 1707, act 3, scene 2. See Georg Lukács, *Studies in European Realism* (New York: Grosset and Dunlap, 1964), 13.

6. Georg Lukács, *The Meaning of Contemporary Realism*, trans. John and Necke Mander (London: Merlin Press, 1972), 75; originally published as Georg Lukács, *Wider den mißverstandenen Realismus* (Hamburg: Claassen, 1958), 84. Since this English translation takes great liberties with the original text, at times rendering it unrecognizable, all of the passages from this work have been retranslated from the German and the original pagination has been provided.

7. Lukács, *The Meaning of Contemporary Realism*, 34; *Wider den mißverstandenen Realismus*, 34.

8. Lukács, *The Meaning of Contemporary Realism*, 74–75; *Wider den mißverstandenen Realismus*, 83.

9. *Hamlet*, p. 1708, act 3, scene 2.

10. Georg Lukács, "Realism in the Balance," in *Aesthetics and Politics: The Key Texts of the Classic Debate Within German Marxism*, by Theodor Adorno, Walter Benjamin, Ernst Bloch, Bertolt Brecht, and Georg Lukács (London: Verso 2002), 56–57.

11. See Lukács, *The Meaning of Contemporary Realism*, 133–35; *Wider den mißverstandenen Realismus*, 150–53.

12. Lukács, *The Meaning of Contemporary Realism*, 19; *Wider den mißverstandenen Realismus*, 15–16.

13. Lukács, *The Meaning of Contemporary Realism*, 19; *Wider den mißverstandenen Realismus*, 16.

14. Lukács, *The Meaning of Contemporary Realism*, 20; *Wider den mißverstandenen Realismus*, 16.

15. Lukács, *The Meaning of Contemporary Realism*, 26; *Wider den mißverstandenen Realismus*, 24.

16. Lukács, *The Meaning of Contemporary Realism*, 63; *Wider den mißverstandenen Realismus*, 69.

17. See Lukács, *The Meaning of Contemporary Realism*, 71; *Wider den mißverstandenen Realismus*, 79–80. For Lukács's critique of commitment, see, for instance, Lukács, *Writer and Critic*, 85, 199.

18. Lukács, *Studies in European Realism*, 78.

19. Ibid., 22.

20. Lukács, *The Meaning of Contemporary Realism*, 25; *Wider den mißverstandenen Realismus*, 23.

21. See Brecht's insightful critique in "Against Georg Lukács," in Adorno et al., *Aesthetics and Politics*, 68–85.

22. Lukács, *The Meaning of Contemporary Realism*, 45; *Wider den mißverstandenen Realismus*, 48.

23. Lukács, *The Meaning of Contemporary Realism*, 48; *Wider den mißverstandenen Realismus*, 50.

24. He also speaks of the "self-dissolution of the aesthetic." Lukács, *The Meaning of Contemporary Realism*, 46; *Wider den mißverstandenen Realismus*, 48.

25. Lukács, *The Meaning of Contemporary Realism*, 53; *Wider den mißverstandenen Realismus*, 57.

26. This is a constant theme in other works, such as *Writer and Critic* (see 20, 74, 77).

27. Lukács did recognize, particularly in *Die Eigenart des Ästhetischen*, that total knowledge of reality could only be approximated, while nonetheless remaining an ideal.

28. Theodor Adorno, "Reconciliation Under Duress," in Adorno et al., *Aesthetics and Politics*, 151.

29. Herbert Marcuse, *Art and Liberation*, ed. Douglas Kellner (London: Routledge, 2007), 195.

30. See, for instance, Herbert Marcuse, *An Essay on Liberation* (Boston: Beacon, 1969), 32, 48.

31. It is revealing that the subtitle of Marcuse's book was at one point *A Marxist Critique of Marxist Aesthetics*. See Douglas Kellner, "Introduction: Marcuse, Art, and Liberation," in Marcuse, *Art and Liberation*, 60.

32. Herbert Marcuse, *The Aesthetic Dimension: Toward a Critique of Marxist Aesthetics* (Boston: Beacon, 1978), 19.

33. Ibid., xii.

34. Marcuse, *Art and Liberation*, 60.

35. Marcuse, *The Aesthetic Dimension*, 11, 29, 16.

36. Ibid., x.

37. Ibid., 9.

38. Marcuse, *Art and Liberation*, 219.
39. Ibid.
40. Ibid.
41. Ibid., 142.
42. Ibid., 191.
43. Ibid.
44. Marcuse, *The Aesthetic Dimension*, 8.
45. Ibid., 41.
46. Ibid., 8. See also Marcuse, *Art and Liberation*, 119: "Form assembles, determines, and bestows order on matter so as to give it an end."
47. Marcuse, *Art and Liberation*, 141.
48. See ibid., 125; and Marcuse, *The Aesthetic Dimension*, 6.
49. Marcuse, *The Aesthetic Dimension*, 7–8.
50. Ibid., 53.
51. See, for instance, Marcuse, *Art and Liberation*, 219.
52. Renato Poggioli, *The Theory of the Avant-Garde*, trans. Gerald Fitzgerald (Cambridge, Mass.: Belknap Press of Harvard University Press, 1968), 95.
53. See Marcuse, *Art and Liberation*, 192: "Duchamp's urinal remains a urinal even in the museum or gallery; it carries its function with it—as suspended, 'real' function: a pisspot! Conversely, a picture of Cézanne remains a picture by Cézanne even in the toilet."
54. Marcuse, *The Aesthetic Dimension*, 53.
55. It is, of course, important to recall that the Frankfurt School's defense of aesthetic form was, in part, a response to the fascist attack on modernism—epitomized by the Nazi assault on "degenerate art"—as well as to the explosive rise of consumer culture and the entertainment industry under mass-market capitalism. Obviously, a similar contextualization could help make sense of some of the positions taken by Lukács and Sartre, which were also clearly anchored in specific sociohistorical force fields (including, for instance, the vicissitudes of twentieth-century communism and the postwar literary purges).
56. Marcuse, *The Aesthetic Dimension*, 22.
57. Marcuse, *Art and Liberation*, 118; see also ibid., 122.
58. Marcuse, *The Aesthetic Dimension*, xii–xiii. See also Marcuse, *Art and Liberation*, 183, 229–30.
59. Marcuse, *Art and Liberation*, 160.
60. Ibid., 161; see also ibid., 181.
61. Ibid., 129.
62. See Marcuse, *The Aesthetic Dimension*, 32, 49.
63. Marcuse, *Art and Liberation*, 226; see also ibid., 186.
64. See ibid., 227–28, 230, 235.
65. In some of his earlier writings, Marcuse of course argued for a closer proximity between aesthetic transformation and revolutionary change: "the revolution must be at the same time a revolution in perception which will accompany the material and intellectual reconstruction of society, creating the new aesthetic environment." Marcuse, *An Essay on Liberation*, 37.

66. Marcuse, *Art and Liberation*, 122.

67. As we will see in chapter 6, Marcuse's stance is remarkably similar to the position that Jacques Rancière ultimately maintains.

68. Marcuse, *Art and Liberation*, 181.

69. On the evolution of Sartre's stance on politics, see Thomas Flynn, *Sartre, Foucault, and Historical Reason*, vol. 1, *Toward an Existentialist Theory of History* (Chicago: University of Chicago Press, 1997); Michael Scriven, *Jean-Paul Sartre: Politics and Culture in Postwar France* (London: MacMillan; New York: St. Martin's Press, 1999); and Jean-François Sirinelli, *Sartre et Aron, deux intellectuels dans le siècle* (Paris: Librairie Arthème Fayard, 1995).

70. See Jean-Paul Sartre, *"What Is Literature?," and Other Essays* (Cambridge, Mass.: Harvard University Press, 1988), 34–35; and Sartre, *La responsabilité de l'écrivain* (Lagrasse: Éditions Verdier, 1998), 10–11.

71. Judging from his writings collected in *Un théâtre de situations*, Sartre also maintains that film and drama have certain fundamental traits that clearly delimit their respective domains, even in the case of hybrid aesthetic forms. Sartre, *Un théâtre de situations*, ed. Michel Contat and Michel Rybalka (Paris: Éditions Gallimard, 1973).

72. It is noteworthy in this regard that Sartre's studies of literature problematically focus on a time period—the nineteenth century—when the supposed differences between artistic genres were under assault by many of the figures central to his concerns, including Baudelaire and Mallarmé.

73. Sartre by no means maintained this stark opposition between poetry and prose in all of his work. In fact, in "Black Orpheus," which was published the same year as *What Is Literature?*, he discussed the functional and committed aspects of "black poetry." See Sartre, *What Is Literature?*, 289–330.

74. Ibid., 28.

75. Sartre explains in a long endnote that poetic commitment, at least in its contemporary form, can only be a commitment to communicative failure and thus to the reign of the incommunicable. This absolute valorization of failure, which he refers to as the "original attitude of contemporary poetry," stands in stark contrast to the prose writer's commitment to communicative success. Ibid., 334.

76. Ibid., 54.

77. Ibid., 81.

78. See Anna Boschetti, *Sartre et "Les Temps Modernes"* (Paris: Les Éditions de Minuit, 1985).

79. Sartre, *What Is Literature?*, 72 (translation slightly modified).

80. In an interesting interview in 1961, Sartre claimed that a novel written about a hero who dies in the Resistance due to a commitment to freedom would be too simple of a solution. Sartre, *Un théâtre de situations*, 166.

81. At this point in his political career, Sartre maintained a Marxian position that was openly hostile to the French Communist Party (an animosity that continued until approximately the beginning of the Korean War in June 1950).

82. Sartre explains that the Church used oral communication as well as a "language simpler than writing: the image" to inculcate both barons and the illiterate masses. Sartre, *What Is*

Literature?, 83 (translation slightly modified). Although he does not develop this passage, it certainly appears that the Church's image-writing is an example of the use of the fine arts to communicate meaning in much the same way as prose writing.

83. Ibid., 104.

84. Ibid., 94.

85. Ibid., 118 (translation slightly modified).

86. Ibid., 113 (translation slightly modified).

87. Ibid., 116 (translation slightly modified).

88. Ibid., 137 (translation slightly modified).

89. Sartre's history of drama in *Un théâtre de situations* includes at least one significant exception: Corneille rejected the psychological theater of the classical age and anticipated contemporary situationist theater by depicting free human beings in their total situation. See Sartre, *Un théâtre de situations*, 58–60.

90. On this point, see Boschetti, *Sartre et "Les Temps Modernes,"* esp. 246–50.

91. It is worth noting that Sartre was aware that there were exceptions to the general rules he established. See Sartre, *What Is Literature?*, 132–33.

3. THE THEORETICAL DESTINY OF THE AVANT-GARDE

1. Thierry de Duve, "Fonction critique de l'art? Examen d'une question," in *L'art sans compas: redéfinitions de l'esthétique*, ed. Christian Bouchindhomme and Rainer Rochlitz (Paris: Les Éditions du Cerf, 1992), 14.

2. On this issue, see Russell A. Berman, *Modern Culture and Critical Theory: Art, Politics, and the Legacy of the Frankfurt School* (Madison: University of Wisconsin Press, 1989), 43–44.

3. As in the previous chapter, I will concentrate primarily on the analytic position found in a single book, while also tracing out its theoretical developments in other works.

4. Jürgen Habermas, *The New Conservatism: Cultural Criticism and the Historians' Debate*, ed. and trans. Shierry Weber Nicholsen (Cambridge, Mass.: MIT Press, 1990), 68.

5. Ibid., 68–69.

6. Jürgen Habermas, "Modernity—An Incomplete Project," in *The Anti-Aesthetic: Essays on Postmodern Culture*, ed. Hal Foster (Seattle: Bay Press, 1983), 11.

7. Peter Uwe Hohendahl, "From the Eclipse of Reason to Communicative Rationality and Beyond," in *Critical Theory: Current State and Future Prospects*, ed. Peter Uwe Hohendahl and Jaimey Fisher (New York: Berghahn, 2001), 19.

8. There are at least two other problematic tendencies that are worth highlighting in passing: the severing of psychoanalysis from the project of critical theory, as well as the general eschewal of economics.

9. See, in particular, Nancy Fraser, *Justice Interruptus: Critical Reflections on the "Postsocialist" Condition* (New York: Routledge, 1997).

10. Peter Bürger, "Avant-Garde and Neo-Avant-Garde: An Attempt to Answer Certain Critics of *Theory of the Avant-Garde*," *New Literary History* 41 (2010): 700, 698. Bürger does add

this important qualification: "Measured against their goals and the hopes that they carried, all revolutions have failed: this fact does not lessen their historical significance." Ibid., 700.

11. Ibid., 711–12. Bürger also refers to what he calls "the revolutionary illusion of the student movement of '68." Bürger, "Pour une définition de l'avant-garde," in *La Révolution dans les lettres: textes pour Fernand Drijkoningen*, ed. Henriette Ritter and Annelies Schulte Nordholt (Amsterdam; Atlanta: Editions Rodopi, 1993), 23.

12. Bürger avers that Cubism "is part of the historic avant-garde movements, although it does not share their basic tendency (sublation [*Aufhebung*] of art in the praxis of life)." Bürger, *Theory of the Avant-Garde*, trans. Michael Shaw (Minneapolis: University of Minnesota Press, 1996), 109. Italian Futurism and German Expressionism attack "art as an institution" and thereby qualify, "with certain limitations," as part of the historical avant-garde (ibid.).

13. Ibid., 47.

14. Ibid.

15. Ibid., 46.

16. Peter Bürger and Christa Bürger, *The Institutions of Art*, trans. Loren Kruger (Lincoln: University of Nebraska Press, 1992), 4–5; see also ibid., 33 and 72.

17. Bürger, *Theory of the Avant-Garde*, 41–42 (translation slightly modified).

18. Ibid., 42 (translation slightly modified, my emphasis).

19. Bürger, "Avant-Garde and Neo-Avant-Garde," 699. Idealist aesthetics seems to be founded, for Bürger, on the assumption that the autonomy of art is an eternal—rather than historical—truth. See ibid., 707. For his most sustained critique of "idealist aesthetics," see Bürger, "Pour une critique de l'esthétique idéaliste," in *Théories esthétiques après Adorno*, ed. Rainer Rochlitz (Arles: Actes Sud, 1990), 171–246.

20. Bürger, *Theory of the Avant-Garde*, 98. See also Bürger, *The Institutions of Art*, 9; and Bürger, "Pour une critique de l'esthétique idéaliste," 177.

21. Bürger, *The Institutions of Art*, 6.

22. Marjorie Perloff, Review of *Les Avant-gardes littéraires au XXe siècle* by Jean Weisgerber and *Theory of the Avant-Garde* by Peter Bürger, *Modern Language Review* 81, no. 2 (April 1986): 427.

23. See, for instance, Benjamin Buchloh, "Theorizing the Avant-Garde," *Art in America*, November 1984, 19; as well as Buchloh, "The Primary Colors for the Second Time: A Paradigm Repetition of the Neo-Avantgarde," *October* 37 (Summer 1986): 41–52; and Buchloh, *Neo-Avantgarde and Culture Industry: Essays on European and American Art from 1955 to 1975* (Cambridge, Mass.: MIT Press, 2000). See also Hal Foster, *The Return of the Real: The Avant-Garde at the End of the Century* (Cambridge, Mass.: MIT Press, 1996), 1–33.

24. Bürger, "Avant-Garde and Neo-Avant-Garde," 703.

25. Bürger, *Theory of the Avant-Garde*, xlviii.

26. Ibid., l.

27. Theodore Ziolkowski, *German Romanticism and Its Institutions* (Princeton: Princeton University Press, 1990), 320.

28. Bürger, *Theory of the Avant-Garde*, 49.

29. Ibid. (translation slightly modified).

30. Ibid., 109, 72. Bürger does assert that "the avant-gardistes proposed the sublation [*Aufhebung*] of art—sublation in the Hegelian sense of the term: art was not to be simply destroyed [*zerstört*], but transferred to the praxis of life where it would be preserved, albeit in a changed form." Ibid., 49; see also Bürger, "Avant-Garde and Neo-Avant-Garde," 699. However, his vocabulary does not remain consistent through the course of the book because he regularly uses the terminology of destruction, or *Zerstörung* (Bürger, *Theory of the Avant-Garde*, 83, 87–89), negation, or *Negation* (ibid., 47, 49, 53), and sublation, or *Aufhebung* (ibid., 54, 58, 63).

31. Ibid., 53.

32. See ibid., 83.

33. Ibid., 58.

34. Karl Marx, *The 18th Brumaire of Louis Bonaparte* (New York: International, 2004), 15.

35. Bürger, *Theory of the Avant-Garde*, 50.

36. Ibid., 54.

37. Ibid., 53–54 (translation slightly modified).

38. Bürger, "Avant-Garde and Neo-Avant-Garde," 697.

39. Bürger, *Theory of the Avant-Garde*, 54.

40. Bürger, *The Institutions of Art*, 8; see also ibid., 18.

41. See Bürger, *Theory of the Avant-Garde*, 59, 72.

42. Bürger, *The Institutions of Art*, 16.

43. Ibid., 7.

44. Peter Bürger, "The Significance of the Avant-Garde for Contemporary Aesthetics: A Reply to Jürgen Habermas," trans. Andreas Huyssen and Jack Zipes, *New German Critique* 22 (Winter 1981): 21.

45. Bürger, *The Institutions of Art*, 12–13.

46. Eric Hobsbawm, *The Age of Capital, 1848–1875* (New York: Vintage, 1996), 280.

47. Bürger, *Theory of the Avant-Garde*, 23 (translation slightly modified); see also ibid., 113.

48. It appears that this is why he makes the following claim: "the relative dissociation of the work of art from the praxis of life in bourgeois society thus becomes transformed into the (erroneous) idea that the work of art is totally independent of society." Bürger, *Theory of the Avant-Garde*, 46.

49. Bürger, "Avant-Garde and Neo-Avant-Garde," 700.

50. Bürger, *The Institutions of Art*, 10.

51. Ibid., 11.

52. Ibid.

53. Ibid., 12.

54. Bürger, *Theory of the Avant-Garde*, 113.

55. Kant, it should be noted, is primarily interested in the autonomy—or, more precisely, the heautonomy—of the power of judgment, which is by no means strictly equivalent to the autonomy of art.

56. Friedrich Schiller, *On the Aesthetic Education of Man in a Series of Letters*, trans. Reginald Snell (New York: Continuum, 1990), 101.

57. Ibid., 107.

58. Ibid., 39.

59. Ibid., 67, 50.

60. Ibid., 27. See also ibid., 110, as well as 50–51: "All improvement in the political sphere is to proceed from the ennobling of the character. . . . We should need, for this end, to seek out some instrument which the State does not afford us. . . . This instrument is the Fine Arts [*Dieses Werkzeug ist die schöne Kunst*]."

61. Ibid., 46; see also ibid., 88.

62. Bürger appears to recognize this but relies on the problematic argument that autonomy is the condition of possibility for heteronomy, and he describes Schiller's project in "moral-philosophical" terms that tend to downplay or excise its political dimension (*The Institutions of Art*, 82).

63. Schiller, *On the Aesthetic Education of Man*, 25.

64. Ibid., 96.

65. See ibid., 59–60, 103, 110, 123.

66. Ibid., 136.

67. Ibid., 133.

68. Ibid., 76.

69. Ibid., 81; see also ibid., 88.

70. Fiona MacCarthy, "The Aesthetic Movement," *Guardian*, March 26, 2011. See also *The Cult of Beauty: The Aesthetic Movement, 1860–1900*, ed. Stephen Calloway and Lynn Federle Orr (London: V and A Publishing, 2011).

71. Oscar Wilde, *The Picture of Dorian Gray* (Oxford: Oxford University Press, 1991), 129.

72. Buchloh, "Theorizing the Avant-Garde," 19.

73. See, for instance, Bürger, "Avant-Garde and Neo-Avant-Garde," 704.

74. "The epoch of avant-garde art and *littérature d'exception*," Renato Poggioli reminds his readers in an important passage, "is also the era of commercial and industrial art." Poggioli, *The Theory of the Avant-Garde*, trans. Gerald Fitzgerald (Cambridge, Mass.: Belknap Press of Harvard University Press, 1968), 114.

75. Gaughan, "Narrating the Dada Game Plan," in *Art of the Avant-Gardes*, ed. Steve Edwards and Paul Wood (New Haven: Yale University Press, 2004), 343.

76. On all of these issues, see Fionna Barber, "Surrealism, 1924–1929," in *Art of the Avant-Gardes*, 427–48.

4. TOWARD A RECONSIDERATION OF AVANT-GARDE PRACTICES

1. Even Tristan Tzara, who notoriously accentuated the role of destruction in his "Dada Manifesto 1918," also emphasized the importance of spontaneity, folly in the moment, freedom, and life.

2. André Breton, *Manifestoes of Surrealism*, trans. Richard Seaver and Helen R. Lane (Ann Arbor: University of Michigan Press, 1974), 26 (translation slightly modified).

3. Marcel Duchamp, "Ready-Mades," in *Dada: Art and Anti-Art*, by Hans Richter, trans. David Britt (London: Thames and Hudson, 1997), 89.

4. See Frazer Ward, "The Haunted Museum: Institutional Critique and Publicity," *October* 73 (Summer 1995): 84.

5. Carl E. Schorske, *Fin-de-Siècle Vienna: Politics and Culture* (New York: Vintage, 1981), 238–39.

6. See *L'art au XXe siècle*, ed. Ingo F. Walther, vol. 1, *Peinture*, ed. Karl Ruhrberg (Cologne: Taschen, 2002), 161–209.

7. See Kenneth Frampton, *The Evolution of 20th Century Architecture: A Synoptic Account* (Vienna: Springer, 2007), 18.

8. Eric Hobsbawm, *The Age of Extremes: A History of the World, 1914–1991* (New York: Vintage, 1996), 186.

9. "Essentially," writes Eric Hobsbawm, "art nouveau triumphed through furniture, motifs of interior decoration, and innumerable smallish domestic objects ranging from the expensive luxuries of Tiffany, Lalique and the Wiener Werkstätte to the table-lamps and cutlery which mechanical imitation spread through modest suburban homes. It was the first all-conquering 'modern' style." Hobsbawm, *The Age of Empire, 1875–1914* (New York: Vintage, 1989), 230.

10. Renato Poggioli, *The Theory of the Avant-Garde*, trans. Gerald Fitzgerald (Cambridge, Mass.: Belknap Press of Harvard University Press, 1968), 56.

11. Ibid., 124.

12. Ibid., 56.

13. See ibid., 1–15; and especially *Les avant-garde littéraire au XXe siècle*, ed. Jean Weisgerber (Budapest: Akadémiai Kaidó, 1986).

14. Bürger partially nuances his argument in "Avant-Garde and Neo-Avant-Garde" by claiming that the avant-garde movements maintain a continuity with modernism insofar as they "respond to the developmental stage of autonomous art epitomized by aestheticism." Bürger, "Avant-Garde and Neo-Avant-Garde," *New Literary History* 41 (2010): 696. However, he clearly rejects the historical continuity found in authors like Adorno and Greenberg (see ibid., 698). See, for instance, Clement Greenberg, *Art and Culture: Critical Essays* (Boston: Beacon, 1989), 210: "'Abstract expressionism' makes no more of a break with the past than anything before it in modernist art has." See also ibid., 208; and Greenberg, *The Collected Essays and Criticism*, vol. 4, *Modernism with a Vengeance, 1957–1969*, ed. John O'Brian (Chicago: University of Chicago Press, 1993), esp. 93.

15. See John Willett, "Breaking Away," *New York Review of Books*, May 28, 1981.

16. Greenberg, *Art and Culture*, 9.

17. Eric Hobsbawm, *The Age of Capital, 1848–1875* (New York: Vintage, 1996), 298.

18. Ibid., 301.

19. Greenberg, *Art and Culture*, 4.

20. See, for instance, the discussion of the role of the Vienna School of art history in Schorske, *Fin-de-Siècle Vienna*, 234–35.

21. On this point, see Reinhart Koselleck, *Futures Past: On the Semantics of Historical Time*, trans. Keith Tribe (New York: Columbia University Press, 2004); and François Hartog, *Régimes d'historicité: présentisme et expériences du temps* (Paris: Éditions du Seuil, 2003).

22. Poggioli, *The Theory of the Avant-Garde*, 69. See also ibid., 72: "The sense or consciousness of belonging to an intermediate stage, to a present already distinct from the past and to a future in potentiality which will be valid only when the future is actuality, all this explains the origin of the idea of transition, that agonistic concept par excellence."

23. Hobsbawm, *The Age of Extremes*, 190–91.

24. Ibid., 181. See the description of all of the different painterly activities of the avant-garde era in Paul Wood, "Introduction," in *Art of the Avant-Gardes*, ed. Steve Edwards and Paul Wood (New Haven: Yale University Press, 2004), 1–10.

25. Benjamin Buchloh, "Theorizing the Avant-Garde," *Art in America*, November 1984, 21.

26. Wood, "Introduction," 5. See also Poggioli, *The Theory of the Avant-Garde*, 135: "What we said about Flaubert and Joyce can perhaps be repeated for Picasso and Stravinsky. They, like many of the greatest avant-garde artists, do not limit their experiments to the avant-garde itself, but in their anxious search for a new and modern classicism often work with the taste, style, and even the mannerisms of neo- and pseudo-classical forms."

27. Poggioli, *The Theory of the Avant-Garde*, 82. See also ibid., 84: "The avant-garde can and should aspire to the tradition: a tradition conceived of not statically but dynamically."

28. Ibid., 83.

29. Ibid., 223.

30. Ibid., 230.

31. Fred Orton and Griselda Pollock, "*Avant-Gardes* and Partisans Reviewed," in *Pollock and After: The Critical Debate*, ed. Francis Franscina (London: Routledge, 2000), 211.

32. On the popular success of Art Nouveau (and the cinema) in creating new public forms of art and novel types of social existence, see Klaus-Jürgen Sembach, *Art Nouveau: Utopia: Reconciling the Irreconcilable* (Cologne: Benedikt Taschen, 1991).

33. Poggioli, *The Theory of the Avant-Garde*, 133.

34. "Neither the German nor the Russian avant-garde," Hobsbawm observes, "survived the rise of Hitler and Stalin." Hobsbawm, *The Age of Extremes*, 187.

35. As should be clear by now, this does not amount to advocating a heteronomous account of art history in which exogenous factors, such as technology or politics, would determine the totality of aesthetic practices.

5. THE SILENT REVOLUTION: RANCIÈRE'S RETHINKING OF AESTHETICS AND POLITICS

1. For the sake of argumentative concision, I will primarily use the vocabulary of 'regimes,' which Rancière introduced in the late 1990s as an apparent continuation of what he called

'poetics' and 'systems' in *Mute Speech*. On this issue, see my introduction "Through the Looking Glass: The Subversion of the Modernist Doxa," in Jacques Rancière, *Mute Speech*, trans. James Swenson (New York: Columbia University Press, 2011).

2. See Jacques Rancière, *The Names of History: On the Poetics of Knowledge*, trans. Hassan Melehy (Minneapolis: University of Minnesota Press, 1994), 56–57, 66–67; and Rancière, *The Aesthetic Unconscious*, trans. Debra Keates and James Swenson (Cambridge: Polity, 2009), 61–64.

3. See ibid., 24–30.

4. See "Jacques Rancière: Literature, Politics, Aesthetics," interview with Solange Guénoun and James H. Kavanagh, trans. Roxanne Lapidus, *SubStance* 29 (2000): 11–12.

5. As we will see in the next chapter, Rancière also uses the term *aesthetics* in a third sense.

6. See Jacques Rancière, *The Politics of Aesthetics*, ed. and trans. Gabriel Rockhill (London: Continuum, 2004), 20–21.

7. Jacques Rancière, "What Aesthetics Can Mean," in *From an Aesthetic Point of View: Philosophy, Art and the Senses*, ed. Peter Osborne (London: Serpent's Tail, 2000), 19.

8. See Jacques Rancière, "Ten Theses on Politics," in *Theory and Event* 5, no. 3 (2001); and Rancière, *Dis-agreement: Politics and Philosophy*, trans. Julie Rose (Minneapolis: University of Minnesota Press, 1999), 21–42, 61–93.

9. Rancière's work on politics shows strong signs of selective historicism insofar as he distinguishes between the singularity of ahistorical forms like politics, the police, and democracy, on the one hand, and the multiplicity of their historical appearances, on the other.

10. Rancière's views on politics should not be confounded with the proliferation of extra-phenomenological discourses on the Other, nor should they be considered a simple extension of Lyotard's project in *The Differend*. Although he clearly relies on the latter's analysis, he is careful to distinguish his project from what he considers to be the essentially discursive nature of *le différend*. Thus, what he refers to as political disagreement (*mésentente*) must not be confused with a lack of comprehension (*méconnaissance*), a misunderstanding (*malentendu*), or a clash between heterogeneous phrase regimens or genres of discourse. *La mésentente* is a conflict over what is meant by "to speak" and over the very distribution of the sensible that distinguishes the sayable from the unsayable, the audible from the inaudible, the visible from the invisible. It is worth noting, in this regard, that Rancière has frequently emphasized the contradiction inherent in the various philosophical attempts to bear witness to the Other: giving voice to the poor, the underprivileged, and the like runs the risk of silencing them in the name of the voice that speaks for them (it might be added that the only way the interminably guilty discourse of deconstruction can correct this is by continuing to talk and write about its own demeritorious discourse).

11. "Jacques Rancière: Literature, Politics, Aesthetics," 13.

12. Ibid.

13. See the following works by Foucault: *The Order of Things: An Archeology of the Human Sciences* (New York: Random House, 1970); *Death and the Labyrinth: The World of Raymond Roussel* (London: Continuum, 2004); and *Dits et écrits*, vol. 1, *1954–1969* (Paris: Éditions Gallimard, 1994), 233–61, 338–437, 498–584.

14. See Rancière, *The Names of History*, 8–9.
15. See Rancière, *The Politics of Aesthetics*, 20–30.
16. See Jacques Rancière, *Aux bords du politique* (Paris: La Fabrique-Éditions, 1998), 128–47 (this chapter was not included in the English translation).
17. See Jacques Rancière, "Is There a Deleuzian Aesthetics?," trans. Radmila Djordjevic, *Qui Parle* 14, no. 2 (Spring/Summer 2004): 1–14.
18. See Jacques Rancière, *The Flesh of Words: The Politics of Writing*, trans. Charlotte Mandell (Stanford: Stanford University Press, 2004), 146–64.
19. To my knowledge, Rancière has yet to deal with the exceptions to this general rule, the best example of which is to be found in Deleuze, "He Stuttered," in *Essays Critical and Clinical*, trans. Daniel W. Smith and Michael A. Greco (London: Verso, 1998), 107–14.
20. See Jacques Rancière, *Film Fables*, trans. Emiliano Battista (Oxford: Berg, 2006), 107–23.
21. See Rancière, *The Politics of Aesthetics*, 13.
22. Rancière has explicitly restricted his claims to the Western tradition—for what is perhaps one of the first times—in the opening pages of *Aisthesis: scènes du régime esthétique de l'art* (Paris: Éditions Galilée, 2011).
23. Rancière's study of Rossellini in *Short Voyages to the Land of the People*, trans. James Swenson (Stanford: Stanford University Press, 2003) provides one of the clearest discussions of the artistic manifestation of equality and its proximity to *la politique* (105–34).
24. See, for example, his analyses of Flaubert, Mallarmé, and Proust in *Mute Speech*, his detailed investigation of Mallarmé in the work whose title bears his name, and all of the individual studies in *The Flesh of Words* and *Film Fables*.
25. It is worth noting in this regard that Rancière never fully enumerates the principles of each regime and that he avoids systematizing them into a closed set of axioms.
26. The equality discernible in various types of democratic literarity must, moreover, be analyzed through the historically specific forms within which it appears. It should not be unduly identified with equality in the political sense.

6. PRODUCTIVE CONTRADICTIONS: FROM RANCIÈRE'S POLITICS OF AESTHETICS TO THE SOCIAL POLITICITY OF THE ARTS

1. Jacques Rancière, *Aesthetics and Its Discontents*, trans. Steven Corcoran (Cambridge: Polity, 2009), 25–26 (translation slightly modified). See also Jacques Rancière, *Et tant pis pour les gens fatigués* (Paris: Éditions Amsterdam, 2009), 590.
2. See, for instance, Jacques Rancière, "The Method of Equality," in *Jacques Rancière: History, Politics, Aesthetics*, ed. Gabriel Rockhill and Philip Watts (Durham: Duke University Press, 2009), 284.
3. See, for example, Rancière, *Et tant pis*, 321, 431, 609.
4. See, for instance, ibid., 367; and Jacques Rancière, *The Politics of Literature*, trans. Julie Rose (Cambridge: Polity, 2011), 43–44.

5. Rancière, *Aesthetics and Its Discontents*, 24.

6. Jacques Rancière, "The Politics of Literature," *Substance* 103, vol. 33, no. 1 (2004): 12.

7. Ostensibly in order to avoid the contradiction between D1 and D2, Rancière has increasingly referred to politics qua distribution of the sensible as the configuration *and* reconfiguration of the sensory order. See, for instance, Rancière, *Aesthetics and Its Discontents*, 24.

8. Rancière, "The Politics of Literature," 10.

9. Jacques Rancière, *Dis-agreement*, trans. Julie Rose (Minneapolis: University of Minnesota Press, 1999), 29 (translation slightly modified). It is arguable that Rancière uses at least two definitions of the police, and that the second opens space for partially avoiding the contradiction of politics and the police: (*i*) the given distribution of the sensible or the self-evident system of sensory facts and (*ii*) a specific distribution of the sensible, "whose principle is the absence of a void or of a supplement." Rancière, "Ten Theses on Politics," *Theory and Event* 5, no. 3 (2001) (translation slightly modified).

10. Rancière, *Dis-agreement*, 29–30 (translation slightly modified).

11. Jacques Rancière, *The Politics of Aesthetics*, ed. and trans. Gabriel Rockhill (London: Continuum, 2004), 22–23.

12. Ibid., 23. See also Rancière, *Aesthetics and Its Discontents*, 36.

13. This level of abstraction is also visible in Rancière's tendency—with the notable exception of worker's literature—to privilege the analysis of de jure equality within works of art over the examination of the de facto institutional inequality inherent in their social inscription (such as the hierarchy separating the 'great works' of authors like Flaubert from the *n'importe quoi* of cartoons, pornography, and the like).

14. Rancière, *Le spectateur émancipé* (Paris: Éditions La Fabrique, 2008), 65–66. The essay cited is not included in *The Emancipated Spectator*.

15. Ibid., 72–73.

16. See, for instance, Rancière, *Et tant pis*, 368, 372.

17. Rancière, *Aesthetics and Its Discontents*, 36 (translation slightly modified).

18. Ibid., 40 (translation slightly modified).

19. Ibid., 60 (translation slightly modified).

20. See, for example, Rancière, *Et tant pis*, 471, 559.

21. Rancière, *Le spectateur émancipé*, 83. For Rancière, this "joining" is dependent on the appropriation of aesthetic configurations by political actors: true politics (D2) is assumed to be outside the realm of the arts (D3)(T2).

22. See T. V. Reed, *The Art of Protest* (Minneapolis: University of Minnesota Press, 2005), 1, as well as Bill Guttentag and Dan Sturman's documentary film, *Soundtrack for a Revolution* (2009).

23. Cited in Frances Stonor Saunders, *The Cultural Cold War: The CIA and the World of Arts and Letters* (New York: New Press, 2000), 350.

24. See, for instance, Andrea Fraser, "From the Critique of Institutions to an Institution of Critique," *Artforum* 44, no. 1 (September 2005): 278–83; and Hans Haacke, "Statement," in *Art in Theory, 1900–2000*, ed. Charles Harrison and Paul Wook (Malden, Mass.: Blackwell, 2003), 930–31. For another interesting and troubling account, see Don Argott's film *The*

Art of the Steal (2009), which details the ostensible theft and displacement of the famous collection at the Barnes Foundation.

25. However, it should be noted that Rancière has been fleshing out this thesis in his most recent work.

26. See Rancière, *Et tant pis*, 429, 589–91, 606, 635; Rancière, "The Method of Equality," 285; and Rancière, *The Emancipated Spectator*, trans. Gregory Elliott (London: Verso, 2009), 14, 105; *Le spectateur émancipé*, 20, 62–64, 114.

27. See Rancière, *Et tant pis*, 556.

28. I have critically explored this issue in "La différence est-elle une valeur en soi? Critique d'une axiologie métaphilosophique," *Symposium* 17, no. 1 (Spring 2013): 250–72.

29. Rancière, *Et tant pis*, 624–25.

30. Rancière, *The Nights of Labor*, trans. John Drury (Philadelphia: Temple University Press, 1989), 82.

31. See, for instance, Rancière, "The Method of Equality," 274.

32. Ibid., 277.

33. Ibid., 274.

34. Ibid., 280 (my emphasis).

35. Rancière, *Et tant pis*, 593.

36. Rancière, "The Method of Equality," 285 (my emphasis).

37. Rancière, *Le spectateur émancipé*, 70. See also Rancière, *Et tant pis*, 559; and Rancière, "The Politics of Literature," 11–12.

38. Rancière, *Aesthetics and Its Discontents*, 23 (translation slightly modified). See also Rancière, *Le spectateur émancipé*, 61; and Rancière, *Et tant pis*, 469.

39. See, for instance, Rancière, *Le spectateur émancipé*, 69; and Rancière, "The Method of Equality," 279.

40. See Rancière, *Le spectateur émancipé*, 67. Rancière does, of course, make room for the strategies deployed by artists who attempt to change the reference points of the visible and the sayable. See ibid., 72–73.

41. Moreover, Rancière defines politics (D2) as a transhistorical process that is always and everywhere the same. Although he does, of course, recognize that there are certain historical differences and a "history of the political," the form of politics proper remains an abstract constant that is or is not implemented in various and sundry historical configurations. Rancière, "The Method of Equality," 287; see also Rancière, *The Politics of Aesthetics*, 51.

42. See Rancière, *The Politics of Aesthetics*, 20–30. For similar arguments regarding the historicity of the modern concept of art, see Paul Oskar Kristeller, *Renaissance Thought and the Arts: Collected Essays* (Princeton: Princeton University Press, 1990); and Larry Shiner, *The Invention of Art: A Cultural History* (Chicago: University of Chicago Press, 2001).

43. On these issues, see the work of some of the theorists who have developed research on circulation and reception, such as Hans Robert Jauss, *Toward an Aesthetic of Reception*, trans. Timothy Bahti (Minneapolis: University of Minnesota Press, 1982); and Raymond Williams, *The Long Revolution* (New York: Columbia University Press, 1961).

44. For the sake of concision, I am not considering those works of art that are, in and of themselves, forms of political action, such as Gianni Motti's UN intervention during the fifty-third session of the Commission on Human Rights in Geneva (1997). Occupying the seat of the absent Indonesian delegate, Motti made a speech prior to the vote on the forty-eighth resolution concerning ethnic minorities, and he thereby helped instigate a walkout by representatives of the American Indians and other ethnic groups.

45. Rancière's passing comments regarding the politicity of the novel space-time of the aesthetic regime of art are extremely provocative precisely insofar as this new space-time is linked to the emergence of the modern museum and a new social framework of exhibition.

46. It is interesting that Rancière admits to learning about the US program of extraordinary rendition—an extraordinary euphemism for the illegal international kidnapping, transfer, and detention of suspected 'terrorists'—from an artistic performance by Walid Raad. See Rancière, *Et tant pis*, 606.

47. It is rather ironic that the FBI file on William Carlos Williams described him as being "a sort of absent minded professor type" who employs "an 'expressionistic' style which might be interpreted as being 'code.'" Cited in Saunders, *The Cultural Cold War*, 195.

48. See, for instance, Benedict Anderson, *Imagined Communities* (London: Verso, 2006); Esteban Buch, *La neuvième de Beethoven: une histoire politique* (Paris: Éditions Gallimard, 1999); and Aimé Césaire, *Discours sur le colonialisme* (Paris: Éditions Présence Africaine, 2004), 85–86.

49. Claire Bishop, "Antagonism and Relational Aesthetics," *October* 110 (Fall 2004): 69.

50. Hugo, *Selected Poems of Victor Hugo*, trans. E. H. and A. M. Blackmore (Chicago: University of Chicago Press, 2001), 165–67.

51. "Brave New World," *Socialist Review* 21 (1991): 62. In the nineteenth century, Charles Baudelaire had already insisted on the intertwining relationship between style and politics. See Baudelaire, *Oeuvres complètes*, ed. C. Pichois (Paris: Éditions Gallimard, 1976), 2:494.

7. THE POLITICITY OF 'APOLITICAL' ART: A PRAGMATIC INTERVENTION INTO THE ART OF THE COLD WAR

1. Serge Guilbaut, *How New York Stole the Idea of Modern Art: Abstract Expressionism, Freedom, and the Cold War*, trans. Arthur Goldhammer (Chicago: University of Chicago Press, 1983), 1–2.

2. Ibid., 8.

3. "Electronic Prying Grows," *New York Times*, April 27, 1966.

4. Frances Stonor Saunders, *The Cultural Cold War: The CIA and the World of Arts and Letters* (New York: New Press, 2000), 398. It is more than ironic that this work was euphemistically retitled for its American release in 2000.

5. Thomas W. Braden, "I'm Glad the CIA Is 'Immoral,'" *Saturday Evening Post*, May 20, 1967.

6. Ibid.

7. Ibid.

8. Christopher Lasch, "The Cultural Cold War," in *Towards a New Past: Dissenting Essays in American History*, ed. Barton J. Bernstein (London: Chatto and Windus, 1970), 356.

9. Max Kozloff, "American Painting During the Cold War," in *Pollock and After: The Critical Debate*, ed. Francis Frascina (London: Routledge, 2000), 131.

10. Eva Cockcroft, "Abstract Expressionism, Weapon of the Cold War," in Frascina, *Pollock and After*, 147–48.

11. It is interesting to note that "MoMA bought the U.S. pavilion in Venice and took sole responsibility for the exhibitions from 1954 to 1962." Ibid., 150.

12. Rockefeller also went on to become the assistant secretary of state for Latin American affairs, and in the early 1950s Allen Dulles and Thomas Braden briefed him on covert operations. See Saunders, *The Cultural Cold War*, 260–61, as well as 144 on the role of the Rockefeller Foundation in the Cold War.

13. See E. W. Kenworthy, "Whitney Trust Got Aid," *New York Times*, February 25, 1967.

14. Cockcroft, "Abstract Expressionism," 150.

15. Ibid., 149.

16. Saunders, *The Cultural Cold War*, 264.

17. Cockcroft, "Abstract Expressionism," 150.

18. Robert Burstow and Irving Sandler cite personal conversations with Thomas Braden and Waldo Rasmussen suggesting that, at least within certain windows of time, they were unaware of any CIA involvement in directly funding American painting. See Burstow, "The Limits of Modernist Art as a 'Weapon of the Cold War': Reassessing the Unknown Patron of the Monument to the Unknown Political Prisoner," *Oxford Art Journal* 20, no. 1 (1997): 69, 78; as well as Sandler, *Abstract Expressionism and the American Experience: A Reevaluation* (Lenox, Mass.: Hard Press, 2009), 191.

19. See, for instance, Sandler, *Abstract Expressionism*, 182; and Michael Kimmelman, "Revisiting the Revisionists: The Modern, Its Critics, and the Cold War," in *The Museum of Modern Art at Mid-Century: At Home and Abroad*, ed. John Elderfield (New York: Museum of Modern Art, 1994), esp. 299.

20. See Michael L. Krenn, *Fall-Out Shelters for the Human Spirit: American Art and the Cold War* (Chapel Hill: University of North Carolina Press, 2005), 9–49.

21. Cited in William Hauptman, "The Suppression of Art in the McCarthy Decade," *Artforum* 12 (October 1973): 48.

22. "Artists Protest Halting Art Tour," *New York Times*, May 6, 1947. See also Jane de Hart Mathews, "Art and Politics in Cold War America," *American Historical Review* 81, no. 4 (October 1976): 762–87.

23. Cited in Hauptman, "The Suppression of Art," 50.

24. Saunders, *The Cultural Cold War*, 254.

25. Cited in Hauptman, "The Suppression of Art," 48.

26. Saunders, *The Cultural Cold War*, 271.

27. See Krenn, *Fall-Out Shelters*, 9.

28. Ibid., 10.

29. Braden, "I'm Glad."

30. Ibid. See also Thomas Braden, "The Birth of the CIA," *American Heritage* 28, no. 2 (1966): 4–13.

31. Quoted in Saunders, *The Cultural Cold War*, 98.

32. Ibid., 197.

33. Ibid., 1.

34. Ibid., 2.

35. Hugh Wilford, *The Mighty Wurlitzer: How the CIA Played America* (Cambridge, Mass.: Harvard University Press, 2008), 101–2. For details concerning the CCF's budget and funding circuits, see Giles Scott-Smith, *The Politics of Apolitical Culture: The Congress for Cultural Freedom, the CIA and Post-War American Hegemony* (New York: Routledge, 2002), esp. 122–24.

36. Wilford, *The Mighty Wurlitzer*, 103.

37. Saunders, *The Cultural Cold War*, 377. According to Saunders, the instant success of *The New York Review* "clearly signalled that not all American intellectuals were happy to act as Cold War legitimists orbiting around the national security state." Ibid., 361.

38. Cockcroft, "Abstract Expressionism," 150–51.

39. Guilbaut, *How New York*, 110.

40. Ibid., 35. See Trotsky's essay "Art and Politics," published in the *Partisan Review*.

41. "The CIA has declassified only a tiny proportion of the presumably vast cache of records." Wilford, *The Mighty Wurlitzer*, 8–9.

42. Frances Stonor Saunders, "Modern Art Was CIA 'Weapon,'" *Independent*, October 22, 1995. It is surprising that some of the antirevisionists have either ignored or simply dismissed this testimony: see Burstow, "The Limits of Modernist Art," 68; and David Caute, *The Dancer Defects: The Struggle for Cultural Supremacy During the Cold War* (Oxford: Oxford University Press, 2003), 551.

43. Saunders, "Modern Art Was CIA 'Weapon.'"

44. Saunders, *The Cultural Cold War*, 119; see also ibid., 268.

45. Cited in ibid., 268.

46. Wilford, *The Mighty Wurlitzer*, 107.

47. Ibid., 108.

48. Saunders, *The Cultural Cold War*, 116.

49. Cited in ibid.

50. On Eliot and Pound, see ibid., 245–51.

51. See Wilford, *The Mighty Wurlitzer*, 109.

52. Ibid., 111, 108–9.

53. See ibid., 109–10.

54. Ibid., 111.

55. See ibid., 111–12.

56. Ibid., 112.

57. Ibid., 120.

58. However, Wilford also argues that Hollywood's financial viability and self-censorship made it less of a candidate for CIA patronage than noncommercial cultural endeavors. For

a detailed and insightful analysis of the role of the American film industry in the cultural Cold War, see Peter Decherney, *Hollywood and the Culture Elite: How the Movies Became American* (New York: Columbia University Press, 2005).

59. See Wilford, *The Mighty Wurlitzer*, 117–19; and Daniel Leab, "The American Government and the Filming of George Orwell's Animal Farm in the 1950s," *Media History* 12, no. 2 (2006): 133–55.

60. Wilford, *The Mighty Wurlitzer*, 121.

61. Ibid., 10. Saunders, whose thesis is clearly being called into question here, claims that "I have always said that this was not some sort of ventriloquist act except in some cases— there are clearly some pieces planted at certain times and they actually were penned by CIA agents, but that's minimal and almost insignificant." "Revealing the Parameters of Opinion: An Interview with Frances Stonor Saunders," conducted by W. Scott Lucas, in *The Cultural Cold War in Western Europe, 1945–1960*, ed. Giles Scott-Smith and Hans Krabbendam (London: Frank Cass, 2003), 25.

62. Krenn, *Fall-Out Shelters*, 238.

63. Theodor Adorno, Walter Benjamin, Ernst Bloch, Bertolt Brecht, and Georg Lukács, *Aesthetics and Politics* (London: Verso 2002), 162, 163.

64. Ibid., 143. See also Saunders, *The Cultural Cold War*, 30; and Scott-Smith, *The Politics of Apolitical Culture*, 91–93. On the major economic support provided by the Rockefeller Foundation to the Institute for Social Research during the Nazi reign, see Nancy Jachec, *The Philosophy and Politics of Abstract Expressionism, 1940–1960* (Cambridge: Cambridge University Press, 2000), 47.

65. Rolf Wiggershaus, *The Frankfurt School: Its History, Theories, and Political Significance*, trans. Michael Robertson (Cambridge, Mass.: MIT Press, 1994), 406. "In 1943," writes Wiggershaus, "six more or less full associates of the Institute [for Social Research] were in full- or part-time government service, and were in this way visibly contributing to the war effort." Ibid., 301. Four of them, including Herbert Marcuse, worked for the Office of Strategic Services (OSS), the wartime predecessor to the CIA. For a revealing account of the work done by Marcuse, Franz Neumann, and Otto Kirchheimer for the Research and Analysis Branch of the OSS, see Raffaele Laudani, ed., *Secret Reports on Nazi Germany: The Frankfurt School Contribution to the War Effort* (Princeton: Princeton University Press, 2013).

66. Saunders, "Revealing the Parameters," 25. In *The Politics of Apolitical Culture*, Scott-Smith writes: "Culture, and especially the autonomous, apolitical culture that the Congress [for Cultural Freedom] ostensibly represented, was institutionalized by the US government (in particular the CIA) as an ideological force representative of the free society of the West from which it emerged" (1).

67. Saunders, *The Cultural Cold War*, 312.

68. In spite of the fact that she bases some of her arguments on the contestable analogy between avant-garde art and political progressivism, Nancy Jachec has provided an interesting account of the leftist background and orientation of many of the Abstract Expressionists in *The Philosophy and Politics of Abstract Expressionism*.

69. Annette Cox, *Art-as-Politics: The Abstract Expressionist Avant-Garde and Society* (Ann Arbor, Mich.: UMI Research Press, 1982), 25.

70. Ad Reinhardt, *Art-as-Art: The Selected Writings of Ad Reinhardt*, ed. Barbara Rose (New York: Viking Press, 1975), 175.

71. Cited in Cox, *Art-as-Politics*, 114.

72. See his "Government and the Arts" article in *Art-as-Art*, where he is critical of corrupt economic and political practices.

73. *Jean-Luc Godard par Jean-Luc Godard*, ed. Alain Bergala (Paris: Éditions de l'Étoile, Cahiers du cinéma, 1985), 238.

74. See Emile de Antonio, "The Agony of the Revolutionary Artist," in *Emile de Antonio: A Reader*, ed. Douglas Kellner and Dan Streible (Minneapolis: University of Minnesota Press, 2000), 261–64.

75. Cited in Randolph Lewis, *Emile de Antonio: Radical Filmmaker in Cold War America* (Madison: University of Wisconsin Press, 2000), 155.

76. Kellner and Streible, *Emile de Antonio*, 362.

77. This is indeed what the editors of *Emile de Antonio* suggest. Ibid., 361.

78. Louis Menand, "American Art and the Cold War," *New Yorker*, October 17, 2005.

79. Ibid.

80. David and Cecile Shapiro, "Abstract Expressionism: The Politics of Apolitical Painting," in Frascina, *Pollock and After*, 194.

81. Menand, "American Art."

82. Cockcroft, "Abstract Expressionism," 154.

8. RETHINKING THE POLITICS OF AESTHETIC PRACTICES: ADVANCING THE CRITIQUE OF THE ONTOLOGICAL ILLUSION AND THE TALISMAN COMPLEX

1. Jean-Paul Sartre, *"What Is Literature?," and Other Essays* (Cambridge, Mass.: Harvard University Press, 1988), 28.

2. Theodor Adorno, *Notes to Literature*, ed. Rolf Tiedemann, trans. Shierry Weber Nicholsen (New York: Columbia University Press, 1992), 2:84.

3. Gertje R. Utley, *Picasso: The Communist Years* (New Haven: Yale University Press, 2000), 25.

4. Cited in ibid., 1.

5. R. W. Fassbinder, *The Anarchy of the Imagination*, ed. Michael Töteberg and Leo A. Lensing (Baltimore: Johns Hopkins University Press, 1992), 61.

6. For the sake of brevity, I am not considering here works of art that are themselves types of political action. However, it should be noted that even these aesthetico-political acts do not produce univocal social effects and do not, therefore, function like talismans with innate political powers.

7. David L. Robb, *Operation Hollywood: How the Pentagon Shapes and Censors the Movies* (Amherst, N.Y.: Prometheus Books, 2004), 25.

8. Ibid.

9. John Pilger, "Hollywood's New Censors," February 19, 2009, www.antiwar.com/orig/pilger
.php?articleid=14271, accessed on October 1, 2013.

10. Sartre, "*What Is Literature?*" 52; see also ibid., 93. In fact, I would want to go further than
Sartre and argue that the very creation of a work of art, insofar as it is a social practice
undertaken by a situated cultural agent, is always already a social process (even if it takes
place in utter isolation).

11. Cornelius Castoriadis, *Postscript on Insignificance: Dialogues with Cornelius Castoriadis*, ed.
Gabriel Rockhill, trans. Gabriel Rockhill and John V. Garner (London: Continuum, 2011),
11.

12. Theodor Adorno, Walter Benjamin, Ernst Bloch, Bertolt Brecht, and Georg Lukács, *Aesthetics and Politics: The Key Texts of the Classic Debate within German Marxism* (London:
Verso 2002), 123.

13. See, for example, Theodor Adorno, *The Culture Industry: Selected Essays on Mass Culture*
(London: Routledge, 2001), 196.

INDEX

Abstract Expressionism, 10, 193–202, 216–17.
 See also CIA patronage of the arts
Adorno, Theodor, 73, 93, 95, 100, 208; and
 autonomy of art, 207–9; Brecht and, 220;
 Lukács and, 66, 207–8; passing statement
 on film audience, 230–31; Picasso and,
 220–21
Advancing American Art (State Department
 exhibit), 197–98
The Aesthetic Dimension (Marcuse), 66–74
aesthetic regime of art (Rancière's concep-
 tion), 141–42, 151–53, 256n45; and ambigu-
 ous nature of homonyms, 154; and art in
 the singular, 179; contradictions in, 159;
 Deleuze and, 155–58; and distribution of
 the sensible, 153–54, 172; and Rancière's
 definitions of aesthetics, 167
Aesthetic Theory (Adorno), 67, 73
The Aesthetic Unconscious (Rancière), 161
aesthetics: aesthetic form (*see* form-
 alism); aestheticism, 114; contradiction of aesthet-
 ics, 168; Deleuze and, 156–57; dissensus,
 169, 170, 176, 177; and distribution of the
 sensible, 140–41, 144, 172, 177; Rancière's
 definitions, 167–68, 172, 177; Rancière's
 distinction between two meanings of
 "aesthetics," 140–41, 144
Aesthetics and Its Discontents (Rancière), 170
Agee, Philip, 215
agency, 6, 44–55; alternative account of, 6–7,
 235–37; and the avant-garde, 105, 119, 125,
 126; and Cold War politics, 10, 205–8; con-
 tending agencies within variegated social
 topography, 44, 45, 52, 236; and description
 of radical historicism, 225; examples of
 agency outside the human subject, 44–46;
 and ontological illusion, 46; and *Painters
 Painting* (documentary film), 209–15; and
 political efficacy, 54–55; range of, defined,

46; of readers, 77–78; and Sartre's account
 of literary history, 84; in *Sherlock Jr.* (film),
 45–46; site of, defined, 46; and social
 dimensions of aesthetic practices (cre-
 ation, circulation, reception), 47, 48, 192;
 and talisman complex, 46; tier of, defined,
 46; types and tiers of, 44–46, 207, 217, 236;
 and U.S. government, 207; and Vietnam
 War protests, 54–55
ahistoricism, 2–3, 18, 31–32, 80, 224, 252n9. *See
 also* transhistorical notions
alternative logic of history. *See* history, alterna-
 tive logic or order
Altes Museum (Berlin), 101–2
analytic of immanent practices, 225–26; distin-
 guished from theory, 4, 37; and interven-
 tionist concepts, 32–33, 191–92; and theory
 of multidimensional agency, 44–55. *See also*
 social politicity of aesthetic practices
Annales School, 145–47
Aragon, Louis, 116
The Archeology of Knowledge (Foucault), 146–47
architecture and design, 9, 126, 130–31, 133
Aristotle and Aristotelianism, 63, 158; Aris-
 totelian ontology and realist literature,
 61; Aristotelian para-politics, 142–43;
 and forms of cultural transition, 21; and
 representative regime of art (Rancière's
 conception), 141; and "what is man?"
 question, 61
art: as act of sublimation, 71; art by desti-
 nation and art by metamorphosis, 27;
 artistic commitment/*engagement* (*see*
 commitment/*engagement*, artistic); asser-
 tion that there is no *epistēmē* of art and
 politics, 5, 35, 180, 228; autonomy of (*see*
 autonomy of art); Badiou on transhistori-
 cal essence of, 24–25, 27–28; bourgeois art,
 67, 97–98, 103, 106, 126;